Ralph STEADman 's

∪NExTiNCTioN

BLOOMSBURY

LONDON · OXFORD · NEW YORK · NEW DELHI · SYDNEY

PIECE OF DOVE

Bloomsbury Natural History
An imprint of Bloomsbury Publishing Plc

50 Bedford Square 1385 Broadway
London New York
WC1B 3DP NY 10018
UK USA

www.bloomsbury.com

First published 2015

British Library Cataloguing-in-Publication Data
A catalogue record for this book is available from the British Library.

Library of Congress Cataloguing-in-Publication data has been applied for.

ISBN: HB: 978-1-4729-1168-1
ePDF: 978-1-4729-2505-3
ePub: 978-1-4729-1169-8

2 4 6 8 10 9 7 5 3 1

Designed in UK by Julie Dando, Fluke Art
Printed and bound in Tallers Gràfics Soler, Barcelona, Spain.

To find out more about our authors and books visit www.bloomsbury.com.
Here you will find extracts, author interviews, details of forthcoming events and the option to sign up for our newsletters.

WITH A WING and a PRAYER

COMMENTARY

by

CERI LEVY

Theory of Nextinction

Ceri: We should write about the birds that are next in line for extinction.

Ralph: The next in line for extinction… are waiting for… nextinction.

Ceri: Nextinction! By George, I think he's got it. Perfect, Ralph, absolutely perfect.

Ralph: It's obvious, really.

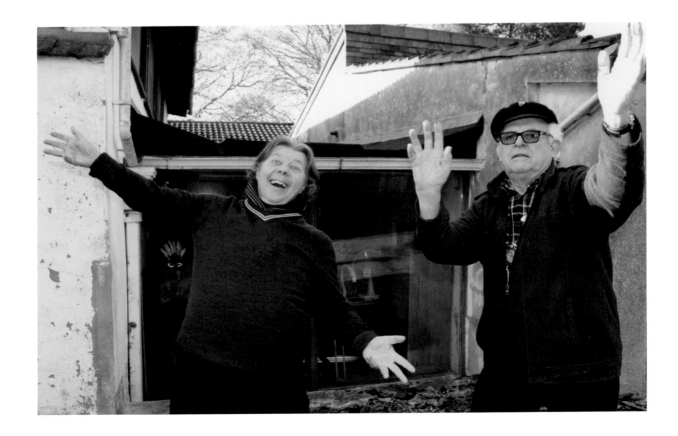

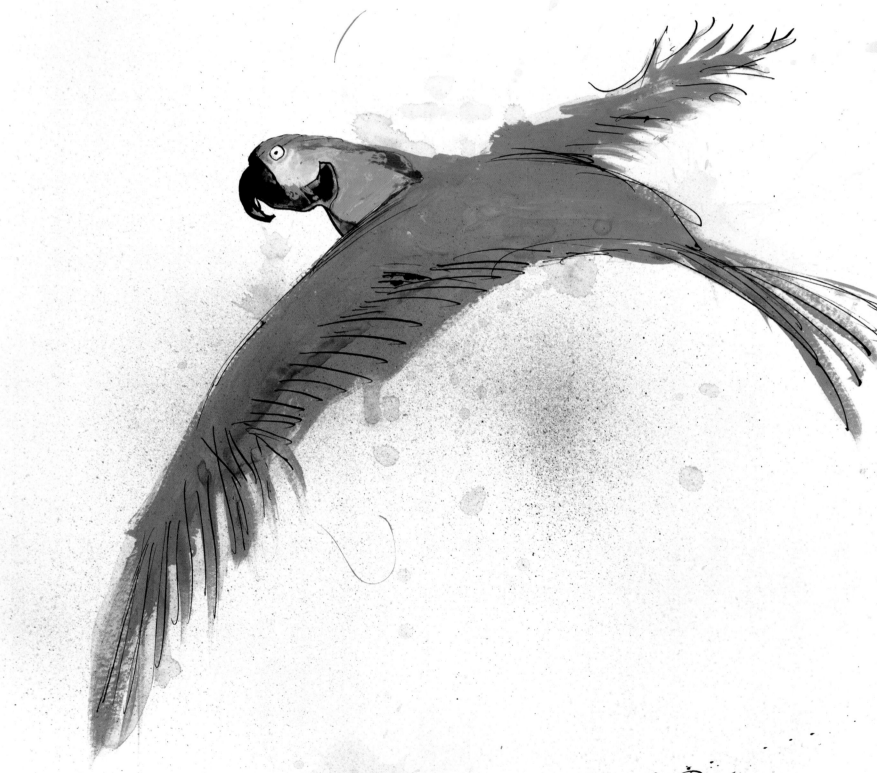

BLUE-THROATED MACAW IN FLIGHT... Ralph STEADman

Nextinction Awaits

What led to this conversation was the moment Jim Martin, our editor at Bloomsbury, called me and said, 'I think it's high time that you and Ralph did another book, so have a think about what that book could be. Get your thinking caps on and get back to me. Cheerio!'

Ralph and I thought long and hard about a follow-up book to *Extinct Boids* and we trawled through potential ideas until it suddenly flashed up that we needed to create a positive book about present-day problems, a book that could show that all is not futile. We want to gently massage the message down throats that we can save creatures. So many species today have become endangered too easily and too readily. And the creatures and monsters that thrive through this era of extinction are the banks, supermarkets, shopping malls, corporate entities and organisations who really should put far more back into the world in return for their role in the decimation of so much nature, which threatens not only our wildlife but also mankind itself. We need change.

If our last book was about all the birds we have lost, then this book has a positive spin as in principle it is about all the birds we can save. These nextinct birds are teetering on the brink and we need to find them and share their stories with you. There is a chance they can be removed from the darkness and returned to the light. In so many ways these birds are the forgotten birds for most people, even though they are living creatures. Everyone knows at least one extinct bird, usually the Dodo, but how many people can actually name a Critically Endangered species, let alone understand what one is? And why are we so much more connected with our past than our present? Why do more people know of an extinct species rather that the plight of the Black Stilt? This collection of birds that Ralph and I are exploring can rectify this. The majority of these critters could be saved with the right medication and there are doctors at the ready waiting to apply the correct cures. It just needs funding through time, money and education.

Scientists estimate the rate of extinction of all species on Earth to be between 1,000 and 10,000 times higher than the natural rate of extinction. As for the birds, since the year 1500, 140 species have become extinct. In this the 21st century there are 1,373 species (one in eight of the world's birds) that are threatened with extinction and 213 species that are specified as Critically Endangered by BirdLife International for the IUCN Red List (International Union for Conservation of Nature), which generally projects that these species will in all likelihood become extinct within the next 10–20 years. This means that too many species are crucially walking the tightrope towards imminent extinction. These birds are somewhere terrible.

What causes the majority of problems? The simple answer is man. Simple enough? But oh how complex everything becomes after that first thought. Many of these birds don't only face one issue but several. Agriculture is the highest ranked threat, with 123 species affected by it. In second place are invasive species, which threaten 108 species; third is climate change, affecting 86 species; fourth is logging at 74 species; then fifth is hunting and trapping, which decimates 64 species. There are lower ranked causes such as human disturbance, energy production and pollution but these first five are the main causes of nextinction.

This is very much a present-tense book. What we describe happening to the birds is happening at this moment in time. What you see and read is our immediate response to this situation. Throughout this period of working with Ralph I have been continuing my journeys through the bird world as I endeavour to complete my filmic exploits of *The Bird Effect*, a documentary I have been making examining how much birds affect people. Conversely, the more I learn, the more I find how much, on the whole, we adversely affect them. I am not the same person I was before this adventure began and for that I am grateful. I have met some wonderful people, have been to extraordinary places and seen bountiful birds. I have also become engrossed with the subject of exactly what it is that threatens our birdlife.

I have been to Malta and seen the unnecessary slaughter of migratory birds by hunters – hunters who have a voracious appetite for the taking of birds' lives and who seemingly desire ownership of their very souls. This is a continual process throughout the world and Malta is just one representative of a large clan of shooters, but what I saw on that island is indicative of a fraternity that numbers millions of people aiming their guns skywards in the name of sport.

I have worked with many people at BirdLife International and the RSPB (Royal Society for the Protection of Birds) and seen first-hand conservation in action. This book points out a lot of the work done by BirdLife's Preventing Extinctions Programme, which endeavours to raise money and awareness to save Critically Endangered birds and has our continued support.

I have travelled far and wide and found birds to be everywhere. But the more I talk to people, the more I discover that abundance is not as abundant as it once was. And so this book is a very necessary step in my development as a would-be conservationist and a perfect place for Ralph to demonstrate a different viewpoint on so many wonderful birds. We're just a couple of gonzovationists who are sticking up for the little guys.

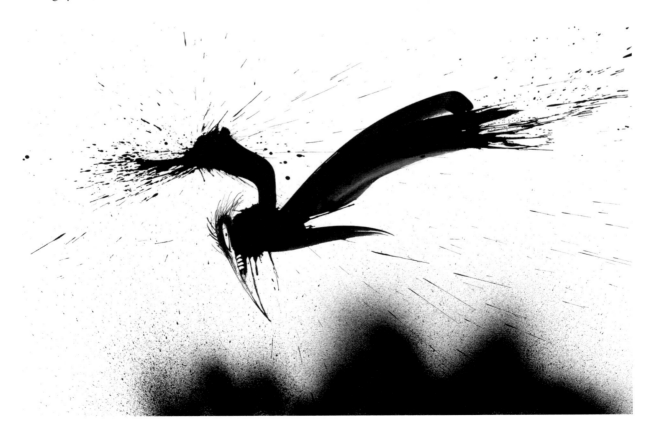

The Guano Collector

The Science and How a Small Amount of Money Can Save a Species

BirdLife International is the NGO that coordinates and organises worldwide projects to look after what remains of our birds. They work in conjunction with governments, other NGOs, scientists and on-the-ground conservationists. Money is needed at all times to help save the world's birds and the continual search for supporters and funding is relentless. I wanted to see what the work carried out on the ground could do. Often the most important thing in saving birds from extinction is identifying the problems that face them.

Jim Lawrence, who runs BirdLife's Preventing Extinctions Programme, travelled with me to Kazakhstan, where we wandered on the steppe with Rob Sheldon, from the RSPB, and saw the work being carried out to save the Critically Endangered Sociable Lapwing from dropping off this mortal coil. The Sociable Lapwing has its breeding grounds on the steppe and its numbers were noted to be in rapid decline. The Sociable Lapwing Project was set up in 2004 by the RSPB (BirdLife's UK partner and conservation project leader) and ACBK (BirdLife's partner in Kazakhstan). It studies the migration and breeding progress of the bird in the face of potential extinction and tries to ascertain what the issues are that threaten its existence. The initial feeling was that the reason for the species' rapid decline was possibly trampling by livestock and the destruction of eggs. But it now appears that this is not the case at all. One of the main issues is the hunting of the bird along the Middle Eastern corridor. My main bugbear, hunting, appears.

Ceri's Diary – Kazakhstan: What I discover is a huge amount of work being carried out by a small number of dedicated people. There is something heart-wrenching about watching three people sat atop a small hillock looking over a country equivalent in size to the whole of Western Europe. As we sit and stare out over this flat land I watch Rob Sheldon, the RSPB's project leader, as he scans 360 degrees for Sociable Lapwings. Incredibly he picks up three birds coming in to land by their distant flight call; they appear and then disappear again, but I am sure this dedicated group will relocate them later. The enormity of the task at hand for this team of people dawns on me as I realise that trying to find the birds is a relentless job that takes a huge amount of time and effort. But through their dedication birds are found, studied and watched over. Every new egg is important in the potential fight for the bird's survival. Extinction seems so much more possible and closer at hand when faced by the relentless, often bleak landscape that spreads ever outwards in front of us. And this is what conservation on the ground is all about in the 21st century: small groups of committed conservationists fighting a fight that the majority of people neither know of nor care about. Thankfully there are organisations like BirdLife International that work tirelessly to support the work that needs to be carried out in so many parts of the world. And in this country we have to be grateful that the RSPB sees the value in working abroad as well as in the UK. After all, as Tim Appleton, the Reserve Manager at Rutland Water and co-curator of Birdfair, would say, 'A pound spent abroad buys you so much more than a pound spent in the UK.'

The great thing is that it is not all doom and gloom. Since 2008, BirdLife has taken action on behalf of 115 Critically Endangered species and 80% of these are judged to have directly benefited from this. Of this percentage, 20% have improved in status and 63% seem to have declined less rapidly, meaning that some birds have experienced both beneficial changes.

I would love to visit more and more projects and problem areas to report back my findings. The more I tell Ralph, the more I feel his interest is being stimulated again and I can feel the engines start up and begin to tick over on the *Steadmanitania*. We have so much to report and so little time. This really is a clock-watching exercise. By the time we have finished this book a bird or two may have to be moved to a reprinted *Extinct Boids*, if you take my meaning. For some it may be too late, but for many there is the true possibility that we could save them and even boot them out of this book, as they become no longer threatened. It's a thin defining line and Ralph and I feel the urge to walk this line and see what we will see.

It's so easy to look at the state of the world and man's treatment of its creatures and to then despair. But there are success stories and this is what gives us hope that all is not lost. In the greater scheme of things the amount of money needed to potentially save birds from extinction is minimal compared to, say, building a football stadium or creating a high-speed rail link between two points on a map. Nevertheless, money is exceedingly hard to come by as far as nature is concerned. But when it is found it can do incredible things.

The story of conservation today has many optimistic tales to tell. For example, the turnaround in the decline of the Indian Vulture, which at one moment was the world's most populous bird of prey and the next, incredibly, lost more than 97% of its population due to the introduction to livestock of the anti-inflammatory drug diclofenac. Vultures were eating carcasses of animals treated with the drug and this was causing kidney failure within the birds, which were found to be sick and dying across India, Nepal and Pakistan. The lobbying of governments managed to get the drug banned, although diclofenac is still being discovered in carcasses. But the decline was, on the whole, arrested. There are other upbeat stories involving the Hooded Grebe, the Araripe Manakin and the Azores Bullfinch, which also serve to prove the point. The list is increasing of encouraging upward trends for many species, although there are still more birds that need saving. But species can be turned around and become successful breeding birds again.

Recently I chatted to Jim Lawrence, and he summed things up for me as to how contemporary conservation works in saving species from extinction. 'Targeted conservation action, which is based in sound science, is nowadays followed up by innovation and thinking outside the box.'

What does this mean exactly? Well, it means that out of innovation come unusual and intriguing success stories and none more so than with the plight of the Chinese Crested Tern. China's rarest seabird now numbers fewer than 50, but forward thinking has had an immediate effect on its population. This tern normally nests within colonies of Great Crested Terns and was known to be a part of only two of their colonies. But in early 2013 a tern colony restoration project proved to be an immediate success. Tiedun Dao, a former island home and breeding ground for Great and Chinese Crested Terns, was cleared and prepared for a potential new colony. The birds had originally disappeared from the area due to egg collecting by fishermen who would then sell the eggs as roadside snacks. To lure birds back into their former breeding site, conservationists developed an idea to place 300 tern decoys on the island and use solar-powered playback systems installed amongst them to emit the contact calls of the terns.

The thinking was that it might take several years to attract the birds back to their former home, but it proved an instant success and by the end of July, 2,600 Great Crested Terns had been recorded and hundreds of pairs had begun to lay eggs. In amongst them were 19 Chinese Crested Terns, the largest number seen in one colony since the species' rediscovery in 2000, and at least two pairs laid eggs. By September 2013 at least one Chinese Crested Tern chick had successfully fledged alongside approximately 600 Great Crested chicks. The latest reports for 2014 show the remarkable trend is growing: 43 Chinese Crested Terns came to the island, forming 20 breeding pairs, and an incredible 13 young terns fledged. There is a long way to go but inventive thinking has shown just what can be achieved.

So what makes a bird Critically Endangered? Usually the main reasons are that the bird has a small population and its numbers have declined rapidly in three generations or less. One hundred and thirty-six countries are home to at least one Critically Endangered species and Brazil numbers the most with 24. In total, 74% of the Critically Endangered species are in decline, while some have stabilised or increased their populations thanks to conservation support. Fifteen species may already be extinct in the wild, although further information and searches for them are required. For some birds it is already too late, but there is still time and hope for many other species and work continues to keep so many birds alive. BirdLife responded to the extinction crisis in 2008 by launching the Preventing Extinctions Programme and already it has been responsible for taking action for over 500 threatened species. This is a great story to concentrate efforts to work with these species, but the work continually needs improving, adapting and updating. As BirdLife states, 'The BirdLife Preventing Extinctions Programme is turning the tide and bringing species back from the brink of extinction.'

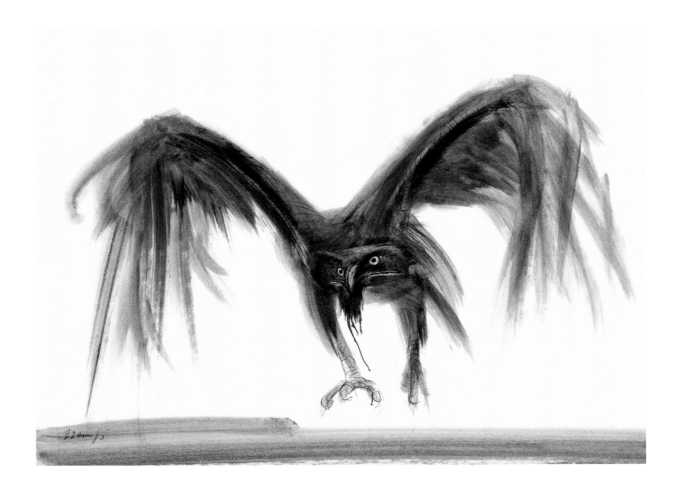

Science lesson over. Back to Ralph for a comment.

Ralph: 'It's funny what you can put a beak on' – that's what God thought at the beginning. That's how God created birds.

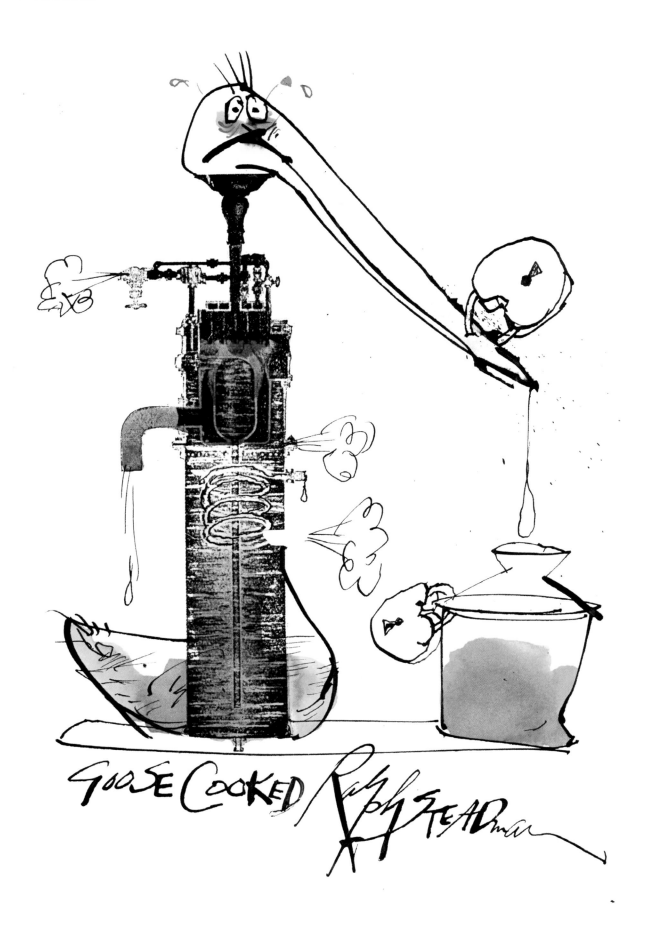

Rifling Through Ralph's Drawers

Ralph told me that birds had never really interested him and that he had never really drawn birds before I entered his life. This I took as gospel until one day I mentioned to him that I was surprised that he had never incorporated birds into his work before *Extinct Boids*, as birds provided such adaptable shapes to bend to his style and became commanding characters under his penship.

This suggestion of mine has got him so intrigued that he rifles through his drawers, which are filled to the gunnels with art, to see if any birds had snuck into view in his past work, and he discovers that more birds had indeed flown into his pictures than he had first thought. He sends me pictures that are littered with birds. Comic creations, gentle studies, portraits of hawks and owls hunting – birds appear from stages left and right. As we look at the subject of nextinction and talk of which birds may disappear forever, some apt birds appear from the past. Vultures. Ralph's vultures sit on rocks while others circle over the endangered birds and us, sniffing fresh meat below. Too many birds may fall and become carrion for those that wait overhead. Therefore we decide to tackle the task of this book immediately. There is not a moment to lose. We have both developed an affinity with birds that neither of us realised was lying in wait inside us.

Ralph now finds birds in everything and today sent me a whole new species of pool birds and creatures, which appeared to him in photographs he took of his swimming pool's plastic covering and its water stains, which are then magically turned into these images. They are quite extraordinary and it amazes me how Ralph sees so much in so little, such as in a pool cover. He creates art from everywhere and nowhere.

Ralph emails:
Finding that my interest in Birds does go back a looong way… Keep coming across Birds that never saw the light of day!! Distinct Birds!! And a Leonardo strange Bird!! A wine heron!!

I told yer I was going ta go off at a tangent!! But for me it is a pleasant surprise!!!

Very Organic stuff – a whole new departure!!! Now where are we going to put these????!! An Umbrella Bird and a Stone-tailed Fossilot!!!

(*Ceri:* About here I reckon.)

And this??? wot I discovered???!!

(About here.)

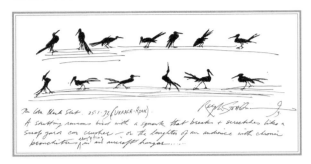

Ceri's Diary: For those unable to decipher Dr Steadman's scrawled notes: 'The Coba Black Slat. 25.1.93. (Urraca – Rook).' Ok, I agree this makes no sense to me either. Sometimes Ralph's handwriting is worse than a doctor's.

'A strutting raucous bird with a squawk that breaks and screeches like a scrap yard car crusher – or the laughter of an audience with chronic bronchitis erupting in an aircraft hanger…'

The latest influx of birds has made me realise that wheels have been set in motion in Ralph's mind and we are well on the way to compiling more and more birds together, with many from the past ready to join those that will be created in the present. His fervent imagination never ceases to astound me and I know that he is rummaging through his studio searching for other bird-related pieces that he realises he has done over the years. The rook drawings are beautiful studies of a bird in action with a few of the poses very striking, such as the one with the bird looking directly upwards. These drawings are so simple and yet so graceful, elegant and beautiful. It is so easy to be sidetracked by Ralph's humour in his work that pictures like this remind me just what an accomplished artist he is. Several of the pictures he has sent through of eagles and vultures make me giggle and then admire his skill and beauty of line, as with the Cape Vulture that seems to be beckoning us in.

Ralph: We must make sure there is humour in the book.

Ceri: And not be pompous about the subject.

Ralph: Oh no, I want to be very pompous.

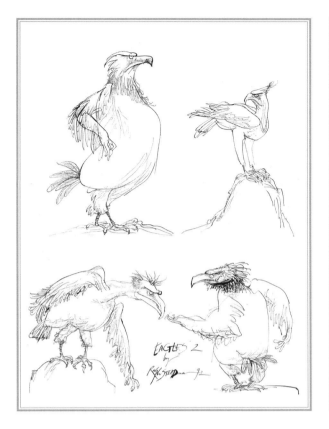

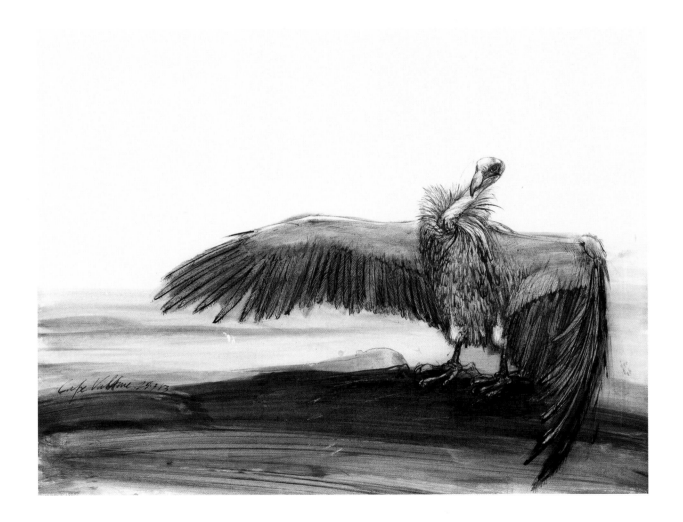

Blow Your Penny Whistle

Phone:

Ceri: We have to find the Critically Endangered birds and tell their stories. They've got to be somewhere…

Ralph: Of course they're somewhere. Everybody and everything is somewhere.

Ceri's Diary: Ralph and I have been talking about getting back on board the HMS *Steadmanitania* and travelling back to Toadstool Island. In our first book, *Extinct Birds*, we discovered this was the place where the extinct birds and boids lived out their extinctness. Now we wish to return to the dark side of the island where it is believed those birds that face extinction sit and wait for the outcome of their fate. On old maps it is known simply as somewhere. This is where the nextinct live.

Somewhere is a place; it can be a dark space, where forgotten birds and knowledge about them are held, where reality is lost or hidden from our minds. Somewhere can be like a black hole, where things, thoughts and species are mislaid and often found. Somewhere can rip through the world as we know it. Somewhere can be nowhere that is tangible. This is the place where we find creatures that wait for extinction. Somewhere is for the endangered, those that listen to the clock ticking, watch the sand ebbing and feel their life fading. Somewhere is a holding bay for all the nextinct birds, including vultures, cranes, ibises, songbirds and seabirds, that could disappear from our sight forever, perhaps to become no more, to become extinct from our world. Somewhere is the space that we have to accept exists. We need to find where somewhere is and bring it to a somewhere more visible. We have the ability and the power to change where somewhere is but first we have to place it on the map. Somewhere is where this book will be written and where it will be seen and read.

We knew it was time for Captain Ralph to don his tricorne and for us to climb back aboard the HMS *Steadmanitania* and venture back on the high seas to head towards the Strait of Nextinction and see what awaits us there.

Ralph blows on his penny whistle, stokes up the engine and then looks skywards and I squint to see what he has noticed. I rub my eyes and am staggered to see a flyby of Dodos. Flying in formation we see them heading towards the dark side of the island. Their shadows hit the sea and Ralph cries that it is time to 'Follow the Shadows!' We set forth immediately and stay on our dark path along the treacherous waters. Either side of us rocks beg for our physical contact and call for us to spend time amongst their sharded promontories, as we slip through their potential agonies on our precisely shadowed route. For hours we traverse the stony-strewn water and, beginning to trust our guides, we look and realise how odd it is to see Dodos flying overhead. How can this be? But there they are taking us around the horn of the island. Then, the birds disappear and we find our boat in thick black water. We have come to the dark side of the island. The Dodos of the past have brought us to the land of the crisis-hit birds of the present.

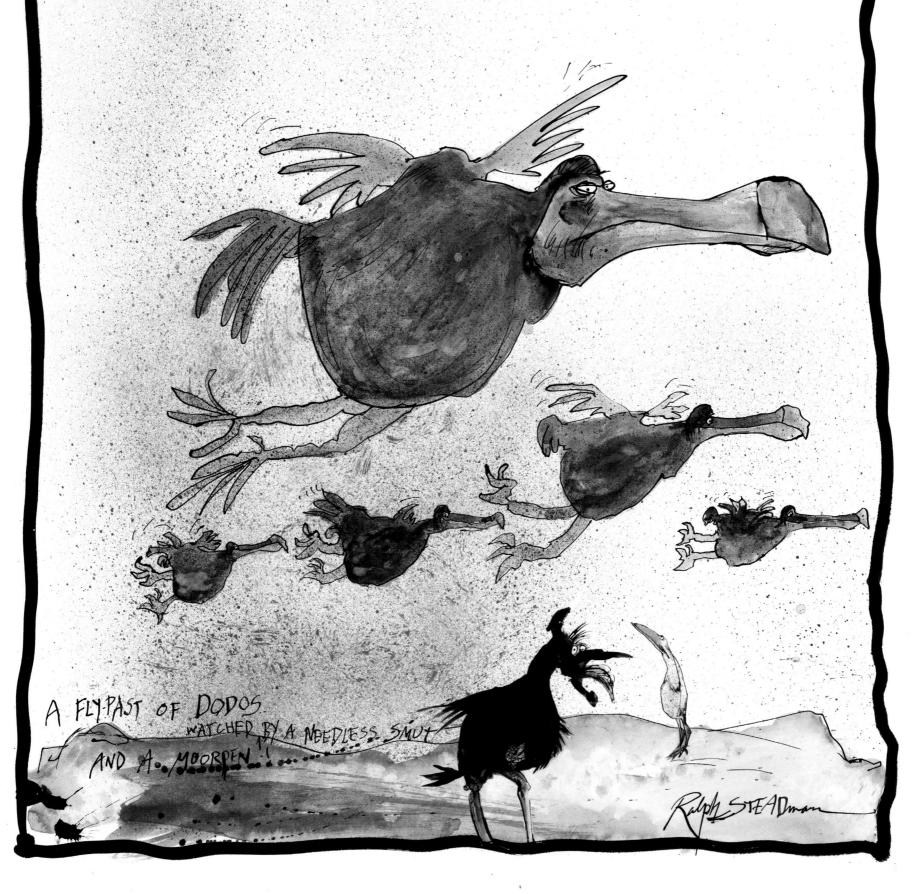

A FLY-PAST OF DODOS.
WATCHED BY A NEEDLESS SMUT
AND A..MOORHEN...!

Ralph STEADman

An Explorer's Tale

Ceri's Diary: At the moment it feels as though the HMS *Steadmanitania* is grounded in shallow waters. Pressure of outside work for both of us is slowing the start of our journey completely. Ralph has a book, *Proud Too Be Weirrd*, which came out last month and the documentary about him and his work, *For No Good Reason*, is nearing completion with its American premiere on 23 April. I have to be patient but also have to find a way of getting the engine started again and steering our boat back to deeper waters. Ralph never responds to pressure and I just have to see where everything takes us and if it isn't the right time to do the book then so be it. One can only do these things when the stars are in the correct alignment. And right now we are both looking at blank pages.

Phone:

Ceri: It's always hard to know where to start and when there are so many birds to choose from it's even more difficult. I suppose with extinct birds the story is done and dusted but with these living birds the stories alter daily and we have to keep abreast of the situations each faces. We are still a couple of explorers searching for clues, birds and answers, aren't we? Much like those famous explorers of yore. Remember the trouble you had with birds from Rodrigues such as the Rodrigues Solitaire, which you thought was named after the man not the place?

Ralph: I do, and it was an easy mistake for a gonzovationist like myself to make. After all Diogo Rodrigues did discover the island in 1528 and even though it *was* named after him, no man is an island!

Ceri: We should look to him to get our venture back on track. We need to get out and start discovering exactly what these critical critters are. Look windward!

Ralph: You can get tablets for that.

Ceri's Diary: Guess who has just appeared in my inbox? Diogo Rodrigues in all his glory. A fine-looking gentleman with that twist of Ralphicity. We now have a figurehead to look up to – we can follow in his footsteps and now we are on course to plot the chart of nextinction. We are free of the shallow waters. The stories will begin.

Phone:

Ceri: I love Diogo. He looks a little out of sorts; I hope he hasn't picked up something other than that little fruit bat attached to his finger. I love his hang-bat expression! It's appropriate that you've painted a Rodrigues Fruit Bat, or Flying Fox if you prefer, which is endemic to Diogo's island. It's pretty symbolic too, as I have just looked up this little feller and discover that as we embark on this venture to portray the Critically Endangered birds of the world this other flying, non-bird creature is also Critically Endangered. It must be a portent that we are on the right track. The threats to its existence seem to be similar to those of birds, i.e. habitat loss, human disturbance and hunting.

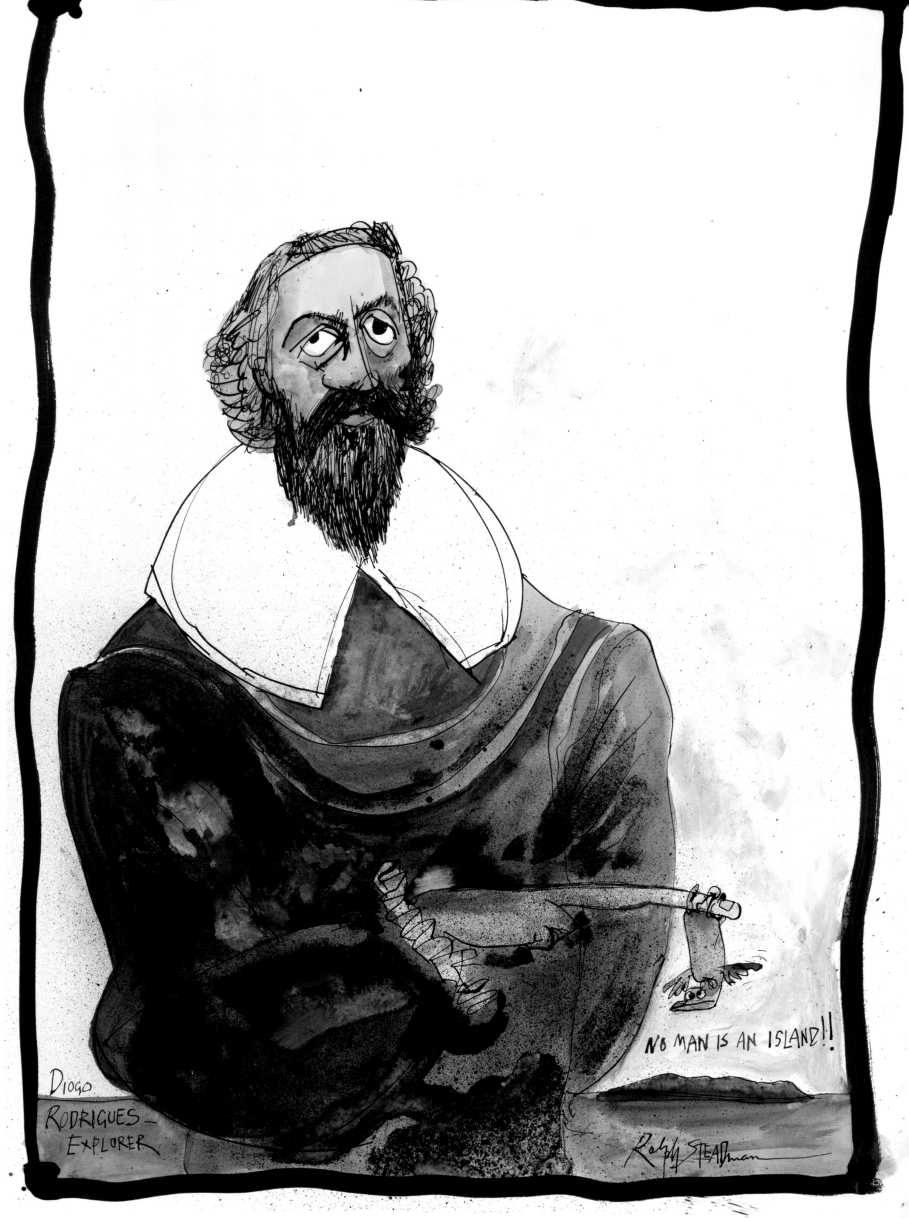

NO MAN IS AN ISLAND!!

DIOGO
RODRIGUES —
EXPLORER

Ralph STEADman

Ralph: Talking of hunting, have you seen Diogo's supposed son, Kevinio? He's a nasty bit of work. You wouldn't like him. He's one of the most terrible of hunters. A brute!

Ceri: I have been looking up the family tree online and discovering the truth about Kevinio's lineage. He was actually the son of the ship's bosun who was killed early in the voyage. Diogo, feeling pity for the poor child, who was only nine years old and had been stowed on board by his father, took the kid under his wing and looked after him. Within a short space of time Kevinio was calling him father, which Diogo permitted. He was given a job in the galley where he learnt the awful arts of slaughter and axemanship from Benicio Blades, the ship's cook. Kevinio was often found in the galley playing with tools of butchery and continually cutting carcasses into smaller and smaller pieces, laughing and licking the blood from the block, and the only person who was amused was Benicio, who actively encouraged such behaviour. After some time it was obvious that the child was demented and when Diogo discovered Toadstool Island, Kevinio's suggestion that he and some of the ship's waifs and strays could cultivate the island and make it a perfect place for Diogo to return to at the end of his journeys was greeted with resounding approval. Benicio's wife Lola, who had had enough of the sea and her husband and now wanted to stay on the flat, joined them. She decided she could look after the boys and bring them up as if they were her own.

In Kevinio's mind he wholeheartedly believes that Diogo is his father who he is working for and for whom he prepares the land, while waiting for him to return to Toadstool Island. Meanwhile, he wanders the island with his henchmen, who call themselves 'the blue-panted bird-killers', seeking out the extinct and the greatest prize of them all, the nextinct. Slaughter, bird blood and guts. That's their credo. Bodies are dissected and examined in his workshop, called The Blood Shed.

Ralph: If there was a Hunters Anonymous he should be forcibly made to attend. But he's incurable as so many of these damn people are. Something should be done!

Ceri's Diary: And he's right: something needs to be done about the issue of hunting, which I am sure we will discuss throughout the book. This is also a very good place to start an exploration of what the main causes of species becoming endangered are. Explorers and their ships and crew proved to be the source of a multitude of problems for indigenous species, as with them came introduced species, such as cats, rats, dogs, mosquitoes and livestock, pestilence and settlers who would invariably change the agricultural systems and who became hunters and generally changed the landscape and way of life. The boats brought human interference and the world would change forever as man spread out and conquered all that was not his.

Boids are endangered too

It's not only birds that are endangered, because boids are under threat too. As can be seen by Ralph's depiction of Kevinio Rodrigues, the extincter of distinction, busy at work. Kevinio is a heartless monster of a man who is actually afraid of worms, snakes and eels. Other than that he is fearless and only has to worry about his Achilles 'eel occasionally. He likes to tell of his sea-faring ancestors but there is no connection at all. He is a charlatan, as was his father before him. As one can see by the cowering Madagascar Chickens in the background, birds are 'afeared of him' and try to keep out of the way, but their hapless friend managed to get nabbed as he was doing a polka dance to impress a young chicklet he had his beaky eye upon. It just goes to show that with hunters you have to keep your wits about you and take the correct precautionary measures to ensure safety from Kevinio's axe of hate and destruction.

He is a hunter who seems to be a throwback to the Dark Ages and has no place in the modern world, which is how I feel about all hunters. From my perspective, there is no reason for hunting to be considered a sport – how can it be a worthwhile hobby to take a creature's life for one's own entertainment and amusement? Is it impossible to simply watch and enjoy what's left of our wildlife and not reduce the numbers of it? Take pictures not life, that's my motto, and I cannot get my head around grown men destroying the creatures in our airspace, especially when so many of these killers are actually in tune with their surroundings and have such incredible knowledge about the world around them that surely they could find a greater purpose in helping our environment to survive and thrive? Rant over...

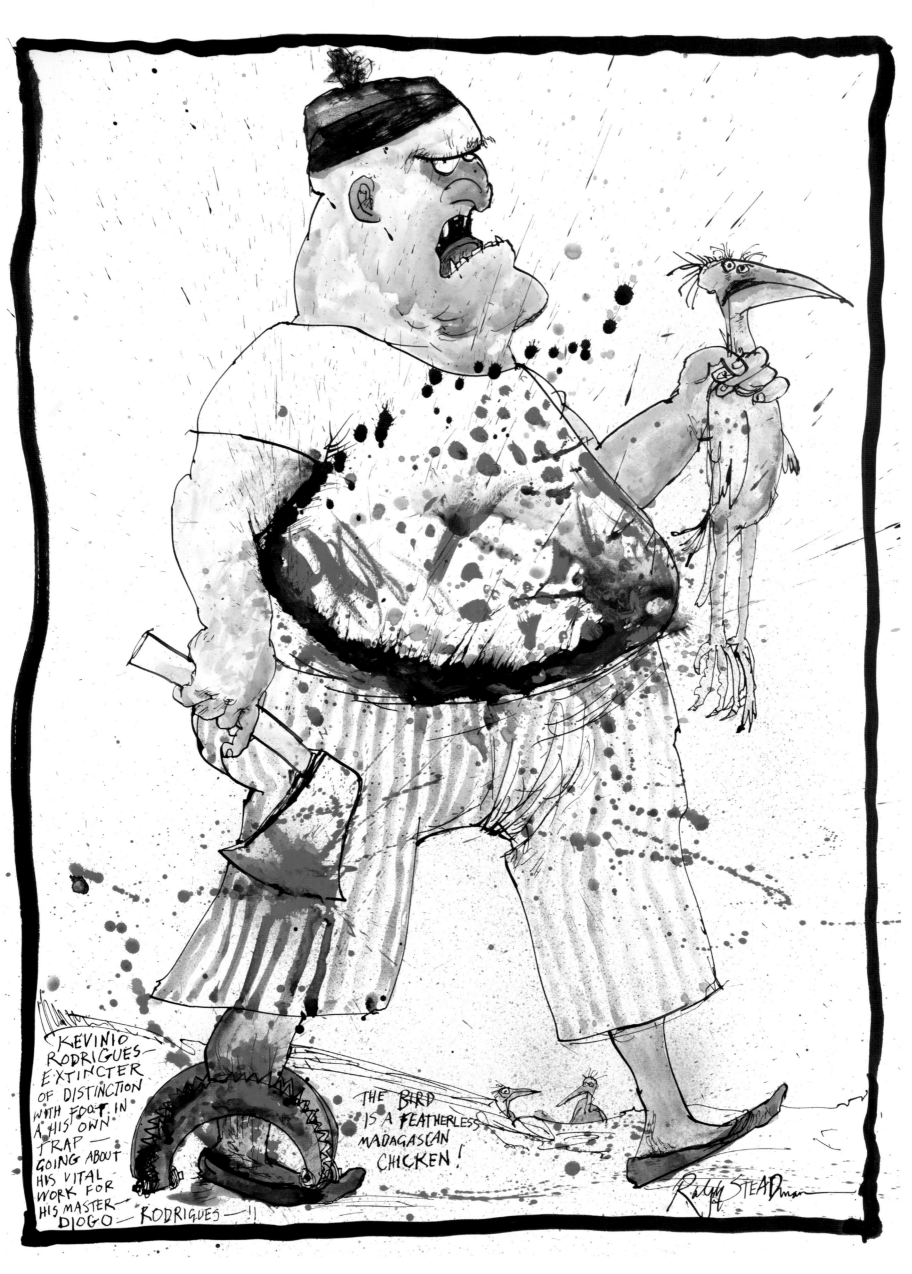

KEVINIO
RODRIGUES—
EXTINCTER
OF DISTINCTION
WITH FOOT IN
A HIS OWN
TRAP—
GOING ABOUT
HIS VITAL
WORK FOR
HIS MASTER—
DIOGO—RODRIGUES—!!

THE BIRD
IS A FEATHERLESS
MADAGASCAN
CHICKEN!

Ralph STEADman

Ceri's Diary: Here we see one of Kevinio's henchmen, a member of the 'blue-panted bird-killers'. They are incredibly proud that they managed to build their own guns and will shoot most things that move on the island. They could have been some of the great conservationists as they know the ways of all of the birds on the island (excepting the Needless Smut, who does not even know his own ways), and consequently are often in the right place at the right time to shoot, maim or kill many of the inhabitants of this under-protected land.

They used to be egg collectors when they were young and only recently wiped out a whole species of bird in one season because they knew where every nest of the once thriving Basic Bird was. This bird was considered to be the link between dinosaurs and birds, as we know them today. It survived all sorts of ages – Ice, Bronze, Resin – and subsequently having survived all of that it failed in the Hunter Age, due to this swinish group of egg bandits. The blue-panted bird-killers discovered that no two Basic Bird eggs were alike and, captivated by their patterns, they wanted to collect the full set, as boys do with football stickers. For several months they followed each Basic Bird and located where it would be nesting through the next breeding season, made a map of this and waited until the birds started laying eggs. Then one fateful moonlit night they set out upon their trail of devastation and extinction: one by one each nest was robbed, and over a period of three nights they managed to take the clutch of eggs from every single bird. They knew that there was no chance that there would be a second clutch of eggs as the birds only laid one clutch every two years. Proudly they put their takings on display in their house, where they all lived as one community.

Their surrogate mother, Lola, unaware that these were Basic Bird eggs, broke a quantity of them the next morning and made scrambled eggs for the whole group. They fluffed up very nicely and had a most appealing orange glow to the yolks. One member of the group was out having his portrait painted by Ralph and when he went home later that morning, he discovered the whole of his 'family' face down in scrambled egg on toast, dead from Basic Bird egg poisoning. He wailed in horror at the true awfulness of Lola's culinary mistake.

But his was not the only trauma from this sorry affair. One by one the Basic Birds realised that they had lost their eggs and were so affected by this that none of them ever laid an egg again. This last man and Kevinio blamed the Basic Bird for the fall of the killers and vowed to see off the rest of the species. There remains one male bird known to still be alive and he is in constant search of a possible mate, which is rumoured to be alive in the foothills of the Avaquack Mountains. He spends his days avoiding the blue-panted bird-killer and continues his search. For the moment it has proved fruitless. As you may see from the picture, he has a question mark tied to his tail. This is so everyone who sees him can ask the question 'Why?' as to the demise of his species. We must never forget those creatures that we have lost due to man's indiscretions.

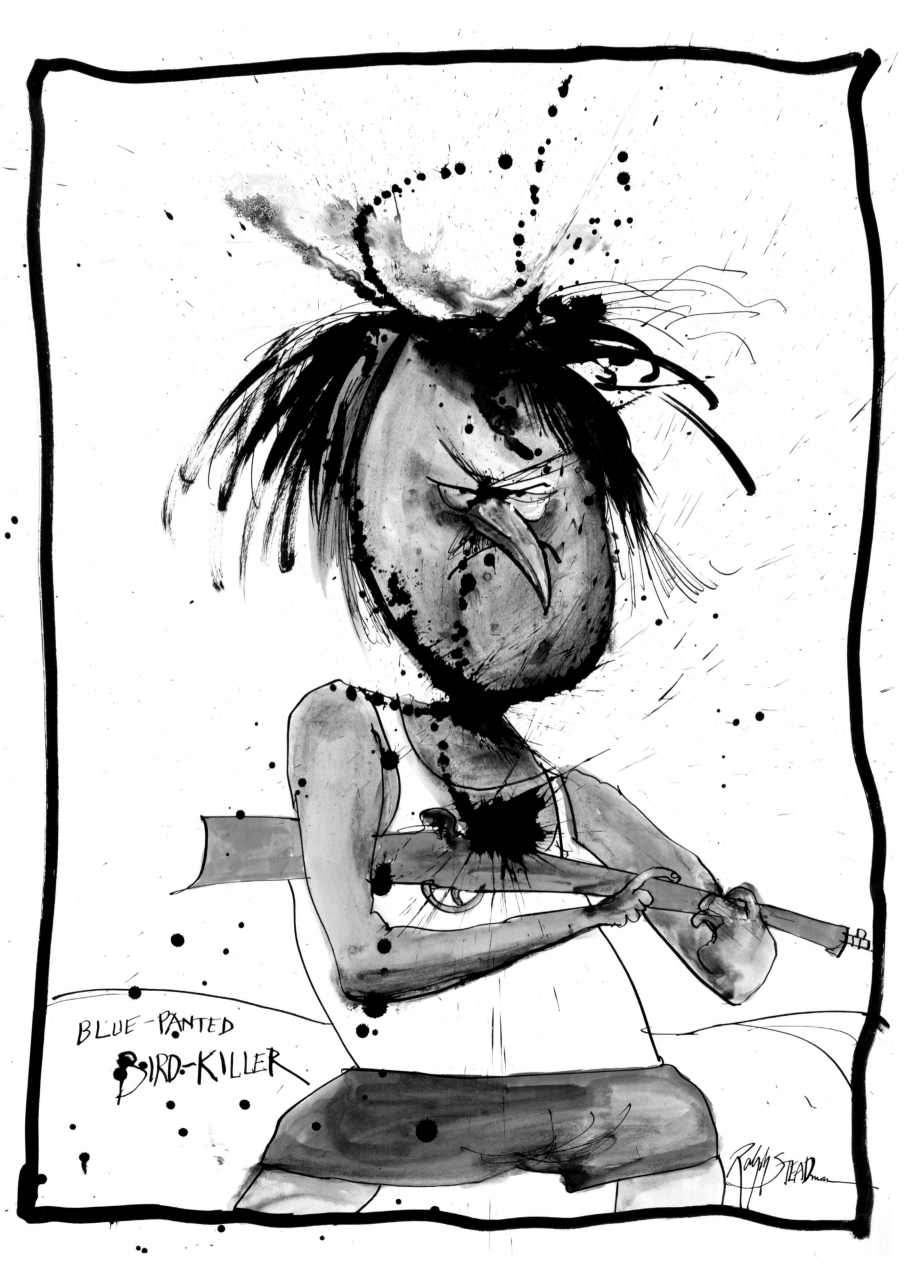

BLUE-PANTED
BIRD-KILLER

Ceri's Diary: Both of us have felt that if we do something for the birds again, it mustn't become too stuffy, especially now that we are ornithologists. Once we decide that nextinction will be the subject for this book we set about examining the reasons why there are so many endangered birds, but want to make sure we present the subject in a convivial manner.

Phone:

Ralph: I feel that if a new bird book is to be approached it must be more fanciful, amusing and/or entertaining than the last – or it will be received with open arms and remarks like 'Just what the world needs – ANOTHER bird book'!!

Ceri: It will be different. You draw them your way and I'll write them mine.

Ceri's Diary: And then Ralph begins to draw.

And I begin to write…

And as the lines of communication open up things begin to happen.

Ceri's Diary: It's that quiet moment immediately after New Year and everyone hasn't got a clue what to do to get away from the holiday period and how to get back to everyday living. I drop Ralph an email and tell him a little about a Critically Endangered bird that could make an excellent starting point for the birds and for him too. The Spoon-billed Sandpiper. I feel that with the right nudge in the right direction we could get going with the book and start the year with a bang. (As long as it's not a bang from a shotgun.) We need to find the right bird to set us on our way to telling the story of the nextinct. And this may be the one.

Ceri emails:
Hi Ralph,
Happy New Year to you. Hope it's all going however you want it to go! I have been looking at a bird I thought might appeal to your sensibilities – it is called the Spoon-billed Sandpiper and is a very odd creature indeed and I think very beautiful. It is Critically Endangered and its population is in a parlous state. But people are hard at work trying to save it from heading through the exit marked Toadstool Island to join the extinct.

Ralph replies:
Spoonbill – but not as we know them.

Ceri's Diary: And there perched on top of a fiscal cliff is a Spoon-billed Sandpiper. A fiscal cliff? Ralph has likened this bird's existence to the parlous state of the financial world. This is a precarious position for a small beautiful bird to find itself in, as it stares down into the dark sea below it. The irony being that if our world of fat bankers and fiscal servants chose to, they could save the majority of the world's endangered species in a split second of time. But instead the corporations and conglomerates grow and expand across the globe, destroying so much in their wake, in the name of economic progress. They are part of the darkness that envelops our natural world.

Spoon-billed Sandpiper

Eurynorhynchus pygmeus

The Spoon-billed Sandpiper is a good place to start this book. It numbers a mere 240–400 individuals. This beautifully weird-looking fella, a tad larger than a sparrow, encounters many of the reasons why so many birds have become extinct from this world: predation by dogs and foxes and skuas, which take eggs and chicks, as well as human disturbance, inclement weather and habitat destruction and alteration, particularly the industrialisation along the bird's migratory flyway and the development of its tidal wetland feeding areas. The only thing I thought was missing from the list was hunting. But I have now discovered that hunting on its wintering grounds in the Gulf of Martaban in Burma and Bangladesh is proving to be a major factor in its demise. Village fishermen have discovered that their fishing nets actually make great mist nets to trap birds for food. They are normally looking to ensnare large waders such as the Endangered Nordmann's Greenshank and godwits, but the bycatch is smaller waders such as the Spoony. As if it didn't have enough problems as it is.

Alternatives to trapping and the provision of alternative fishing equipment are being explored with the local villagers. Ecotourism is also playing a part as plenty of people want to see this special bird, and this brings money into the area and provides work for the former spoonbill hunters from the community. There is a way to go, but major inroads have been made into creating a future for the species.

The first breeding programme for the bird was initiated in 2011, whereby eggs were brought from the Sandpiper's distant breeding grounds in Russia to the conservation breeding facility at WWT (Wildfowl and Wetlands Trust) Slimbridge, in the UK. This has continued over the last few years and has formed a solid platform from which the well-looked-after flock of birds can help sustain the species' global numbers. The first birds bred at Slimbridge are expected in the summer of 2015. Meanwhile, eggs have been taken from the wild to protect against harsh weather and predation and have been hatched under the care of the WWT. They have then been released back into the wild, therefore bolstering numbers of the bird. This is an incredibly proactive project and one which looks as though it is working and turning the tide.

At the same time, BirdLife and its respective partners are working to halt the trapping of the species and stop the loss of wetlands. This is a large international conservation initiative including Birds Russia, the RSPB, the WWT, the BTO (British Trust for Ornithology) and BirdLife, along with the many individuals who have supported the project. There is a genuine hope that this wondrously odd, charming and enigmatic creature will be saved from the precipice it is peering over.

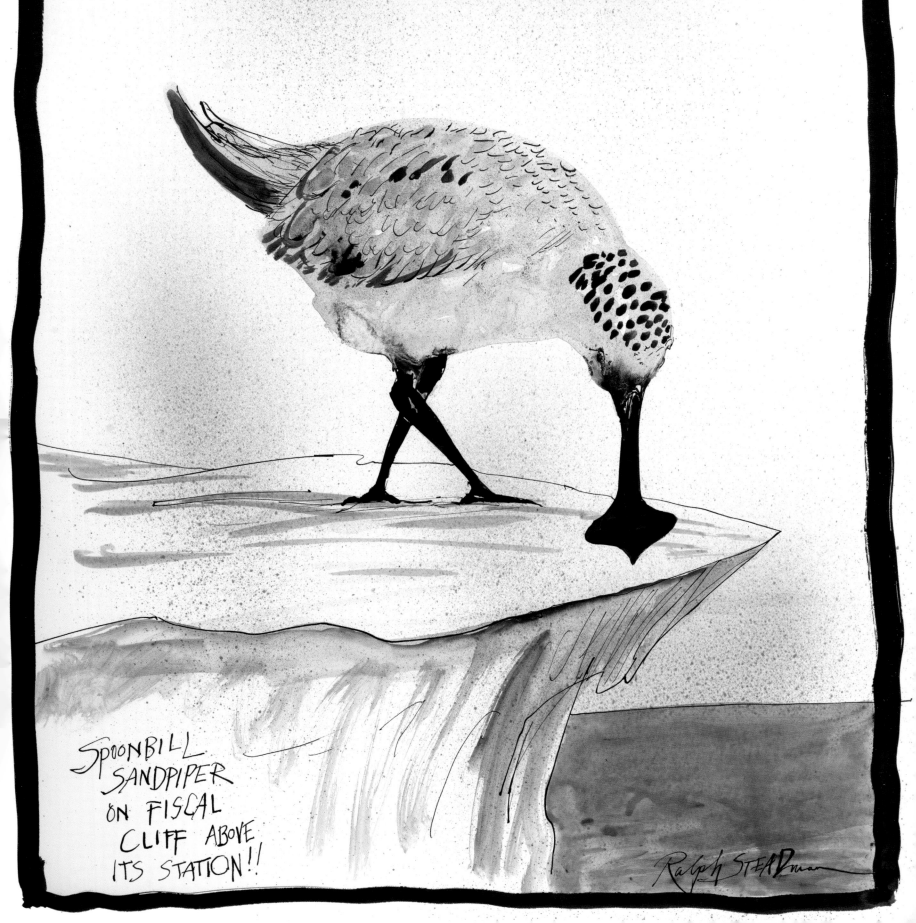

SPOONBILL
SANDPIPER
ON FISCAL
CLIFF ABOVE
ITS STATION!!

Ralph STEADman

Javan Green Magpie

Cissa thalassina

With my first look all I can see is this majestic green magpie. Even in the photo I can make out the thickness of the paint on its body. It's a stroke of genius with a stroke of paint. Its eye hypnotically seems to rotate in its head like a kinetic art piece. A beaten termite hangs loosely from its mouth, as the bird stands firm on the rock beneath its talons. The population of this magpie is reckoned to be between 50 and 249. It is endemic to western Java in Indonesia. There have been very few sightings of it and it may only have four areas within which it now lives. The main threats to this species are habitat change due to agriculture, logging and mining, and trapping for the caged-bird trade.

It is hoped that the magpie will become a protected species and that human encroachment onto protected land will be stopped. Captive birds that are recovered or found in bird markets will be released back into the wild, and awareness programmes for locals are also important to dissuade them from trading in the species. Attempts will also be made to set up a captive-breeding programme.

Teeny Spint

Eencius weencius

I wonder where the second bird is and suddenly I notice it by the magpie's foot. It is tiny, hence its name, the Teeny Spint, which must never be confused with a Little Stint. In fact, if you do confuse it with a stint the spint will have something to say and may end up pecking you very hard wherever it may be able to reach – usually somewhere around the little toe area. Spints are in decline themselves at a rapid rate as they rely on the magpie's terrible eating habits – it often drops bits of food everywhere as it never seems to eat with its mouth closed. So if the magpie goes, then unless it can find another poor chewer the spint will be in trouble too.

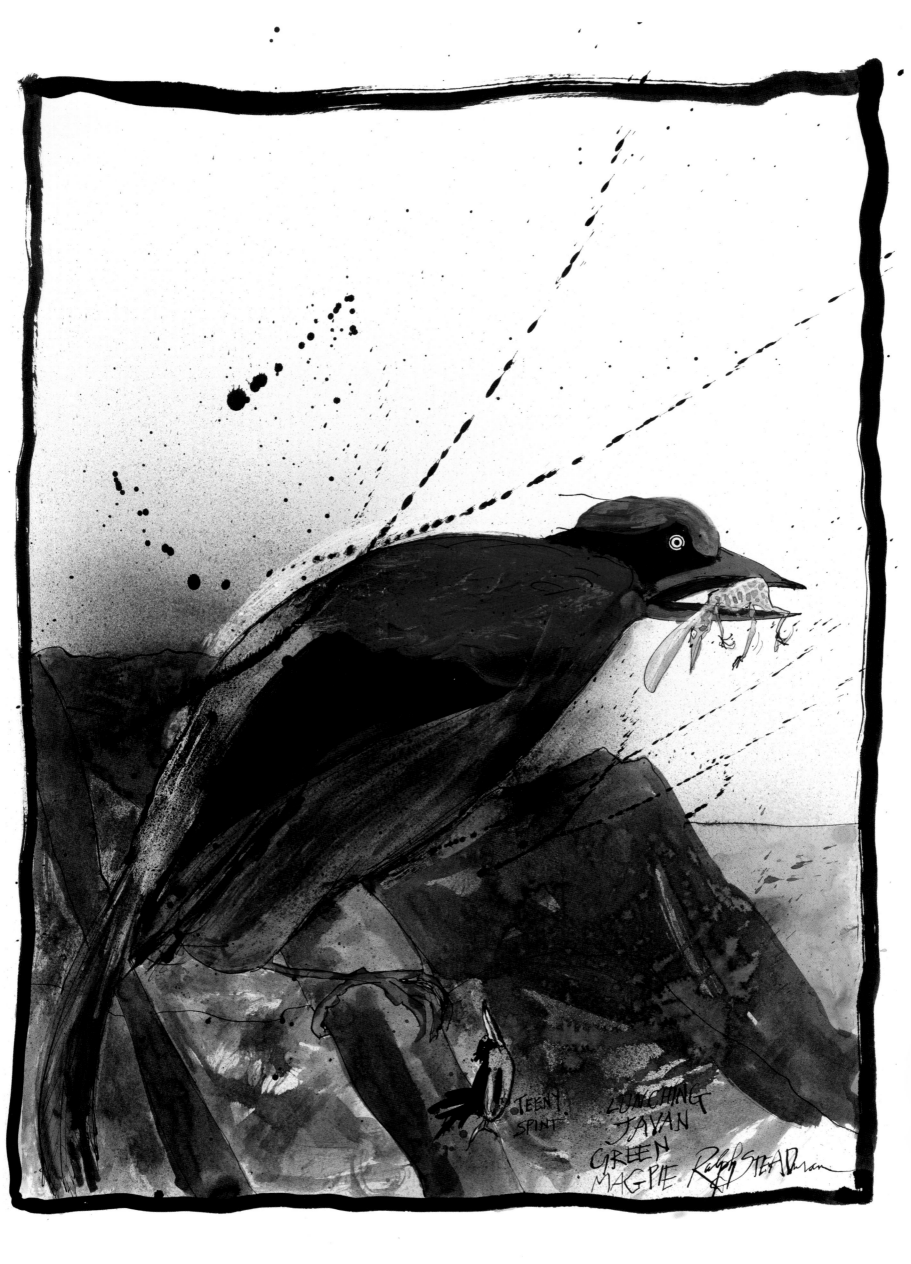

TEENY
SPIRIT

LUNCHING
JAVAN
GREEN
MAGPIE Ralph STEADman

Ceri: I love the different collective nouns for birds such as a committee of vultures. I start imagining all sorts of other things that could use a collective noun. What about collaborators?

Ralph: You could have a scratch of collaborators, a bitch of collaborators, or just the two of us would be a both of collaborators! Look there, I see a grump of elephants!

Ceri: What would a group of artists be? It could be a nightmare of artists.

Ralph: Which would quickly degenerate into a crap of artists.

Ceri: Thus the artist spake.

Ceri's Diary: This morning, simply the most magnificent creature I think Ralph has drawn so far arrives in my email – this is what I love about his drawings: each one becomes my latest favourite – the Red-headed Vulture. Each day that brings a new bird is a day closer to building a fine collection of nextinct birds. After all, the work that Ralph and I are creating is not solely about birds. They are symbolic of all the creatures that are endangered on this planet and there are a myriad of them. They just happen to be the ones that we believe can best represent all that man has done wrong with this planet. For Red-headed Vulture read tiger; for Javan Green Magpie read elephant; for Kakapo read rhinoceros. Wildlife is in a perilous state and we need to remind ourselves that if a habitat is being destroyed for a particular bird then it is probably being destroyed for other creatures too, whether they be insects, amphibians, reptiles or mammals. Birds have always been one of the best indicators of an environmental issue as they usually respond to change quicker than other life. Take note of birds and we can alter our world for the better.

Red-headed Vulture

Sarcogyps calvus

Reasons for this species' rapid decline have been laid firmly at the door of the anti-inflammatory drug diclofenac, which was widely used in the 1990s for treating livestock in India and Pakistan. Because vultures congregate to feed on the dead carcasses of animals, large numbers would be ingesting diclofenac in one fell swoop. The drug has proved to be fatal to vultures at only 10% of the normal cattle dosage, and one treated carcass was enough to damage a large number of vultures. Dead birds were examined and were found to have crystals of uric acid forming on their livers and other organs, a sign of gout, and diclofenac was found in their kidneys. Gout was proved to be the killer of many types of vultures including Indian Vultures, Slender-billed Vultures, White-rumped Vultures and the Red-headed Vulture. Numbers fell dramatically across the board. The Indian Vulture's numbers dropped by ore than 97% and the White-rumped Vulture's plummeted by 99.9%; these, along with the Slender-billed Vultures, were placed on the Critically Endangered list.

The Red-headed Vulture followed later, probably because at feeding time for the committee of vultures the larger birds kept the smaller vultures away from the diclofenac-carrying carcasses. Naturally, once these bigger birds had been wiped out it was only a matter of time before the Red-headed Vulture would be left alone to devour as much as it wanted of the carrion and the drug inside.

In 2006 India, Pakistan and Nepal banned the manufacture of diclofenac, and vulture-safe drugs are now being used. But it is unlikely that numbers of vultures will ever return to what they were.

Ralph's picture denotes the Red-headed Vulture in action. Regally he stands atop his latest victim, who unusually is alive. Perhaps he was hoping to play dead and be left alone but little did he know that a dead creature is best for a vulture. Anyhow, his days look numbered. More numbered than the vulture's future, that's for certain. In the words of The Beautiful South song, let's hope the vultures can 'Carrion Regardless'.

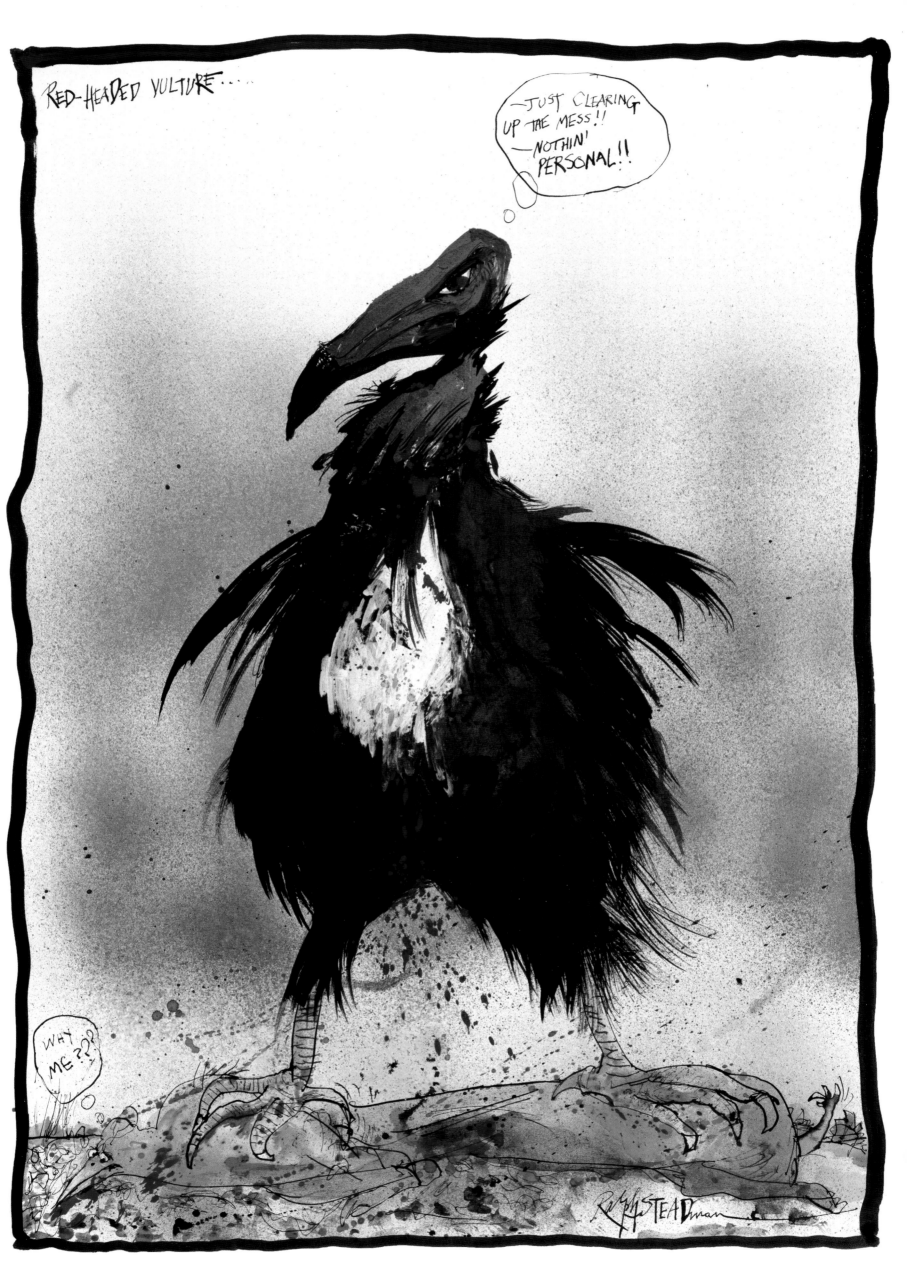

Ceri's Diary: A box of *Extinct Boids* has been sent to Ralph to sign and I love the way it turns into receiving an email of pure Ralphness.

Ralph emails:
I have signed all those books – AND they are already boxed up ready for collection!! They have been fried and sautéed – and shot through with truth… macerated, trampled and left for the deliverer to sanctify…

I bashed down hard on white paper and left to dry out – and indeed a graded gumph is born to man who knows not yet what form it shall take. It may yet be embittered… Later it shall be revealed – along with a whole list bestowed upon me from whence cometh wisdom!!

The Books have been picked up and out the door like guano off a shovel!

Now where are we going to put this????!!

It is a LONE Ptarmigazi Bird!!

Ceri's Diary: Today we chat about the fact that the ptarmigan isn't a Critically Endangered species, but this picture serves a useful purpose for us to discuss what the term 'endangered' means. I am explaining that there are various levels of endangered species and they range from Least Concern through to Vulnerable, up to Endangered and then the daddy of them all, Critically Endangered.

Phone:

Ralph: So there are levels of being endangered, but does it really matter which birds we choose to do, as they are all ENDANGERED! What difference does it make as to the level. They are ALL endangered. It's just that some are a little slower to catch up! I can only draw those birds that interest me. And then I find so many that intrigue me and once I start I can't stop.

Ceri: I get that, but if we concentrate on the most endangered birds that would be good.

Ralph: In fact, I'm more critically endangered than you!

Ceri: But it's only because you're older than me.

Ralph: Yes, that's true… Did you know that Chaulmoogra oil is very good for leprosy and other skin complaints?

(I realise it must be time for lunch.)

Rock Ptarmigan

Lagopus muta

Ok, this is not nearly extinct or even in danger and its status is that of Least Concern. The confusion is upon the artist. But what a great picture this is, so we couldn't leave it out. Not sure what Gin Martini, our editor, will make of it but I am sure he will like it and it's not as though we haven't deviated from our subject before!

Just for the record, the Rock Ptarmigan is a chunky game bird and member of the grouse family, which breeds on rocky mountainsides and tundra across Eurasia, North America and Japan, where it is known as the thunder bird, perhaps on account of its harsh and raspy voice. It adores pretty remote places such as the Scottish Highlands and loves to frolic in the snow.

What surprises me is the fact that ptarmigans are still being hunted in Scotland, apparently only in small numbers, as their population is not so large. It seems like an easy target as they are pretty tame creatures and are mainly shot by walking up to them. Why not take up cat shooting, as it is probably just as easy? Hunters will tell you that it is one of the most difficult birds to hunt because of the terrain, almost justifying the act by claiming that because of the dangers of scrambling across hurtful terrain it is a just reward to have a tame target such as the friendly ptarmigan to hand. I simply don't get hunting and I never will. Certainly it is eaten elsewhere in the world where it is more numerous, but in Iceland, for example, where it is a meat that is eaten at certain festivities, hunting of the Rock Ptarmigan is continually being appraised as its numbers decline and then rise again. So one year it is being shot and then the next year it may not be possible to shoot it, to get the numbers back up to a sustainable level to start killing it again. It seems a strange cycle for the bird to live through. My answer? Forget about shooting it. Let the bird live.

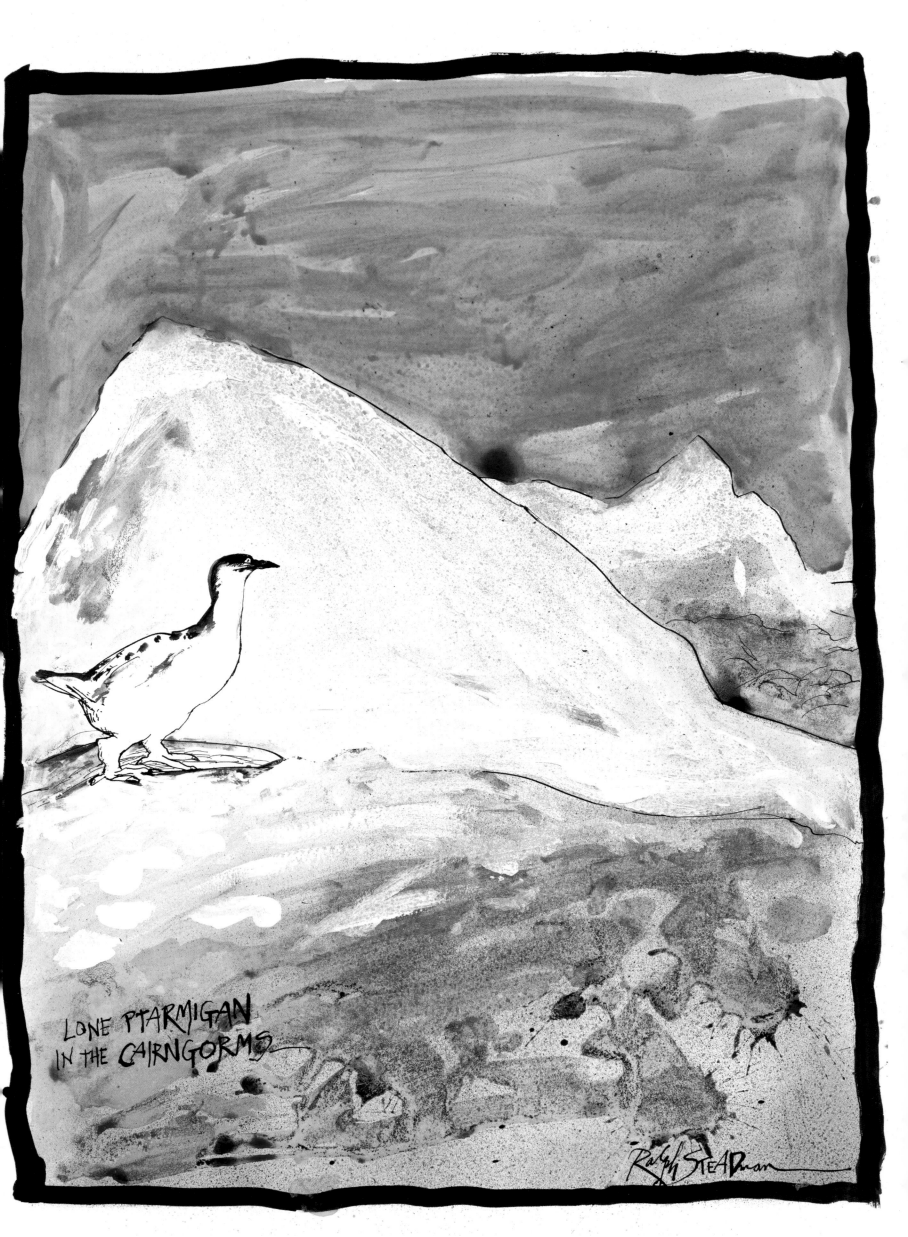

LONE PTARMIGAN
IN THE CAIRNGORMS

Ralph STEADman

Enigmatic Static

Snailbeak Ponder

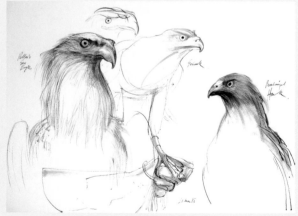

Hunting Owl Eagle and Hawk

Ralph: This tit has become Critically Endangered because it has had too many strokes.

Big-breasted Conspicuous Tit

Titus magnificus

We are no sooner started than the nonsense begins. I chuckle as soon as this hits my computer. I have forgotten that thousand-yard stare that Ralph gives some of his creations, as it strides off to somewhere with purpose. The tit is seemingly oblivious to the fact that there is a blackness pouring out of it. 'Whaddya mean there is something going on with my behind?' What is it? Who can say? Is it some sort of effluence? Or just a black-feathered derrière? Does Ralph know? I ask him and he says, 'Don't ask me, I'm just the poor artist who has to paint what he sees before him. This is realism. Boidal realism.' Maybe we should ask Dr Sigmoid Flexure, the well-known authority on bird rectal issues. The tit also seems to have a hump – sorry, with a second look I see that it is indeed a breast – upon its back, which makes this the most conspicuous and eye-catching boid I ever did see. One can see why this bird is Critically Endangered. But hopefully it is not in danger from the critics.

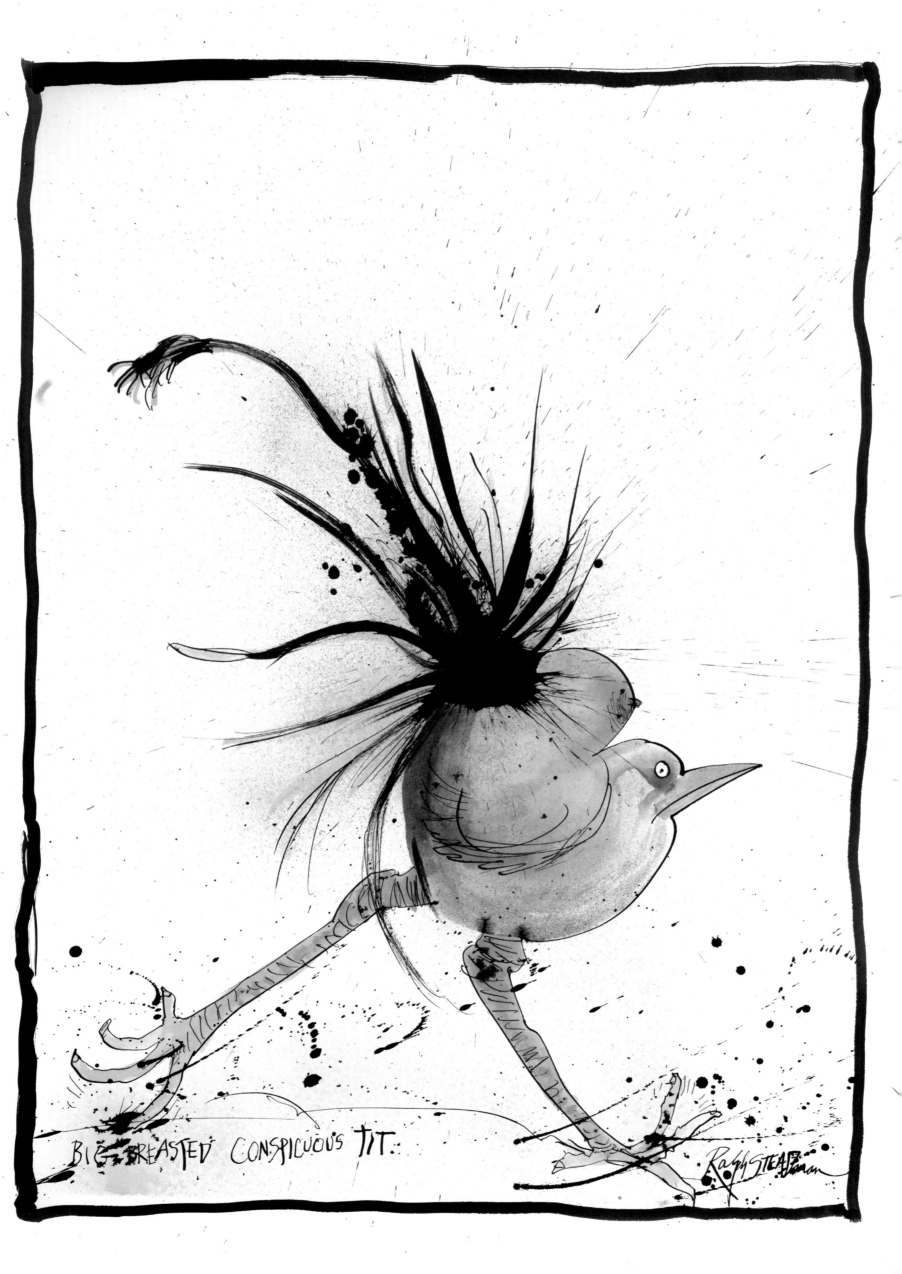

BIG BREASTED CONSPICUOUS TIT.

Ralph STEADman

Ceri's Diary: I'm a little concerned as to how few birds we have got on the board so far. It's been a month since the Conspicuous Tit, a month without a bird or too much contact with the good Captain. The last few weeks have not been easy for Ralph as there is so much press to do for the recently completed, wonderful film about him and his work, which is entitled *For No Good Reason.* He seems to be constantly in demand for interviews, which is great for the film but it takes up a lot of time and energy. So on the one hand I am a little worried about the lack of birds but on the other I know that the only way to really work with Ralph is to let things come naturally, as they surely will. He is not a man to press to do something and I would never try to. I also believe that once he gets on a roll the birds will start flocking in, so patience is a necessity right now. Meanwhile I wait for the wheels of industry to turn in our direction.

Ceri's Diary: And today two more birds are thrown into the mix. Actually, thrown is not quite the right word... Splattered comes to mind – after all, one of them is called the Gregorian Thwacksplat (chanting gently down in the key of G) and this is quickly followed by the Urban Council Skip Chick. Good to see that Ralph's mind is still full of fertile soil from which these creatures unearth themselves.

Talking of chanting, which the Thwacksplat loves to do, Pope Gregory I (540–604) is considered the creator of Western plainchant, hence Gregorian chants (and this Thwacksplat) being named after him. He is the patron saint of much, including musicians, singers, teachers and students, and against gout and the plague.

Unprotected electric pylons have been a major problem worldwide and I have witnessed first hand the sight of a once majestic creature reduced to an electrocuted sadness, such as this Steppe Eagle I photographed lying beneath a pylon on the Kazakhstan Steppe.

MME, BirdLife's partner in Hungary, has thankfully developed an insulating plastic cover for the metal crossarms of pylons, which should help decrease the number of bird deaths. It is to be hoped that these can be adapted to work with all the pylons in the world, as uninsulated electricity pylons cause too many needless deaths of birds. Now let's get them all fitted.

Gregorian Thwacksplat

Cantum harmonicum

This Hungarian Steppe-dweller may look like an inelegant flying machine, but his voice performs the most exquisite songs. He is the Cyrano de Bergerac of the singing bird world. A stonking big beak belies the beauty of his creations and he can be heard far and wide in the endless steppe.

This species' plight is that of many Hungarian birds, particularly those on the larger side, such as raptors and crows. Unprotected electric pylons litter the countryside and it only takes a fraction of a second for two wings to touch two cables and kerblammo! No more bird. Ralph has drawn this bird in full gentle-chant mode. This is when it is most vulnerable, as even though it looks as if it is concentrating on its surroundings and looking out for danger it is actually composing its flight song as it flies. This total dedication to its songs and its refusal to ever chant the same chant twice is what has left it as a Critically Endangered species.

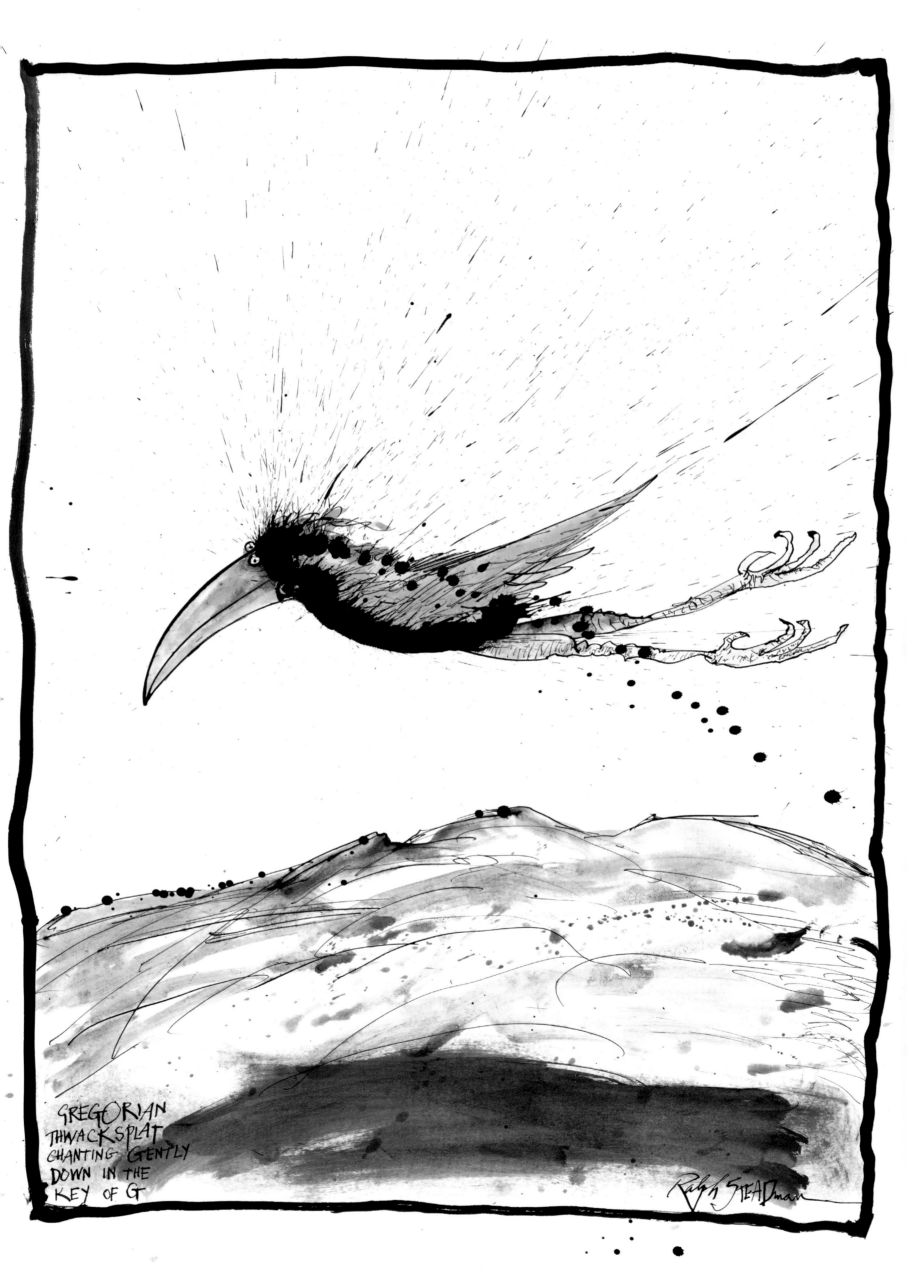

GREGORIAN
THWACKSPLAT
CHANTING GENTLY
DOWN IN THE
KEY OF G

Ralph STEADman

Urban Council Skip Chick

Urbicus quisquiliae

Left him in a skip to sit... Oh mother!!!! Lost and forlorn, his feathers all worn, what did his parents think when he was born? A happier skip chick would be able to pick the food from the bin that it finds itself in. But not this poor fellow who, in his skip oh so yellow, is waiting for a feed as this is his need, as strength is important for all birds to breed, so feed the bird, five quid a bag, then the urban skip chick's spirits won't flag.

Skip chicks are endangered because their habitat is decreasing. As more and more of our cities are transformed, fewer skips are being ordered and used in the streets. The gentrification of urban wilderness is destroying one of our best-kept secrets, the Urban Council Skip Chick. This habitat destruction has highlighted the skip chick's plight but also shines a light on other birds which inhabit urban areas, such as House Sparrows. Between 1994 and 2001 the number of London sparrows fell dramatically by 70%. No one knows for certain the cause of these declines, but the loss of hedgerows and front gardens plays its part, along with more cats and more pesticides being used. I used to live in central London and we used to have many sparrows and skip chicks outside our flat. But the last time we saw them was in the early 1990s. I miss sparrows.

The decline seems to have steadied for the moment, but it is a situation to keep an eye on. After all, what would the world be like without that continual chirruping from these little chaps as they rummage around our streets? It might be good for Ralph to draw a sparrow at some point, as birds can face local extinction as well as global extinction. For me, a local extinction is as bad as losing a species entirely. A species lost from my world is an emptier space that I inhabit. I miss sparrows and the Urban Council Skip Chick.

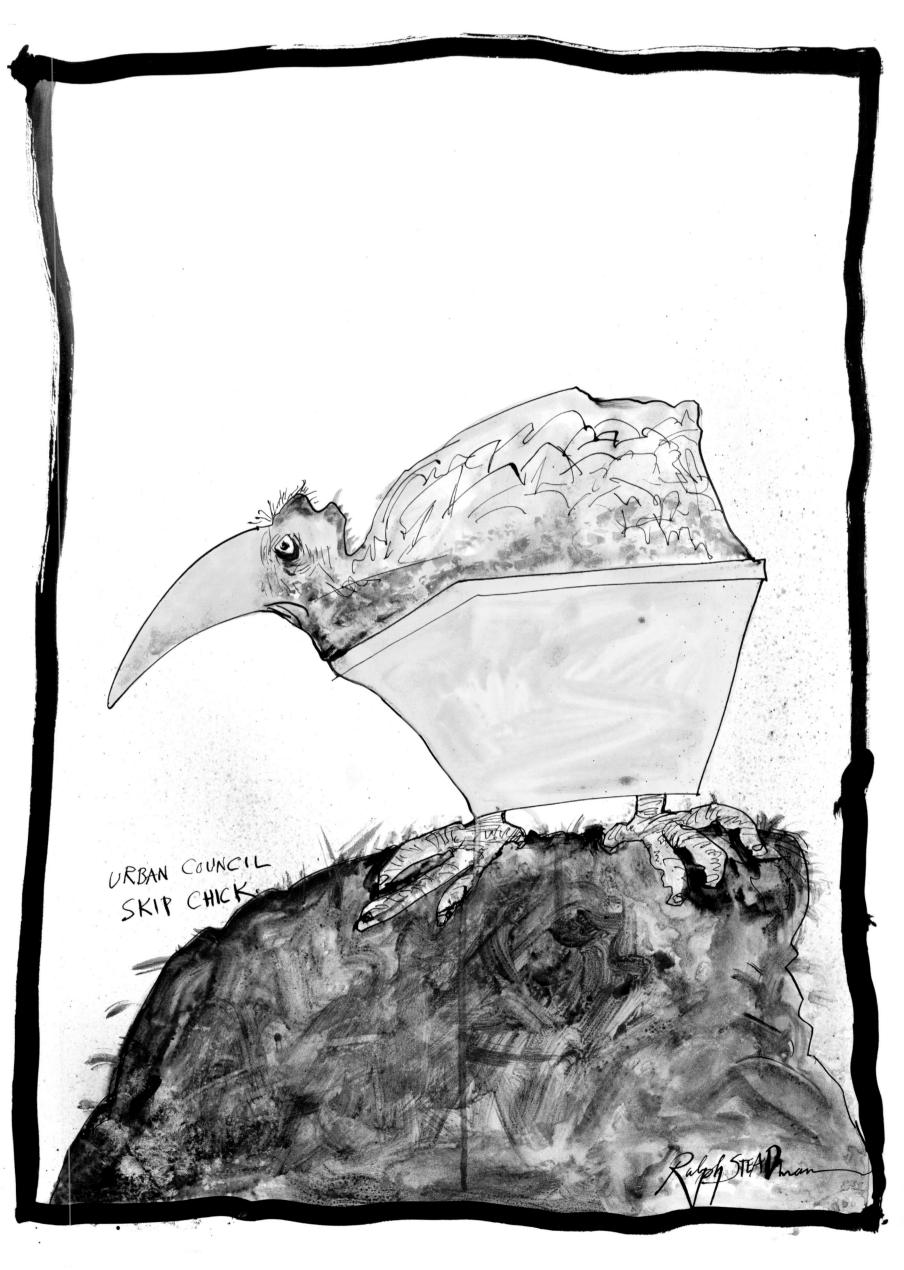

URBAN COUNCIL
SKIP CHICK

Ceri's Diary: In truth, since we finished the last book birds have never stopped appearing to Ralph, continually flocking around him long after *Boids* had been put to bed. New inventions came into being and longed to be uncaged and to be free to fly around his studio. What was Ralph to do? He painted what he saw and he accompanied them when the birds took him upon their flight of fancy. And then they were put into the art drawers and were forgotten about by Ralph until now, which is the right time to give them life and succour and let them breathe the studio air once more.

And the first, a Blue-beaked Waddle creeps up on me, followed quickly by the Hey Look Out! and then the Twim Wheedle-nit. All three are escapees from another world.

Blue-beaked Waddle

Pila magus

The Blue-beaked Waddle is a voracious eater and drinker, although he often eats the wrong things, such as fences, logs and sports equipment. If he sees it he eats it. He believes he is fit for his size and that he has immense sporting ability. To prove his prowess he wants to set up a nextinct football team, but the other birds tell him that this is not a birdly thing to do. The only support he gets is from an old Scottish grouse named Brrrddd (roll those rrrs), who hides out in the mountains making a nutty and woody concoction of moonshine birdseed liquor. The waddle is his main distributor of the potent tipple but unfortunately drinks way too much of the stock and is constantly in debt to Brrrddd, who insists he dries out twice a week under the care of the dance instructor and personal trainer of the island, the Hey Look Out!

Here we see the waddle working out, which is something he hates more than hangovers. These sessions are rigorous and make him so hungry and thirsty that he begins the cycle of habit once the session is over and seeks solace in some moonshine. If only someone would support his football idea it might take his mind off food and drink and give him something worthwhile to live for.

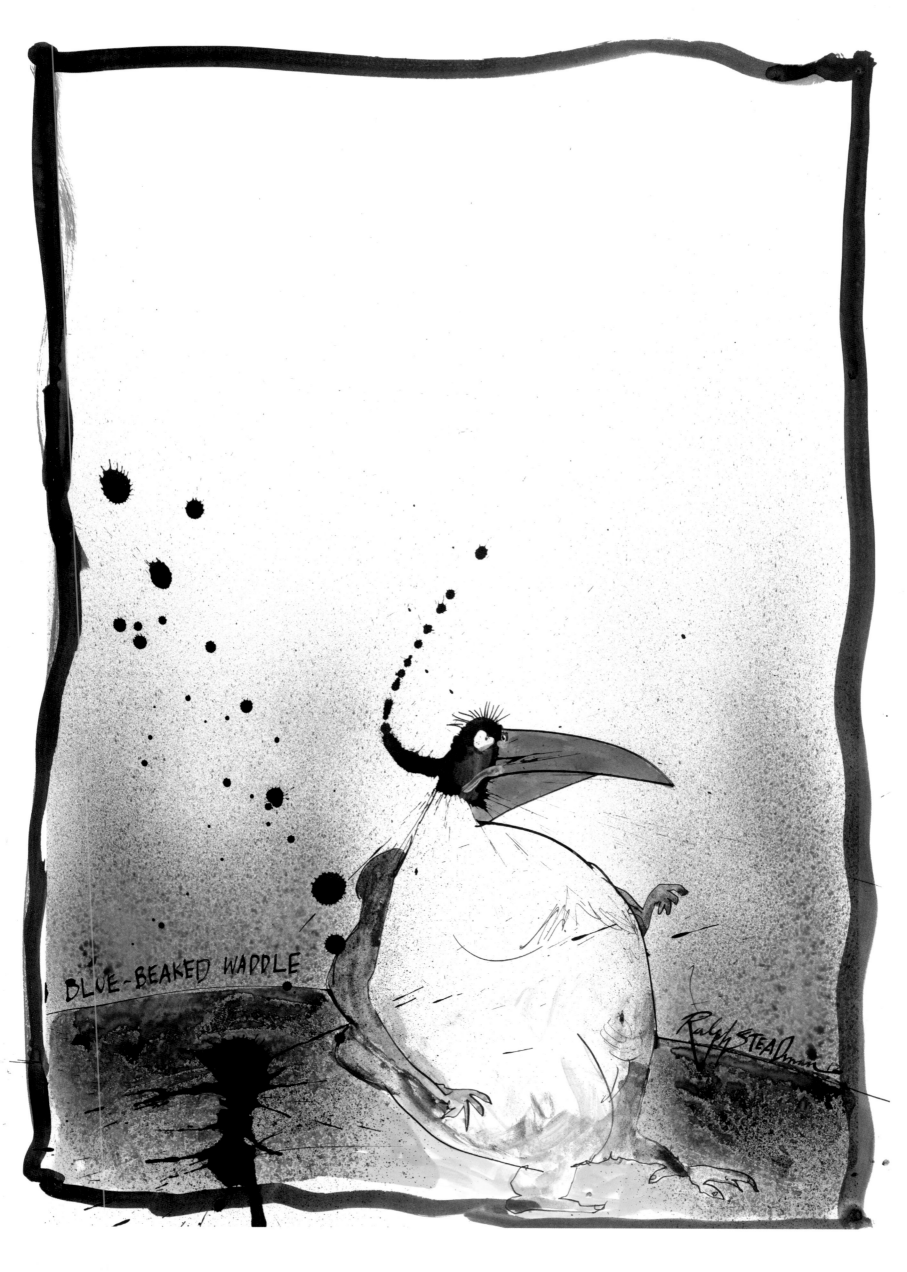

BLUE-BEAKED WADDLE

Hey Look Out!

Dominus chorum

Here we have the nextinct dance studio's infamous dance instructor, the Hey Look Out! His classes are legendary across the land and most tend to avoid his strict regime like avian flu. His shriek is just as bad as his bite and can perforate eardrums if the Hey Look Out! decides to use his highest, piercing falsetto voice. He usually keeps this for special occasions, such as alien invasion of the island or the appearance of a cloud of grasshoppers, his favourite food, which freeze at the emitted shrill sound, making them easier to eat.

One of the angriest creatures on the dark side of the island, the Hey Look Out! enjoys taking out his frustrations on his clients. Well, actually client. The Blue-beaked Waddle is the only remaining client he has and that's only thanks to Brrrddd, the drinks manufacturer, who, at least twice a week, sends the waddle for rehabilitation and a detox.

First there was voguing, then there was twerking and now there is boiding. This is the Hey Look Out!'s contribution to boidal body fitness. It is a complex and technical dance based on pelvic movements, coupled with vigorous leg thrusts and then a bellow from the soul. It's not the best dance for those with short legs, hence the Blue-beaked Waddle's misery in the dance studio. He much prefers the parallel bars as he can perch on those. Strike the pose!

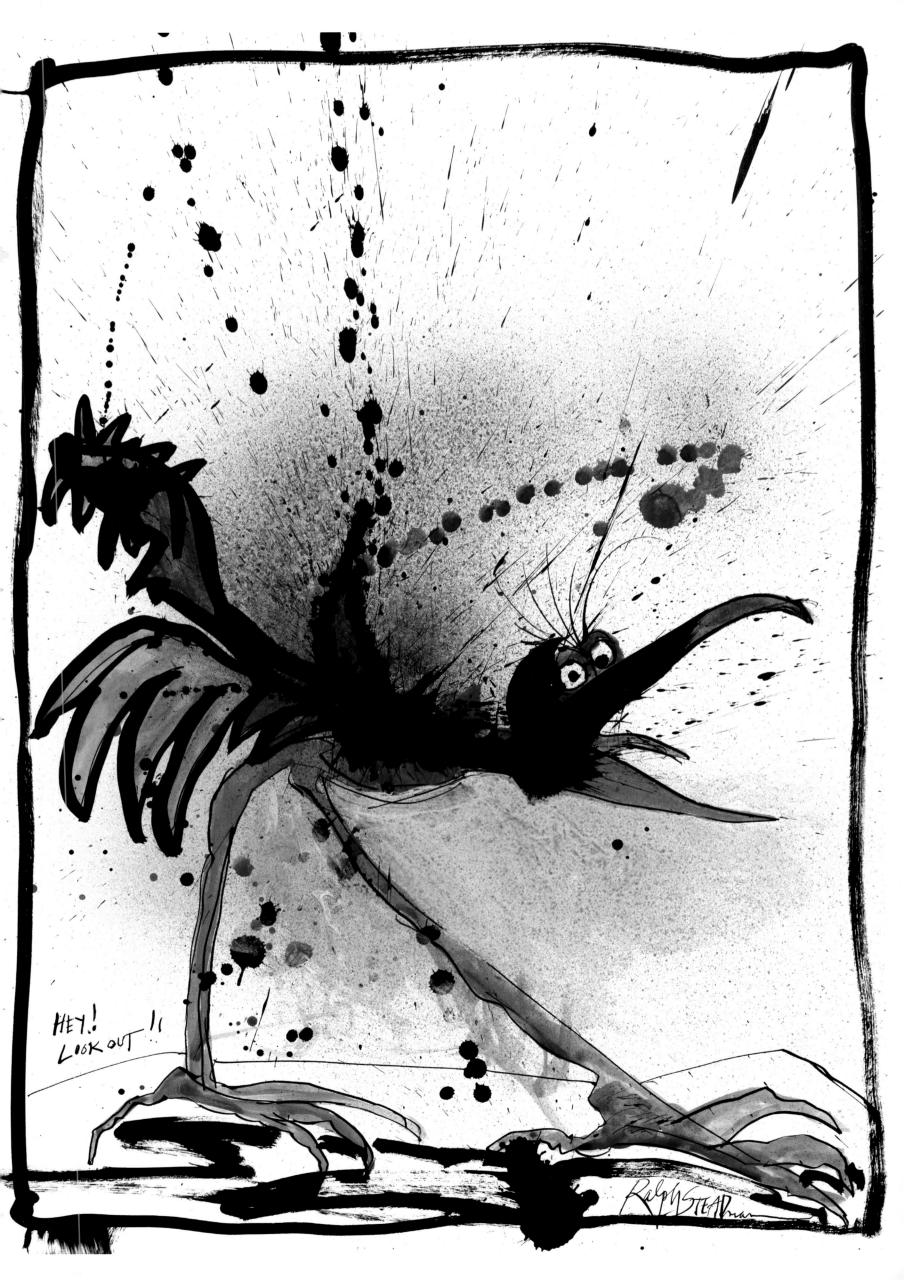

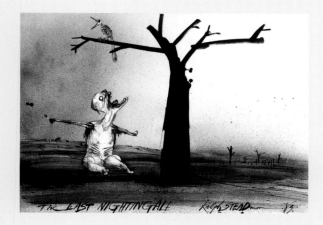

Ralph: Look! I bin doing birds for years. This is from 1983.

Ceri: That's pretty harrowing.

Ralph: It's what the world might look like if all the birds were gone.

Ceri: I hope you're not prophetic.

Ralph: Who you calling prophetic?

Twim Wheedle-nit

Bibitor immodicus

The Wheedle-nit is the island's big drinker and has proved to be one of the best clients for Brrrddd's moonshine concoction, which he has nicknamed 'Oooch Hooch' because of the pain it causes him when he is drinking it, as well as when he isn't. Over the years the 'Oooch' that courses through his sinews has twisted his form and his mind and converted him into a bar-propping Falstaffian fellow. Once he was the equivalent of the Squadron Leader and was responsible for protecting Toadstool Island from unwanted invasive species, but his drinking became an issue and he had to down his flying goggles and retire from active duty. His wing-like feathery fingers are no longer fit for flying and in his early dotage he enjoys quaffing the local brew and regales all and sundry with tales of when he was full of derring-do and could do no wrong in the eyes of the island's inhabitants as he dive-bombed and attacked any predator that came near the island's boidal colonies.

But time has passed and the drinks have grown larger, as have his stories. He is still an excellent companion but one has to be wary of his habit of inviting companions to a round of the drinking game Spoof, which involves being able to guess and count amounts of coins hidden in hands, which becomes harder and harder with each alcoholic top-up. He is a master at the game and most participants lose their minds, their money and the clothes they are standing in when partaking of a seemingly simple jovial diversion. Best kept at wing's length.

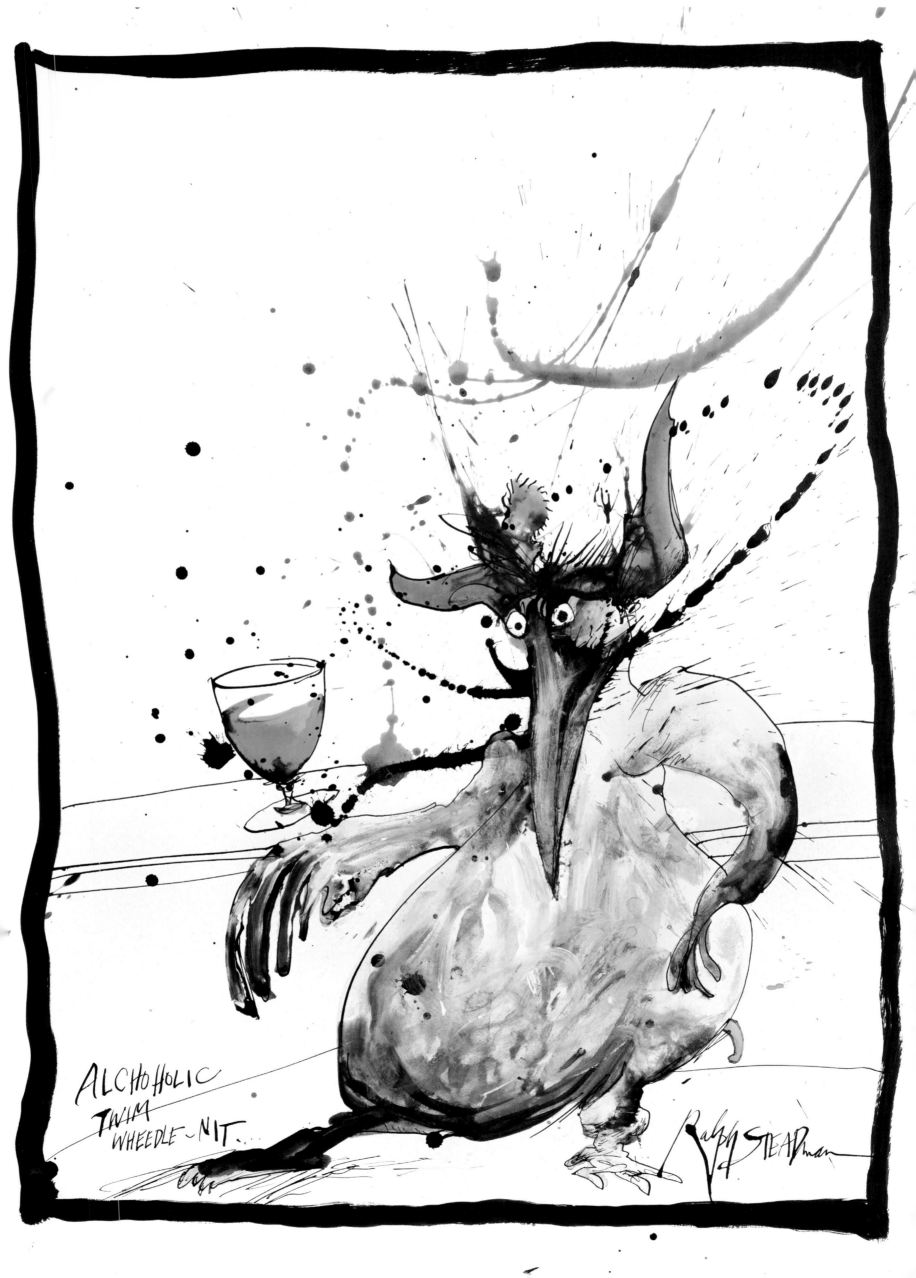

ALCHOHOLIC
TWIM
WHEEDLE-NIT.

Ralph STEADman

Brown Minor Blackbeak

Radi barbam

They often say that pets reflect their owners and vice versa, and never was there more a case of that than here. Roy looks like a man with a lot on his mind and it must be hard to work things out with this bellowing blackbeak perched upon his head. Roy was the founding father of the Club Français des Moustaches Guidon (the French club for handlebar moustaches). He decided to make it a French title as it sounded exotic to his neighbours in Penge and also got him discounts on certain ferries to France. The membership grew, as did the moustaches, but once he took ownership of Siegfried, a Brown Minor Blackbeak, he was disturbed to find that every morning the bird would have neatly trimmed his waxed ends away through the night. Consequently, Waxy Thompson, the club secretary, launched a direct and hostile takeover bid under a motion of no confidence in Roy's moustache due to its now consistent lack of permanence and upright behaviour, and the game was up for Roy. Now with no club to run Roy has decided to grow a more drooping upper-lip number, which thankfully Siegfried doesn't cut any more. Unfortunately, he does bury small olive stones within it, which is one of his compulsive disorders.

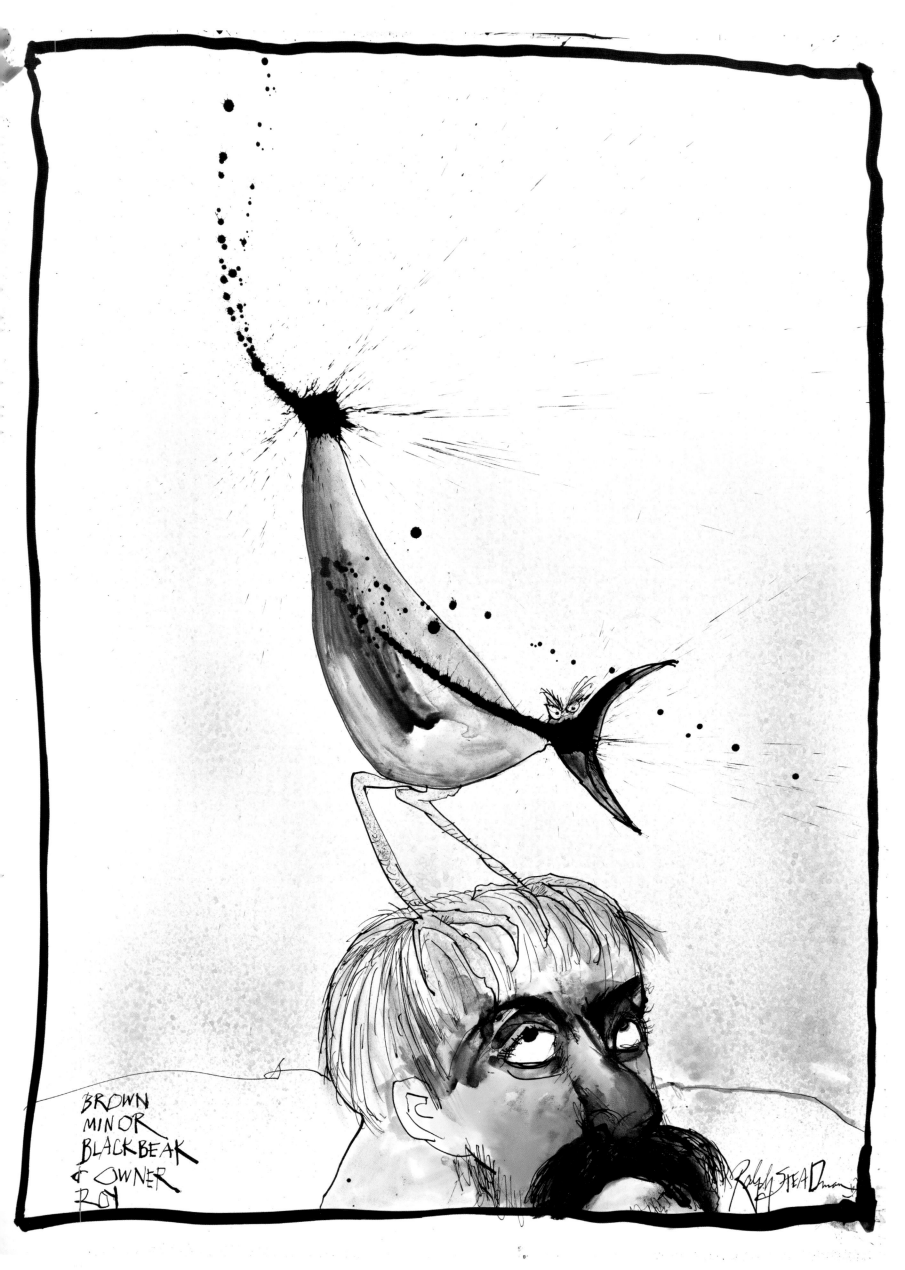

BROWN
MINOR
BLACKBEAK
& OWNER
ROY

Spot-tailed Neck Back

Collum superbus

Well here's an unusual sight. This epitomises exactly why the Spot-tailed Neck Back is becoming nextinct. It remembers the time when there were no roads, no cars and no danger. Arrogance and a refusal to move with the times means it haughtily crosses the road, deliberately oblivious to the fact that in a one-on-one situation with a moving vehicle, machine beats bird every time. But a stubborn genetic inability to accept that the world is not what it once was leaves the numbers of this extravagant creature at an all-time low.

Luckily for this cocksure stiff-necked primping pedestrian, the driver of the car is none other than Dr Sigmoid Flexure, who as well as being one of the leading bird proctologists in the world also takes time to teach various species how to avoid becoming nextinct. Here he is driving his mother Hildebrun's Hillman Imp directly at the bird to try and scare it into learning the severity of its situation. Concern is writ large upon his face, for this is a daily test which the bird continually fails, and Dr Flexure is think of moving to another form of therapy as the brakes on his mother's car can't take it for too much longer. Maybe the insertion of a simple work probe would give the Spot-tailed Neck Back something else to think about, although it is unlikely that this bird will ever change its spots (mainly on the tail). Sigmoid will never give up trying to help the nextinct, although he did become a little sidetracked when he became quite the celebrity thanks to his hit radio show about embroidery, *That's the Point*.

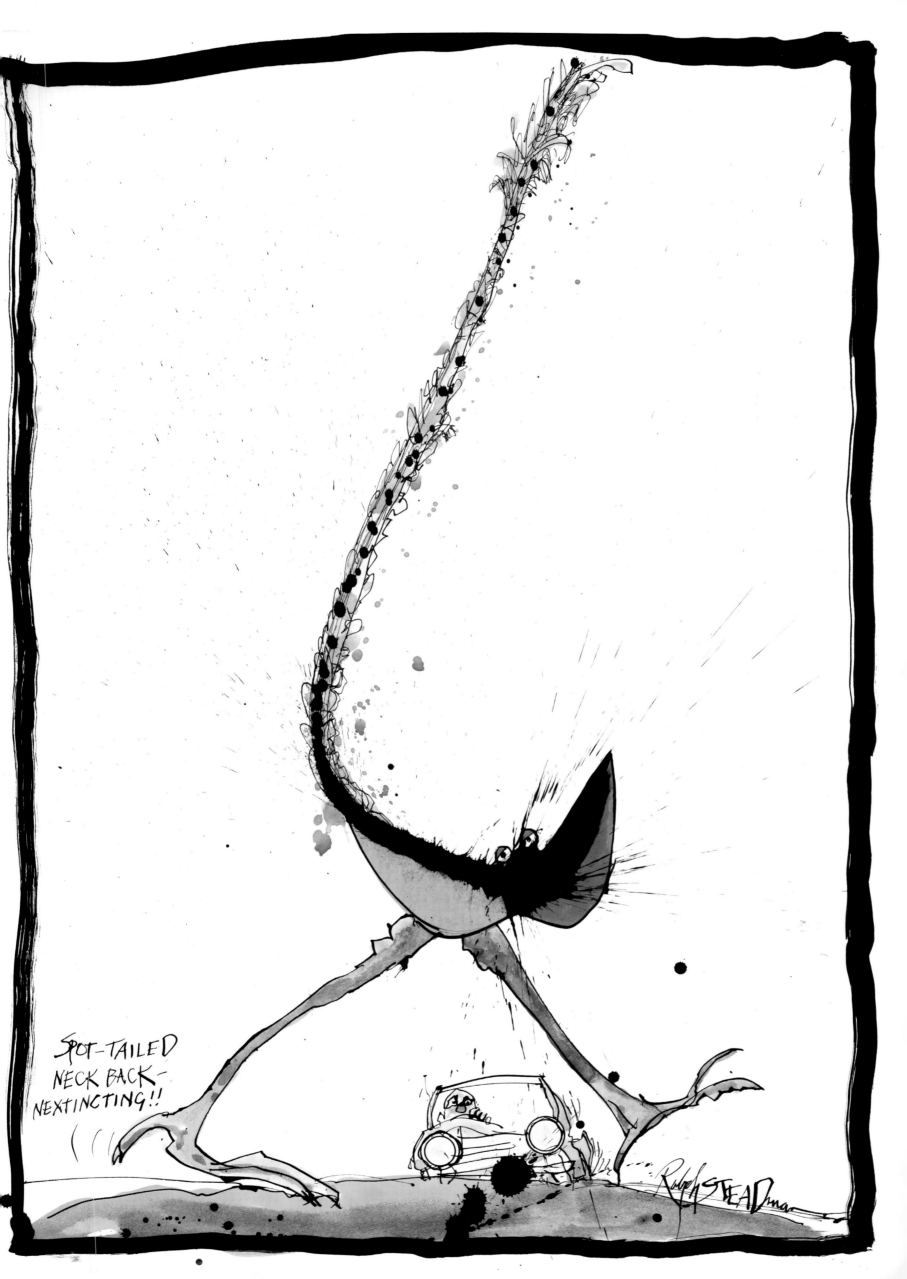

SPOT-TAILED
NECK BACK-
NEXTINCTING!!

Maltese Mayhem

Ceri's Diary: I am feeling guilty at the moment as I can't get out to Malta this year to take part in BirdLife Malta's annual spring watch to oversee the activities of the local hunters during the ridiculous hunting season, which is about to start (12–30 April). Many of my friends will be out there fighting the good fight and making people aware of exactly what is going on in the Maltese countryside. A multitude of protected species are being shot out in the wild, and the worst thing about spring hunting is that the birds are on their way to breed, so each kill is not just one bird but their potential offspring too. People have been approached to sign a petition to ask for a referendum on banning spring hunting altogether in Malta. If enough signatures are collected there will be a public debate and a referendum, and then many believe that this will rid the island once and for all of the spring slaughter. Come on, people of Malta, make your voice heard!

What we run to see, they run to shoot

When I first started making my documentary *The Bird Effect* I set out to make a short, light film about a strange pastime I had discovered called birdwatching. I had gone to the Isles of Scilly with my wife, Jackie, for a holiday one October, and whilst we were out walking we stopped and looked at this little bird hopping in a tree in front of us. I had no idea what it was, but it was a pretty enough creature. Before we knew what had happened we were surrounded, and then removed from the scene, by a group of people with tripods, cameras and binoculars. 'It's here!' Within seconds we were at the very back of the group of pushy people and we distanced ourselves even further. We had heard about these people… the locals had warned us. This army descended upon the islands every October; apparently these were twitchers. (I would discover the difference between a twitcher and a birder at a later date. A twitcher is a person who travels a distance to see a particular rarity, while a birder happily watches whatever is on offer.) We asked one of the slightly less excitable members of the group what the bird was. He blurted out it was a 'something something war ball'. We walked away none the wiser and I took a photo of the group as a memory. I later discovered that it was in fact a Blackpoll Warbler, an exceedingly rare American vagrant.

Since that day, I started filming birdwatchers as they watched birds and then became more and more interested in the birds themselves. The more I learned about them, the more I became interested in conservation issues, and when I heard the writer Margaret Atwood giving a lecture about the problems that birds face today I became converted to wanting to help in any way possible. Soon I was following many different stories and one subject kept reappearing before my eyes. Hunting.

I have been travelling regularly thanks to the birds and my interests have taken me to 'hunting hotspots' such as Malta. This well-known 'holiday hotspot' with its all-you-can-drink-and-eat hotels is littered with holidaymakers who are oblivious to the rampant slaughter of birdlife that can happen within sight and sound of the swimming pool. I have witnessed egrets being shot at while tourists sip piña coladas and burn rapidly in the sun. It's an odd juxtaposition and on the whole these tourists are shocked when you explain the situation to them.

When I discovered Malta and the illegal hunting of migratory species that happens there, I decided to go and investigate and see the situation for myself. I took part in BirdLife Malta's autumn Raptor Camp and then went back the following spring for their Spring Watch to be a part of a team that watches for illegal hunting activity on the island. What I discovered was horrifying to say the least. What we run to see, many Maltese hunters run to shoot. Amongst the birds I saw shot, or lying dead, were Eleonora's Falcons, Black Storks, White Storks, kestrels, Marsh Harriers, bee-eaters, Hoopoes, Night Herons, Little Bitterns and swallows. The list grew and grew and my distaste, horror and mistrust of hunters and their sport did likewise.

There are between 10,000 and 15,000 hunters on Malta, an island that is only 23km long. This equates to approximately 46 hunters per square kilometre. What chance do birds have of surviving as they migrate across such hostile terrain?

I will never forget my first experience of the light and dark of the situation in Malta. There was about an hour until sundown and all was quiet. Then, floating in on the air currents, appeared a Lesser Spotted Eagle, a majestic creature circling and searching for a roost site. I marvelled at the spectacle of this rare raptor floating above my head. This was only my second day out, the first time I had ever seen this bird, and I got lost in the birdwatching aspect of the afternoon. I was caught up in the beauty of this bird, knowing that it had undoubtedly just travelled some hundreds of kilometres on its migratory route and was now probably exhausted and in need of somewhere to sleep. As the light faded so the bird got lower and lower, and at the last light of day it descended towards a tree as it began disappearing into the darkness of night-time. 'Well, that's not so bad,' I thought to myself. 'Safely down for the night. Now we'll just keep an eye on it through the night and protect it for a safe take-off in the morning.' The bird inched closer and closer to the trees and then, just as I could imagine its talons opening to grab a bed for the night, 14 shots exploded above my head. This was gunfire ringing out in the twilight. And in that moment we knew the bird was dead. Shot emphatically. Car lights in the distance glowed as the hunters left the scene of the crime, now too dark to gain any evidence of the perpetrators. This was a shocking glimpse of the deviant reality of the situation on Malta. Since then I have vowed to help as much as I possibly can. But we need to be aware that hunters are prevalent all over the world and we can all do something wherever we live, whether in the UK or elsewhere.

It is important to stress that Malta is by no means the only offender. I use it as an example as I have been there and witnessed atrocities being committed. Hunting is a widespread disease that shows no signs of responding to treatment. There are over 700km of mist nets along the Egyptian coast, which snare small songbirds numbering into the millions, while Cyprus allows lime-sticking to continue capturing hundreds of thousands of birds. Lime-sticking is a particularly vile way to capture birds as a stick is covered with sticky lime, akin to superglue, and once landed birds become stuck to it, perhaps by a wing or a leg. Birds have been known to bite through their own leg to get away or have torn off a wing in an attempt for freedom. It is a barbaric practice.

Idealistic notion

I read a story today about a hunter being prosecuted on Malta for shooting an owner's racing pigeon – pigeon racing is an extremely popular pastime on the island. This is not the first time that this has happened. These pigeons can be expensive, too, with a good breeding bird costing up to €2,000 and more often than not a good racer in the region of €400. The upshot of it is (pardon the pun) that the hunter will be fined several thousand euros for shooting the bird, as it is someone's property.

This made me think for a moment, as it is the first time I have ever equated birds with having a monetary value. If a racing pigeon is worth €400 then what is a White Stork worth? Or a Little Bittern, a Marsh Harrier, an Eleonora's Falcon, a Pallid or Hen Harrier? You get my drift? And if a bird only has a value because it belongs to someone, then don't these wild birds actually belong to the world, to everybody?

Perhaps we should have a world list of birds complete with their monetary value. If money is the only thing the modern world understands then let's take conservation down that path too. Is a White Stork worth more or less than a racing pigeon? It has to be more, so what price to put on it? One has to consider a bird's rarity and whether it is a protected or endangered species. Could a White Stork be worth €25,000? What would you say? Would that make a Lesser Spotted Eagle worth €50,000? It becomes like Top Trumps. If a hunter is caught shooting a protected species then he should be paying the predetermined list value of the bird.

What if the government of the country within which the incident occurs is fined the same amount too? This would ensure that governments actually carry out their duties for the protection of the environment, and if no hunter is found to prosecute for a shooting then the government alone is fined double the cost. All monies collected would go into an environmental bird-protection pot, which would be used under the guidance of conservation groups to go to the protection of endangered species. This probably sounds too idealistic for many, but why shouldn't it be possible? If countries were held equally accountable for the death of a species, wouldn't our birds have more of a chance of survival? The Maltese government would have a large bill to pay, as would the Cypriot government and the UK government, especially where Hen Harriers and other raptors are concerned. It would also make countryside dwellers more vigilant knowing that there was hope that action would be taken against bird killers and species would be further protected. We must stand up for our birds and our wildlife and politicians around the world have to join the fight and mean it. Let's begin to value our birds. Literally.

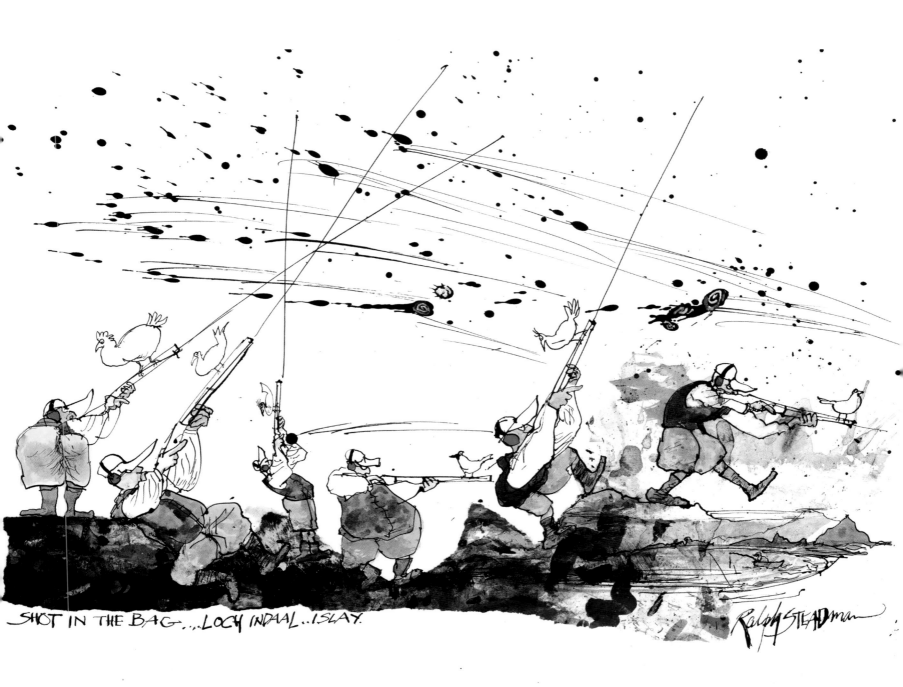

SHOT IN THE BAG....LOCH INDAAL..ISLAY.

Ralph STEADman

Ralph emails:
The Clueless Easily Spotted SWORDBEAK – below

Ceri's Diary: At first glance it is not certain why this fellow is facing nextinction, especially armed with such a pronounced and vicious swordbeak. But the reality is that he is unable to close it, therefore leaving himself prone to becoming stuck in various places as well as ingesting things he never wanted to eat.

Ralph emails:
Yesterday to get out of the house we took a friend who is staying with us to the Music Museum called Finchcocks, a stately home near Goudhurst. Marvellous collection of Pianos – Spinets – and Pianolas – we have one here!! But someone came here to fix it 10 years ago – took away parts to replace – and never came back!!

Anyway, haven't been able to get near my camera for two days because granddaughter Grace has been recording my own stuff for pissterity – but managed to shoot the Splatwack – which was common to the Mersey area until quite recently. Sociable Lapwing is on my board – to be followed by the 'Socialist Leftwing' – soonest!! Then all Hell breaks Loose in Loose. Saw a male and female Blackbird nesting and rooting about on the lawn this morning. I think the nest is somewhere in the Veg Garden Hedge – you betcha!!

Look out below!!! Incoming!!! Duck!!! No it isn't! It's the much forgotten Splatwack… Messy creature, WATCH OUT!!! Too late. SPLATTT!!!! Eh WACK!!!! He knows the Liverpool Pigeon, doncha know??!!!

Ceri's Diary: Ralph tells me, while he tidies his studio and his granddaughter, Grace, organises, photographs and archives his pictures, 'There's just so much of everything…'

To which I add, 'and so little of nothing.' By which I mean there is no empty space anywhere as so many images, words and ideas abound throughout his studio. The only space for nothing is the board upon which he draws, and that fills up every time he places another piece of paper on it and begins again.

Ralph chuckles, 'That is the truth of this place.'

Actually, the truth of the place is that it needs somebody to devote time to archive the ever-increasing amount of work that there is in the studio. Grace has begun to do this and is devising a system for the art in this book, which I am certain will prove essential. After all, a picture disappeared from view with the last book and never showed up again. The Pale Blue Piddles, for it was they, just piddled off to some dark recess of the studio and they were gone. This time, I hope we have all bases covered.

Blue-beaked Splatwack

Infligo turbamentum

Not to be confused with its steppe-dwelling cousin the Gregorian Thwacksplat, the Blue-beaked Splatwack is endangered due to the lack of clothing in its habitat. Its beak is akin to a pair of scissors and it used to survive by cutting up material and clothing to build its nest. This would often take as long as a year as the bird never knows when to stop cutting, eventually turning all material into powder and being unable to build a nest from this pile of residue. Consequently the splatwack often misses a whole year of breeding and numbers have therefore declined. If only it had the sense and grace of the original Asian Tailorbird, which cleverly sews leaves together to form its nest. But it doesn't; after all, it's a splatwack!

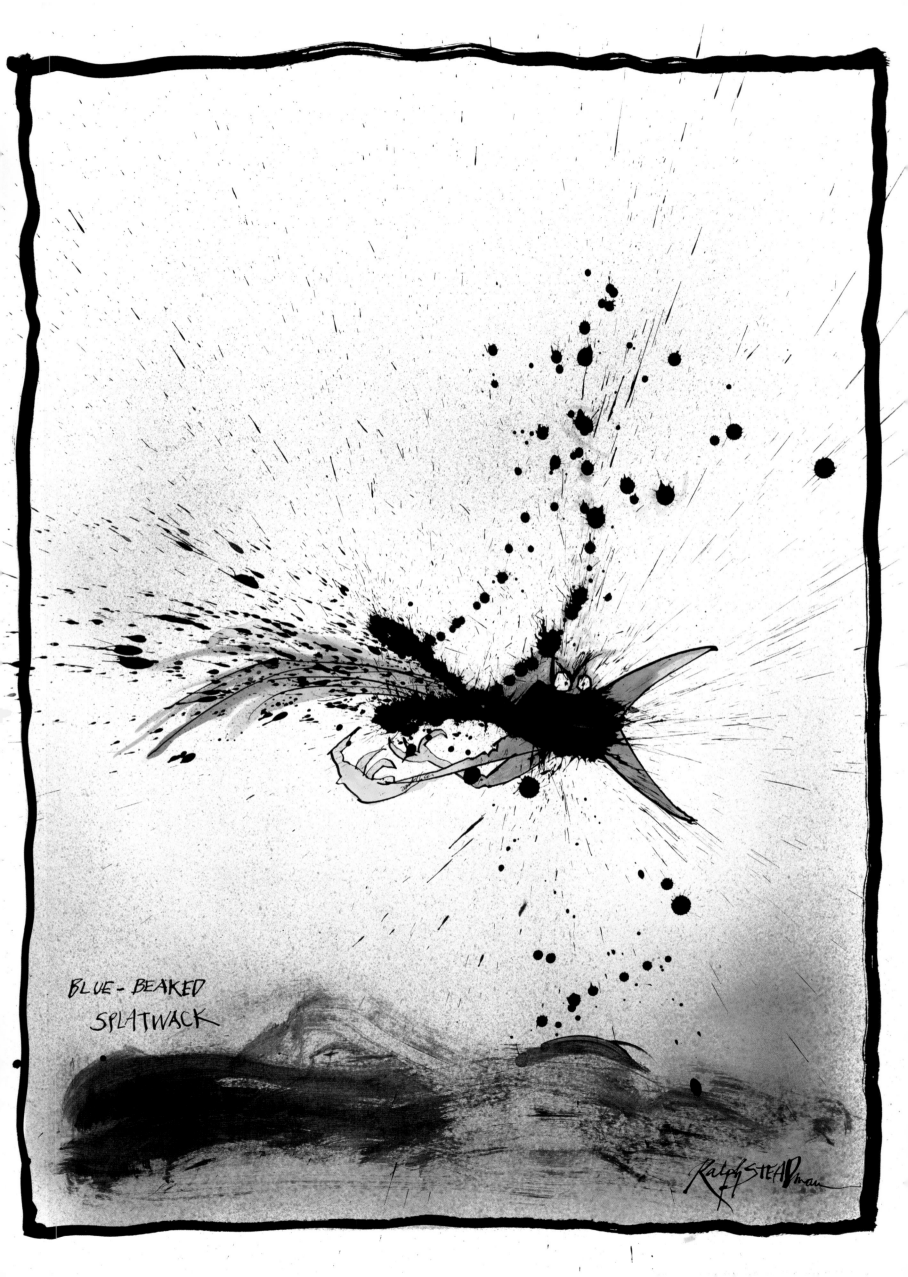

BLUE - BEAKED
SPLATWACK

Ralph emails:

Can't photograph the Sociable Lapwing until I take possession of my camera equipment again!! By the way – it's the Socialist Leftwing, who may be coming soon!! I need background for this one – a tad!! Here comes the camera... Lapwing, stand back, turnover and ACTION!!!!

Ralph emails:

Can't photograph the Sociable Lapwing until I take possession of my camera equipment again!! By the way – it's the Socialist Leftwing, who may be coming soon!! I need background for this one – a tad!! Here comes the camera... Lapwing, stand back, turnover and ACTION!!!!

Ceri replies:

He looks a lovely kind of fellow. Far too trusting I would say! No wonder he's in so much bother! The other bird, I think you mean, is the Unsociable Leftwing! A true revolutionary and quite angry fellow who is trying to get the hunters that keep shooting his cousin, the Sociable Lapwing, to turn their guns upon themselves. He brooks no nonsense and is a militant but fair bird with socialist tendencies...

Ralph emails:

NAH!! It's the Anti-Social Leftwing – who only has the one wing and he uses it to shove other creatures and hunters aside... I will look at the situation and consider the Lilies... NAH!! I decided!!! The UN-Sociable Leftwing is due for NEXTinction... A little bird told me that!! But I knew it already. And the KIWI is a fruit. So we are lost in our quest to become the Leaders of the Nest.

Ceri's Diary: The Sociable Lapwing is one of my favourite birds and actually one of the first birds I ever saw on my bird travels for my ongoing documentary, *The Bird Effect*. I was on the Isles of Scilly when the cry went up that a potential Sociable Lapwing had been seen on the airfield of St Mary's, the largest island. The Sunday afternoon was closing in and we headed along the darkening coastal path to discover a few hundred people all staring through the gloom at a Sociable Lapwing walking hurriedly up and down the unused (on a Sunday) airstrip. This was a major rarity, as it was only the 43rd sighting of a Sociable Lapwing in England and a first for Scilly. This had been my first major twitch for a bird and I found the atmosphere electric. The urgency and anticipatory feeling one sensed in the hurrying of bodies and feet up to the location was palpable. This was no ordinary moment and I began to realise exactly the power that birds hold over many people. Whether it's twitching or simply birdwatching that floats your boat, a bird is central to either and has the power to make your day or ruin it completely.

This particular bird was seen for several days in different locations, and what fascinated me was how it was treated like a rock star on its first appearance. The crowds turned out and those that couldn't get there on the first day hurried over from the mainland the next day to pay homage. By the third or fourth day I remember watching it in a field with only a handful of people, and thought about how strange that this once revered bird had been surpassed by whatever had appeared next. After all, it was still a beautiful sight and I had no idea just how much the species would come to mean to me as I filmed it on its breeding grounds in Kazakhstan.

Sociable Lapwing

Vanellus gregarius

The Sociable Lapwing's rapid decline and loss of numbers is estimated to be around 98% of its population in recent years. One of the main threats to the species is hunting along its flyway, which takes in Europe and the Middle East as it flies between its breeding grounds of Asia, in particular Kazakhstan, and its wintering grounds in Africa.

It was first believed that there was a problem with eggs being trampled underfoot by cattle and other animals on the breeding grounds. But more research has been carried out and hunting is now considered to be the main cause for the alarming decrease in numbers of the lapwing. Therefore, the countries along the bird's flyway are working together to halt its demise and efforts made could lead to the lapwing's status being changed. This is a potential success story, although the work is ongoing and needs total attention paid to it.

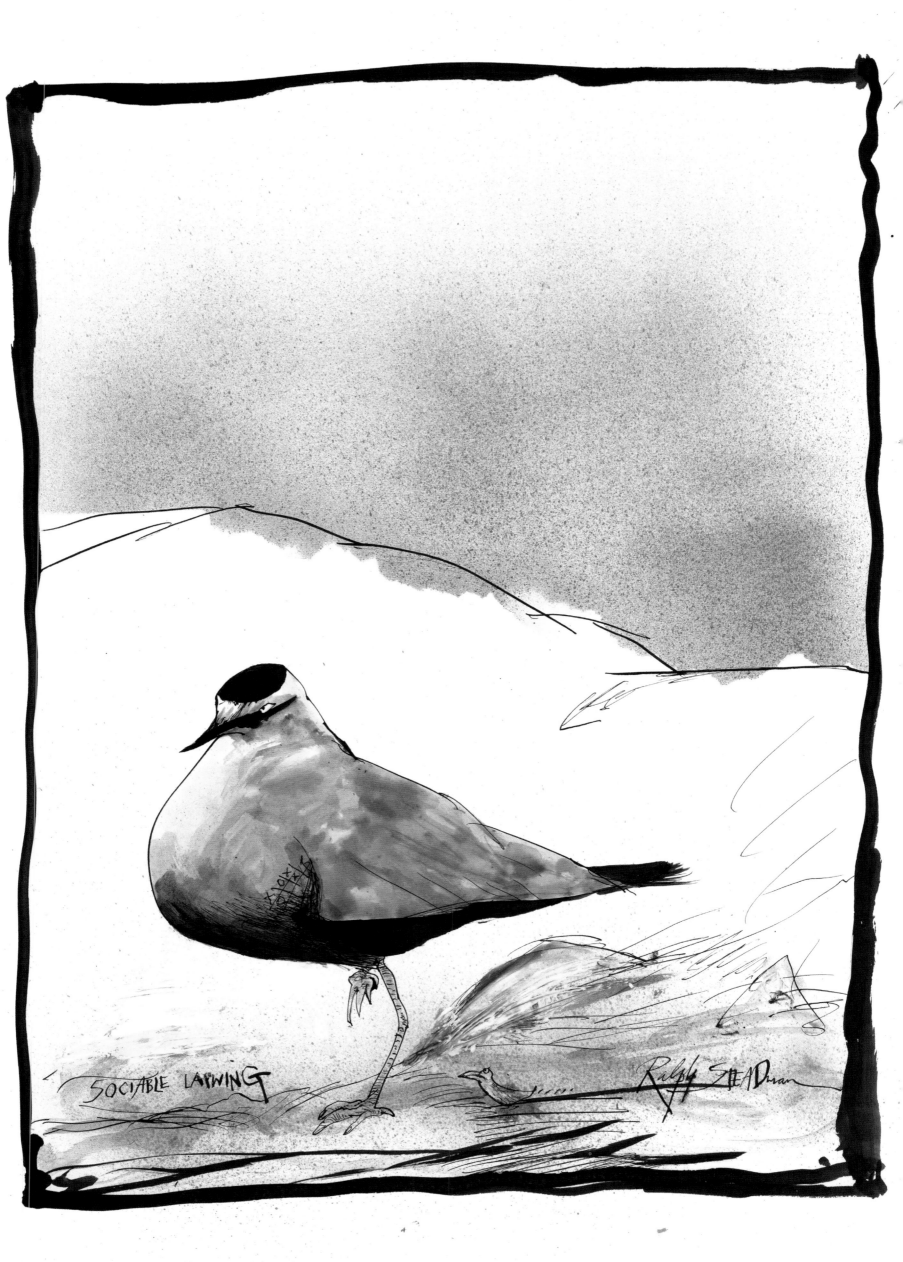

SOCIABLE LAPWING

Ralph STEADman

Ralph: I am going soon to Ronto for some film festival, which is showing *For No Good Reason.*

Ceri: Ronto? Where's that?

Ralph: You don't know where Ronto is? How strange for a well-travelled man like yourself. To-ronto, Toronto... Get it?

Ceri: I'm so slow...

Ralph: Don't be! I can't bear slowness.

Ceri: Are you looking forward to it?

Ralph: Not really. It will only be full of people wanting something. Interviews, talking, endless repetition. But if it helps the film, I will do it.

Ceri: I'm sure it will be fun once you're there.

Ralph: Are you? You're just saying that for no good reason.

Ceri's Diary: Sometimes, actually often, Ralph surprises me and today is one of those days. He deliberately keeps birds from me; of this I'm certain.

On Skype:

Ceri: Have you been giving any thought as to which birds to do next? Be good to get some on the board again.

Ralph: Yes of course I have. In fact, I am right this minute working on Edwards...

Ceri: What, the pheasant? Edwards's Pheasant?

Ralph: I did that a while ago! No, I am working on Edwards himself. All these birds get drawn and made a fuss of and no one ever pays much heed to the poor bloke who found them in the first place. So I'm getting on with Edwards to make up for this terrible injustice. Look, I'll show you.

(Ralph comes back with a sheet of paper with a Blue-throated Macaw on it.)

Surprise!!!

Ceri: That's neither a pheasant nor Edwards! That's a Critically Endangered Blue-throated Macaw. I've never seen him! When did you do him?

Ralph: Did 'im ages ago. You've not seen him before? But you're supposed to be the bird expert here, how come you missed him? Call yourself an authority? Pah!

(Then he goes back to the studio and brings back another sheet of newly inked paper and shows me Edwards and the pheasant and they go well together.)

Ceri: If you could send me photos of those two pictures when you get a chance that would be wonderful.

Ralph: SQUAWK! SQWAWK!! Always after something!! I will send this Blue Macaw what I did draw!!!

Blue-throated Macaw

Ara glaucogularis

I remember as a kid I would walk down with my mum to the local pet shop and admire the animals that they had in the window. Apparently, I wanted the fruit bats more than the parrots and macaws, but I would always ask why this zoo had such small cages for such big animals. My mum would then have to explain to me that it was a place where people bought animals to take them home, to which I would reply that surely they were meant to be living in the jungle and similar places. How times have changed since then. Now we, as a race, know better than to take animals from the wild and put them in cages, don't we? Apparently not.

Today the Blue-throated Macaw is endemic to only two locations in Bolivia, and unfortunately a history of always being a popular macaw for the caged-bird trade has left its grubby mark upon its numbers. And if that wasn't enough, loss of habitat has played its part for those birds that have avoided being caught.

Much work has been done to halt the caged-bird trade with a fair amount of success, but it is still going on. The worrying trend is that for many of the traded birds their numbers are higher in captive populations than they are in the wild, and this needs redressing.

But things are moving forward and work involving landowners and placement of nest boxes is helping the macaws to survive. With luck, they will never be seen in a pet shop again.

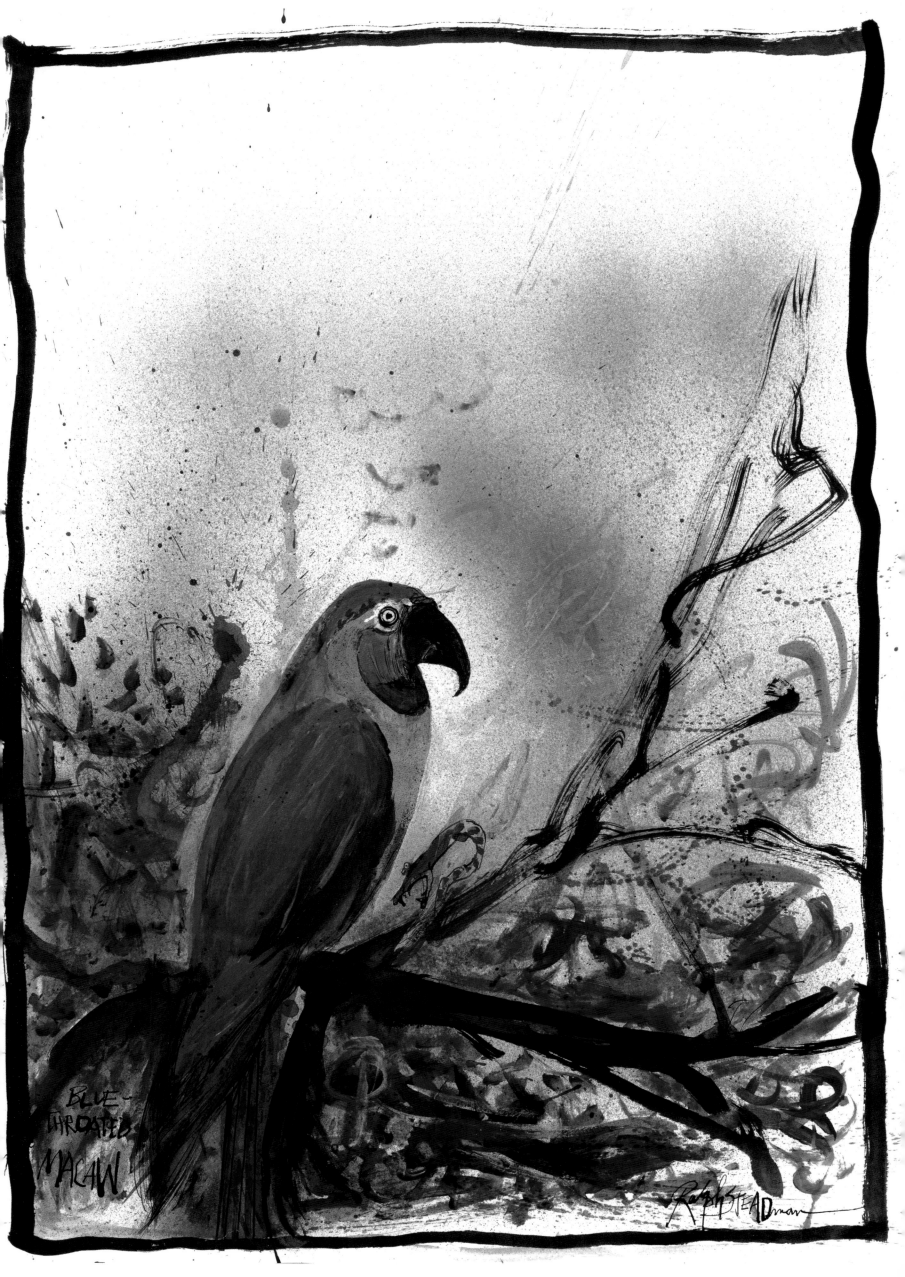

BLUE-
THROATED
MACAW

Titograph

We live in the age of graphs. You can get a graph for everything whether it be related to health, wealth, knowledge, sport or something as ridiculous as how long the contents of a toothpaste tube will last for. With imagination a graph can be created for anything. So what happens here? You sit a couple of Steadmans down with a good bottle of wine of an evening and invention will have its way and the world ends up with a Titograph! Ralph and his daughter, Sadie, discovered this eclectic group of tits over a glass or two of a fine red. All bases were covered and I think my particular favourite is the toothy Ibitit. He just looks fiendishly naughty and I wouldn't want to find myself anywhere near those gnashers.

It still needs to be converted into a bar graph or a pie chart but these are the finest ingredients to use. We just need someone to correlate the information and draw it. I guess we will need a drawtit.

Having a deep fascination with collective nouns I asked Sadie what a group of Steadmans would be called and she immediately answered, 'A struggle of Steadmans.'

TITOGRAPH

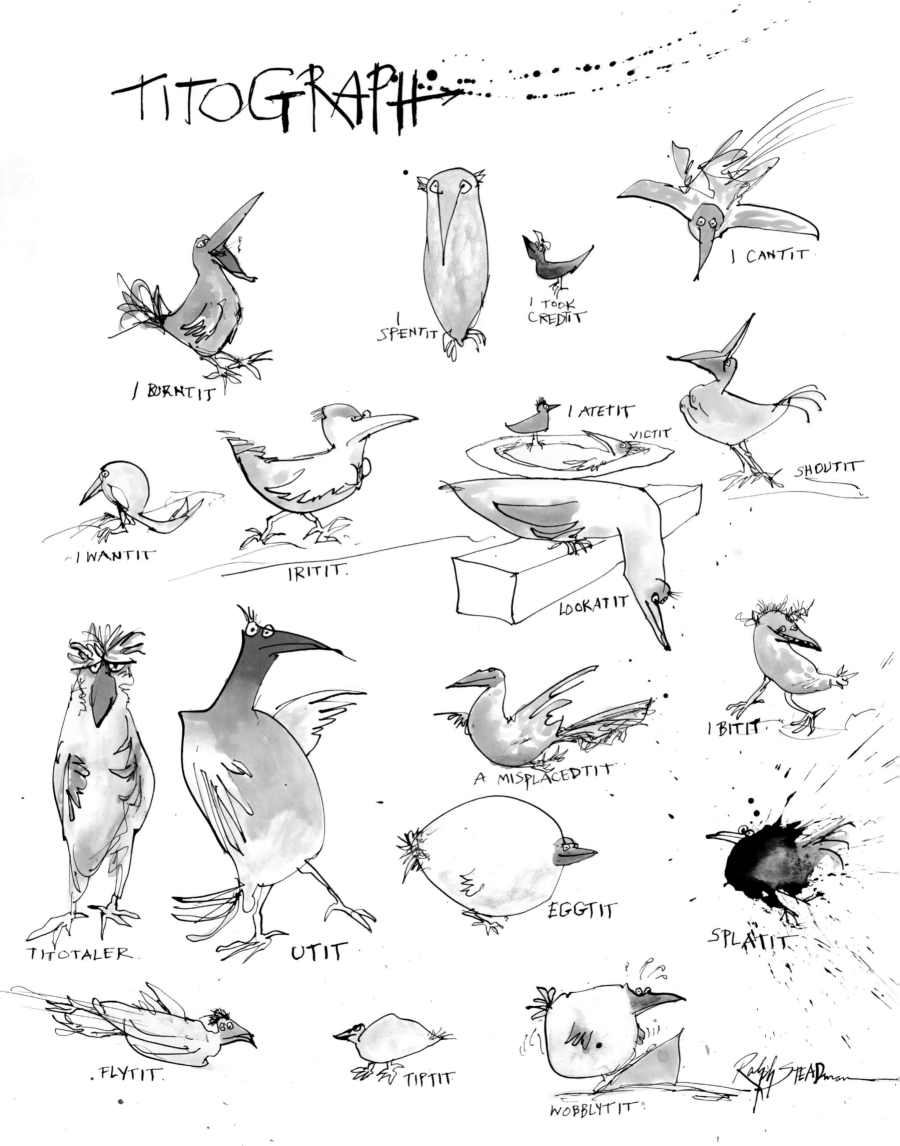

Ceri's Diary: I wonder what else he's been keeping from me. There's bound to be something, that's for certain. Every now and then I get the urge to go and visit Ralph, not solely for the great company and wonderful lunch laid on by Anna, his wife, but also to have a rummage through the studio just to make sure we haven't overlooked a bird or two. It has been known to happen and also birds have managed to escape from the studio and often need rounding up and putting into the relevant folder. I love doing this because nothing ever prepares me for the first time I see these birds in all their A1-sized glory. Although things have changed with Grace's arrival and I can rest a lot easier.

Phone:

Ceri: We're lucky that Grace is now on hand to put things in order and archive your work.

Ralph: I shall bestow upon her the title of Studio Explorer.

Ceri: Technically, shouldn't that be Studio Explorer-in-Chief?

Ralph: Quite right, and so it shall be from henceforth!

Ceri's Diary: And so Grace's role is defined and not only has she begun to archive the whole studio, but she will also archive every little bird that appears, document it and send us photos before they can flit away and make an unseen nest elsewhere in the studio. This will help immensely with the book. It's a good day.

This week I sent Ralph some books from BirdLife, which give information about the birds we are documenting. They are useful for Ralph to have to hand, instead of having to rely on myself, or the Internet, for information. I am sure he will make use of them and that they will prove invaluable.

Ceri emails:
Don't forget to photograph Edwards's Pheasant.

Ralph replies:
Well, DON'T BE BOSSY!! My Muvver tort me that!!!

One minute I tell you about Toadstool Island – and you've hijacked it as an ideal place for the Birds. What about the Creatures hiding in the Bloodshed??

I was perusing your Bird Books last night and thought Blimey!! There's farsands of 'em linin' up for Nextinction!!! I'm a little concerned!!!

Here's Edwards!

Edwards's Pheasant

Lophura edwardsi

Here is Edwards's moment in the spotlight courtesy of Ralph. This is the moment he first espies the pheasant. In fact, which came first, Edwards or the pheasant? They share a peculiar similarity to each other with the discoverer flushing the same colour as the bird's face. Such a seemingly English-sounding name belies the fact that Alphonse Milne-Edwards was a French ornithologist.

Edwards's Pheasant is endemic to Vietnam and is a forest-dweller. Habitat destruction (i.e. deforestation), hunting and the use of napalm and other extreme defoliants during the Vietnam War have all threatened the bird, which was believed to be extinct until it was rediscovered in 1996. Unfortunately, there have been no confirmed sightings since 2000 and it looks ever more likely that the species has decreased to smaller and fragmented numbers. Camera traps have been set up in various locations but have not managed to capture a single glimpse of this pheasant. The last search was carried out in 2011, but more are needed to try and locate the last living birds and protect them.

EDWARD'S
PHEASANT
AND EDWARDS!

Ralph emails:
I can't make my scanner work!! I have spent four hours so far!!! So I took photos... of birds!! And then more birds!!! There are simply too many birds in the books you gave to me!! I think this one should be an ART BOOK!! But experiment! Experiment!! Or we could do a book about David Attenborough. I will continue to browse until it all falls from the sky!!

Here is a bird scan 'aesthetic' I came across which you won't have seen! I think it is a pleasant pheasant. We must meet!!

Pleasant Pheasant

Must do the AKOHEKOHE!! I've just drawn this table for our first book of extinct boids. Why have I done it? I am now going over to the house for Supper... ring in the morning!!

Ceri replies:
I have no idea why you have drawn this but it's a pretty amazing table. We should make it. Maybe take some orders for it. I would love one and I'm sure other people would too...

The Extinct Birds Coffee Table

HURRY, WHILE STOCKS DON'T EXIST!

For all enquiries please phone EXT 333 and ask for Spurnley Boggins. Orders will take up to three years to process, another three years for fabrication and then a further three years for delivery.

The EXTINCT BIRD
COFFEE TABLE.

Ralph STEADman

Ceri's Diary: The story of the bustards and the floricans of this world has been a tale of great sadness. The ways of the world have not worked in favour of these creatures that love what many would consider to be great swathes of wasteland such as steppe and arid, dry grasslands. The modern world likes to convert these areas into agricultural nirvanas, irrigated to the max and producing crops galore. But this means that the bustards and the floricans have to move on in search of other land. Nomadically they trudge on and then have to face their next challenge. Due to the size of them, they are considered a hearty meal and a perfect trophy for the 'hunting sportsman', although what can be considered sporting about taking out an unarmed (or should that read unwinged?) bird with a gun is beyond me. All of these birds live in Asia and much work is being done to protect these species before they disappear down the tubes.

Great Indian Bustard

Ardeotis nigriceps

The Great Indian Bustard is extremely likely to become extinct sooner than many of the other birds in this book. It was first listed as Endangered in 1994 but its status was elevated to Critically Endangered in 2011 as its numbers crashed severely. The majority of these birds live in Rajasthan, which holds 175 individuals of the species. The rest of the pitiful numbers of this gigantic bird are sparsely dotted around the Indian subcontinent. Its favoured habitats are dry grasslands and scrublands, and the threats to the bird are environmental degradation, habitat loss and hunting. Standing at up to 1.2m tall, and one of the world's heaviest flying machines, it is an easy target for hunters and poachers alike.

Another difficulty is that the male birds don't become sexually mature until they are four years old and the females when they are two years old. Then when they do breed they have other problems to face, such as the eggs being stolen and eaten by mongooses, monitor lizards, foxes and vultures, and if that was not enough to worry about there is the threat of the eggs being trampled underfoot by grazing cows. There is a lot to contend with when a bird is fighting for species survival. Consequently, conservationists are keen to find any nesting bird and protect it as much as humanly possible. In July 2014, an egg hatched for the first time in just under six – yes, six – years in Jaisalmer, in Desert National Park, where park officials have managed to oversee the nest and keep predators and cows away from it. And now the work really begins to keep this single hatchling alive – hopefully it can grow up into an adult. Fingers crossed.

But there is still hope that something can be done to rectify the situation. In April 2014 it was announced that a plan to improve bustard habitat was in place, whereby trees that had been planted on great swathes of grassland that were once important sites for the bird would be removed and the land would be encouraged to turn back to grassiness. This could potentially give the birds back the habitat they need to live in. Warora, Gangewadi and Nannaj are the three key areas where this work will be carried out. Locals will be involved in the project, too, and where the grass grows too thick for the birds it will be cut and given to the residents for fodder. By adding monetary incentives for growing grass it is hoped that the threat of poaching by the Pardhi community can be removed.

THREE GREAT
INDIAN
BUSTARDS!

Ralph STEADman

Florican Sketches

Philippine Cockatoo
Cacatua haematuropygia

Up until the 1950s this was a common enough bird, but its decline has been rapid thanks to habitat loss and trapping for the caged-bird market. There are between 370 and 770 mature individuals and a protection programme set up in 2008 on Pandanan has already seen a rise in numbers there from approximately 40 birds to 110 at the last count. This cockatoo commands high prices, with upwards of $300 being the norm. Awareness programmes, captive breeding and site protection should help the future of this bird and then it won't have to play dead to fool the trappers as Ralph has depicted in this sketch.

Bates's Weaver
Ploceus batesi

This mysterious little weaver has not been sighted for a few years and very little is known about its habitat, needs or location. Field surveys are planned to attempt to locate some of the population, but for now it is classified as Endangered.

Bengal Florican
Houbaropsis bengalensis

The Bengal Florican has a small population which is in steep decline due to its grassland habitat being converted for agriculture. It lives in the Indian subcontinent, Cambodia and perhaps in southern Vietnam. In Cambodia, villagers receive a financial reward for discovering nests and a further reward if there are fledglings from those nests. Work is ongoing to decide on an overall plan to save and protect all Asian bustards.

Lesser Florican
Sypheotides indicus

The Lesser Florican is a small Indian bustard that is expected to go into sharp decline as its natural grassland habitat is undergoing major change, being converted for agriculture and grazing of livestock. There has also been intense hunting pressure on the bird, which was regularly shot for both food and sport. Rajasthan banned the hunting of the bird in 1983 and this has become incredibly effective in the last 10 years. Plans are in place to protect grassland areas and to work with local people to protect the birds.

Greater Florican't
Cannae existus

You can't beat the old can/can't gag! Maybe that's why the Greater Florican't is so down in the beak, because he is the butt of this joke. Not sure what he can't do exactly but I presume he can't exist, although because Ralph has now drawn him into being, he actually does exist! So get happy, little creation, because it seems that you can!

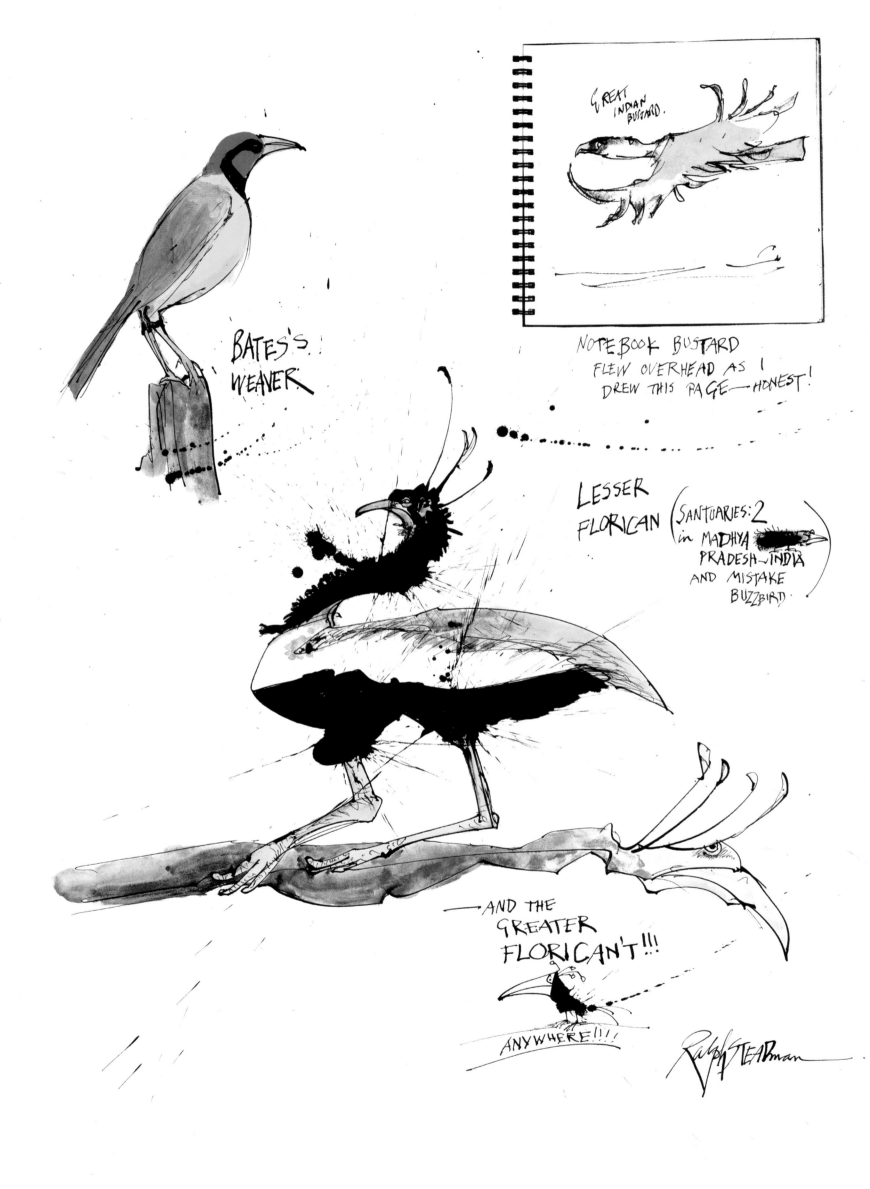

BATES'S WEAVER

GREAT INDIAN BUSTARD.

NOTEBOOK BUSTARD
FLEW OVERHEAD AS I
DREW THIS PAGE—HONEST!

LESSER
FLORICAN (SANTUARIES: 2
in MADHYA
PRADESH—INDIA
AND MISTAKE
BUZZBIRD.

AND THE
GREATER
FLORICAN'T!!!

ANYWHERE!!!!

Ralph STEADman

Ralph emails:

Ralph emails:

YOU watch out!! Here comes the Glowing Orange WOTALOTIBLOT!!! Phone you in a mo!!

RALPHORDALIXXX

The World of Las Vegas

Phone:

Ralph: Strange creatures have been appearing a lot recently. I lock the doors of the studio at night. Seal the whole place off and yet there they are in the morning waiting for me to draw them. What did I do to deserve this? They seem to appear for no good reason.

Ceri: Perhaps they know that only you can do them justice. After all, you don't see these in any of the normal bird guides. We are breaking new ground, bringing previously undiscovered species into the human domain. This is why you're the captain. You find previously unsailed waters for us to explore.

Ralph: Hmmm, well, all I can do is draw them once I've found them to stop their interminable screeching. This one only drinks my ink and then splatters the page I am drawing upon.

Ceri: For certain the wotalotiblot loves a quink ink drink.

Ralph: You think? Watch out!!! He's a sprayin' his latest ingestion again. I have to say he's rather accomplished at it. I can use this splatter for certain! I will draw him with his own splatter.

Glowing Orange Wotalotiblot

Blottus non-subsisto

The Nextinct Ringmaster: Roll up, roll up! May I present to you, before your very eyes, the first ever collaboration between the artist known as Ralphordali and the nextinct boid known as the wotalotiblot. Better than Warhol and Basquiat as an art duo, more outrageous than Gilbert and George. Be confounded by the perfect formation of the wota's blots and be amazed by Ralph's true depiction of such a wondrous creature. Marvel at the intensity of such a yellow, be shocked at the true formation of the boid, and be prepared to tell all your friends that you have been changed by this odd and unique wonder of the world! This puts all bearded ladies, mermaids and seven-toed pigs in the shade. This is the ultimate sideshow. Art performances will be at 7 pm every night until the artists have had enough…

Ralph shouts from the side of the tent, 'ENOUGH!'

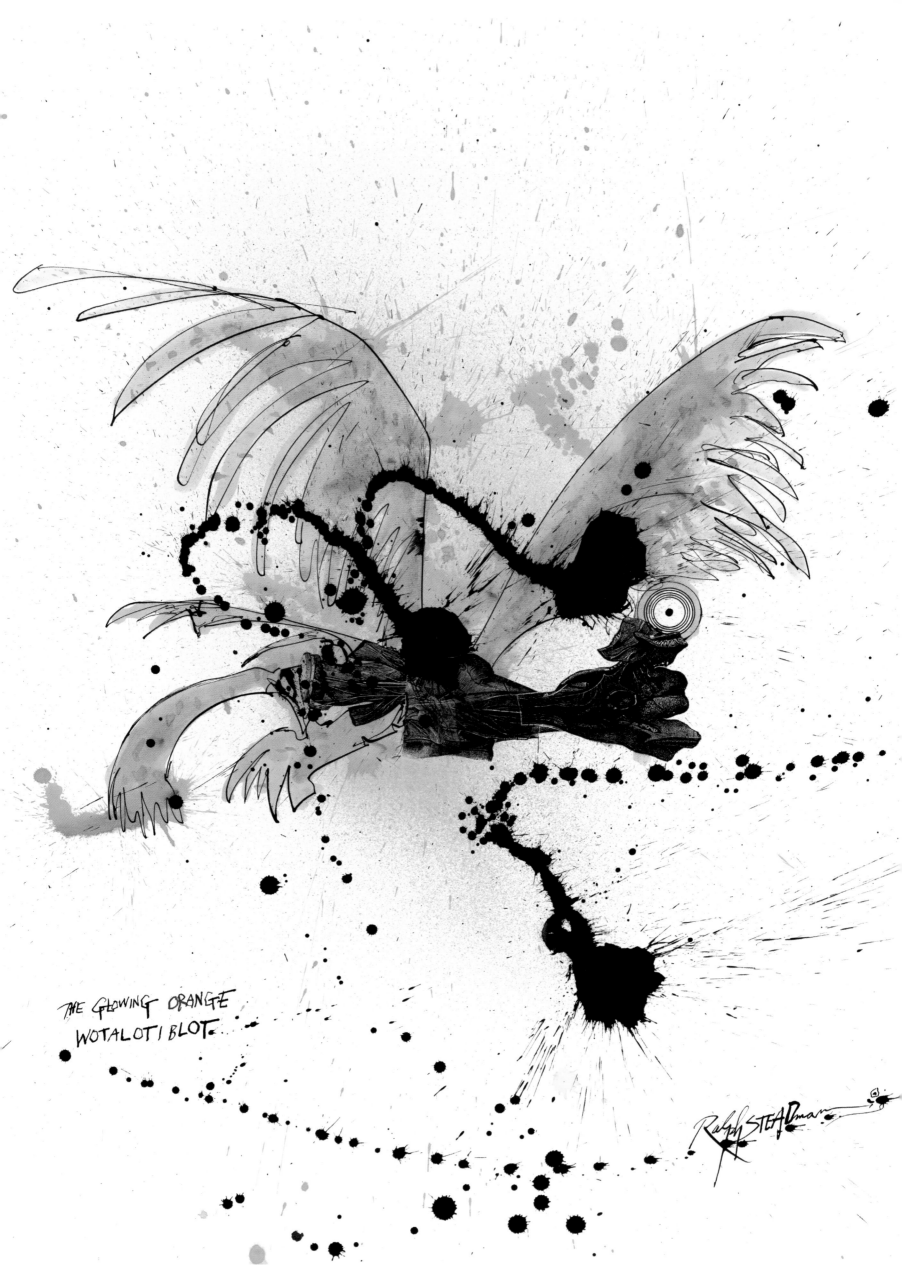

THE GLOWING ORANGE
WOTALOTI BLOT

Ralph emails Jim Martin:
HI! JIM!!

I spoke with Ceri Wotsizname last evening and he twittered and squawked about some Fan-Tailed Mottled URGE – or HUNCH – or was it a Bottled Tosser?? Can't quite recall... Anyway, I worry that now Birds are getting such overkill attention what with TWEET OF THE DAY! etc, etc, we should perhaps concentrate on Fantasy Creatures or even Facebook morons...???

I suggested NEXTINCTION as a working title – but the whole thing must make us laugh!!! And THINK!!!

For those multiplying, twittering individuals who are supposed to remain very quiet whilst observing rare feathered Beak Freaks, they are a noisy crowd!!!

I'm just waiting for the California Condor to dry – I believe the Condor is now on the mend and in Arizona they have 59!!! Here is another one... a weirrd one...!! A squawking call!! I present... The Orange-beaked Ten Percenter.

Orange-beaked Ten Percenter

Pretium mini

Like so many offers in life today, '10% discount to all employees of this company' sounds like a too-good-to-be-true offer. Well it is. After all, this boid doesn't have a company and therefore has no employees. So why does he wander round with this message hanging from his neck? Possibly to make people believe that he is a successful business boid and that his non-existent company is going somewhere and in the hope that this look may help him when trading for grain and corn. Unhappily for him, no one takes him seriously and he is left to forage within the Urban Council Skip Chick's skips when he's not looking. This is also impacting on the skip chick's future as there is not enough food to go round. This is why the ten percenter is one of the nextinct, as he is useless at feeding himself and he needs to be given an opportunity to succeed and feed. Money is now being raised to send him on a boid business-management course, which could help him redefine his life and turn the species around. This will help realign the skip chick's prospects too. Amazing how help for one species can have an impact on another.

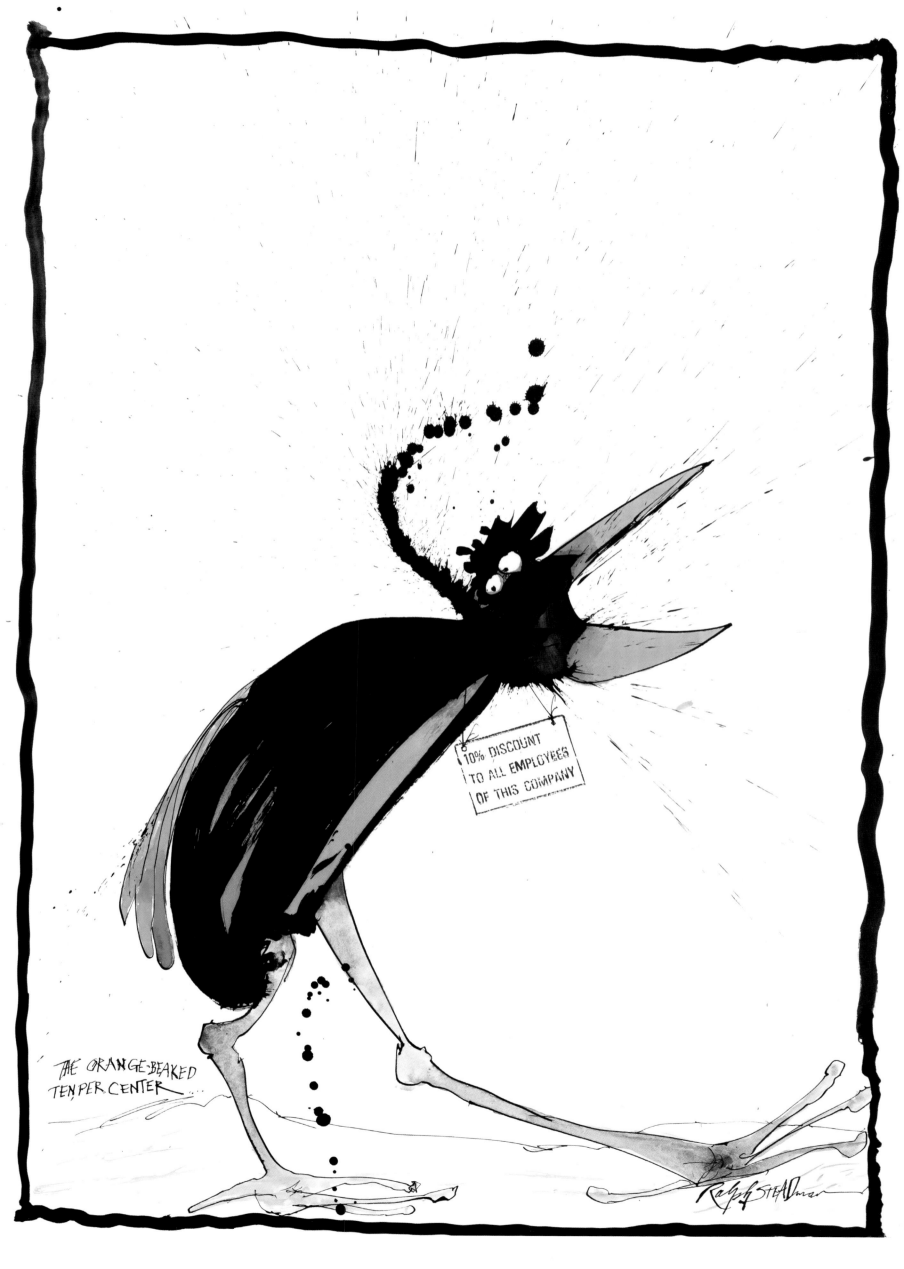

THE ORANGE-BEAKED
TEN PER CENTER

10% DISCOUNT
TO ALL EMPLOYEES
OF THIS COMPANY

Ceri's Diary: And so this majestic yet slightly world-weary bird appears before me. This is one helluva bird. To quote a birding friend of mine and his father, Rob and Stephen Lambert, 'What a bird!' How could we have let such a magnificently odd gigantic creature come so close to extinction?

Many Native American tribes revered the condor as a sacred species and it featured in much tribal art. It was considered to have healing powers and condor feathers were often used in medicinal ceremonies. For different tribes it symbolised and meant different things. Some considered it to be a destroyer of man, while others believed it to eat the moon, therefore creating the lunar cycle. It was also thought to be the re-creator of mankind after man had been wiped out after a flood. If so, then surely we owe it a debt of gratitude for this and now is the time for us to repay the condor and help it to survive.

Ralph's portrait is a study in magnificence as this condor surveys his arid surroundings, pondering his chances of staying alive. This bird has been written off for a long while now and many have said it is only a matter of time before it becomes extinct, but things are turning around for the condor and its numbers are rising.

Ralph emails:
HERE CONDOR HERE!!!

California Condor

Gymnogyps californianus

The California Condor is the largest North American bird, with a wingspan up to 3m across. Friends of mine have seen these birds approaching from the horizon and have likened the sight to that of a decent-sized plane coming in to land. This is one huge flying machine. What I would give to see one of these. It has to be on my bucket list of things to do before I nextinct. It is also one of the world's longest-living raptors with the potential to live for 50 years or more. Once it was widespread along the western coast of North America, but it has suffered terribly throughout the 20th century, mainly due to persecution and lead poisoning from ammunition in the carrion that it eats. If hunters changed to using copper ammunition it would have an immediate impact on wildlife in general, and not just the condor. Lead is harmful to birds, and not just when they are shot. It can take hundreds of years to decompose, and there is a movement to outlaw this type of ammo. It can't happen soon enough.

Ingestion of micro-trash consisting of small pieces of plastic and glass, as well as collisions with power lines and habitat destruction, has also been part of the picture. In fact, so appalling has the decline of the bird been that the last wild individuals were taken into captivity in 1987. There then followed an intensive period of captive breeding, and finally a small population was allowed out into the wild again. Since its reintroduction the bird has gone from strength to strength and now numbers 44 mature individuals (i.e. those that are capable of reproduction). There are also immature individuals out there and the total numbers stand at 173 in captivity and 213 in the wild. This may not sound like an awful lot of birds, but considering this bird was truly on the brink of extinction, never mind nextinction, it is one of the great success stories for conservation. Long may this giant of the airways, the bird god of the skies, continue to fly and scavenge along the North American coast.

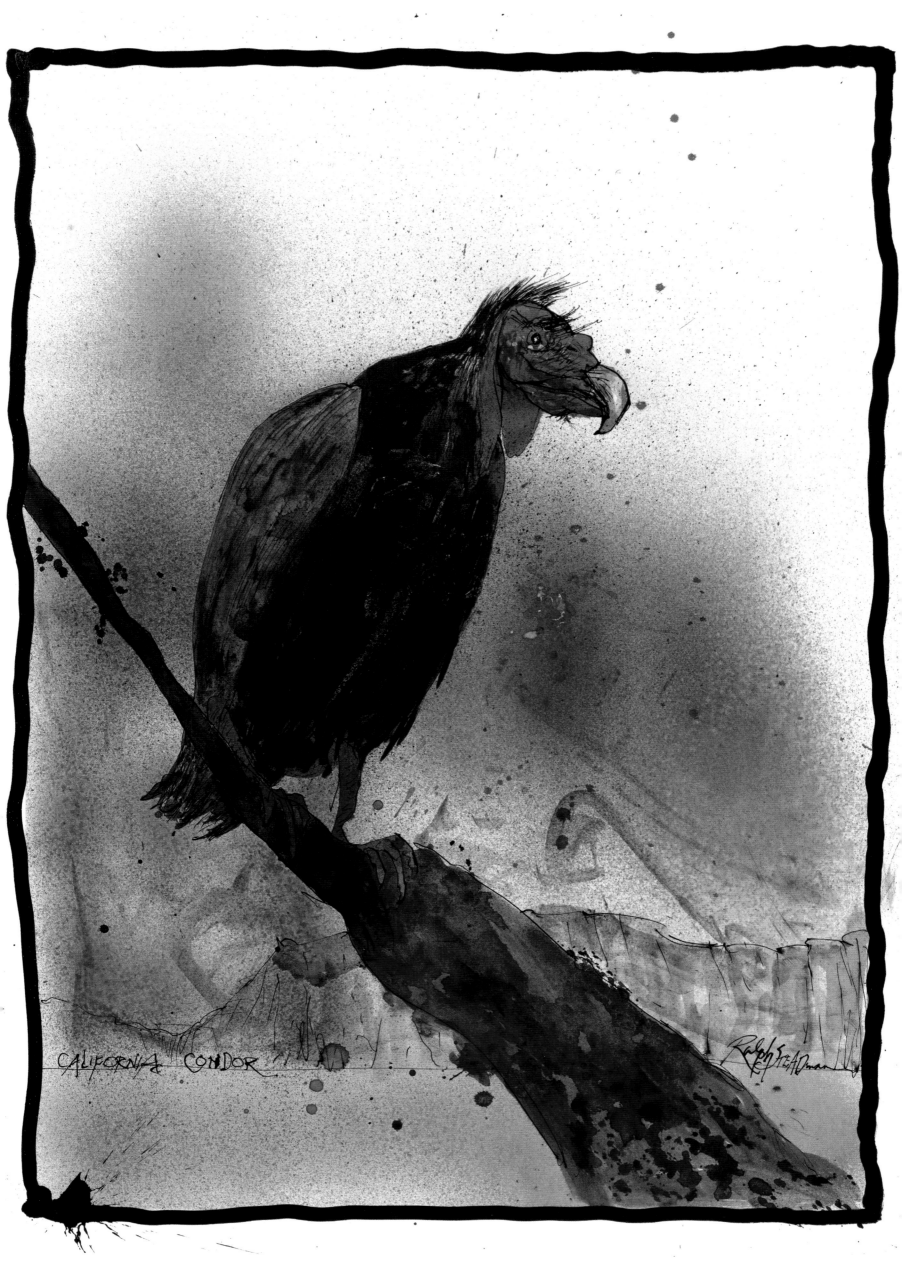

CALIFORNIA CONDOR

Ralph emails:
Birds to do – here's two – in one drawing! Shags arguing!! Who will win?

Doing the Japanese Crane next… have some good pics sent to me from John Farmer in Japan – who used to photo my Artwork!!!

Ceri replies:
I love the shags! One thing about the Crane – it is the SIBERIAN Crane that is Critically Endangered, not the Japanese or Red-Crowned Crane, which is Endangered, but perhaps you could incorporate the two birds into one picture and then I can explain the difference between Critically Endangered and Endangered.

Chatham Shag

Phalacrocorax onslowi

These two shags have just discovered a new reason for their endangerment. Blots. As Ralph has described it, we are witnessing an altercation with blots. Only Ralph could discover what no other conservationist has found. Whether this is relevant to their survival only the shags know.

The small, 720-strong population of this New Zealand bird exists on only four of the Chatham Islands and the North East Reef. The shag, which is a large black and white cormorant, is under fire on many fronts. Human disturbance, agriculture and introduced species such as feral cats and livestock all disturb the colonies of this ever-declining species. At the moment no conservation action has been taken, but plans are afoot to take a census of the colonies every five years and to monitor the actual Chatham Island colony every year to determine the trend of the population. Awareness programmes could help educate locals about the birds and teach them that even the walking of dogs in certain areas can have an impact on the species. It is a bird that needs to have a beady eye trained upon its future.

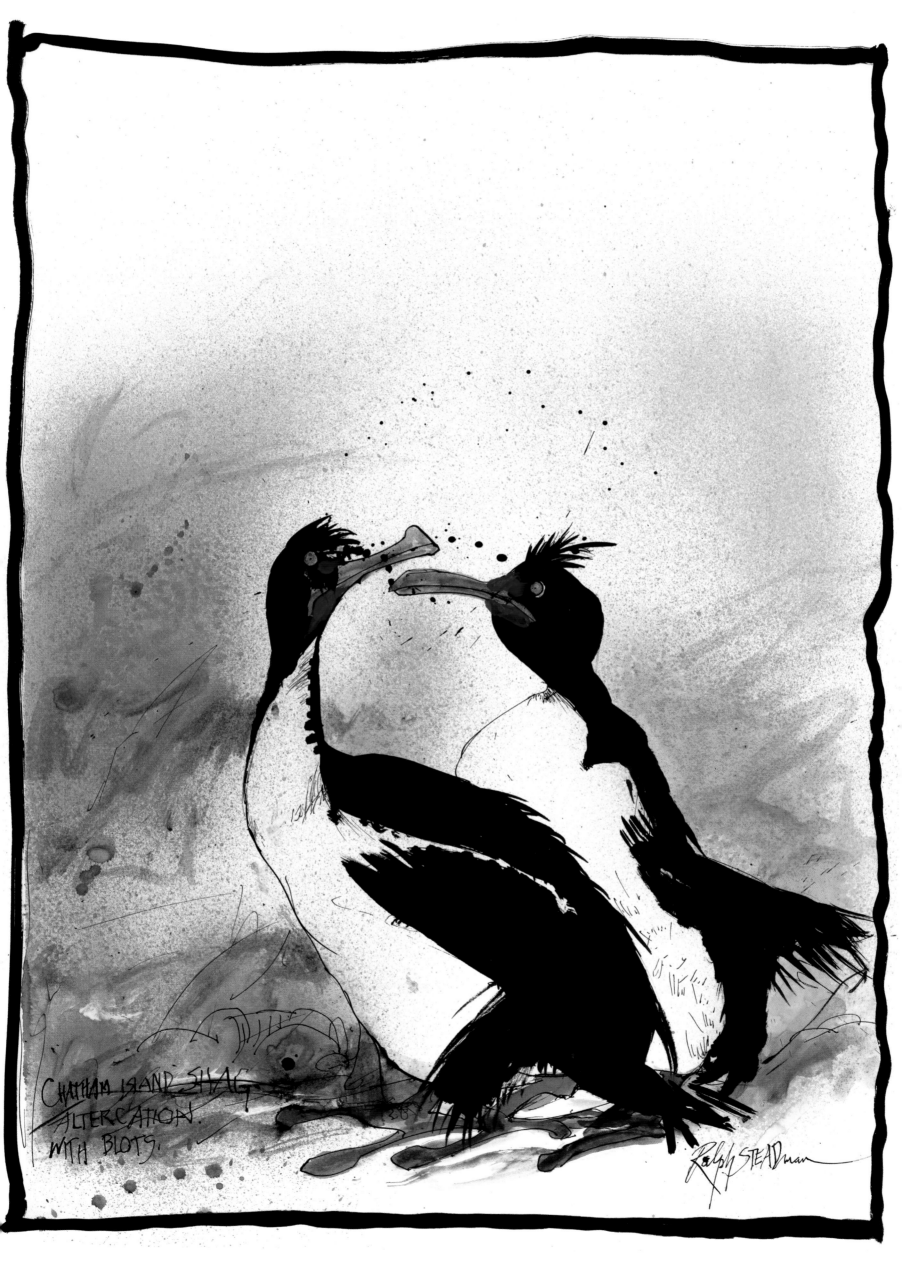

CHATHAM ISLAND SHAG
ALTERCATION.
WITH BLOTS.

Ralph STEADman

Ceri's Diary: 'The Crane Wars' have come about because Ralph depicts this Japanese Crane even though I have pointed out it is only considered to be Endangered and our intention is to represent the Critically Endangered birds of the world.

Phone:

Ceri: I think the Japanese Cranes are wonderful. But you do know that they are only Endangered, don't you?

Ralph: It's all very well saying they're only Endangered but they aren't well, are they? Endangered must be a bad thing to be! If you were Endangered would you think well at least I'm not Critically Endangered? No you wouldn't! You would think, 'Bloody hell, I'm Endangered!' Whichever way you look at it, Endangered or Critically Endangered means trouble! So I don't think we should worry so much… as the birds that are only Endangered will soon catch the others up. Then what? 'Oh, I wish we had done more when they were only Endangered?'

Ceri: When you put it like that, you've got a point, and these cranes are obviously a marking point for what we are trying to do. As you say, the Endangered species are the next in line to the nextinction throne once the Criticals have gone or been saved. I take your point. Carry on, Cap'n!!

Ceri's Diary: The initial premise was to only incorporate Critically Endangered birds into this book, but after Ralph has put across his viewpoint, I have to say that I agree with him and I think it is important to include some Endangered species as well. It also frees Ralph up to draw what appeals to him rather than have to draw only those birds that are on a particular list. This crane is ONLY considered to be an Endangered species, but when I start looking at statistics, I concur with Ralph and realise that Endangered is a pretty bad state of affairs for any bird to find itself in.

Red-crowned Crane

Grus japonensis

For Korean Krane read Japanese Crane or, to give it its proper name, the Red-crowned Crane. Also please ignore Ralph's comment and thought that the Japanese Crane is tasty with rice. This is actually not one of the problems that face this bird. In fact, it is revered in Japan and is a symbol of loyalty as it pairs for life.

This crane breeds in eastern Hokkaido in Japan, as well as in Russia, Mongolia and China. The Japanese population seems to be quite stable, whereas the Asian population is in decline and is therefore considered to be Endangered, due to its small population of 1,650 mature individuals. The key danger to the bird is the loss of much of the wetland habitat on its wintering and breeding grounds, caused by agriculture and industrialisation. This has a knock-on effect of creating overcrowded and overpopulated sites elsewhere. The Japanese colony does not migrate, while the others winter at various places including the Yellow River delta and along the coast of Jiangsu province in China.

The other place they go is the DMZ (demilitarised zone) between North and South Korea. This goes to show that birds fly wherever they want and are not put off by barriers or altercations or what we would consider disruptive behaviour. I remember visiting the Great Bustard Project, run by the wonderful David Waters, on Salisbury Plain. This is where the birds are raised and it also happens to be next to Ministry of Defence land where they carry out exercises including bombing and artillery practice. I asked David if this was a problem for the birds and he said no. The harder problem was if hikers appeared within sight of the birds, as once the bustards noticed them they would all fly up and leave immediately. Bombs yes, walkers no!

The Red-crowned Crane is now legally protected across its range and international cooperation is being sought to protect its habitat, especially at breeding times. The crane is also an emblem for good fortune. It's time for that luck to rub off on the bird itself.

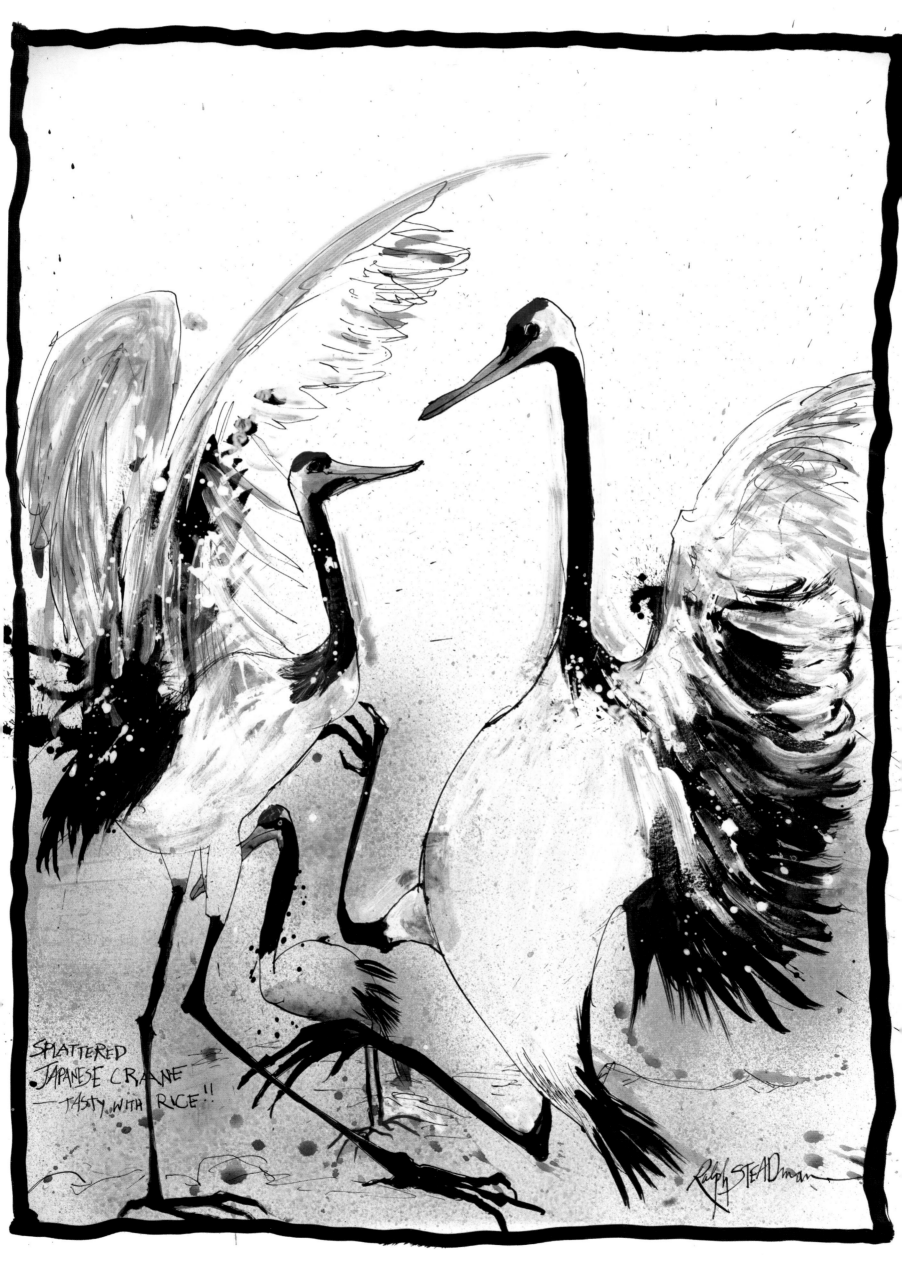

SPLATTERED
JAPANESE CRANE
—TASTY WITH RICE!!

Ralph STEADman

Akohekohe

Palmeria dolei

The Akohekohe now exists in one small part of Maui in the Hawaiian Islands, within 58 square kilometres of wet forest canopy on the north-eastern slopes of Haleakala, which is a volcano. It feeds mainly on the nectar from the blossoms of the 'Ohi'a trees. It is also known as the Crested Honeycreeper because of its white crest, which helps plants with pollination, as the pollen attaches itself to the bird as it feeds and then gets redistributed wherever the bird goes. Threats to it include feral pigs, goats and deer, and new fears have been raised by the introduction of a species of disease-carrying mosquito, which can survive in the more temperate climes of the bird's habitat. Work is underway to try and protect the bird from the feral animals and a captive-breeding programme has begun.

Poo-uli

Melamprosops phaeosoma

The Poo-uli also feeds on the 'Ohi'a trees in the same location as the Akohekohe. Its population is much smaller and was only discovered in 1973. Of the last three remaining birds, one died in captivity and the two remaining individuals have not been seen since 2003 and 2004 respectively. The words 'extinct not nextinct' look probable.

Mauritius Olive White-eye

Zosterops chloronothus

And just when I thought we were settling in for a page of Hawaiian birds, Ralph whisks us off to Mauritius. This little Mauritian fella now only inhabits a small area of less than 25 square kilometres in the south-west of the island. This is one of the last places it could find that has the right habitat of wet upland forest, where it feeds on nectar and insects. Predation by introduced mammals is hastening the bird's decline. Conservation action has been taken and birds that have been artificially incubated and hand-reared have been released successfully on the predator-free Ile aux Aigrettes. Research continues to determine the best way forward for the white-eye.

Negros Bleeding-heart

Gallicolumba keayi

This ground-dwelling pigeon is from the Philippines where it lives on the islands of Negros and Panay. Forest loss is the main cause of it becoming Critically Endangered. Hunting and trapping for food and possibly the caged-bird trade have also had an effect. There are between 50 and 249 mature individuals and captive breeding has begun to attempt to bolster the bird's numbers.

Bogota Rail

Rallus semiplumbeus

Drainage schemes have damaged the Ubaté-Bogotá wetland habitats of this Endangered Colombian bird. Introduced species and agriculture have also affected it. The wetlands need to become protected areas before it is too late and the Bogota Rail becomes derailed permanently.

Ou

Psittirostra psittacea

This is another Hawaiian bird that is considered to be possibly extinct, as it has not been seen since 1987, when it was last sighted on Hawaii itself. This was once an abundant species across the islands, but malaria-carrying mosquitoes, introduced rats and habitat loss have all contributed to its probable extinction. But there is always hope until every last area of the region has been explored. Fingers and toes crossed. *Où est l'ou? Il a disparu!*

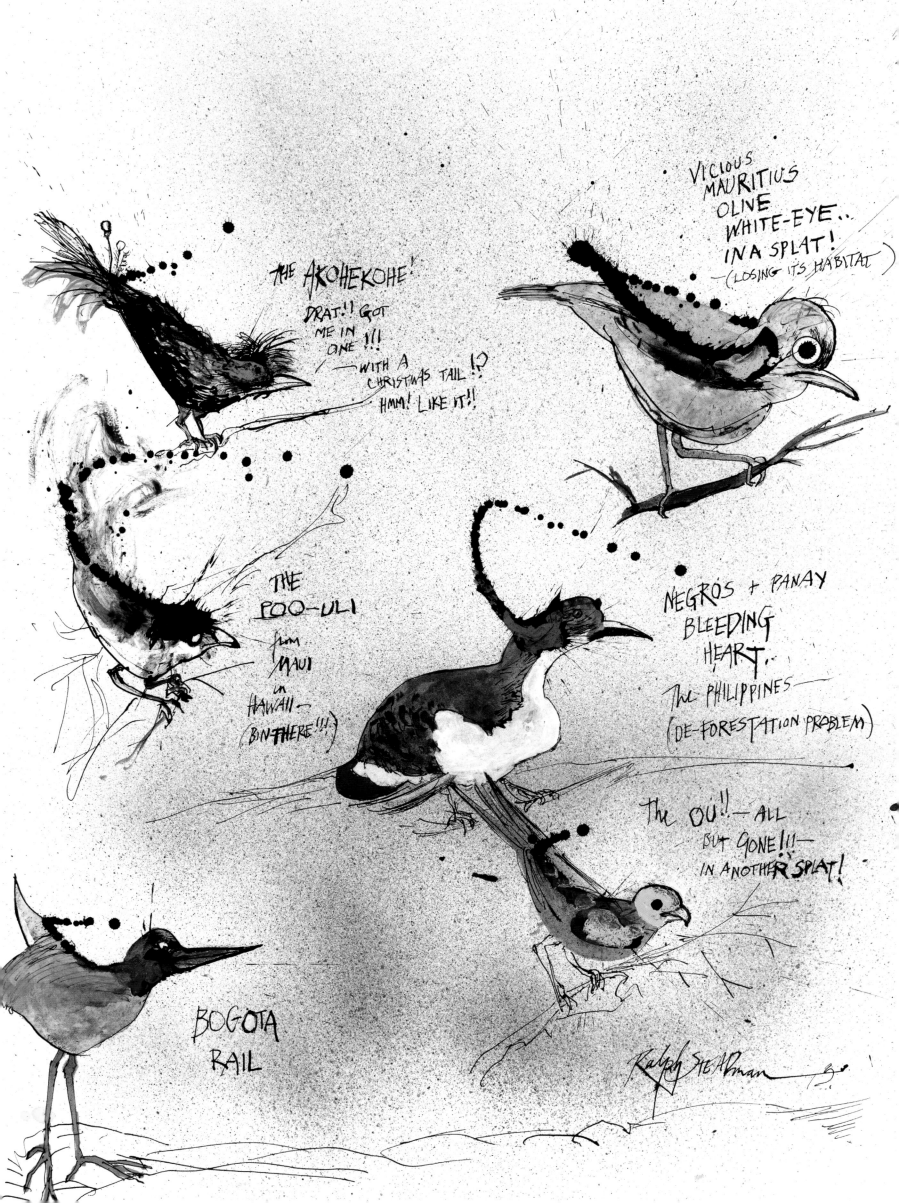

Ceri's Diary: In this picture we see Ralph depicting Kevinio wearing a crashed bird hat. What is a crashed bird hat? Well, the story goes like this. On a cold and blustery day, a bird, called Harry, was flying, lost control and ended up slap bang on Kevinio's head. Having landed with a fearful splat, so strong that it left Kevinio with a mild concussion, Harry kept very still for fear of being discovered to be a live bird upon the head of the Great Extincter, as this would be a certain death sentence.

Kevinio, in a somewhat groggy state, believed someone had thrown away an expensive decoy hat, which had luckily landed upon his head. After all, it was winter and Kevinio's baldness gets very cold. He was happy to have the warm hat, although it did seem to leak a little. But Kevinio was far too intent on seeking out birdlife to maim, injure and destroy and the leak was warm so he didn't worry too much. Harry had fooled Rodrigues minor but he knew he had to get away and escape from the clutches of Kevinio, before the truth was realised.

So one night Harry the Hat, as he was destined to become, snuck out of Kevinio's house to visit his Uncle Roy, and between him and the birds, they created a replica hat to replace Harry on Kevinio's head. The story became known far and wide and became a thing of legend and birdlore; it was turned into a well-known bird song, here translated by Sigmoid Flexure.

The Ballad of Harry the Hat

A small young bird was flying
Experimenting with diving
When a thermal threw him down towards the ground
His wings did more than stall
But a bald pate broke his fall
Belonging to the baddest man around

What chance was this? A decoy hat?
Had landed now, just like that
It gave Kevinio deep unbridled joy
He wears it day and night
In sleep he holds it tight
But Harry escaped to see his Uncle Roy

'Harry, where've you been?
Atop that hunter you were seen
What's the story there, my dearest oldest chum?'
'Well, I landed with a splat
And became his decoy hat
And now I fear my dreaded time has come.

For sure he has to see
I was not a hat but me
And the only way this ends is very bad
So where should I try to go

To hide from Kevinio
For when he finds his hat was me he will go mad!'

'Don't worry little friend
Your life is nowhere near the end
We will make another hat right through the night
As he wakes the swine will see
The same decoy hat to be
Of such perfect form that it will seem just right

So now let us see whether
When we collect some feathers
Other birds will keenly donate to your cause.'
Well, the feathers flooded in
And the hat was born again
And by morning it received a winged applause

Kevinio never knew
What happened all night through
And he never noticed that his hat had changed
Steeped in ignorant bliss
Nothing seemed amiss
He never found the cause to become deranged

Now Harry is anew
He flies so straight and true
Having recently escaped the bully's might
He sees that hat ahead
And lets fly on Kevinio's head
It just seems so perfect and so very right

Kevinio cries in horror
'I'll get you tomorrah'
And waves his giant fist towards the sky
But Harry isn't scared
His vision no more impaired
The birds have stuck together do or die.

Their cunning won the day
Quick thinking showed the way
To trick the vilest man upon this earth
Harry had made a stand
Joined by his birding clan
Those clever birds had shown what they were worth.

So when you see that hat
Just remember the great splat
That started this whole process on its way
Don't think you have to do
A thing that rings not true
And know sometimes the mild can win the day.

CRASHED
BIRD HAT

Madagascar Pochard

Aythya innotata

Having last been seen in 1991 at its usual stamping ground of Lake Alaotra, a flotilla of Madagascar Pochards was discovered in 2006 over 300km away in a series of lakes in Bemanevika. This wetland is not a suitable environment for the bird, but it was the only place that it could find that was far enough away from the effect of human activities for it to exist. The total number was reckoned to be between 20 and 49 birds and was considered to be a critical problem, although recent research led by the WWT is suggesting that there may be as few as 25 individuals remaining in the wild. The study has also revealed that 96% of the chicks are dying because there is insufficient food in the water for them, plus the lake is too deep for them to dive for food. No one is certain of the exact causes of the bird's previous decline, but pollution and hunting are two of the possible culprits, along with habitat loss and human interference.

More populations of the pochard are being looked for as there still may be some undiscovered groups, but in the meantime captive breeding has begun, which is proving successful, and searches are underway for a suitable location within which to release the birds. It is felt that if this can be found then there is every chance that the pochard will survive and thrive. However, for the moment this is one of the rarest birds in the world.

Djibouti Francolin

Pternistis ochropectus

This game bird, which numbers between 200 and 500 mature individuals, is Djibouti's only endemic bird. Its preferred habitat of juniper woodland and heath is under threat for various reasons, including potential damage from acid rain, collection of firewood, grazing of livestock and human disturbance, and the species is also hunted. Protected status is being sought for the woodland and a juniper-restoration programme is underway. There are also awareness programmes for locals regarding the importance of the habitat and the bird.

Long-billed Tailorbird

Artisornis moreaui

The Long-billed Tailorbird's population is divided into two areas in Tanzania and Mozambique. Both areas are under threat from logging and human disturbance. Awareness programmes for locals are teaching them about the bird, and more effective wood stoves are being introduced to slow the need for wood and so reduce the decimation of the bird's habitat.

Taita Apalis

Apalis fuscigularis

This Kenyan bird of the Taita Hills is under threat due to loss of forest habitat. Consequently the population has become fragmented. The remaining forest is now under protection and there are plans to reintroduce native trees to the depleted habitat.

Taita Thrush

Turdus helleri

The last 930 Taita Thrushes also live in the Taita Hills alongside the Taita Apalis. It has suffered a decline for the same reasons and it hopes to gain the same benefits as the apalis with the conservation actions that are taking place.

Elevator Whitebill

Ascenditur verticalis

'Going up? First floor for the nextinct, second floor for the extinct!' This little climber is unable to walk on the flat as it gets giddy on level surfaces, so spends its time at a perpendicular angle. The main threat to it is its own mind, which knows life would be so less tiring if it could simply flap its wings and fly away or, at the very least, walk normally. Too many whitebills fall from the sides of cliff faces as they forget which angle they are climbing at.

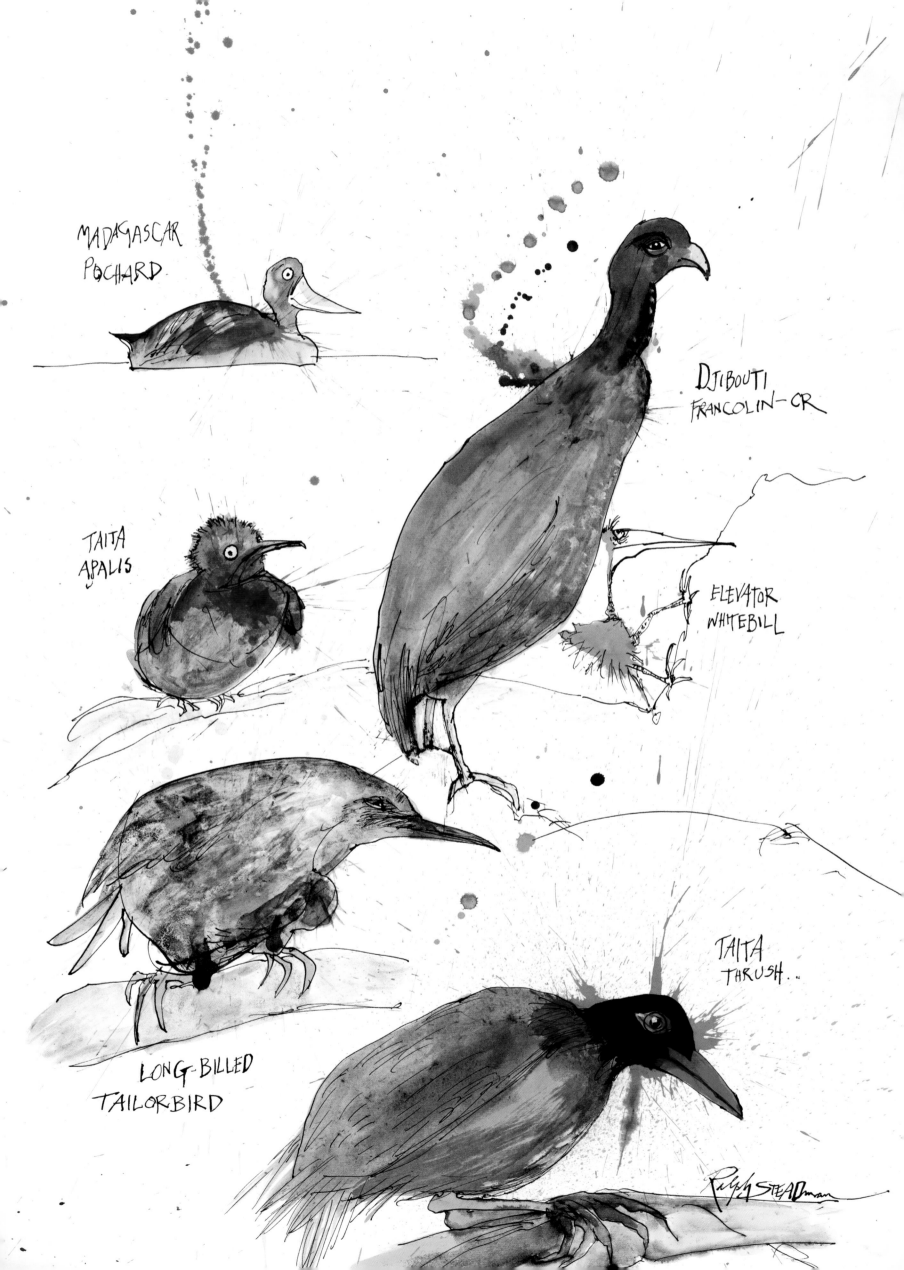

MADAGASCAR
POCHARD

DJIBOUTI
FRANCOLIN-CR

TAITA
APALIS

ELEVATOR
WHITEBILL

LONG-BILLED
TAILORBIRD

TAITA
THRUSH...

Ralph STEADman

Ceri's Diary: Captain Ralph draws these three boids who are not enjoying the full moon on a wet, windy and terribly splatty night. At first glance there appear to be three birds but on closer inspection I believe there to be four. In fact, I may have discovered a new species here that wasn't apparently clear to Ralph although he managed to capture the moment perfectly. It is like those old photos taken at Spiritualist events at the turn of the 20th century that Sir Arthur Conan Doyle was so fond of, when you see strange apparitions in photographs that could be figures or ectoplasm or someone messing around with the photographic plate. All the birds have a look of some kind of possession about them. Is it the full moon affecting them as they all gaze heavenwards in some strange sort of trance-like state? Anyway, make your own mind up. If you look to the left of the Blue-beaked Flybynight, there appears to be a bird facing in the other direction, with a body made of a giant splat and a large beak. Are my eyes deceiving me? Am I seeing things? Or am I connecting with the avian hereafter? Knock once for yes, twice for no...

Ralph emails:
I can tell you are speechless with wonder – wonder wot the F- he's gonna do now. Nearly done two Siberian Cranes passing in the street... meanwhile... Sheiks... and then you start to wonder have I lost it completely!!

Ceri's Diary: I have absolutely no idea what is going on but here is the first sighting of Siberian Cranes as they pass overhead in this picture, presumably on migration. I'm not sure where they are heading to, but hopefully somewhere where they can reproduce. In the latest assessment by BirdLife International in 2014, 1,373 bird species are threatened with extinction. Within that statistic, 73% of all cranes are in imminent danger. Other high percentage species are albatrosses at 68%, parrots 28% and pheasants and pigeons 20%. It is thought that the larger-bodied birds and those with low reproductive rates are at the greatest risk. Things are not getting any easier for the birds.

Hungarian Flappabout

Malus volanti

This struggling creature once only flew by day, as his eyesight isn't all it should be, but neither is his flying. He found daytime flying too embarrassing, as all the other birds watching his poor attempts at getting off the ground would squawk themselves hoarse at his inability to take off properly. So now he tries to hone his aeronautical skills by night when there are fewer mockers about. Luckily for him, the other two in this picture are concentrating on moving in the opposite direction and are not watching his strained manoeuvres. Never say never is his motto, but the one thing this flappabout doesn't understand is that he is actually a flightless boid – maybe never does mean never in this case. Maybe he should just be happy to take the bus.

Blue-beaked Flybynight

Furari horologium

Generally speaking, a fly-by-night is considered to be an unscrupulous and perhaps untrustworthy fellow, especially when it comes to matters of money. Well, this geezer is a little bit like that. He has the habit of collecting metal and shiny things and has quite an education in what's worth a few grains of corn, to say the least. He often makes his way to the nightly corn exchange where under cover of the night he can swap his trinkets for food. Keep your valuables under lock and key if you see this one about.

Orange-beaked Thrust

Inopinatum athleta

This chunky chap is another flightless machine, but he is capable of running at speeds like no other bird, hence the name thrust. It is almost as though he is jet-heeled and turbo-powered. He recently challenged the Ostrich, which can run at up to 50km per hour, to a race. The thrust was still accelerating away by the time he had reached the finishing line, where his speed was recorded at 110km per hour. A recent challenge to the Cheetah (115–120km per hour) may be a bridge too far for him. It surely proves that appearances can be deceptive.

HUNGARIAN
FLAPPABOUT.

BLUE-BEAKED
FLYBYNIGHT.

TURBULENT SCENE
IN WIND AND WET

ORANGE-
BEAKED
THRUST

Ralph STEADman

Ceri's Diary: This has been an interesting period as we have wrestled with the merit of whether an Endangered bird is as relevant as a Critically Endangered bird and I think we have our answer in that they are all important and relevant.

At first Ralph was concerned about taking on the Siberian Crane as he had already drawn the Red-crowned Crane, but on inspection he discovered the cranes were different enough from each other so as not to matter. They were very separate entities. Ralph seems to hate repetition and at the moment he has been poring through the bird books I gave him, pulling out the ones that he feels will engage with him and allow him to present these birds in his unique expressive ways. The *Collins Bird Guide* this is not, but his style will expose these creatures to people who would not normally know of them or their plight.

When we are a little further down the line I will finally send him a list of all the birds that he has done and the ones left to choose from. It's always good to have a checklist to hand. I'm sure he will find it useful.

Siberian Crane

Leucogeranus leucogeranus

Ralph's cranes look as if they are grimacing in whichever part of the world they have found themselves. Perhaps they are in Siberia and the temperature has dropped. Or perhaps they are grimacing at their future.

What do you think of when you think of cranes? I think of them as folded origami, a symbol for majesty, or a portent of a successful marriage. But most of all I consider them as a sign of good luck and at the moment they need all the luck and help they can get.

Siberian Cranes can live a very long time indeed, with one recorded at 83 years old. There are two main breeding populations, one in Siberia and the other in Arctic Russia. Two of the main reasons for this bird's steep decline in numbers are hunting and the loss of its wetland habitat across Eurasia. I recently saw a documentary about hunting in China, where at night-time, in a mountain village, hunters turned on spotlights to attract and light up migratory birds including storks, herons and cranes, and then blasted them out of the sky.

The creation of dams in China could seriously affect their wintering grounds and fears are that the population will continue to fall, but there is a chance that numbers may not be affected too dramatically. Will the water change drastically affect the birds? The answer is in the tap of the gods.

Cerian Crane

Leucogeranus leucocerinius

I have a soft spot for this crane. The smallest of the cranes, you will find. Having decided to invent a crane, the Cerian Crane, giving it my name, Ralph has bestowed an honour upon me in what has been 'The Crane Wars'. As for being a part of a new creation, well that is something very special indeed. The Cerian Crane definitely has my legs. I feel proud of my namesake. Apparently he's a persistent pest, continually asking questions and making demands about what to do and where to go. He's not known to sleep too much as he is always running around thinking of ideas and things to do, but the rest of the flock put up with him and their often sleepless nights as he means well. He is rather bossy for a little guy. But then so was Napoleon. Hmmm, look where that got him in the end.

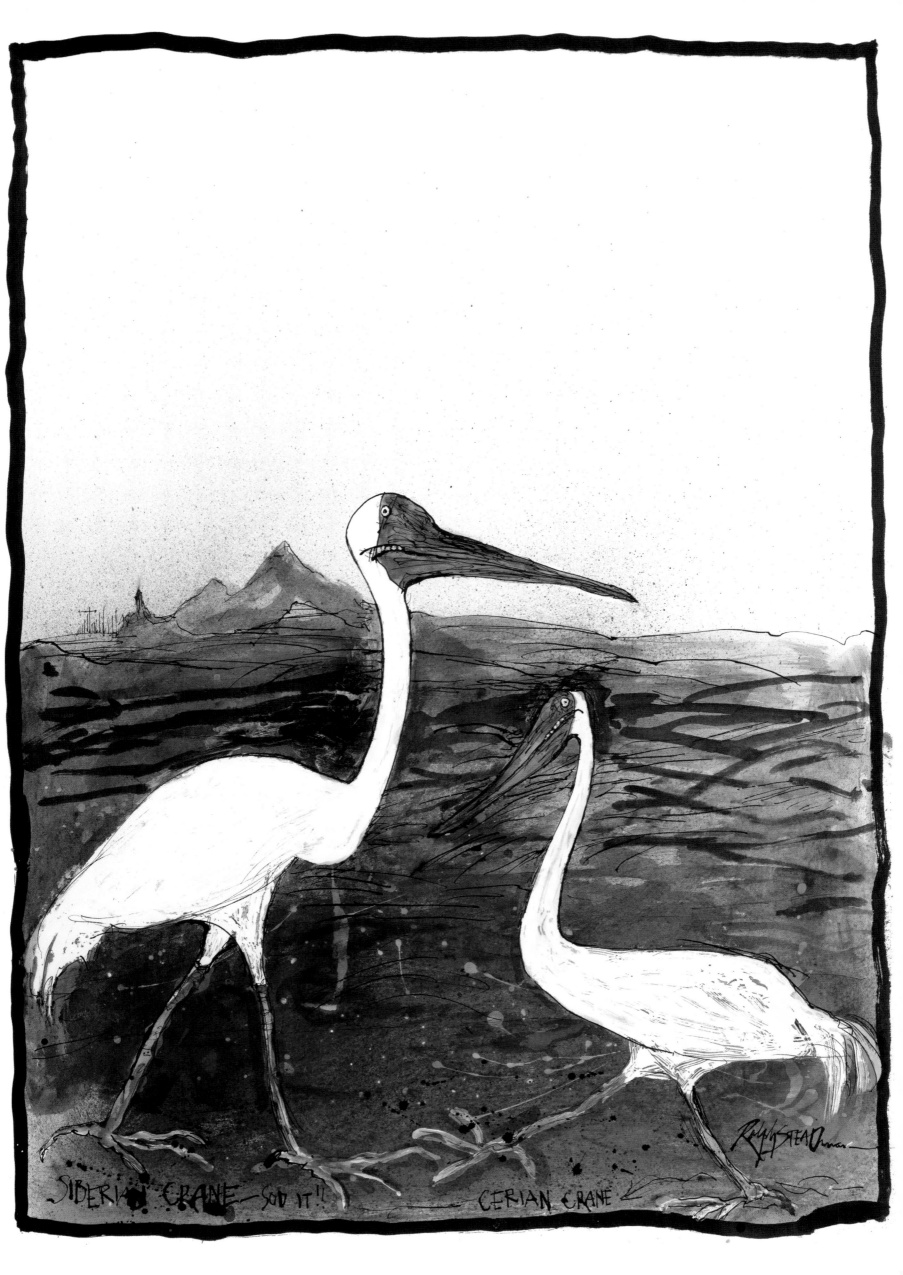

SIBERIAN CRANE—SOD IT!!　　　　　　CERIAN CRANE

Yellow-Bellied Training Crane

Gimbalus suspensus

And this drawing includes the last part of the crane trilogy, following on from the Red-crowned and the Siberian Cranes. I present to you the Building Site Crane. But if one looks closely there does seem to be a very unusual Yellow-bellied Training Crane doing some tethered flying to learn exactly how it should be done. This training can take up to three years to master. Then with certificate in hand they can do tethered flying from any tall structure. I'm not quite sure what purpose it serves but it is something they like to do. I think it is to compensate for the fact that they can't actually fly.

Sulu Hornbill

Anthracoceros montani

The Sulu Hornbill is one of the most endangered birds in the world and could become extinct at any moment. It was once found on three islands of the Sulu Archipelago in the Philippines, and considered as a common and abundant species in the late 19th century, but the island of Tawi-Tawi is probably now its only abode. There are sadly only 27 mature individuals left. Deforestation and habitat change have been the major reasons for the bird's decline, especially within the last 10 years. Hunting for food and being shot for target practice have also been factors in its demise. The Sulus are a hotbed of military activity and insurgency, meaning it is extremely difficult to conduct conservation activity. Captive breeding is seen as an option. The hornbill is, sadly, one of the likeliest candidates for extinction, unless an intervention can be made.

Cerulean Paradise-flycatcher

Eutrichomyias rowleyi

Somewhere between blue and cyan you find cerulean, and somewhere in paradise you find this jewel of a flycatcher. Its locale is the island of Sangihe in Indonesia. Unfortunately, paradise has had its trees and forests removed, leaving no more than eight square kilometres of suitable habitat on the island. Somewhere within this tiny last outpost remain between 13 and 90 birds. It is possible that the small bird tourism there may help to give islanders a financial incentive to keep the remaining trees intact. There is also a wish to create a wildlife reserve within the last of the forest.

Archer's Lark

Heteromirafra archeri

I am sure that is the artist peering over a wall doing some birdwatchin' of the Archer's Lark as it sings in B, B and C. That should work as a musical sequence. The Archer's Lark used to be seen between Somalia and Ethiopia, but it has not been seen since 1955. It is believed that refugees who settled on and cultivated the bird's habitat may be the reason for its disappearance. This is an under-watched part of the world and searches are planned to find the bird, which is not yet considered to be extinct.

Isabela Oriole

Oriolus isabellae

The Isabela Oriole is found in Luzon in the Philippines. Deforestation has destroyed and fragmented the bird's habitat, and a conservation action plan is being worked upon to include searches for the bird as well as awareness-raising to inform the locals about the species and the problems it is facing.

Araripe Manakin

Antilophia bokermanni

This little Brazilian fellow was only discovered in 1998 and was immediately put on to the Critically Endangered list due to agricultural change, along with developers creating houses and therefore also recreational centres such as swimming pools and open parks for the new residents. This deforestation has led to an alert for the Araripe Manakin and conservation plans are in place to create a protected area for the species and to raise awareness about it.

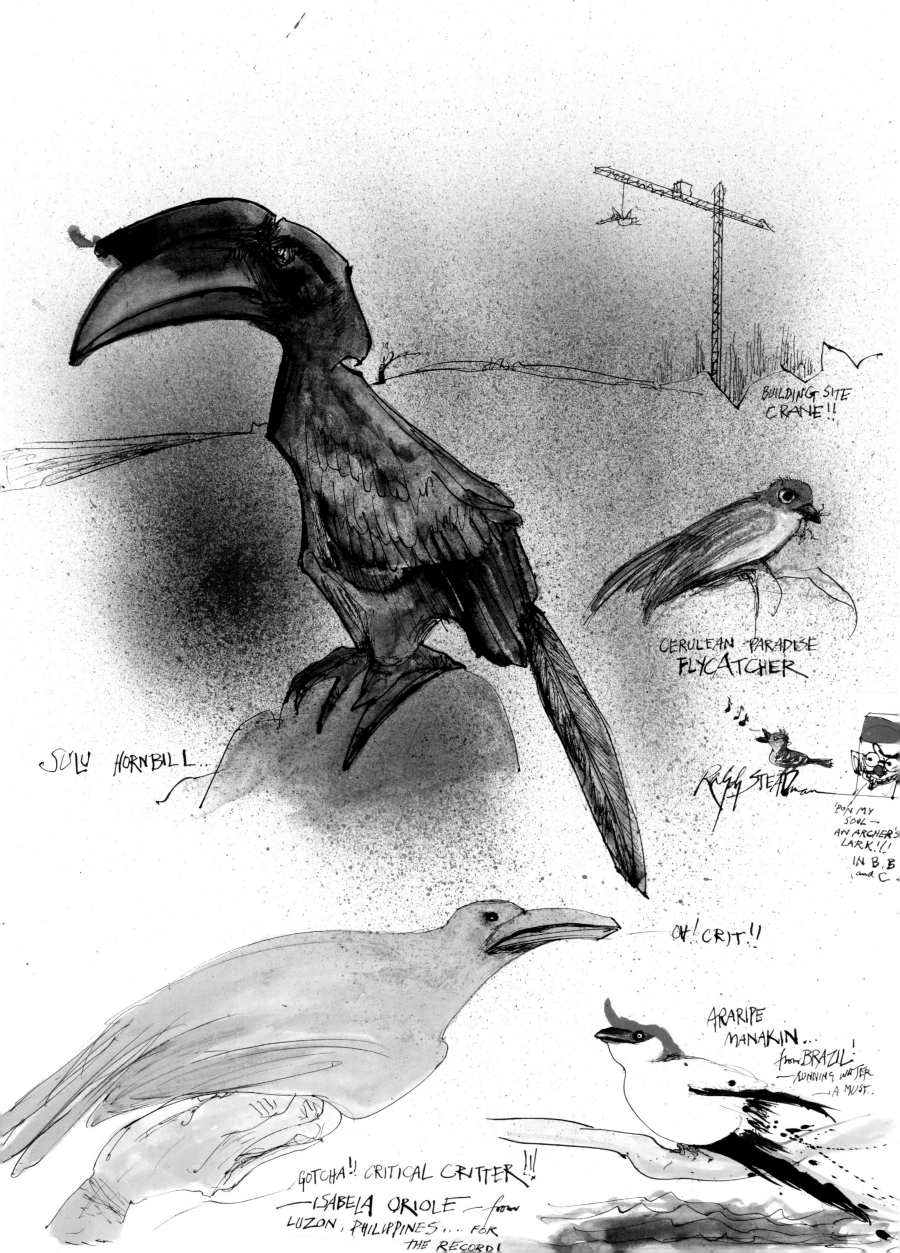

BUILDING SITE CRANE!!

CERULEAN PARADISE FLYCATCHER

Ralph STEADman

'PON MY SOUL — AN ARCHER'S LARK!!! IN B, B and C

SULU HORNBILL...

OY! CRIT!!

ARARIPE MANAKIN... from BRAZIL! RUNNING WATER A MUST.

GOTCHA!! CRITICAL CRITTER!!! ISABELA ORIOLE from LUZON, PHILIPPINES... FOR THE RECORD!

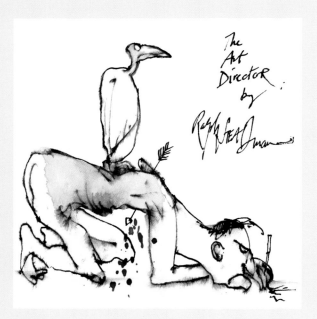

Uluguru Bush-shrike

Malaconotus alius

The Uluguru Bush-shrike is endemic to Tanzania. It is in decline due to deforestation and loss of its habitat. There is now an Uluguru Forest Reserve, which has been newly created and numbers the bird amongst its inhabitants. Forest patrols are trying to control the illegal harvesting of wood and there is work being done to restore some of the habitat by planting indigenous trees. As Ralph's depiction asks 'I'm purty, ain't I?' Yes this bird is pretty, but unfortunately it is purty endangered too.

Chinese Crested Tern

Thalasseus bernsteini

Once considered to be extinct, the Chinese Crested Tern was found still to be alive in 2000. The numbers of this bird are fewer than 50 due to egg collecting, overfishing, rats and oil spills, amongst other problems. A tern egg is considered a delicacy in China and local fishermen have taken eggs when and where they can. Nowadays, if the fishermen are caught collecting eggs they have their fishing nets taken away from them. This has proved to be an extremely successful deterrent. As previously mentioned, an inventive use of birdcall recordings has brought in Chinese and Great Crested Terns to form a strong colony on a former breeding site. This is proving to be a major conservation success story.

Long-billed Tailorbird

Artisornis moreaui

Hold on, haven't we only recently seen this bird before? Repetitious Ralph! That's the artist's new name. Mind you, it is a lovely study of this still Critically Endangered species. And this one even likes to crack a joke while waiting for its future to be sorted out. Just pay the bill, my friend, just pay the bill.

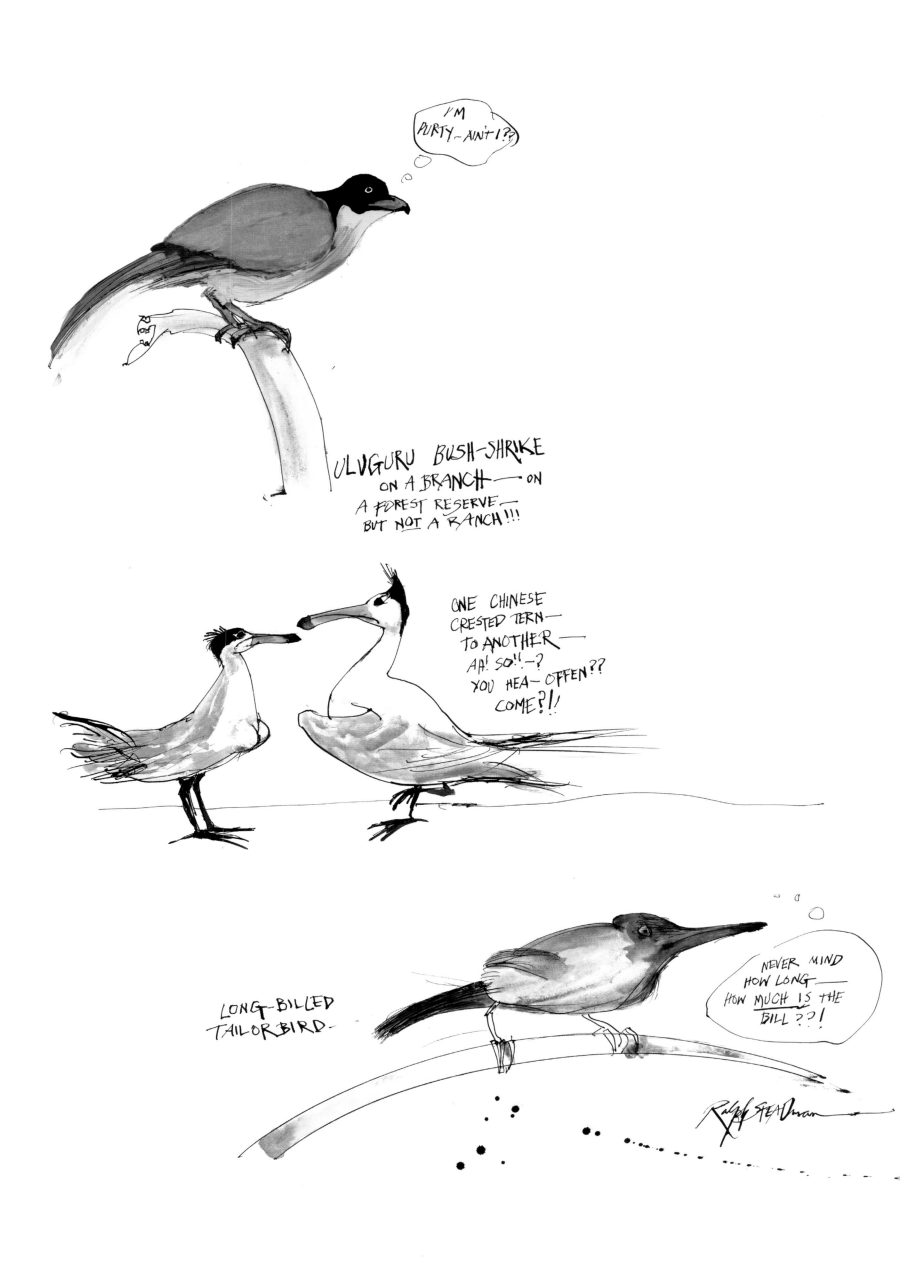

Ralph emails:
Now – wasn't my fault!! They flew through my open Studio door early this morning!! Honest!! Couldn't get rid of them.

Ceri's Diary: Today I am going down to see Ralph and family as it has been a long time since I checked out the studio and it will also be good to see the new system that Grace, our Studio Explorer-in-Chief, has put in place. I am looking through the newly organised system and the contact sheets of all the pictures that have been photographed and organised by Grace and I discover a few I never knew of! A Diving Orange Spronk, no less! I didn't even need to search through the drawers to find a great, lost species. We are heading into the 21st century, a little late granted, but Happy Millennium everyone!!!

Ralph emails:
Lovely to see you yesterday and find the long lost Spronk thanks to Grace!! Good to giggle, wattle and gaggle – a right couple of old wafflers... You could be good if you didn't fart so much!!

Bless your heart – and here is the good one we found – maybe I done it!!!!? ANYWAY – there's nowt better 'n a good pitcher!!! Soon to start them finches I told you about. Got to stop them flappin' so much in the studio so I can draw 'em.

Ceri replies:
It was great to see you too. It's been too long since we messed around in your drawers!

I am good! And I am excellent at farting!! Although I did think that was you yesterday...

Ralph emails:
Addenda vender forthwith! You missed the Orange Nutflap on Monday! He was born right after you left!!!

Ceri replies:
I am sure I will see him in due course. I'm just delighted we found the spronk.

Diving Orange Spronk

Luteus spronkonicus

The Diving Orange Spronk is an air swimmer. Somehow the spronk manages to glide through air as one would through water. This allows him to sneak up on his favourite source of food, Green Buttermoths, which are easy takings for this silent surfer of the skies.

There is talk of creating a new category for the Nextinct Olympics especially for air swimming, but as the spronk is the only one that can perform this feat there is doubt as to whether it would be a valid thing to do. After all, you couldn't give gold, silver and bronze to one entrant, could you? The debate will rage on and a referendum may have to be held to make this decision.

A DIVING ORANGE SPRONK

Javan Green Magpie

Cissa thalassina

Whoops! Here's one of those banana skins spread large and wide on the artist's studio floor. Ralph has already portrayed this bird but what the hell, this is another beautiful rendition of what has gone before.

Cebu Flowerpecker

Dicaeum quadricolor

Cebu Island in the Philippines is home to the Cebu Flowerpecker. It was considered extinct up until 1992, when it was rediscovered. Since the 1890s Cebu has lost over 99% of its original forest, which was the living quarters for the bird. Reasons for the loss are numerous and include road building, settlement, logging and mining. Habitat restoration is now underway and hopefully this will help bring about a revival for this stunning bird.

Banggai Crow

Corvus unicolor

This Indonesian corvid, believed to have been extinct since 1884, has been found to exist in one last location on the mountain slopes of western Peleng, the largest island in the Banggai Archipelago. Deforestation through logging and conversion of land for agriculture are two of the main threats to the crow, and mining companies moving into the area are also a concern. Awareness programmes are underway to promote the conservation of the species and searches continue to find other birds in different areas of the island.

Black-chinned Monarch

Monarcha boanensis

Created from a single gigantic splat of ink, the Black-chinned Monarch stands guard over its future and maybe it has been doing this better than first thought. It comes from Boano, an island off Seram, South Maluku, Indonesia, and had not been seen since 1918 until it was sighted again in 1991. Deforestation is the cause of its decline, with only a minimal amount of suitable forest remaining. Around 30 birds were seen or heard in 2011 in one area, and searches hope to determine that there are more monarchs in other parts of Boano.

White-eyed River-martin

Eurochelidon sirintarae

Ralph has written 'My name is Jim,' and I think he is alluding to our editor, Mr Jim River-martin.

Having only been discovered in Thailand in 1968, the White-eyed River-martin has gone AWOL apart from several unconfirmed sightings in Thailand, Cambodia and Burma. The last confirmed sighting was way back in 1978. Very little is known about the bird or the reasons for its decline, although habitat destruction, as the bird's reed roosts have been converted for lotus growing, and hunting and trapping for food are significant parts of the problem. Searches for the species have taken place with no success and a poster campaign is planned to aid the search, asking locals to keep an eye out for this elusive, reclusive creature.

Orange Nutflap

Repetus flapetus

And here is the Orange Nutflap that was born yesterday. He consistently gets himself into a flap about most things, but especially about flying, as he has a fear of it. Once he realises he is actually flying high up in the air he begins to panic and flaps repeatedly as he doesn't have a head for heights. Consequently his excessive flapping causes him to lose the art of flight and often he comes crashing down to earth and vows never to fly again. But flight is in his DNA and subconsciously he is up, up and away before he knows it, in a never-ending repetitive cycle of flight and pain. Donations for flying lessons can be made at Justflyingnutflap.com.

Stawking Tit

Peepus extremus

The Stawking Tit is actually one of the good guys. An ornithologist, Patrik Wite, who was a notoriously bad speller, gave his name to him. He first discovered the bird furtively looking around his campsite in the middle of the night. 'That tit's stawking me!' he exclaimed with an added 'w'. Of course the tit was merely doing what a nocturnal bird does. It was searching for food, and had just spied an open tin of baked beans lying on the floor and was making its way towards it when it was seen. And so a Stawking Tit he became. For Wite, this was his only discovery and he went on to become a very unsuccessful English teacher.

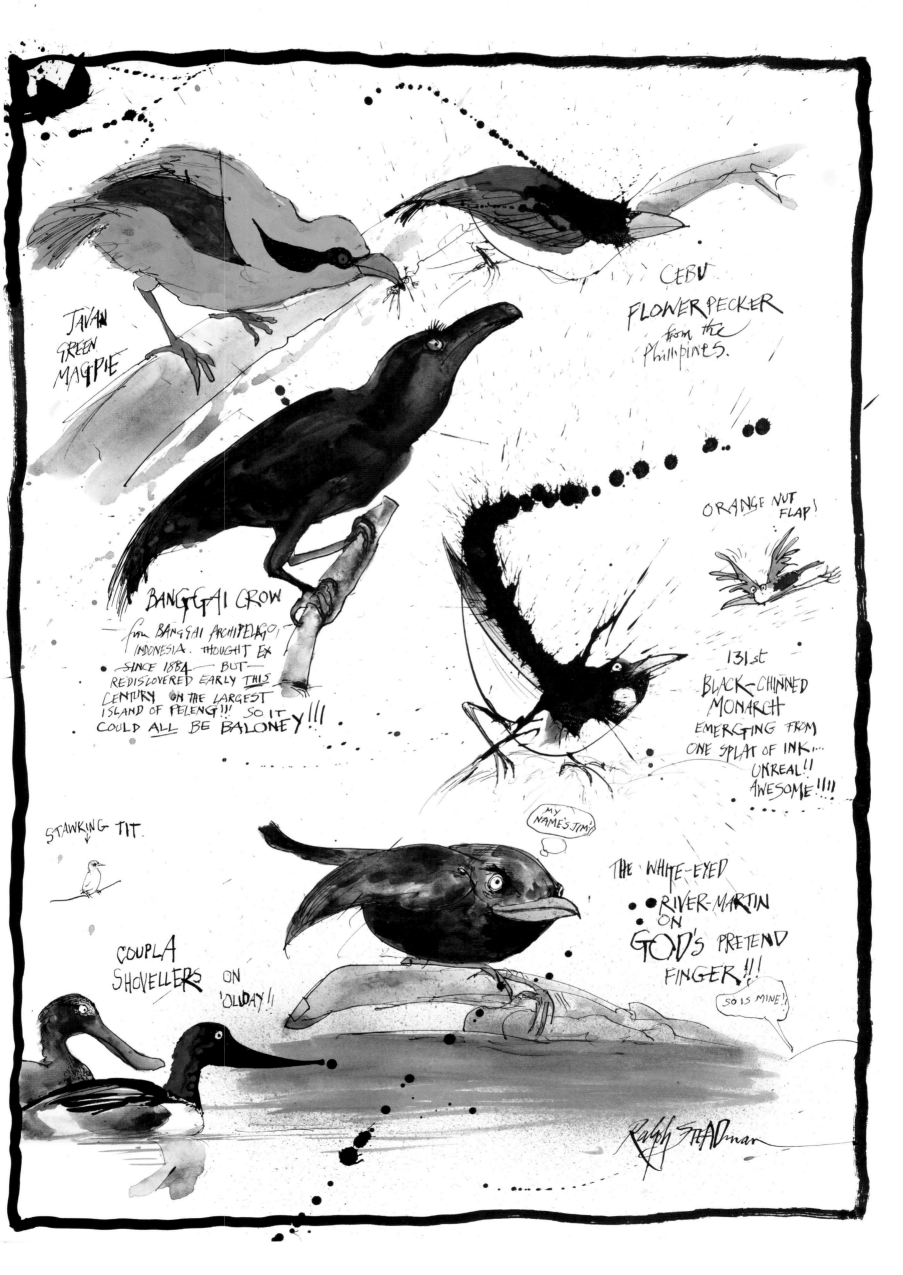

Ralph emails:
Nextincting Frenzy. OK! Let's GO!!!
Here is the Ivory-Beaked 'Big-headed' Woodpecker!

Now doing the crimson Finch and other Finches in the trenches and there is a flight of Dirt Birds in the Neighbourhood!!!

Ceri's Diary: Dear me, Ralph has made a birding faux pas of the highest order. He accidentally wrote in his mail Ivory-beaked as opposed to Ivory-billed Woodpecker. There is a timeless confusion as to when is a beak a beak and when is a bill a bill. Well, here is the Oxford Dictionary definition of a bill:

The beak of a bird, especially when it is slender, flattened, or weak, or belongs to a web-footed bird or a bird of the pigeon family.

So the definition of a bill has the word beak in it...

And here is the definition of a bill, no, I mean beak!

A bird's horny projecting jaws; a bill.

And the definition of a beak has the word bill in it!

Confused? I am... But I believe the main difference to those that know is that on the whole bills belong to... oh, whatever! This bird has a bill!

Ceri's Diary: I am driving down to Spain and have told Ralph I will be incommunicado for a few days. I hope that when I can finally access my email there may be a bird or two waiting for me to write about.

Ralph emails Ceri and Jim:
Dear You Two... (meaning Jim, our editor, and myself)

HELP!! I am being held against my crimson Finch!!! Done some more Birds!!! Tried to photo them and my memory card seems weirrd!!!

It was that Ceri wot said I never drew Birds!! I was certain I had done a couple!! But back in them ole days I was doin' everyfing!!! Tried the phone a few times – so reckon you are away... found this in my drawers, which you have probably never seen. I bit off more than anyone can chew. But I didn't swallow so the swallow is still to do as soon as endangerment kicks in...

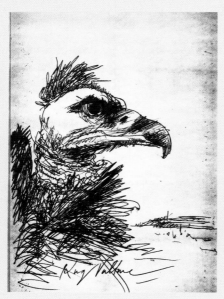

Ivory-billed Woodpecker
Campephilus principalis

Logging and hunting are the two probable main causes for the Ivory-billed Woodpecker's disappearance. Recently this giant of a bird has been causing a stir amongst the birding community, as officially it has not been seen since 1944 in the USA and the late 1980s in Cuba. But since 2004, there have been several contentious records of the supposed bird in Arkansas and Florida, including sightings, sound recordings and a video. The doubt is as to whether it may be the somewhat smaller, but similar, Pileated Woodpecker that is being confused with its long-lost relative, although the sound recordings especially would suggest this not to be the case. In the meantime, searches will continue for the ultimate incontrovertible truth and all birdwatchers have been asked to keep an eye out for this lost species. The truth is out there.

IVORY-BILLED
WOODPECKER

Ralph STEADman

Ralph emails Ceri and Jim:

Dear Ceri and Jim
Whether you Ceri are on the Ferry – and you Jim are with him – here is a darkun – so harken.
I wondered about Night Pictures – but do birds fly-by-night???
Here are them crimson red finches I told you about when you wuz 'ere and a Black Diver with a Flappulence of other creatures.

Ceri's Diary: A flappulence – a gang of birds that stick together and protect all who live on the island from predators.

Black-fronted Tern

Chlidonias albostriatus

This Endangered bird breeds in the South Island of New Zealand and the main threats to it are introduced mammals such as feral cats, rats, hedgehogs, possums, dogs and several species of bird, including the Australian Magpie. It is also threatened by human disturbance and hydroelectric developments, particularly on the Wairau River, where 12% of the population nests. Project River Recovery is restoring the bird's habitat and predation control is having a slight impact. Monitoring of the tern colonies is planned too.

Black Diver

Nox ascensor

A crepuscular and shadowy creature, which lives to attack predators at night as they sleep, wreaking havoc as he descends from great heights to spear the unsuspecting varmint below him. He is in love with the…

Red-beaked White Angel

Ascensor amator

She adores the Black Diver and even though she is not crepuscular she flies with the Black Diver to patch up any injuries that might befall him. The Florence Nightingale of the boid world.

Yellow and Pink Boobies

Pectora coloratum

These sisterly birds have always fought about who has the finest figure since they were chicks. There is never a winner and their altercations are a nuisance to the rest of the gang, who attempt to creep around without drawing attention to themselves.

Yellow-breasted Bluewing or Bling

Nitidus obiectum

This is the boobies' aunt who knows she has the best figure of them all and keeps an eye on her nieces in case they ever try to turn upon her. This is unlikely. Known as Bling for her love of Gangsta Rap… Innit.

Yellow Chairfinch

Sella avis

This bird has earned the name chairfinch because it flies as though seated in a chair. This should not be aerodynamically possible but this is how it flies. Always has a big smile across its beak as it defies scientific explanation.

Blue-beaked Blackhead

Macula caput

Dazed and confused, the blackhead listened to far too much Tangerine Dream when it was young thanks to being born to prog-rock listening parents. There may be no hope for this bird.

Red Finch One and Red Finch Two

Demens gemini

Identical twins, although the tir… up into a round shape and Two spread gracefully. When attacki… and then Two claps its wings t… their battered victims fuzzy-hea…

Yellow-beaked Blu…

Nasum magnus

The size and weight of his bill can… look of apprehension upon his… with force. Known amongst the…

Decorated Epaule…

Caseus grandis

The epaulette is the generalissin… and all from the ground and str… the band of brothers and sisters… his motto.

Swoop Owl

Impetum collosaeus

The true fighter pilot of this ens… the enemy, silently swooping f… lurk below. Relentless once in a…

Red-beaked Ducky

Pugnae anas

This ducky, originally from Q… always wants news from the fro… now, mother, General wants a b… quack with the best of them ar… cowering prey.

Ralph emails:
Here is one I did for a vicious gang of cubs who had me 'demonstrate' how to draw something unexpected! So I discovered the critically unknown KUBOBOO who arrived out of NOWAR! In the early evening!!! Are you there yet? We gotta book to wrap up very soooon!! It's Tuff being Ruff!!!

Ceri replies:
Ah, the infamous Kuboboo... He's a random and rum fellow! I like him but you got to watch out for those cubs as one day they turn into bears.

Ralph emails:
There's a white sheet o'paper upon Board waitin'!? What was that particular feathered beast you mentioned???
Was it the Welsh Avocado Frush – or summink!
You are the dragonfly ringmaster!
I bow before your proficiency... Or is it stuffed???

Ceri replies:
No, it was the Kakapo. The Welsh Avocado Frush is a fruity and plump little bird, which deliberately picks avocados and drops them on innocent people sitting underneath... A dastardly Welsh swine with no middle name. If only he had Idris in the middle of Avocado and Frush he would be ok!

Ralph emails:
No pictures exist unfortunately.

Black Flutterwot

Nodo implexi

The Black Flutterwot is all of a flutter because it cannot fly. It can muster a flutter to a distance of several inches from the ground but that is it. It is aware of its birdly urge to ascend higher than this, but in actuality it can raise no more than a breeze of wind beneath its fluttery wings. It appears that it is wearing a scarf but this is part of its wingly ensemble and doesn't help with lift-off. Being one-legged doesn't aid its take-off technique either. Destined to be a very low air-dweller, it has developed the art of pogoing across the land, which is useful as it kills many tasty insects under its footfall.

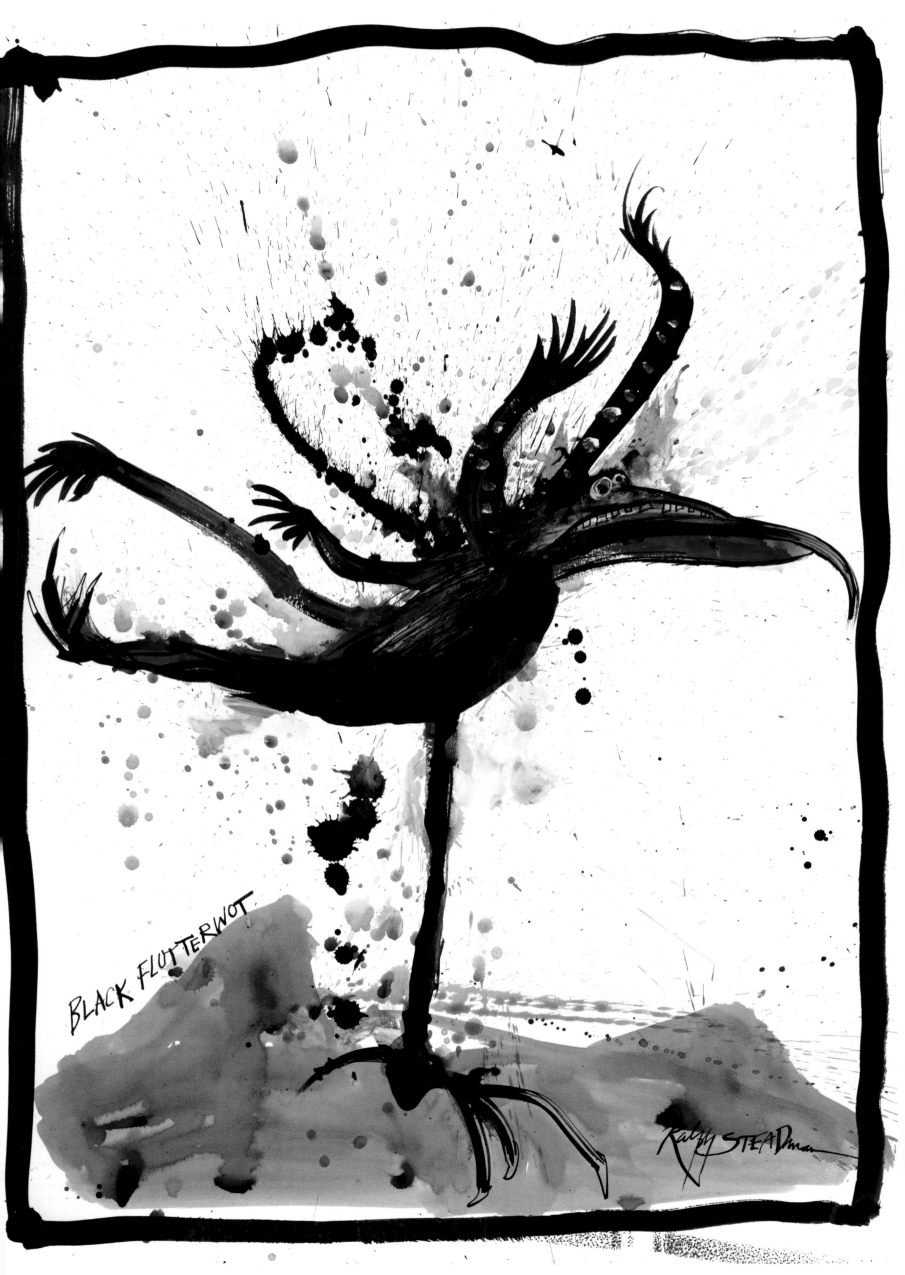

BLACK FLUTTERWOT

Ralph STEADman

Ralph emails:
Did this one on its own – wondering…

Ceri's Diary: Today I learnt about Romeo Error, who I believed to be a well-known explorer of nextinct species, but whose name I discovered to mean something quite different. It means: 'To assume that something is believed to be extinct when it proves not to be.' This came to light when the Cebu Flowerpecker was discovered not to be extinct way back in the 1950s. Calling Romeo Error… Calling Romeo Error… What is your latest discovery? Over…

Kakapo

Strigops habroptila

This large flightless parrot can be found rooting around at night carrying on with whatever a Kakapo does in the wee small hours. Once found across New Zealand, this bird has gone the way of so much wildlife down under and is now only found on four small, predator-free islands. The last birds on Stewart Island were relocated to these islands between 1980 and 1992. Kakapos can live up to 90 years of age and it is hoped that their island life will enable them to live out their years in peace and harmony and grow old and be able to tell their grandfledglings about how it used to be so tough back in the old days. Seventy-eight breeding adults grace the night-time in this safe haven and the total population has increased to 126 individuals. The birds are continually monitored and ways of increasing their breeding frequency are constantly being looked at. It is hoped that by 2016 there will be 60 egg-bearing females. And who knows, then the night-time may indeed become the right time.

If naturalists go to heaven (about which there is considerable ecclesiastical doubt), I hope that I will be furnished with a troop of kakapo to amuse me in the evening instead of television.

Gerald Durrell, 1989.

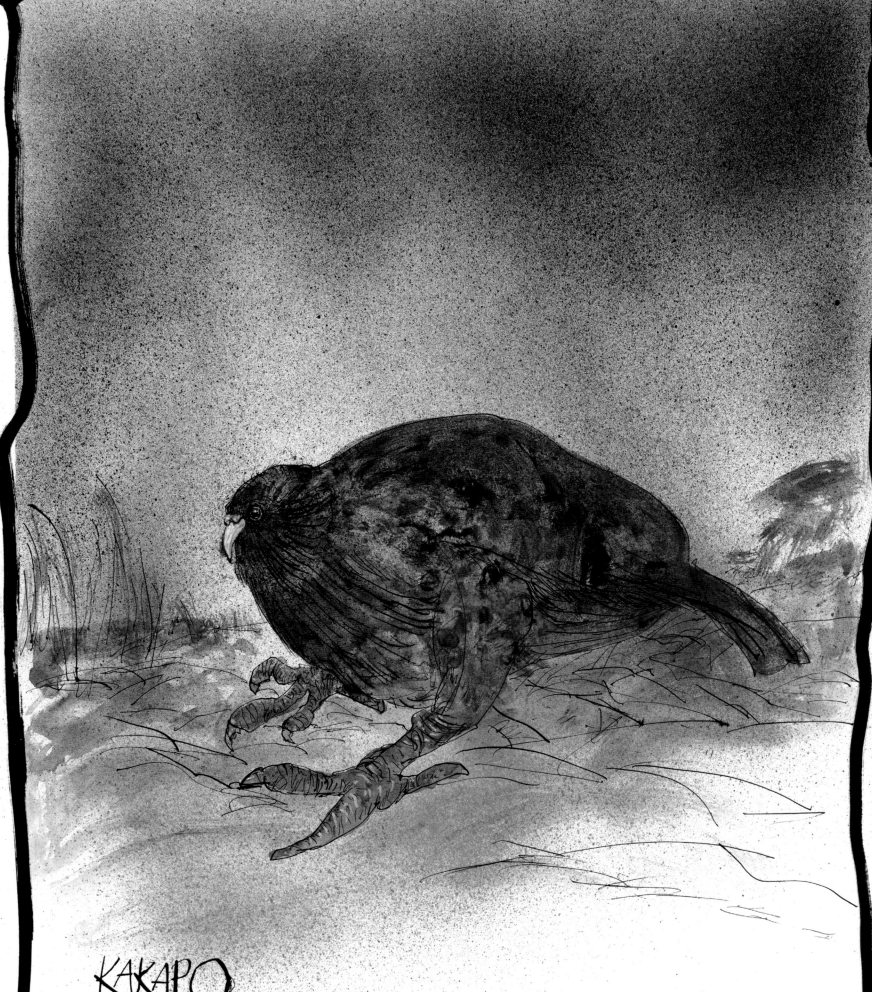

KAKAPO
FLIGHTLESS, NOCTURNAL
PARROT — NEW ZEALAND
— TOO TRUSTING FOR ITS
OWN GOOD!! . 90 YEARS OLD — THIS ONE!!

Ralph STEADman

Rio Branco Antbird

Cercomacra carbonaria

Deforestation is the main present-day threat to this species, which lives along the Rio Branco in the north of Brazil. Conversion of forest to cattle ranches and soya production is the main topic on the agenda and it is believed that future work will destroy more of this habitat. The burning of habitat has also had an enormous impact on the species, and the extent of this has to be assessed. Changes to the Brazilian Forest Code, which may allow a reduction in the width of riverside forest, where the bird dwells, are to be campaigned against. These habitats are protected as Permanent Preservation Areas and need to be kept as such if the antbird is to stand any chance of survival.

Rio de Janeiro Antwren

Myrmotherula fluminensis

Little is known about the Rio de Janeiro Antwren. It was first discovered in 1982 and possible sightings have been reported since, though they remain unconfirmed. The loss of the majority of its lowland forest habitat is the main threat to the bird and surveys need to determine its status. However, it is thought this bird may not survive.

Stresemann's Bristlefront

Merulaxis stresemanni

The Stresemann's Bristlefront is another bird that was lost and then found again, in 1995, and is now considered to be Critically Endangered. Its forest habitat has been decimated because of cattle ranching and logging. Fewer than 50 individuals now seem to exist in the Brazilian State of Minas Gerais, in a valley close to the border with Bahia, and here there is the constant threat of agricultural change eating up the last remaining habitat. A small reserve, the Reserva do Passarinho, has been created in Minas Gerais, and hopes to turn round the prospects of the bird. Surveys still need to clarify the size and status of the population and the remaining forest is in need of protection.

Fringe-backed Fire-eye

Pyriglena atra

This Endangered bird is found in Bahia and Sergipe. It has survived much habitat change but its range is severely affected by human encroachment and agriculture. It is believed that its habitat will become smaller and smaller, although its population size may be larger than first thought, with between 667 and 1,666 mature individuals in existence. It is a protected species and surveys need to ascertain its exact population size and status.

Royal Cinclodes

Cinclodes aricomae

This Peruvian and Bolivian Andes inhabitant was probably once common, but now its *Polylepis* forest habitat is under threat from destruction due to fire and grazing, and also felling for firewood, timber and charcoal. Much work has gone into saving this species from extinction and there

has been research and surveys into the numbers of birds that exist and their distribution. Since 2004, a *Polylepis* conservation programme has been working with local people at Royal Cinclodes sites, setting up greenhouses, growing alternative trees to *Polylepis*, providing nearly 6,000 fuel-efficient stoves and running environmental-education programmes in schools. The planting of *Polylepis* trees in a reforestation programme is underway, with over 480,000 trees planted since 2002. There has been a lot of work committed to this bird and it is certain that much more is intended to be done to save this species. Good luck to one and all.

White-bellied Cinclodes

Cinclodes palliatus

Up at around 4,000–5,000m on the boggy areas of the Peruvian Andes, the White-bellied Cinclodes is found enjoying the high altitude. Overgrazing, peat extraction, mining and the dumping of mining deposits into the wetlands are the main reasons for the bird's loss of habitat, and concern for its continuing decline in numbers. Surveys need to ascertain its population size and status and reserves need to be set up to protect the bird. Then it may stand a chance of survival.

Antioquia (or Urrao) Antpitta

Grallaria fenwickorum/urraoensis

This bird was only described in 2010 and only inhabits a tiny area of habitat, in this case a small parcel of forest in the Colombian Andes. The main threats are deforestation, logging, changing land use, mineral extraction and hunting. Two good things for the future of this antpitta are that, for the most part, the species lives within a private reserve and there is some level of protection for the remaining forest. Surveys continue to ascertain its population size and distribution.

Brazilian Bluelid

Semel insomnem

Ha! You can't fool me, Cap'n Ralph! I'm not going to be looking up a Bluelid! Who in their right minds would think this was anything other than one of your cunning ruses to make me look foolish? The bluelid, of course, is a boid. He looks rather glum and this could be because bluelids don't sleep until they turn 40. This one here is 39 and has seen a lot of things, 24 hours a day. Soon, though, sleep will draw him in and then he will only wake up to reproduce once every three years. Bluelid breath smells like pollen and consequently while he is sleeping, when he eventually does, flies and insects are attracted into his mouth where they stick to his glue-like tongue and are digested as he slumbers, keeping up his strength as he sleeps. Isn't nature brilliant?

Mottled Cornford

Lurkus papyrus

You've heard of treecreepers and wallcreepers – well, this is a pagecreeper. It is always found creeping around at the bottom edges of paper checking out exactly what's on a page. No sighting has yet revealed the bird in full and Ralph's drawing of it is the closest that science has got to this rarity.

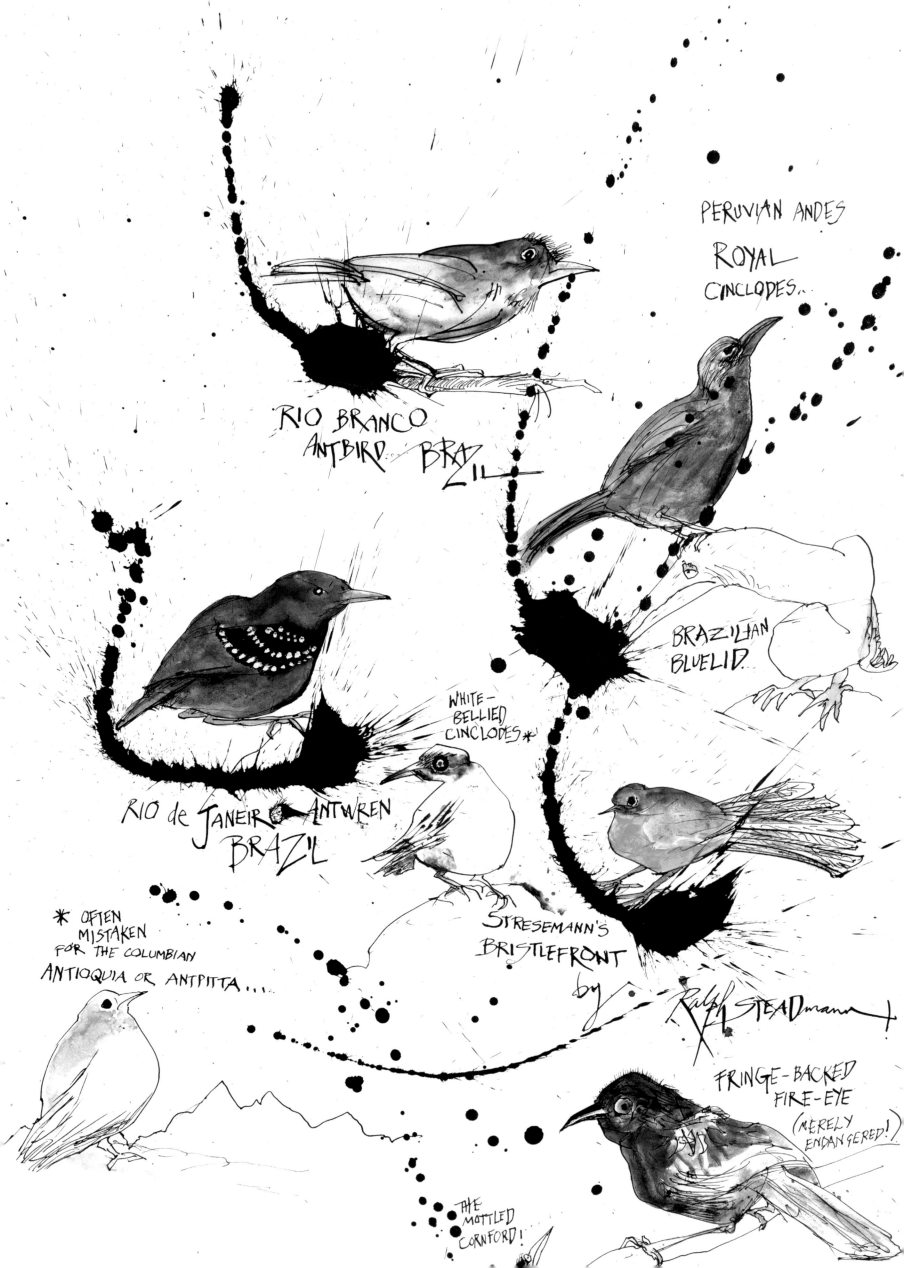

RIO BRANCO
ANTBIRD. BRAZIL

PERUVIAN ANDES
ROYAL
CINCLODES..

RIO de JANEIRO ANTWREN
BRAZIL

BRAZILIAN
BLUELID.

WHITE-
BELLIED
CINCLODES *

* OFTEN
MISTAKEN
FOR THE COLUMBIAN
ANTIOQUIA OR ANTPITTA....

STRESEMANN'S
BRISTLEFRONT
by Ralph STEADmann

FRINGE-BACKED
FIRE-EYE
(MERELY
ENDANGERED!)

THE
MOTTLED
CORNFORD!

Ceri's Diary: I have just sent Ralph a list of the Critically Endangered species as a handy checklist with the ones that we have completed marked as done. I think this will be a very useful tool and hopefully it will be good for Ralph to see just how far we have come and how far we still have to go. I have also marked down the ones that have been completed and the ones that are preparatory drawings, such as the Florican sketches.

Ralph emails:
Ceri, I'm done. YOU write your critical stuff!! I have had my fun… now it really is becoming a pointless exercise – and I have done so many items for it already!!!

Ceri's Diary: Ah, the list has not gone down too well. I wasn't expecting that reaction. I better give him a call in the morning and sort this out. I don't wish to upset the artist.

Phone:

Ceri: Just thought I would call about the list I sent to you yesterday, as you didn't sound very happy about it all.

Ralph: It's just such a long bloody list. It's quite depressing really. It just made me realise how much we've got to do to tell this story. I don't like lists. And there was something else… I can't remember what it was; I'm all a bit confused dot com.

Ceri: But lists can be helpful.

Ralph: And they can be unhelpful. (Pauses) I have nearly finished an albatross…

Ceri: Can't wait to see it. Albatrosses have had it pretty tough recently.

Ralph: I know how they feel!

Ceri: But we're ok?

Ralph: Yes, let's get on with THE LIST… It just gets me down that there are so many birds that are facing nextinction.

Ceri's Diary: I love the preparatory drawings he does of some of the birds. But today I discover exactly what the other thing was that was also bugging Ralph about the list I sent to him. Before I can batten down the hatches I realise my dreadful mistake too late and get blown out of the water by the captain of the HMS *Steadmanitania*. He has just sent me a drawing of a Slender-billed Curlew, which captures an essence of the bird perfectly, and I am looking forward to seeing this fully resolved as a completed picture. I Skype Ralph and I mention that he never seems to make preparatory drawings for his finished works, but this one works really well and I am looking forward to seeing the finished picture. This is the trigger that sends him hurtling over the edge and he remembers what was niggling him so badly yesterday.

Slender-billed Curlew

Numenius tenuirostris

The Slender-billed Curlew is without doubt the rarest bird in Europe, North Africa and the Middle East. It is so rare that it may already be extinct. The population is considered to be fewer than 50, but that may be pushing it as it is. So little is known about this mysterious and elusive bird that the last recorded breeding was in Siberia way back in 1925, and the last confirmed sighting was in Hungary in 2001. Since then there have been searches conducted to find the bird and a few sporadic unconfirmed sightings of it. But nothing concrete has appeared. Will the truth ever out? I hope so, as I love the curlew family. The way it walks, the way it stands, the plaintive way it calls its name, *curl-eww*, which always reminds me of remote rock-strewn beaches when I was holidaying as a kid. Because of their size, curlews have often been prime targets for hunters, and the destruction of wetland habitat is believed to be the other major cause of the bird's disappearance. The Slender-billed Curlew was once considered a common wader but nowadays is a protected species, if only we could find some to protect. It is very unlikely that we will ever be able to round up a crew of this particular curlew.

Slender-
Billed
CURLEW
from SIBERIA - 1925.

Ceri: I love that preparatory drawing of the Slender-billed Curlew. It's got real vim and vigour…

Ralph: That's what I didn't like about your list as well! Marking some down as preparatory drawings! As if they aren't worthy of being seen alongside the other works. Of course I do prep drawings, but when I want to. Therefore, when I want to do them, I do them, capisce?

Flustered Ceri: I didn't mean to annoy you by calling them preparatory drawings; I only meant that I thought that you didn't normally do prep sketches… That's all I…

Ralph interrupts me: Whaddya mean I don't normally do 'sketches?' 'Sketches?' It may only be a 'preparatory sketch' to you but I think it represents the bird perfectly well, thank you very much. 'Preparatory!??' 'Sketch!!!???' These drawings are fine just as they are. Is this just another 'sketch' too???

(This is when he holds up the notebook again and shows me a haughty-looking Crested Shelduck, which seems to reflect Ralph's mood rather appropriately right now. Within a matter of seconds, Ralph starts thrusting a small notebook at the computer screen, turning pages and revealing several more preparatory drawings. A parade of birds passes before my eyes, such as the aforementioned Slender-billed Curlew and Crested Shelduck, and following these he shows me a Kittlitz's Murrelet, a Giant Ibis, an Elegant Sunbird, a Jerdon's Courser…)

Ceri: Ralph, I didn't mean anything by the comment, I simply meant that they looked as though you were working on ideas to turn into a larger piece. Works in progress to…

Ralph: All work is work in progress! I think these have progressed far enough, too!!! These should definitely go in the book as they are, and that's the end of it. I will not be doing further drawings from these 'preparatory sketches!'

(Ralph pauses…)

Now about Grossenheimer's laws of adiabatic masses… have you worked them out yet, more to the point!

Ceri's Diary: Well, that's me told and put in me cubby hole. So I'd better tell the story of these birds and their sketchy details.

Crested Shelduck

Tadorna cristata

The Crested Shelduck is another bird that may well be lost to the world. The last record of it being seen was in Vladivostok, Russia, in 1964, when a male was spied going out with two females. Since then there have been unconfirmed sightings in out-of-the-way locations between China, North Korea and Russia. It's possibly another bird to consign to the drawer marked 'gone but not yet forgotten'. Searches will continue for the bird and leaflets will be distributed asking for information about it and whether it has been sighted at all by locals. So far, the response to previous leaflet drops has been poor. In 1983, 3,000,000 leaflets were handed out, which resulted in only one tenuous report coming in from North Korea. Didn't they win the World Cup too, allegedly? As I look at Ralph's picture it is obvious that this Shelduck has not given up the ghost yet. Another one of those grumpy, surly and defiant critical critters that appears from time to time from the Indian ink of his nibship's finest pen.

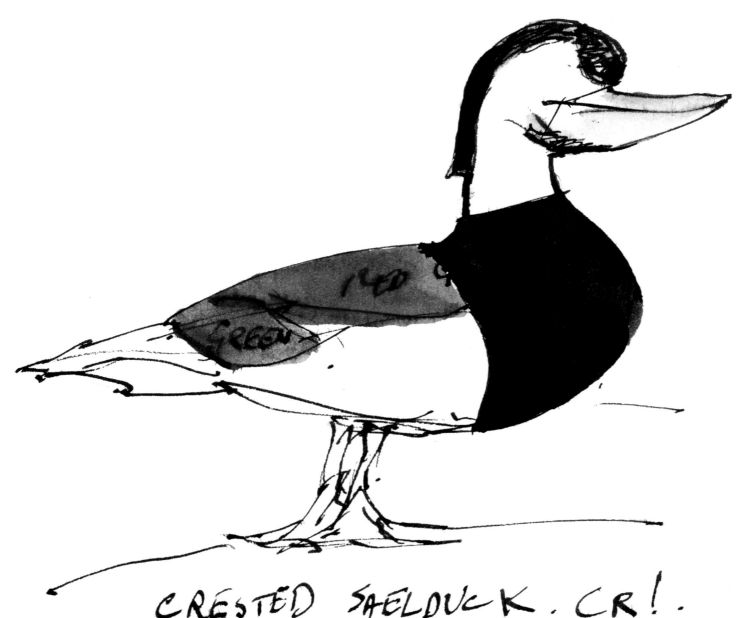

CRESTED SAELDUCK. CR!.

Ceri's Diary: The subject of ibises has been a tricky one for this book as the most renowned of the Critically Endangered ibises is the Great Northern Ibis. So why isn't it in here? Because Ralph mistakenly drew it and we included it in the last book, *Extinct Boids*, even though it wasn't an extinct species. But we never knew we would be doing this book on Nextinction and felt that everyone deserved to see such a picture.

However, it is not the only member of the ibis family that is in big trouble, as the Giant Ibis, the White-shouldered Ibis and the Dwarf Olive Ibis are all Critically Endangered.

Amongst other things, Thoth was the Egyptian god of the moon, magic and mediation. In some cultures he was also considered the creator god and he was often depicted as a man with the head of an ibis, one of his sacred animals. How the ibis family could do with help in re-creating their future, either by magic or mediation or just a plain old godlike intervention.

Ralph emails:
Sinister... Footsy Bird Watcher.

Ceri's Diary: So this is a Footsy Bird Watcher! Some strange surreal watcher of the mountain, he waits for birds to appear. A face watches one way from the back of this upside-down leg and his toes face the other way, towards the mountain; they are actually binoculars through which the leg gets a perfect view of distant scenes. He likes the desolation of his vantage point, which is just as well as he is unable to walk anywhere, being an upside-down kind of fellow.

Jerdon's Courser

Rhinoptilus bitorquatus

This Indian bird is endemic to the mountains of the Eastern Ghats of Andhra Pradesh and extreme southern Madhya Pradesh. It was considered extinct until its rediscovery in Lankamalai in 1986. The bird has not been seen since 2009 and it is believed that encroachment by humans settling in its domain has damaged the habitat, due to firewood collecting, quarrying, agricultural change and livestock grazing. Possible trapping is another threat to the courser. Another danger was the proposition of a canal running through the bird's habitat, but the Supreme Court approved a new route which leaves the suitable habitat alone, although agricultural change is expected simply because of the proposed new path for the canal. Local communities have been employed to find the bird, and surveys and monitoring of specific areas will provide more information as the search continues for a bird we hope has not run its course.

Giant Ibis

Thaumatibis gigantea

Another once-abundant bird, the Giant Ibis, of which there are only about 230 mature individuals remaining, is found in northern Cambodia, southern Laos, and there has been a sighting in Yok Don National Park in Vietnam. Once found across southern Vietnam and Thailand, today it is extinct in these parts. The main threats to it have been wetland alteration for agriculture, deforestation and hunting. A campaign is in place to try and eradicate the hunting of waterbirds in Laos and Cambodia. Protected habitat now exists for the species, and in the Northern Plains of Cambodia members of the local community are paid to watch over and protect waterbird nests and, in particular, those of the ibis. But more needs to be done to keep this, Cambodia's national bird, in existence.

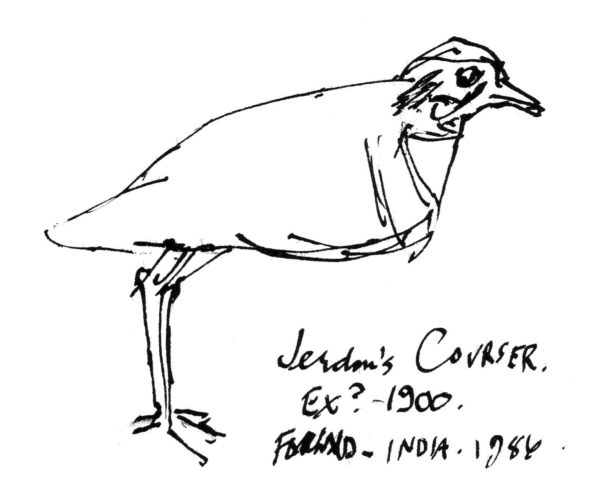

Jerdon's COURSER.
Ex? - 1900.
FOUND - INDIA - 1986.

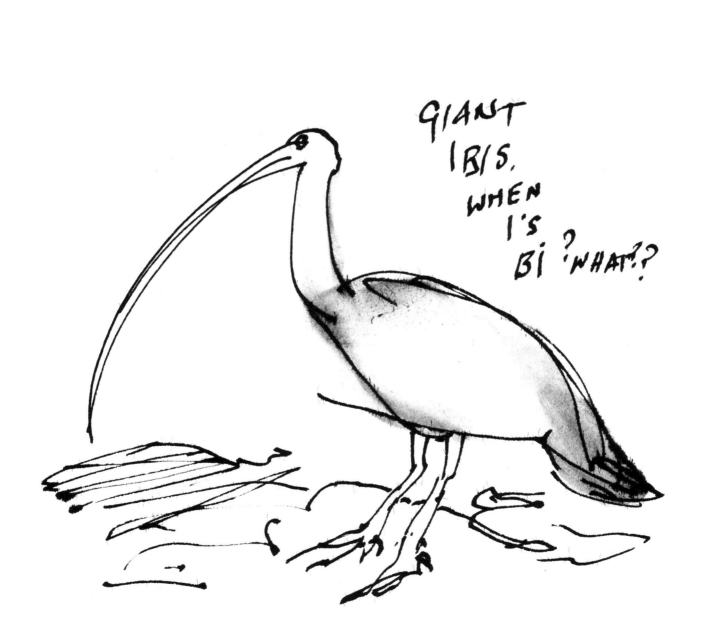

GIANT
IBIS.
WHEN
I's
BI? WHAT??

Javan Lapwing

Vanellus macropterus

The Javan Lapwing was last seen in 1940. This large wader is likely to have disappeared due to habitat loss, which has been exacerbated by hunting and trapping. There is a hope that it may still exist in some as yet unexplored habitat, and surveys need to be made to discover the reality. Whatever the truth, the likelihood is that if it is rediscovered then the population of what remains will be minuscule, probably fewer than 50 individuals. Indonesia declared the Javan Lapwing a protected species in 1978, 38 years after its last sighting. Horse and bolted come to mind. But recent searches in West Java led to locals intimating that the species could still exist.

Kittlitz's Murrelet

Brachyramphus brevirostris

The Kittlitz's Murrelet is a bit of a good-news story. This was considered to be a Critically Endangered species, but recent surveys have indicated that the rate of decline is not as steep as earlier surveys had believed. Consequently, the bird has been downlisted to only Near Threatened. The threats to it are numerous but include glacial decline, bycatch from fishing, human disturbance and, as in the case of the *Exxon Valdez* oil spill, petroleum contamination. The species continues to be monitored in Alaska and Russia and work continues to protect the bird and not allow it to get back onto the critical list again.

Elegant Sunbird

Aethopyga duyvenbodei

The Elegant Sunbird is now only found on the small island of Sangihe, north of Sulawesi, Indonesia. Much of its forest habitat has been removed and the sunbird has been surviving in other habitats, although the main population's location is in one tiny area of remaining forest, which is still being threatened by agriculture. Protection is minimal and the fear is that this Endangered bird could become a Critically Endangered species in the near future. Conservation-awareness programmes have been initiated and there is hope that a wildlife reserve can be created. It's definitely the time to reserve that land for an elegant inhabitant.

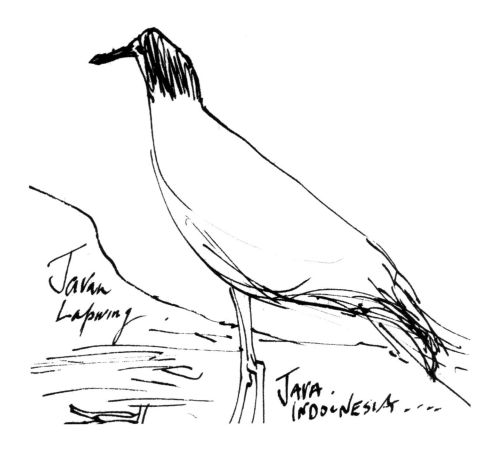

Javan
Lapwing

Java
Indonesia

Kittlitz's
Murrelet
● An Auk . . . !
Bering Sea.
Russian Territory

Elegant
Sunbird.

M. Rueck

Scrutator mysterium

Actually, I'm finding it difficult to show who Rueck was other than that his name seems to be German and is written as M. Rück when in Germany, although the only mention I can find of him states that he was French. As with pets looking like their owners, here we have a case of the bird looking like its discoverer, or the other way round if you prefer. Although I would say that Rueck looks decidedly discontent with his lot, possibly because he knew that time would wipe the contents of his life from its box and leave him with a bird named after him for posterity. But doesn't that in a way make him one of the immortals? A man who has become forgotten but forever remains remembered because of a bird's name. So in answer to the question, 'Who the 'eck was Rueck?', 'I don't know.' But he did discover a little shining beauty of a bird, his blue-

flycatcher, and I think there should be more thanks given to this man, and, for that matter, all the discoverers of species. Thanks to all of you for your discoveries, but today, especially, Ralph and I say thank you to Monsieur or Herr Rueck, for everything. We will never forget you.

Rueck's Blue-flycatcher

Cyornis ruckii

This vivid blue bird is known only from two specimens, which were taken in 1917 and 1918 in northern Sumatra. It has not been seen since, but cannot be considered to be extinct because Sumatra has been poorly watched, and who knows what may be lurking deep within the forest? Recent searches have turned up nothing but if you fancy making a name for yourself then head on over to Sumatra and have a look for yourself. 'He who dares finds birds.' After all, if you go down to the woods today… You could have one Rueck of a surprise.

Cebu Flowerpecker

Dicaeum quadricolor

And here comes another repetitious moment, as the Cebu Flowerpecker has also graced these pages recently. But with Ralph there really is no such thing as unnecessary repetition. The birds never seem the same twice and this one is so beautiful that it merits a second appearance.

Zapata Rail

Cyanolimnas cerverai

This is another species that had been considered lost – it was a familiar bird in south-west Cuba during the first part of the 20th century and then seemingly disappeared from the world until a few sightings were reported in the 1970s. Since then, there have been very few glimpses of the bird. Mammals, such as mongooses and rats, are probably predating it. As the Zapata Rail is a nidifugous species, which means that the young leave the nest shortly after hatching, the young are easy prey for introduced catfish. The dry-season burning of its habitat may be seriously damaging the population as well. Surveys need to be carried out to ascertain the population size, its locations and the exact threats to its future. When all this is worked out then plans can be put into action to help the bird survive.

Cuban Spotted Rail

Spottitus spottitus

Ok, here we go. It's time to play, 'Bird orrrrrr Boid!!!' This has all the hallmarks of classic Ralphism. A slightly droopy and world-weary look about the face, a red splotch by his beak and a spottiness that looks more akin to an affliction than to markings. But I may be wrong! I need to research this very thoroughly before I accuse Ralph of a Boidal misdemeanour. Where's Rueck when you need him? Hmmm… I guess… Boid!

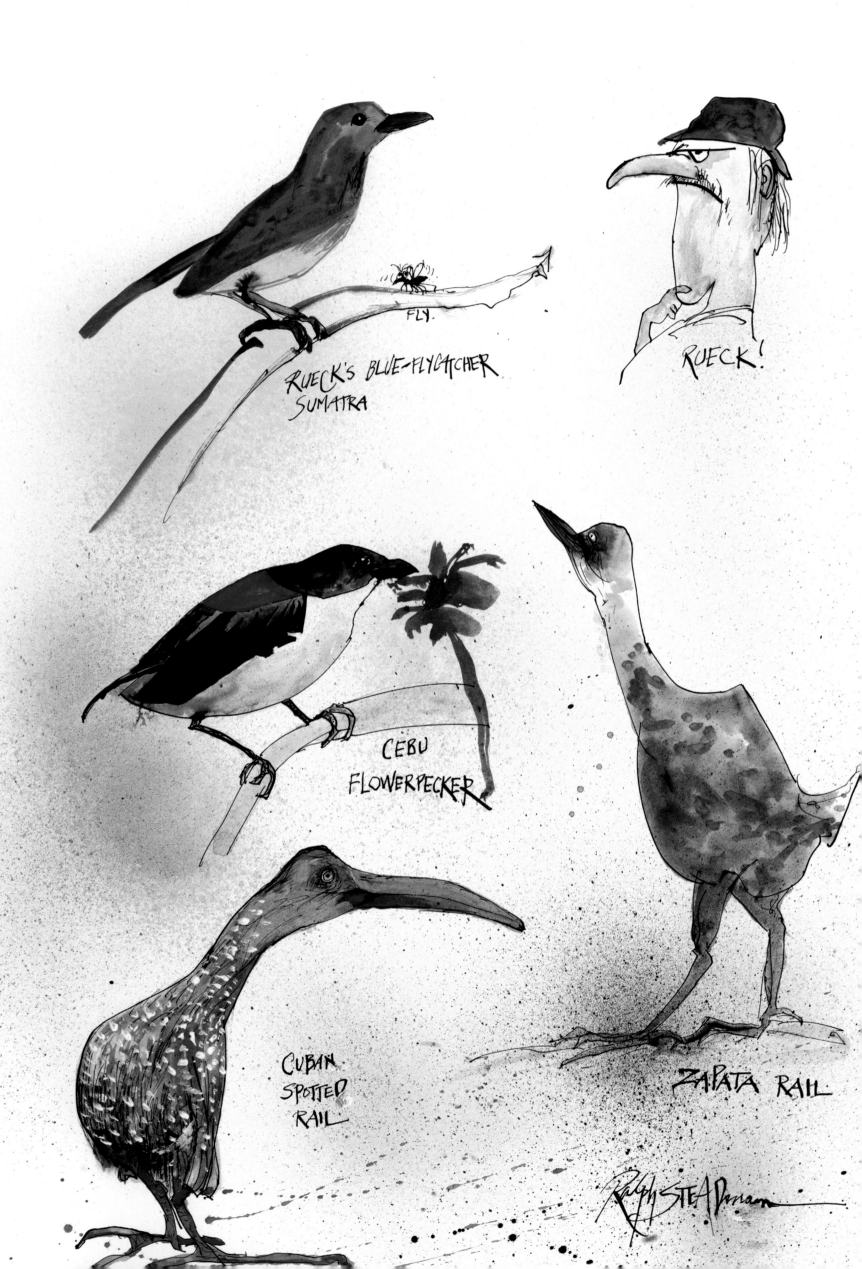

RUECK'S BLUE-FLYCATCHER
SUMATRA

FLY.

RUECK!

CEBU
FLOWERPECKER

CUBAN
SPOTTED
RAIL

ZAPATA RAIL

Ralph STEADman

Yellow-beaked Red-legged Bluet

Patronus invictus

The Yellow-beaked Red-Legged Bluet is the multi-headed guard bird of Boggins Flats Wetlands, which are the breeding grounds of the nextinct. It is believed that far back in this mists of time, the Ooshut Doorbang, the great god bird of the island, created him to guard over the eggs and fledglings of the nextinct, while he had a kip for a thousand years, as gods are prone to do. For centuries there was nothing for the bluet to do other than play Scrabble and have philosophical debates with its multi-headed self. Each head has a varying degree of intelligence and independence and causes heated debate to occur regularly. There was even talk of each head becoming a different political party within the body of the bluet, but a voting system could never be worked out and so politics was left to the rest of the world. The heads manage to coexist and their minds were taken off their squabbles the day that Kevinio and his cohorts arrived on the island. From that moment on a war was declared as 'The Great Extincter' repeatedly tried to enter the breeding grounds. Battles would ensue and the blue-panted bird-killers would be repelled. The nextinct birds felt safe but worried about what would happen if the bluet got older. His reply was that the hunters would be older too, so the fights may be a little slower but he would always have the edge. And of course when the Basic Bird Scrambled Egg Disaster happened there was only one blue-panted bird-killer left to fight alongside Kevinio, which evened out the age issue too as there were fewer enemies for the bluet to fight against.

But one day Kevinio managed to smite a blow so hard that he lopped off a bluet head. This had never happened before, and he and the last remaining hunter took heart, even when they saw the head grow back miraculously in front of them. But they could see damage could be done as the regrowth took an amount of steam out of the bird. They were eventually repelled once more, but knew if the bluet remained alone that perhaps ultimately Boggins Flats Wetlands could be breached.

The bluet knew this too and came up with a plan. He had seen a crazy-looking, rakish, javelin-like Flightless Boid wandering around and knew this boid was desperate to serve a purpose on the island. He hated being flightless and more than anything in his flight-free life he longed to sail through the air. So the bluet came up with a plan that would help this creature change his life forever more.

The Yellow-beaked Red-Legged Bluet devised a catapult system that meant he was able to launch the pointy Flightless Boid by taking its two feet within two sets of beaks and pulling back as far as possible while the boid remained rigidly straight. At the maximum tension the bluet would let go and the Flightless Boid would launch like a spear, hurtling through the air. The whoops of delight that came from him could be heard far and wide and with time he learnt to control his flight trajectory. The idea was to reach the maximum height and then descend like a rocket, straightening out through the descent, turning him into a beaked missile heading towards the ground and towards any enemy that may encroach onto the breeding grounds. A lot of practice ensued and the team got better and better at their launches and descents. Finally they were ready for the next time that Kevinio and the blue-panted bird-killer would attack.

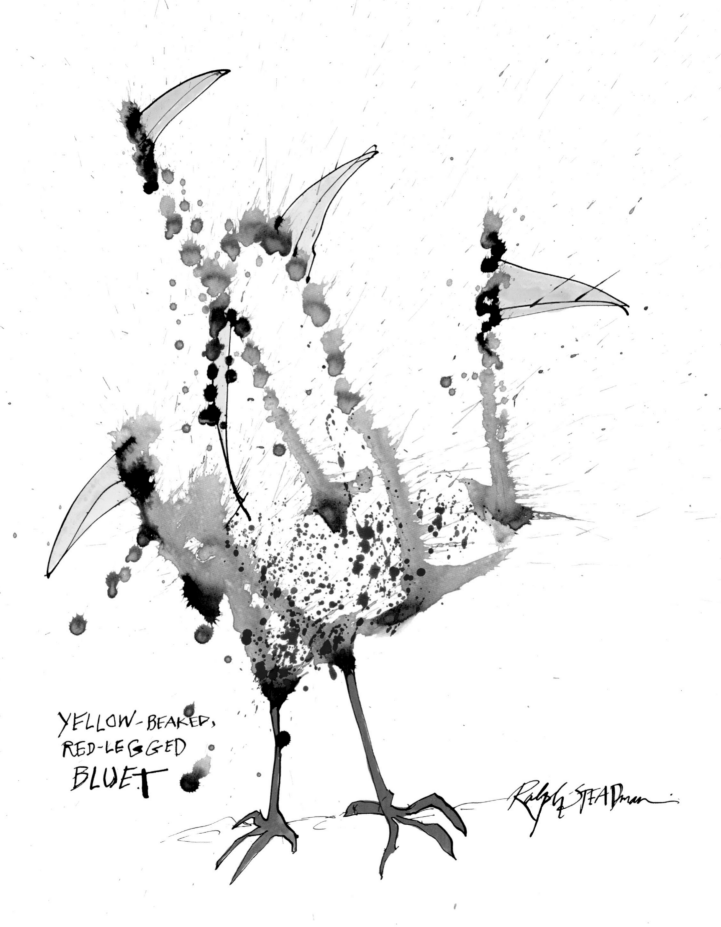

YELLOW-BEAKED,
RED-LEGGED
BLUET

Ralph STEADman

I am halfway up Spain on the Manchego trail heading further north tomorrow and will be back in Blighty by the end of the week... Not sure how the boat is going to be on the Bay of Biscay. Could be rough. We nearly got blown off the motorway today, as the wind was so strong. They were advising people not to drive in Spain at all today... Ah well, Mad Dogs and half Welshmen...

Ralph replies:

DRIVE, MAN!! Drive like the wind!!! I found this strange Puccini Frisk measuring my inside leg this morning as I constructed a cup of Tea for those who would lay cable from my lower depths to Andy's Garage on the Hill beyond... without using Scaffolding... Is it a Bird? Is it a Beast??? And can we trust its Pedigree???!

TURN LEFT, MAN!!! SHAME... You missed it – now you will have to go the long way around... sniff!!! Safety to you both...

PS. Cannot send you the latest picture, which is nearly finished, until I work out my camera... Winged Albatross is Critically Endangered – but at least it is flying!!! We need more twigs and TREES!!!

Puccini Frisk

Whiskus friskus

The Puccini Frisk is whisking up a bisque, although you can't quite see the bowl in this drawing. Part magician, part composer and part chef, his aim is to create the finest lobster bisque in the land accompanied by a symphonic retelling of the recipe, converted into musical notes. Synaesthesia at its most accomplished. This rendition of the recipe is expected to happen at some point around the middle of the end of the time when all is resolved and perhaps finished. Or maybe a little after... or perhaps a little before. It's always hard to get your timings right with a musical bisque.

Flightless Boid

Accuratio erraticus

Thanks to the Yellow-beaked Red-Legged Bluet, the Flightless Boid became the Spearsome One. So adept did he become that his aim was always true. In those exhilarating moments he said that he understood what Yuri Gagarin must have felt like when he was catapulted on his short journey into space.

Previously, the Flightless Boid led a sedentary existence, searching for a way to be a bird of worth in spite of his failings in the flying arena. He worked on the beaches renting out deckchairs; he shelled nuts for lazy birds and even built nests for wealthy birds that just didn't have time to do it themselves. He mooched from location to location on the island but never found his vocation until the Yellow-beaked Red-Legged Bluet came calling. And the rest, as they say, is history or his story, whichever you prefer.

In this picture, Ralph has managed to capture the first moment that the Flightless Boid took flight and then rocketed towards the earth as a fully trained Kevinio-seeking missile. His precise and rapid flight path leaves Kevinio shocked, surprised and unable to evade a collision. Consequently, the wingless creature winged him. Since then, Kevinio and his troops have been hit so many times that they always expect damage when they attempt to enter Boggins Flats Wetlands. They consider it an occupational hazard and have yet to cross the threshold of the breeding grounds, but they will never give up trying to get their hands on the nextinct and their young as they are committed hunters. Keep up the good work, bluet and boid; you're doing a sterling job.

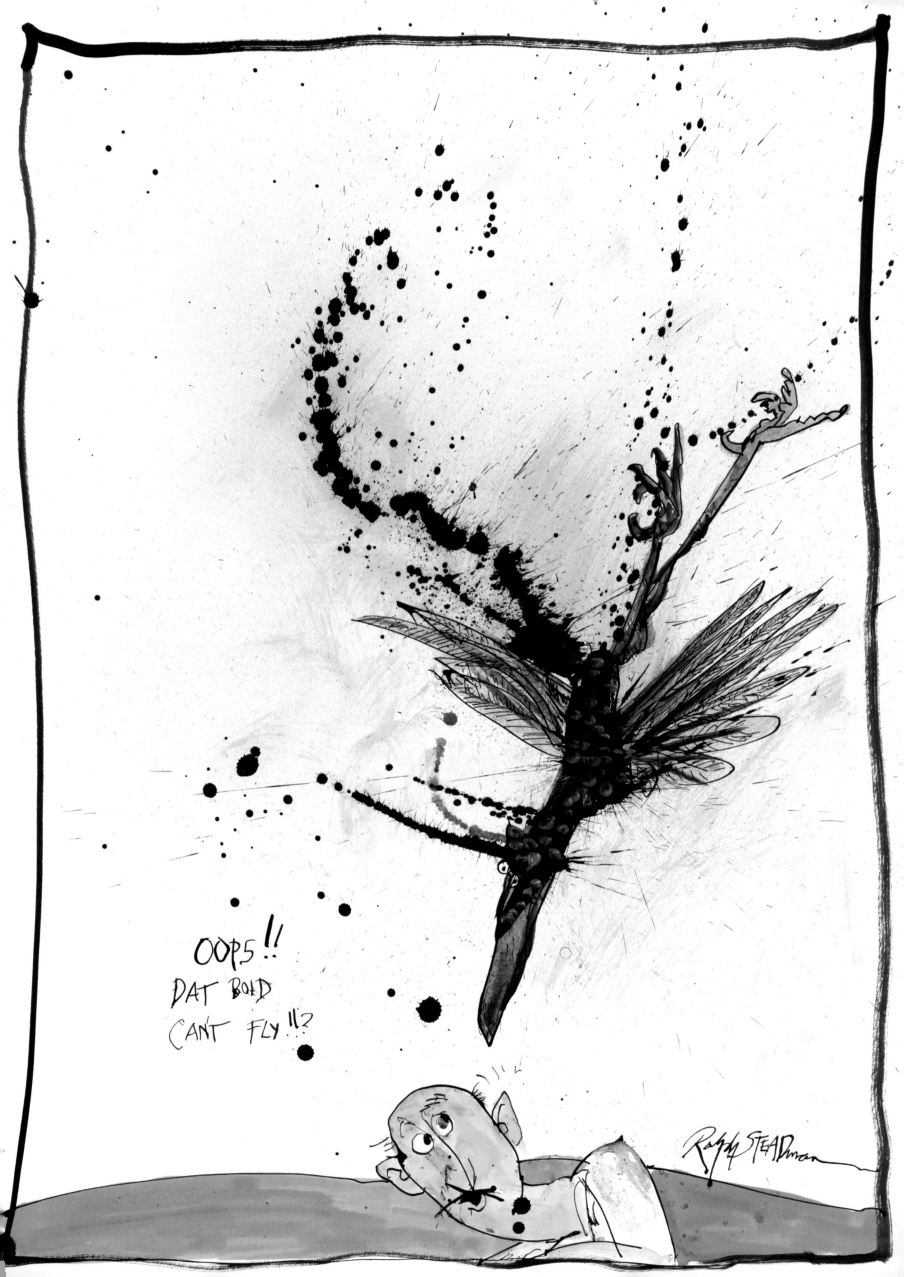

Ceri: I'm glad to be back and to catch up with what's been going on. The sea crossing was uneventful although I did see a lot of great birds on the way back. Did you manage to photograph the albatross you told me you were drawing?

Ralph: Albatross? I never did an Albatross. I think you're thinking of a Monty Python sketch. No Albatross here mate.

(My email pings... There is an Albatross!)

Ralph: One other thing... What about doing one of those old flicker book things of this bird? Then you could see the Waved Albatross wave.

Ceri: You would only have to draw this picture about 20 times to make it work.

Ralph: Hmmm, it's a nice idea, but maybe the book doesn't need a gimmick.

Ceri's Diary: If Dodos are synonymous with extinction then perhaps albatrosses are one of the symbols of the devastation that is being wreaked upon our birds, and in particular our seabirds, today. The troubles that face these creatures are huge issues that need urgent attention.

Ralph's portrayal of the bird has a certain poignancy about it. The bird's eye scans the turbulent sea, and within that eye there is a heart-wrenching gentleness, which evokes sadness within me that this giant of the skies is flying for its survival as it travels in search of food or a place to rest its weary wings. Albatrosses, like so many birds, are continually flying and foraging just to stay alive, and some can travel 1,000km in a single day; they must earn a bucketload of Air Miles for that!

Waved Albatross

Phoebastria irrorata

The Waved Albatross breeds on the south of Española Island in the Galápagos, and possibly on Isla de la Plata in Ecuador, where at most there are 10–20 breeding pairs. In the non-breeding season the albatross is found in the waters of the Ecuadorian and Peruvian continental shelf. Its population had increased to 34,700 birds in 2001, which was more than the estimated 12,000 pairs in 1971, but in 2007 a survey of two breeding sites on Española suggested that the population was in immediate decline, and nothing has happened since then to change that belief.

The Waved Albatross is often the unintentional bycatch of longline fisheries, with the birds being killed as they become caught in fishing nets and on fishing hooks. Eighty-three per cent of the birds caught are male, which has severe implications for the breeding success rate of the species. Industrial longline fishing is now banned within Galápagos waters, but much has to be done to restrict the damage caused by such fishing in the rest of the world. Also worrying are the intentional capture and harvesting of the bird by some fishermen for human consumption and for the feather market. Whatever the causes, it is estimated that the numbers of Waved Albatrosses being killed, whether intentionally or unintentionally, have risen sharply over the last few years.

A tortoise-breeding programme has been responsible for 2,000 tortoises being released on Española in the last 30 years, and being herbivorous they have been munching away at the vegetation, keeping the habitat to the liking of breeding Waved Albatrosses, making them happier breeders. Meanwhile research continues to ascertain the effect of fisheries upon the species.

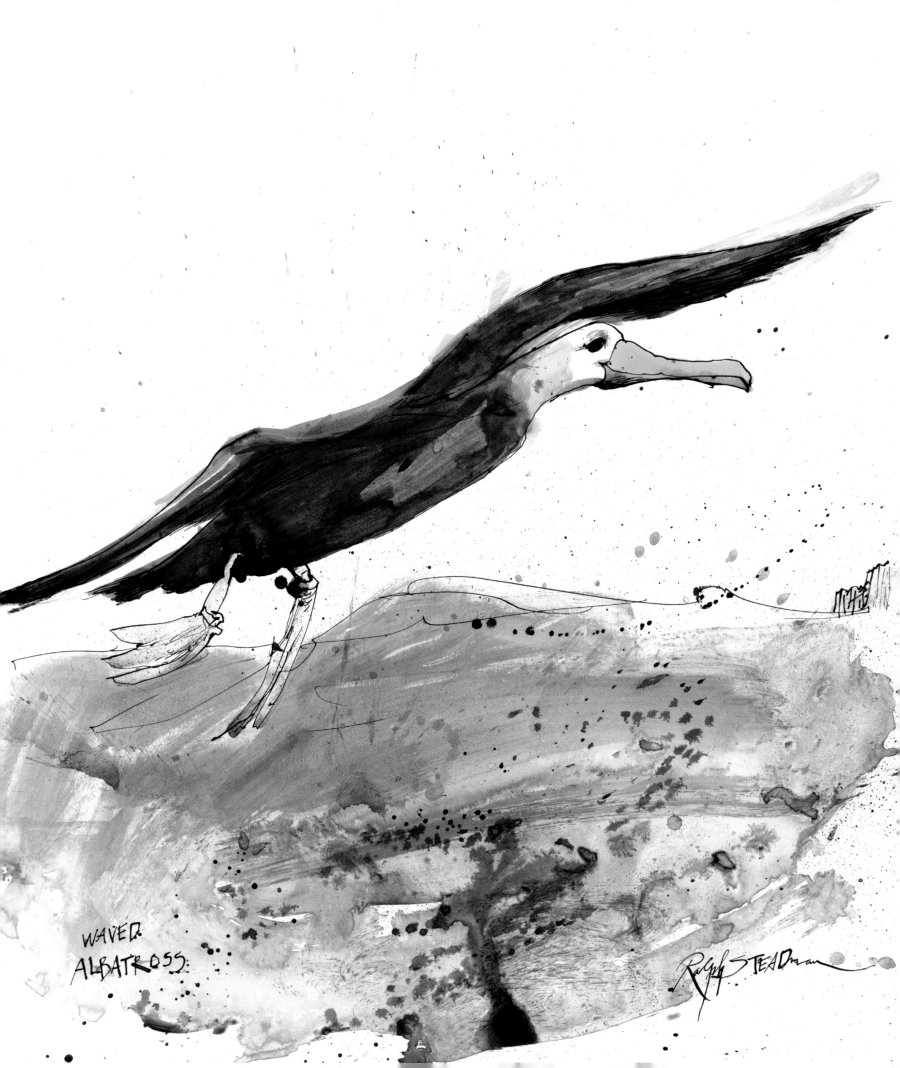

WAVED
ALBATROSS

Ralph STEADman

Indian Yellow-nosed Albatross

Thalassarche carteri

The main population of the Indian Yellow-nosed Albatross is housed on Amsterdam Island in the southern Indian Ocean. There has been an alarming increase in the rate of decline of the population over the last three generations, with an estimated loss of 51% of the species. This has caused it to be considered Endangered. Reasons for the decline have been avian diseases, perhaps brought in by introduced chickens at the French military base, habitat degradation due to former cattle grazing, and longline fisheries. Bycatch in these fisheries is probably the greatest danger faced by many of the world's seabird populations, and a simple change in method is possible without affecting the actual fishing. In fact, it would improve the success and efficiency of the fishing itself. Work is being carried out to promote changes in longline fishing and to lessen the amount of seabird mortality.

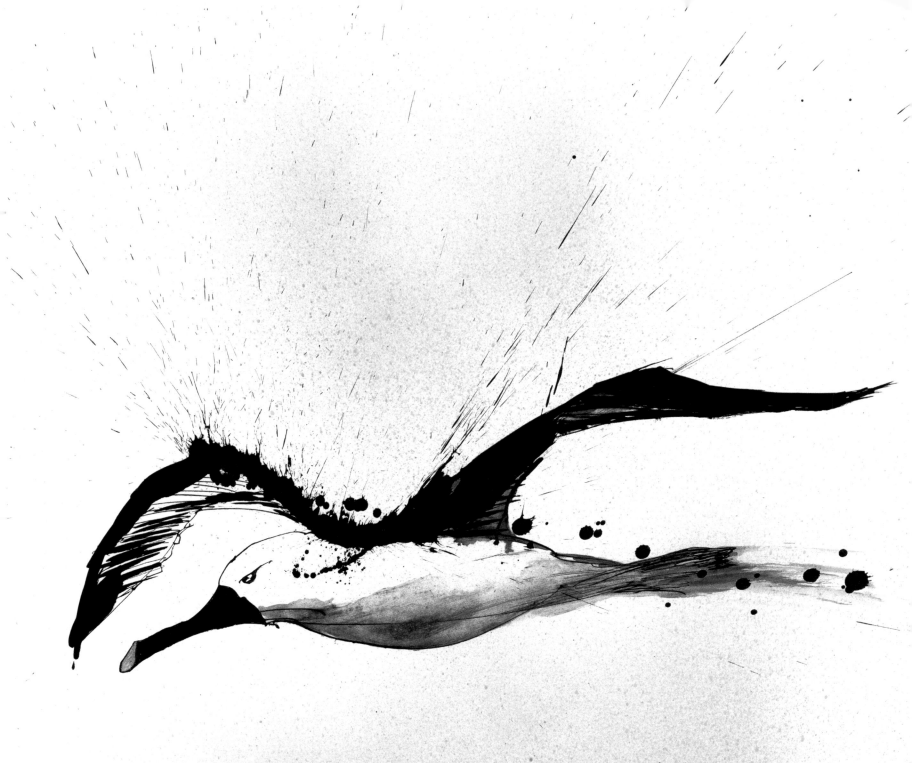

INDIAN - YELLOW-NOSED
ALBATROSS......

Ralph STEADman.

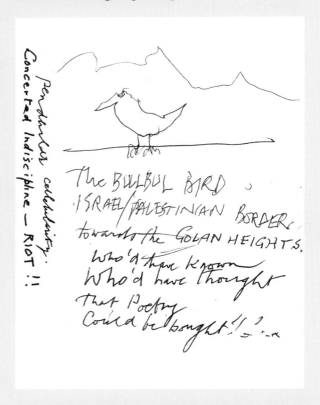

Streak-breasted Bulbul

Ixos siquijorensis

So here we have another artist's dilemma. Has Ralph really seen a Streak-breasted Bulbul on the Israel and Palestine border or not? For a start there is no such things as a Streak-breasted Lesser Bulbul, there's no lesser about it. Plus the bulbul in this part of the world is the White-spectacled Bulbul, but that looks completely different to the bird Ralph has depicted. The Streak-breasted Bulbul is normally found in the Philippines and is Endangered due to the deterioration of its forest habitat in its ever-decreasing range.

But this also sets up the issue of when have you seen a bird or not? In birding parlance it is called stringing. This is when you believe you have seen a rare bird and tell people that you have seen it. Then someone sees the supposed bird, realises that it is not a rare bird at all and the person who called the rarity in the first place gets labelled a stringer. Some can do this because of a genuine mistake but others become perpetual stringers – downright liars – and that's not a good thing to be. Then one day that person really finds a rare bird and nobody in the world believes him. Is this Ralph? I am going to give him the benefit of the doubt as there is always the chance he really did discover a major rarity. After all, birds have the ability to get to all sorts of places purely because they have the power of flight and can be blown many, many kilometres off course by the wind. But 8,979km? I guess anything is possible in this world. Or there is the other possibility that it could be a miracle and that is just what this region needs right now. Perhaps the Streak-breasted Bulbul brings the answers for peace.

White-spectacled Bulbul (or is it?)

Pycnonotus xanthopygos

The second bulbul, purportedly the White-spectacled or White-eyed Bulbul, is the usual inhabitant of this area, albeit with a bright yellow body, which is not the usual body for this bird. Is this artistic licence from Ralph? I can't say for sure. Anyway, I would suggest that this is definitely a confusion of bulbuls courtesy of the artist. And why not? After all, the whole area is amid confusion and what's one bottle-blonde bulbul in the midst of it?

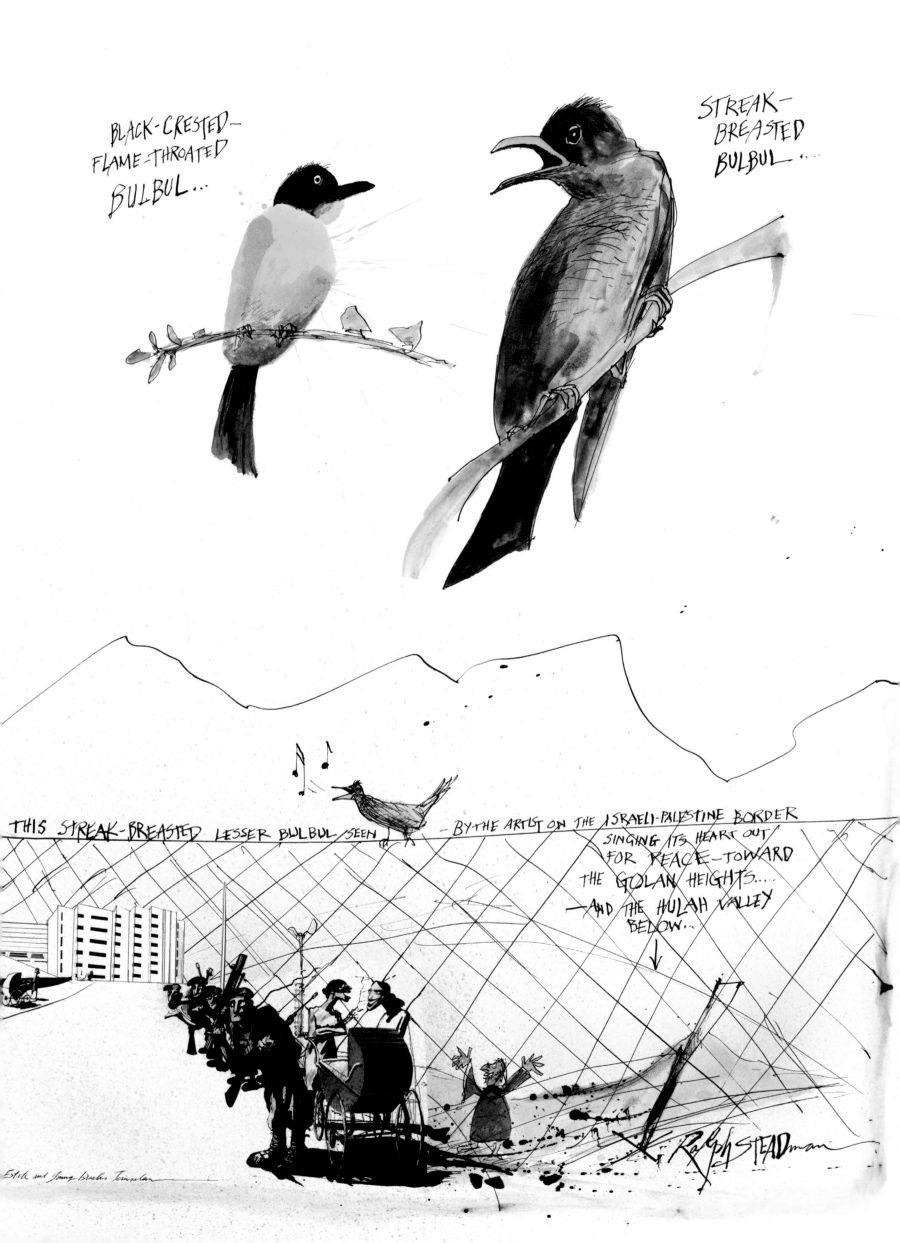

BLACK-CRESTED-
FLAME-THROATED
BULBUL...

STREAK-
BREASTED
BULBUL...

THIS STREAK-BREASTED LESSER BULBUL SEEN — BY THE ARTIST ON THE ISRAELI-PALESTINE BORDER
SINGING ITS HEART OUT
FOR PEACE—TOWARD
THE GOLAN HEIGHTS.....
—AND THE HULAH VALLEY
BELOW...

Ralph STEADman

Ralph: I keep getting emails asking for all sorts of things. One has to be some kind of cardsharper to outwit these electronic swine – probably a streaked outwit. The Internet is rife with vermin.

Ceri: Don't take any notice of people you have never heard of, especially if they are asking you for passwords or PIN numbers. Avoid them like the plague.

Ralph: But what if they really need them?

Ceri: They don't. It's always a scam. Hit delete.

Ceri's Diary: Ralph phones me. He has just got back from New York, where the documentary about him, *For No Good Reason*, has been premiering. He is tired and a little fed up with the amount of work he had to do. 'Right, we need to get on with this book and I've had an idea as to how to deal with that annoying list of yours of birds to do. I'm going to get a pin and stick it in the list randomly. I'll let the birds decide who I am going to do next. That's the only way this is going to work from now on.'

'So it's a little bit like Zen editing? Leaving things to chance?'

'Call it what you want, I call it drawin'!'

Ceri's Diary: Jackie and I have just arrived back at our place in the sunny south of Spain so I can get on with writing this book. Ralph always accuses me of lollygagging in the sun. But I don't touch lollies, not since my dentist told me to steer clear of them, therefore nothing to gag on.

Our goddaughters, Daniela, nine, and Triana, eight, have come round to see us and have some lunch. Skype starts up.

On Skype:

Ralph: Hola, you're in Spain I see! Lazing around in that sun when there are birds to be saved! What do you think you're doing?

Ceri: I'm going to be writing reams of words to accompany your scribbles! And while you're here you must meet my goddaughters, Daniela and Triana.

Ralph: Hola, Daniela and…

Ceri: Triana – it's very Spanish, a name from Sevilla, although Greek in origin.

Ralph: How am I going to remember it… (Pauses) Three Annas, Anna, Anna and Anna, that's how I'll remember Triana. The rule of three!

Ceri: They are both up-and-coming artists, Ralph. They show great promise.

Ralph: As soon as you are elsewhere you're working with other artists! How good are they? Could one of them draw a rhinoceros picking potatoes?

Daniela: I can do that.

Ralph: Ok, well next time I see you I expect to see a rhino doing just that! The challenge has been set.

Black-hooded Coucal

Centropus steerii

This member of the cuckoo family dwells within the forest interiors on the island of Mindoro in the Philippines. Its population is continuing to decline due to the loss of its now-fragmented habitat. At the current rate, deforestation will mean that there will be no forest left by 2020–2030, which will mean no more birds either. The threats to the habitat include logging, dynamite blasting for marble, and slash-and-burn agriculture, which is when forest or woodland sites are chopped down and what remains is burned to create fields to cultivate. These lose their fertility after a couple of years and new sites have to be created, consequently leaving a trail of forest devastation. Surveys need to be carried out to establish the Black-hooded Coucal's current status, while educational and awareness programmes will teach locals about the importance of the bird. It is to be hoped that a forest restoration and protection plan is successful and that the bird has a chance of survival.

Woodlark

Lullula arborea

The Woodlark is neither Critically Endangered nor Endangered, although it is considered to be a Species of European Conservation Concern, which means that conservationists are keeping an eye on the bird and its future. And here he appears, although he normally wouldn't make this kind of journey to the Philippines, as this is only possible in Ralph's art. Perhaps he has drawn him to calm the Black-hooded Coucal with his song, even though, as much as the artist would like it to become a Skylark, it will never have the range to replicate the Skylark's notes. But by the look of it he is going to give it a damn good go and the coucal seems to be listening and enjoying the music, which is taking his mind off his current plight. This is music therapy in action.

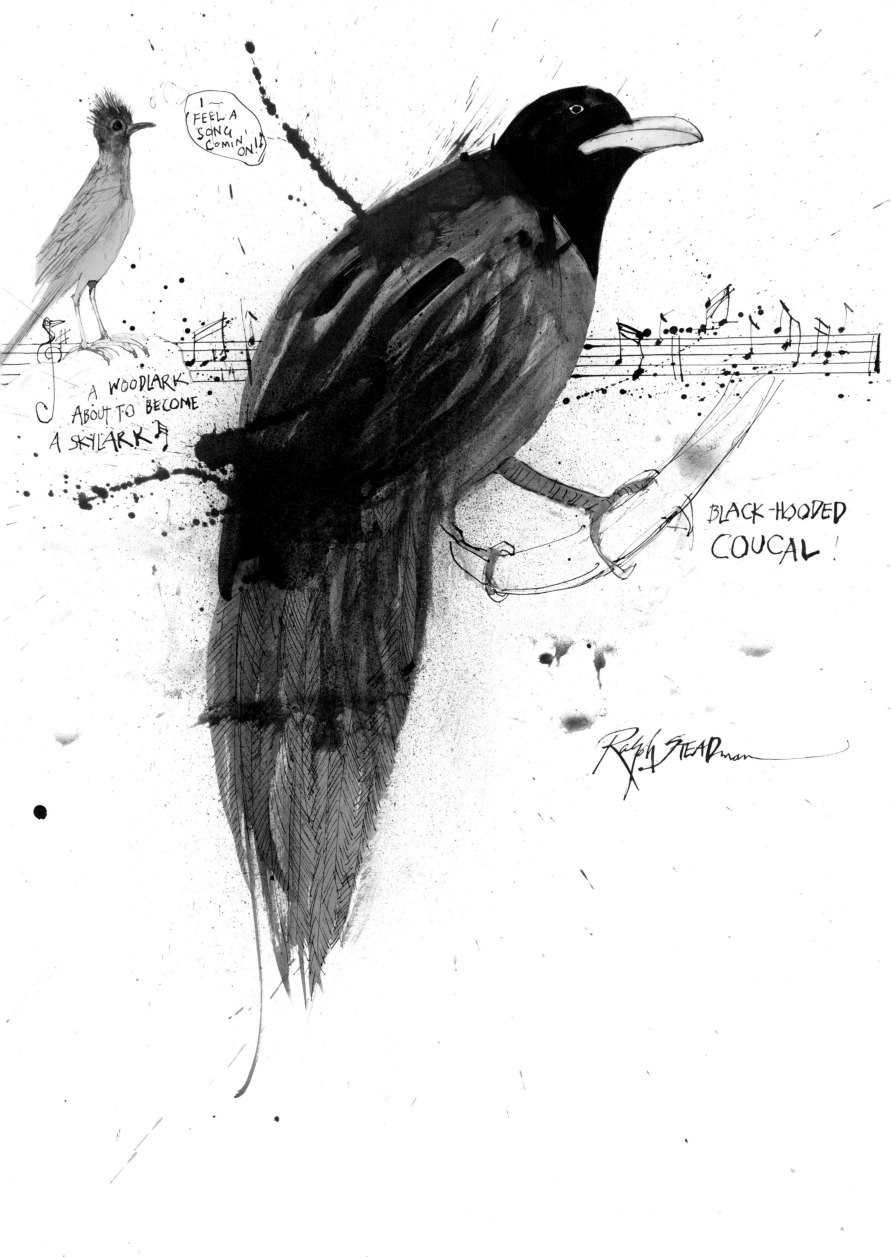

Ceri's Diary: After Ralph comes up with the task for Daniela, she sets to work on creating the picture and I am amazed to see the result. A more studied picture of a rhinoceros picking potatoes could not have been realised by any other artist. I cannot wait to show Ralph.

Ceri emails: Here is Daniela's picture for you. She wants to know what you think of it.

Ralph replies:
What a Rhino!!! Daniela actually does the background as well!! I can't do that!!! But I will try before we have finished!!!

PS. Here is an inkloon to show Daniela!! Ceri will tell you ALL about him!!

Ceri: Inkloons are naturally found in the feathers of the nextinct and busily try to clean the nextinctness away from the bird. They are unfortunately prone to falling over their rather large feet and hence often miss great patches of nextinctness, due to concussion. Hence the rather vacant look on this inkloon's face, as he has totally forgotten what he was meant to be doing and why he was doing it. Sounds familiar to me.

Ceri's Diary: Ralph inspires children to draw, and next to be affected by him are his grandchildren Toby and Ollie, both of whom enjoy spraying paint about and drawing in the studio. First is Toby's drawing of a very rare creature, the Birdbutterflyeagle. I wouldn't want to mess with that critter.

birdbutterflyeagle

Ollieblot

Filius creatio

Following on from the Birdbutterflyeagle is Ralph's adaption of Ollie's splattered paper into an Ollieblot. This is the headmaster of the Nextinct School and numbers are down at the moment as more birds are on the nextinct list than ever before and are not breeding, as they should do. It is hoped that the conservation work that is being carried out will eventually lead to more pupils at the school, which in turn will mean more work for the Ollieblot, although it has to be said that he may not be the greatest headmaster, as the mountain we see behind him is actually a pile of homework which he still has to correct.

When he first became nextinct he applied for the vacancy of headmaster. Not expecting to get a chance of such a job he was surprised that no one at the Town Hall checked out his credentials and he easily got an interview with the mayor, the Needless Smut, who makes all such appointments on behalf of the school. The smut soon discovered that the Ollieblot was not really a teacher but a cocktail barboid who, to his credit, whizzes up the meanest of alcoholic eggnogs. These he served during his interview. It was apparently a straightforward decision to appoint the Ollieblot as the next headmaster of the Nextinct School.

AN OLLIEBLOT ON A LANDSCAPE

Ralph STEADman

Tuamotu Kingfisher

Todiramphus gambieri

This colourful chap is endemic to the tiny island of Niau in the Tuamotu Archipelago, French Polynesia, in the middle of the South Pacific. But life has become very difficult for this little kingfisher. The birds create nests in the hollows of dead and dying trees, and the loss of coconut-palm trees is one of the significant problems on the island. Farmers have now been persuaded to let this type of tree stand for a few years longer than usual to give the kingfisher more chance to breed successfully. The other issue is possible predation by rats and cats, which may also be in competition for the same food as the bird. Rat control is coming into force now, especially within the palm-growing areas, but even though cat control is deemed potentially necessary, the islanders of Niau are loath to pick on their moggies. Analysis is being made of the success of the rat controls and the lack of cat controls.

There is also talk of creating a second population of kingfishers on another island to avert the catastrophe of potentially losing the entire species to a severe natural disaster such as a cyclone. It's a definite case of not putting all your eggs on one island.

What is it about cats? The world refuses to accept that they are a destructive force and an enemy of birds. In Britain, it is believed that cats catch a minimum of 55 million birds per year, although in all likelihood those caught would be considered the weak and the sickly with the least likely chance of survival. In America, recent research has suggested anywhere between 1.4 and 3.7 billion birds are being killed by domestic and feral cats. Many have accused the scientists who have come up with these figures of providing dubious statistics. But one thing is certain: birds don't get along with cats particularly well.

Perhaps a cat cull across the world would help… Calm down, I don't mean it; I know you're a cat lover. I just wanted to startle you a little. Whatever the truth is, a lot of birds do go down a cat's gullet! Does a bell round a cat's neck help? I don't know, but perhaps it is an area that needs to be properly addressed.

Marquesan Kingfisher

Todiramphus godeffroyi

The Marquesan Kingfisher is now endemic to Tahuata, one of the Marquesas Islands of French Polynesia in the South Pacific. There were two populations left of the species, but in 2003 the colony on Hiva Oa became extinct, as introduced Great Horned Owls, the Common Myna and possibly Black Rats predated them. In 2009 the last remaining birds on Tahuata were placed on the Critically Endangered list. This kingfisher inhabits dense and humid forest bordering mountain streams and feeds primarily on reptiles and insects. The main threat to it has been habitat destruction caused by feral livestock, such as cattle, pigs, goats and horses, which all damage its upland forest home. Continual surveys of the bird and its surroundings are important as Black Rats do exist on Tahuata, and it is vital that the Horned Owl does not fly in and colonise the island, otherwise it will be 'nana' (Tahitian for goodbye) to this elegant bird.

TUAMOTO
KINGFISHER
CONFINED TO THE
ISLAND OF NIAU in the
TUAMOTO ARCHIPELAGO.

MARQUESAN
KINGFISHER
—ALMOST
THE SAME!

I MUST HAVE A WORD WITH
THEIR QUEENFISHER !!

Northern Rockhopper Penguin

Eudyptes moseleyi

This eccentric-looking penguin, who looks more like he should be sipping brandy at his club, hails from the Tristan da Cunha islands and Gough Island in the South Atlantic and Amsterdam and St Paul Islands in the Indian Ocean. It is estimated that within three generations, in the last 37 years or so, the species' population has fallen by 57%. This alarming decline may be due to climate change, overfishing and introduced species. Historically, penguin eggs were collected and this may still continue on Nightingale Island. Driftnet fishing and rock-lobster fisheries also cause deaths and there could be competition with seals for food. Monitoring continues to determine the actions needed to help this penguin and for it to keep on hopping.

(Blotted) Galápagos Penguin

Spheniscus mendiculus

Ralph is having a very playful day terming the Galápagos Penguin as blotted. He has certainly given him a blotted, frosty and aquatic feel, which I think is a trick of the light, but this is most definitely a Galápagos Penguin in the picture.

Endemic to the Galápagos Islands, this most northerly-breeding of all penguins has a small range and small population. It is constantly being affected by predation from feral cats and by mosquitoes, fishing and human interference, including the pressures from the large number of tourists who visit the islands. The penguin loves the cool waters around western Galápagos, but these waters have been warmed up too much by the El Niño Southern Oscillation, and this overheating has accounted for many penguin deaths. El Niño is the name for a band of warm oceanic waters that arise intermittently, changing the temperatures around the Pacific coast of South America. These increases in warmth of the waters are likely to continue and possibly become more frequent thanks to climate change. In 1982–83 this accounted for 77% of the Galápagos Penguin population being wiped out and in 1997–98 there was a further decline of 66%. Monitoring of the penguins is ongoing, and the Galápagos National Park Service is controlling the predatory introduced species, but what can be done about El Niño is unclear.

Erect-crested Penguin

Eudyptes sclateri

The Endangered Erect-crested Penguin hails from New Zealand and is another penguin whose population has declined drastically over the last 30 years or so. No one is quite sure why, as there are no predators on the breeding grounds of the Bounty and Antipodes Islands, and cattle, sheep and the Brown Rat have been removed from Campbell Island, although there is no evidence of breeding amongst the population there. It is thought that there may be climate-change issues and marine issues, but work is ongoing to discover the exact reason for this decrease in numbers.

This penguin is another striking character that may be able to join the Rockhopper Penguin at his club for a stiff drink or two and to mull over their respective futures.

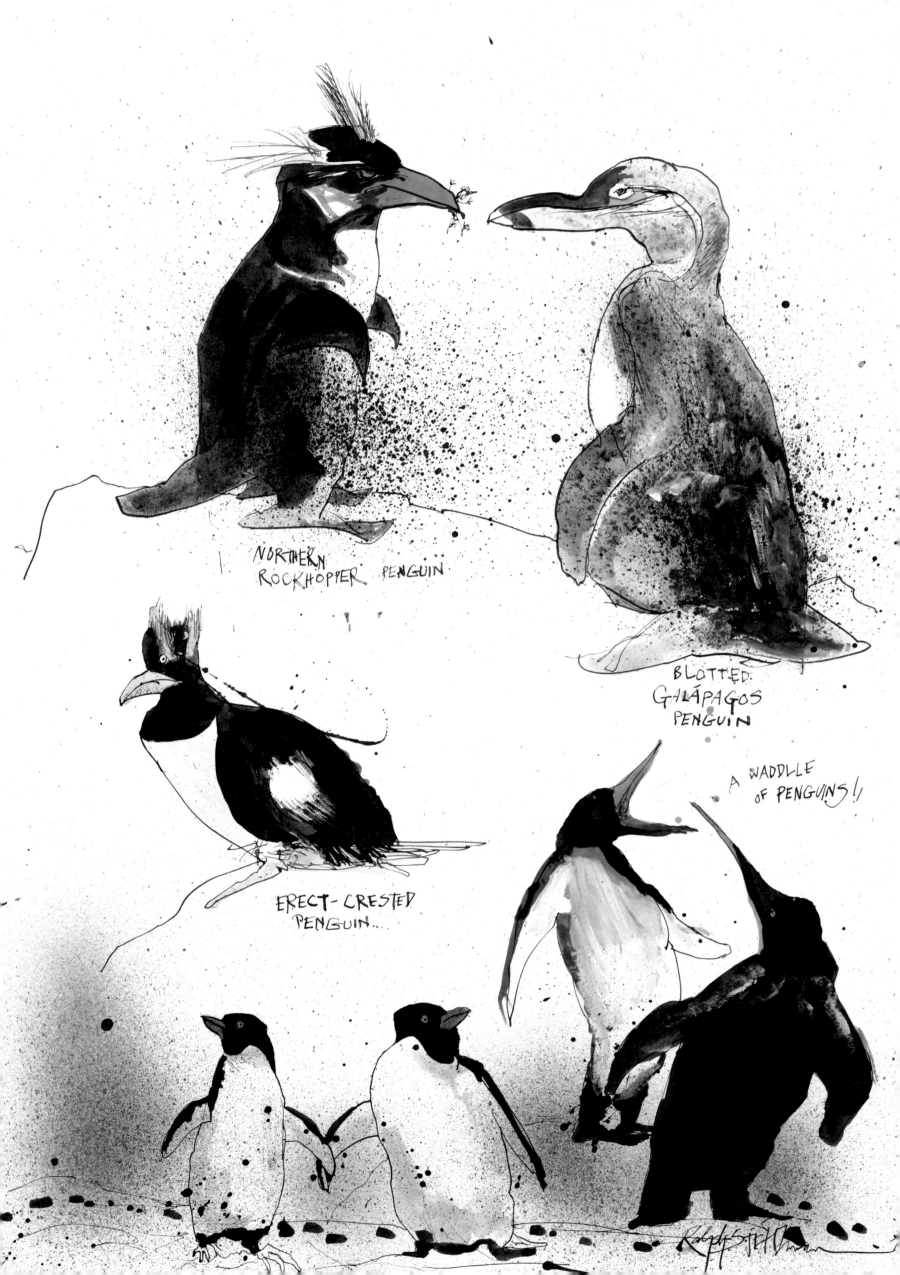

NORTHERN ROCKHOPPER PENGUIN

BLOTTED GALÁPAGOS PENGUIN

ERECT-CRESTED PENGUIN...

A WADDLLE OF PENGUINS!!

Ralph Steadman

Phone:

Ceri: I have just received the Umdan-gonderildi bird.

Ralph: You know what it means, don't you?

Ceri: I translated it as little child or something similar.

Ralph: No, it means sent from my iPhone! It was a bird sent to me by a Turkish friend of mine, who told me that in Turkey it is a bird that is close to extinction.

Ceri: But there is no bird called the Umdan-gonderildi.

Ralph: No, I gave it that name. But the photo they sent and from which I drew it is an actual bird, do you know the one I mean?

Ceri: No, because it doesn't exist. There is no bird that looks like that drawing other than the Umdan-gonderildi.

Ralph: You don't believe me? It's no problem to show you which bird it is – hold on and I will get the photo. (A few minutes later Ralph returns.) I'm afraid my drawers have been interfered with… But it is an actual bird and I saw it in a book.

Ceri (laughing): You just told me it would be no problem to show me… and now it's become a huge problem.

Ralph: Well, I lied about not being able to tell you. Sorry! I lied. I do that. I can't help myself. You don't know what it's like to live with a condition where I continually lie involuntarily.

Ceri: It must be an awful affliction for you.

Ralph: No it isn't… See what I mean?

Turkish Umdan-gonderildi Chick

Telefonus inventus

The truth is that this bird is the rock star of the island. His musical tastes and fashion style may be firmly stuck in the 1960s and '70s and perhaps he is past his prime, but he still manages to cut a dashing figure with his feather-cut hairstyle. He used to have a band called The Small Species who were very popular back in the day; he has recently been creating waves on social media by performing on YouFlew, and is building up a sizeable audience on Flutter. Can be seen on revival tours with musicians and bands such as Crane Eddy, Dave Crossbill, Preen and Vulture Club.

TURKISH UMDAN-GÖNDERULDI
CHICK —

Ralph STEADman

Cuban Kite

Chondrohierax wilsonii

This rather tetchy-looking bird appears like a general who has been rudely disturbed in the middle of the night to oversee a covert military mission as he overlooks the map of Cuba in the operations room. His haughtiness gives him a certain regality that only birds of prey can ever truly muster. Once widespread across Cuba, the kite is now only found in a small area between Moa (not the extinct bird) and Baracoa to the east of the island and may possibly still exist in the provinces of Holguín and Guantánamo. There have been scant sightings of it over the last 40 years, with the last being in 2010 – since then *nada*. Its main source of food is tree snails and slugs, but farmers have hunted it in the misguided belief that it is a bird that would take their poultry. Other main threats to the bird are habitat change because of agricultural development, logging and harvesting, which has supposedly removed much of the bird's prey of tree snails. No wonder the kite looks grumpy and aggrieved.

It is essential to get a handle on just how many birds may or may not exist presently. It is estimated that there are anywhere between 50 and 249 mature individuals, but until a survey is carried out this is more of a guesstimate. The bird needs help and it needs it now. Accordingly, plans are under way to protect the kite's habitat, to educate locals about the bird to prevent further persecution, and to reintroduce snails for food. Then, and only then, the kite may have a chance to soar again.

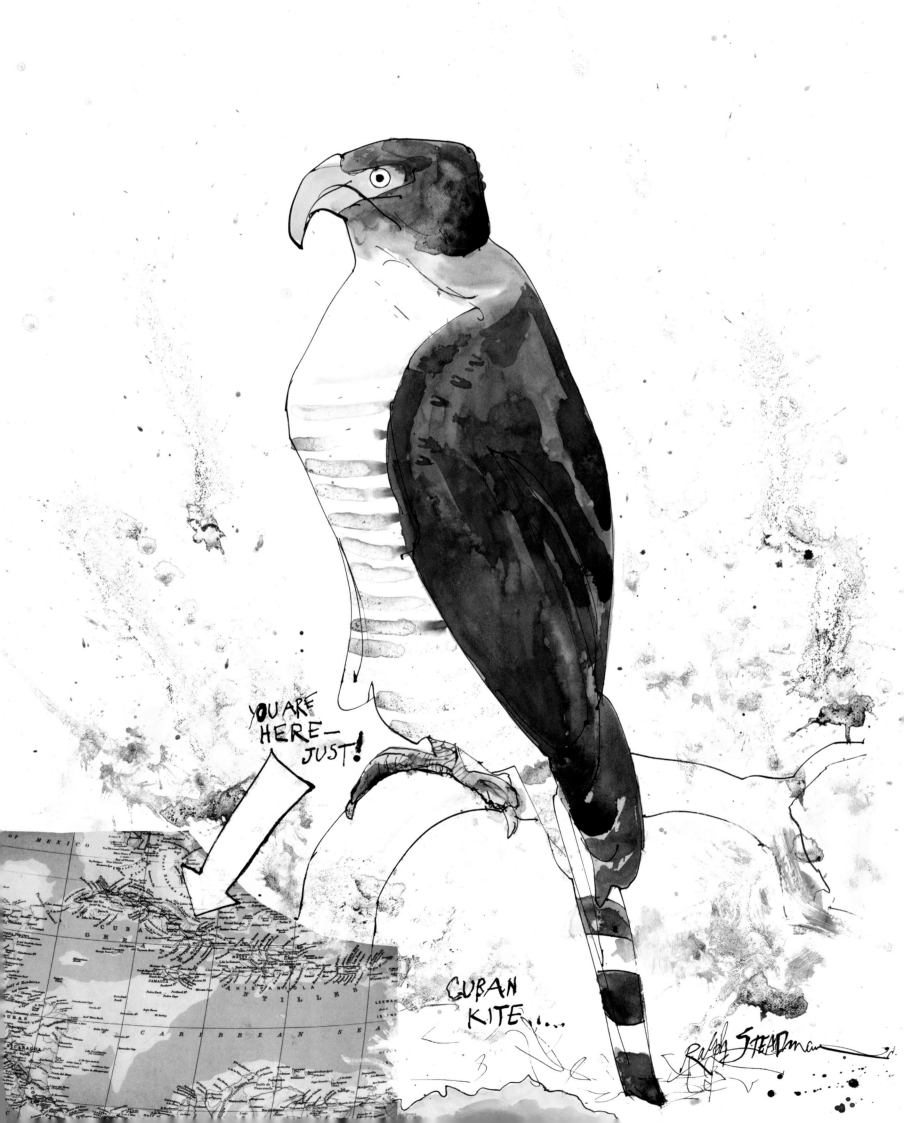

Phone:

Ceri: I love the owlet.

Ralph: He's the one with the mountain of guano.

Ceri: Yes, I remember we were messing around chatting about what could be in the picture and it just came out... as guano does!

Ralph: You know it can come out all at once or take hours and then suddenly Ta-wit... Ta W-OOOOHH!

Ceri: A bit like drawing then.

Ralph: He's got a nice look upon his face. He's as accurate as I can make him. I don't draw with accuracy, if you know what I mean, but at the same time I do. It's expressiveness, put it like that.

Ceri: You capture an essence...

Ralph: Did you say Captain Essence? His boat and crew saved many birds from the clutches of Kevinio Rodrigues and extinction. They even created a land for the nextinct on the dark side of Toadstool Island as there was not mush room elsewhere.

Ceri: I heard Spurnley Boggins was part of his venerable crew, who rowed away one day and discovered what became known as Boggins Flats Wetlands.

Ralph: It was Spurnley's father, Stumley Boggins, and his partner Deadly Derek, the dashing dude, who discovered the wetlands. Spurnley was just a twinkle in Stumley's binoculars back then! Anyway, they told Captain Essence of the land that they had found and suggested it would make a perfect breeding ground for the nextinct, and so it proved to be, and since then the Boggins Flats Wetlands have produced many a fledged critical critter. Legend has it that in times of trouble, the fearsome Ooshut Doorbang will awake from his thousand-year slumber and save the nextinct. Which by my reckoning should be next Thursday, give or take a day or two.

Ceri: The Ooshut Doorbang? The bird god of the nextinct?

Ralph: Yes! Him! And I want to immortalise the immortal at some point in the near future. I just need you to arrange it with the ooshut's PA, the Orange-beaked Spotted Bald Emulsion Cootflake. It would be good to document his waking.

Ceri: I will arrange it. This sounds like an important story.

Ralph: So make sure you write it down, I rely on you to write it all down. That's why you're here.

Ceri: Aye aye, Cap'n Essence. All writ down. All saved for posteriority.

Ralph: Captain Essence and his Merry... Parakeeteers. That's it!

Ceri: What a gonzovation group. I would support them to the ends of the earth.

Ralph: I think so.

Ceri: I do think this is my favourite picture so far.

Ralph: You said that about the other one! The penguins...

Ceri: I know! I keep changing my mind and opinions with each new one that comes through. Is that a crime?

Ralph: Possibly.

Forest Owlet

Heteroglaux blewitti

The Forest Owlet is endemic to central India and in 1997 was rediscovered for the first time since the 19th century. This is quite a common story for birds with small populations. People forget about their existence, stop looking for them and then one day these forgotten birds are miraculously rediscovered by a keen birder, even though the bird has been there the whole time. But this doesn't mean it is any the less threatened. This owlet has a small population, which is probably under threat from removal of its forest habitat. Predation from raptors, a lack of suitable tree-cavity housing and the use of body parts and eggs in local customs also affect the bird's existence. In some ways it would have been better if this species had remained hidden away from it all and never been rediscovered at all, considering the world it finds itself within. Education and awareness programmes for local people are underway and conservation plans for its habitat are ongoing.

Ceri's Diary: I love this owlet with his slightly demented and crazed face. Mind you, if I had produced that much guano I would be a bit nonplussed too. Perhaps this is why he has a slightly bemused look upon his face, as he can't quite believe what he has done and is perhaps working out what to do when it reaches all the way up to where he is sitting. Guano was once an oft-collected commodity and used as fuel. I have heard it said that the best and most effective guano for usage is seabird guano. But if ever there were an award for an amount of this substance produced by only one bird then it would surely have to go to this particular Forest Owlet caught by Ralph in between toileting.

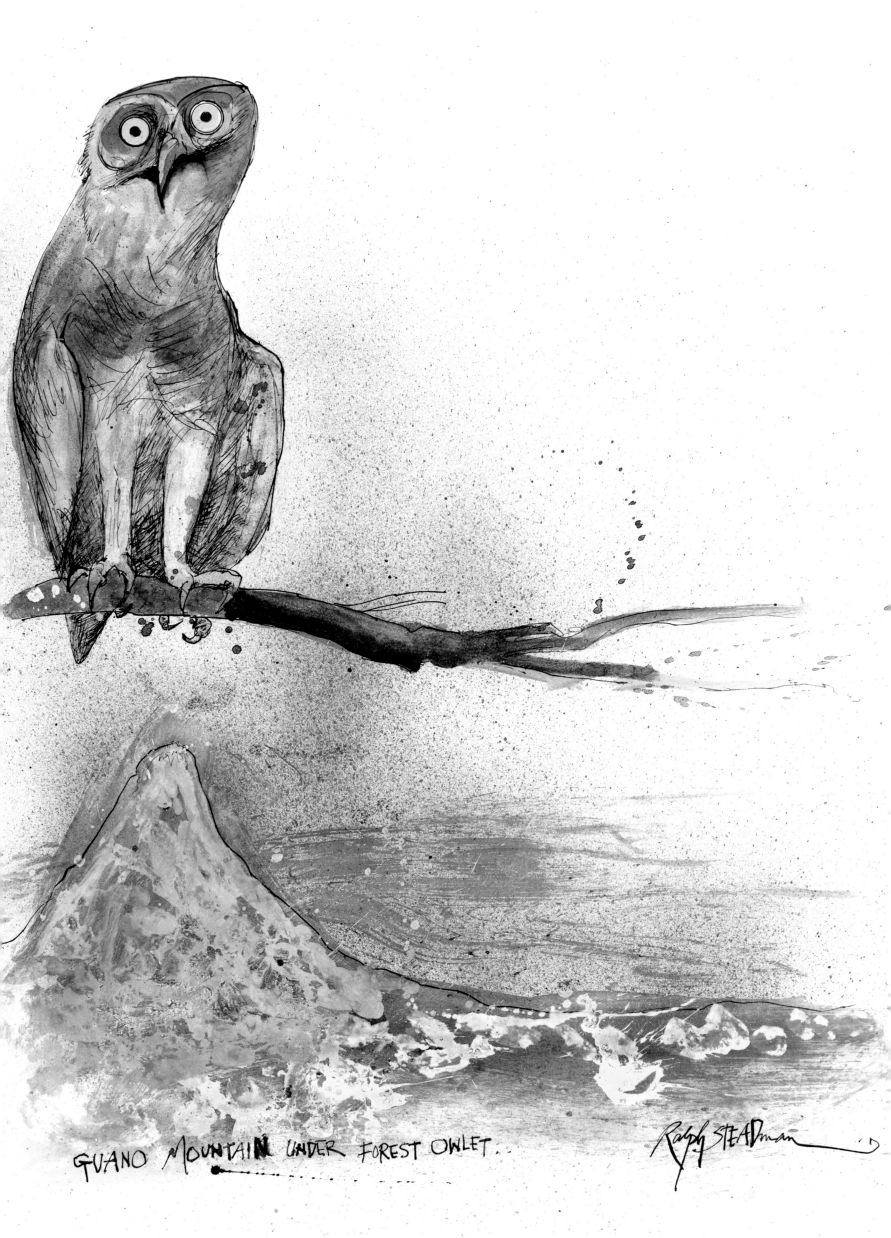

GUANO MOUNTAIN UNDER FOREST OWLET.

Ralph STEADman

Grey-breasted Parakeet

Pyrrhura griseipectus

Ralph has managed to depict these two parakeets as the grumpiest members of their tribe, and when one sees what has been happening to their kind is it any wonder? Could these parakeets end up joining Captain Essence and his Merry Parakeeteers? Unlikely. But maybe they could hook up with the grumpy version. That would be more suitable. Captain Essence and his Grumpy Parakeeteers. They are a shoe-in for that crew.

The Grey-breasted Parakeet hails from north-east Brazil and as its small population is on the decline it is classified as Critically Endangered. Although it was once known in four locations this has now been cut down to two and its numbers continually dwindle. Habitat loss is one reason for its disappearance, especially because of the conversion of land to coffee plantations, but the main concern is trapping for the caged-bird trade. Searches are underway to find lost groups of the parakeet and a previously unknown colony of five individuals was discovered nesting on top of a mountain ridge in August 2014. Finds like this make the searching all the more worthwhile. The bird is very successful in captive breeding and ultimately when the time is right could be reintroduced into the wild. Meanwhile, local awareness campaigns are continuing, as well as exploring the potential for ecotourism.

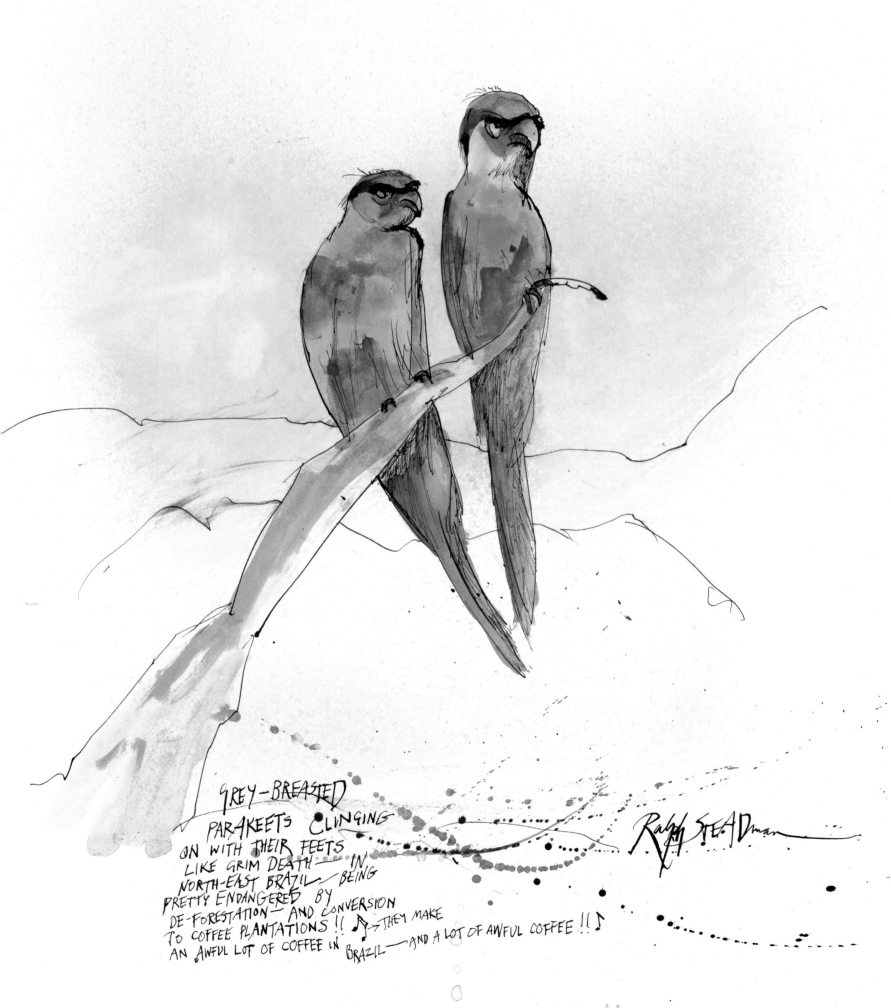

GREY-BREASTED
PARAKEETS CLINGING
ON WITH THEIR FEETS
LIKE GRIM DEATH — IN
NORTH-EAST BRAZIL — BEING
PRETTY ENDANGERED BY
DE-FORESTATION — AND CONVERSION
TO COFFEE PLANTATIONS !! ♪ →THEY MAKE
AN AWFUL LOT OF COFFEE IN BRAZIL —AND A LOT OF AWFUL COFFEE !! ♪

Ralph STEADman

Ralph emails:
I keep finding strange flying creatures wot need to be preserved…

Tried to Skype you but nothing works – and not my bloody printer either!!!

Here is a Tree Insect!!! He is a pet of mine – and I will not have you make light of WALLY!! He is HEAVY!!! Grace is here at the moment and I am trying to do a job for BREAKING BAD – a series that seems to be popular – so I am about that business as I write…

Guano looks GOOD!! Thinks WALLY.

Ceri replies:
The insane in Spain email mainly to the sane but again I wane from Skyping you again! But maybe in an hour or so!!

Ralph emails:
Guano, Yum!! Says the Tree Insect… A perfect condiment to his main course… SKYPE ON FULL BLASTARO!!!

PHLAR Namdeats

Ceri replies:
Will give you a shout shortly!!

Ralph emails:
DON'T call me 'shortly'!!! Captain Essence to you… and don't SHOUT!!! What we have to ascertain is the penendular cellularity of the disparate surfaces within a known/unknown circumference. Is that clear!?? Chief Putty Officer LOVEY!???

ATTENSHUN!!!

CAP'n!

Ceri replies:
I am trying to ascertain that very thing at the moment but someone's bent me abacus! All presently incorrect sah!!

Ralph emails:
Nothing works on my electronic conectimat!!

Hold on I am the Skype type!!! My Skype just came alive again…

RAF – Lower Aircraftsman

Green-beaked Red Spotto

Unguis transverso

This Green-beaked Red Spotto is the only known bird masseuse in the whole of Nextinction. Here we can see the Spotto go to work on the body of one Kevinio Rodrigues. The hypocrisy of Kevinio is quite remarkable. Considering he wants to nextinct every single bird on the island it is extraordinary that he sees this bird in a different light and is willing to use its services. Perhaps if he looked at all birds differently then this hunter could become a friend, but this is unlikely. All the other island inhabitants consider the pain caused by the Spotto's Talonic Massage too unbearable, but somehow Kevinio manages to withstand it, although it does look as though this session is drawing blood. He does seem to so enjoy the pain.

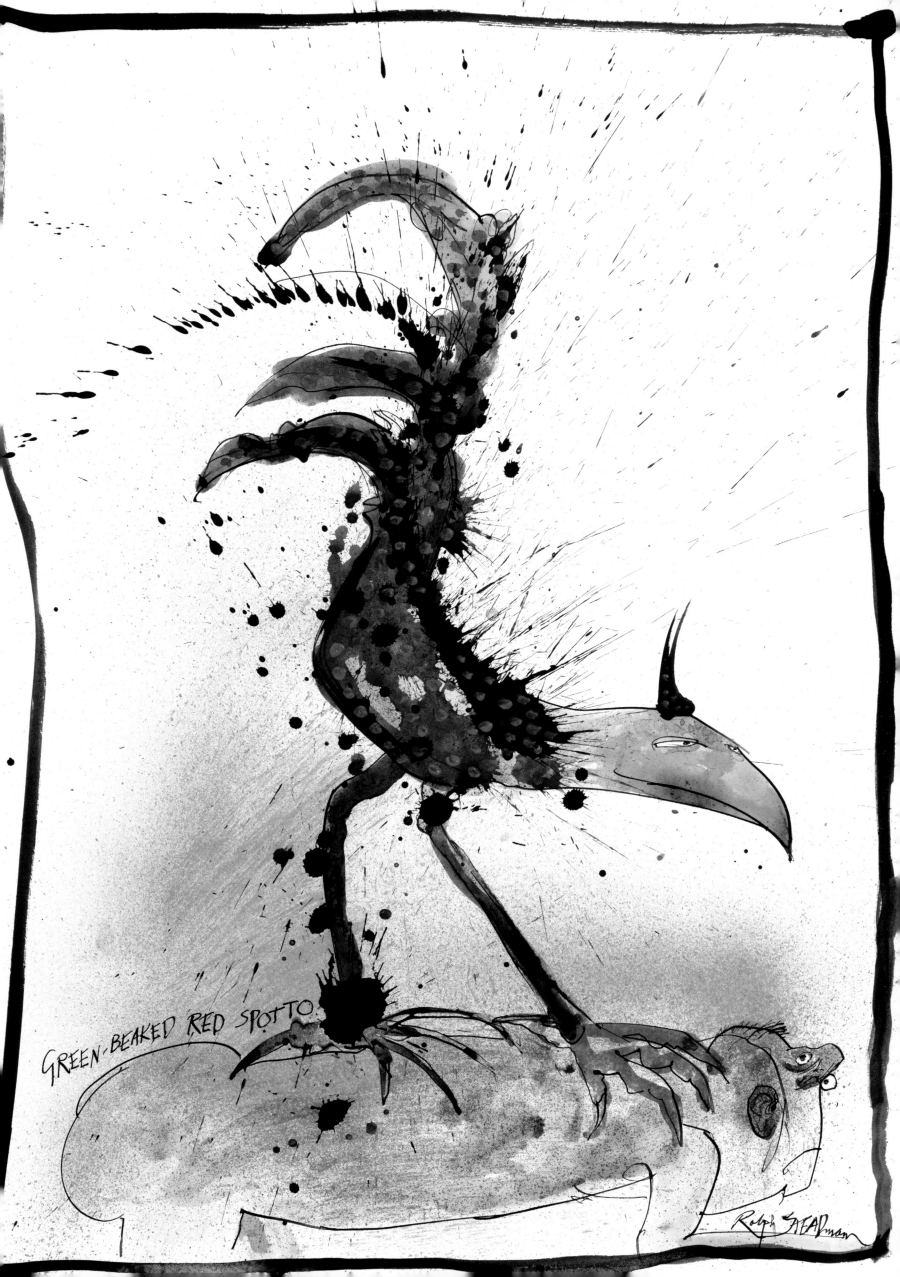

GREEN-BEAKED RED SPOTTO

Ralph STEADman

Fractured Dawn

Ceri's Diary: The Turtle Dove is not on the Critically Endangered list for one reason or another, and is in fact listed as a bird of Least Concern. But it is *the* bird that many in the conservation world fear is heading the way of the Passenger Pigeon, which due to hunting and habitat loss became extinct in the early 1900s.

Since the 1970s the Turtle Dove's population has decreased by 93%. The world seems oblivious to the bird's decline and soon it may be too late. Put it like this: I may have come to birdwatching late in life but I have yet to see one in England, which is incredible considering that this was a hugely familiar farmland bird not too many years ago. But now, try as I might I cannot catch up with one. The story is growing all over Europe and action needs to be taken right now.

On my travels to Malta to support BirdLife Malta's campaign to stop the illegal hunting of migratory species I came face to face with a strange situation. There it is legal to hunt Turtle Doves and Quail, another threatened species, as long as the hunter complies with a self-reported bag quota of four birds per hunting season. Their killings are meant to be texted in, death by text. Having witnessed a large amount of illegal slaughter over there, I find it unlikely that every hunter will comply with this rule. The EU has left Malta to continue on its merry way as it allows hunters to blast birds from the sky. BirdLife Malta does everything it can to highlight the situation on this 23km hunter-laden island, but Malta continually needs our support and help to change the pattern of hunting. This is an extract from my diary written during my last visit there:

It is first light and I am standing with the team on a ridge overlooking a valley littered with hunters. We are watching out for illegal hunting activity and the early-morning chill adds to the eerie and deadly feel of the oncoming spring morning. It is beginning to heat up and so far we have counted 763 shots since daybreak, all of which are intended to kill a bird. This is a normal morning in the Maltese spring, as is the accompanying sound of illegal quail lures, electronic devices which continuously loop the sound of quail calls, drawing in real birds for their imminent death. I find it extraordinary that the Maltese government allows quail and turtle doves to be shot legally, without a real concern for their conservation status. Hunters seem to hold political power here.

This island used to be teeming with turtle doves and even the hunters have complained at the lack of them on their shores. Guess what, Mr Hunter? Habitat change and the hunting of them, especially during the spring as the turtle doves migrate to their breeding grounds, have contributed to this void of them. I find myself in the situation of almost willing these birds not to appear, as apparently they will be fair game. Nothing prepares one for watching a bird being blown out of the sky.

Meanwhile, four hunters below us are in one small field, each with his own quarter to hunt from. One of the hunters is walking through his share of the field with his dog, hoping to flush a quail, which he succeeds in doing. A quail pops up and is blasted out of existence. I know it's legal but it just seems so unfair. These hunters cheat, especially when they use electronic lures to entice the birds towards them.

Then to the left of me a rapid volley of gunfire crackles through the sky. Shot after shot. I turn to see what they are aiming at. It's a pair of turtle doves flying through their very own death valley. They flick their wings and pass through the cacophony of shot as it flies towards them. The birds manage to dodge the bullets as we watch over their plight, helpless to defend them. They are flying upwards and towards us and they land four feet from us in a tree. They seem to be panting, or perhaps that's me humanising the situation, and I wonder if they know what they have just flown through. Are these creatures aware of what happens around them whenever they fly in Malta or other lands where it is considered acceptable to shoot these birds? Are they sentient to the facts? I don't know but as I look at them they certainly don't appear to be particularly happy. They seem agitated. They stay with us for five minutes or so, catching their breath, and then they fly off down the other side of the valley. The shots begin again and we lose sight of them. Hopefully this time they got away and will get to where they need to be to reproduce and continue their lineage. But for the moment and the foreseeable future the outlook is bleak. It's just another day in Malta.

On the second day of Xmas my true love gave to me, two Turtle Doves… Why did she give out these particular birds? Because they have long been the symbol for devotion, a representation of a long and lasting love. It's about time we showed some devotion back to the Turtle Dove and helped it survive in its hour of need, or it is going to become a symbol of nextinction and no longer one of devotion.

The IUCN list states that the Turtle Dove's status is one of Least Concern. But everything is pointing towards a change in status in the very near future. For me it is already a bird that we should be concerned about. Have we learnt nothing from the demise of the Passenger Pigeon? History must not be allowed to repeat itself.

The European Birds Directive is often ignored and makes one wonder about its use, especially during the spring migration. How can its rules be enforced properly? How can particular governments be made to suffer the consequences of choosing not to implement the Directive? These are questions that we need the answers to before it's too late. Why does our birdlife seem so utterly unimportant to so many?

FRACTURED
DAWN — and TURTLE LOOKING FOR DOVES!

Ralph STEADman

Turtle Dove

Streptopelia turtur

This once familiar farmland bird is in decline in Europe, with its numbers falling by a staggering 60% or more since the 1970s. In the UK, where it is a regular breeder, the population has declined by 93% in this time. Yet it still hasn't made it into the list of nextinct birds – but unhappily it will, sooner rather than later. I hope it is not too late for the species when it finally does. Habitat loss and unsustainable hunting across Europe, especially in various hotspots across the Mediterranean, are eating away at the population. Criteria for being placed on the Endangered list need to be met and for the moment the Turtle Dove is heading unhappily towards this end.

It is also important to realise that we can take action for birds before they make the nextinct roll call and we shouldn't wait to take action when it is all too obvious there is a problem. Projects like Operation Turtle Dove (www.operationturtledove.org) are making progress in raising the issue and making more people aware of what is going on. There are too many similarities between this bird and the Passenger Pigeon. Surely we can't make the same mistake again… can we?

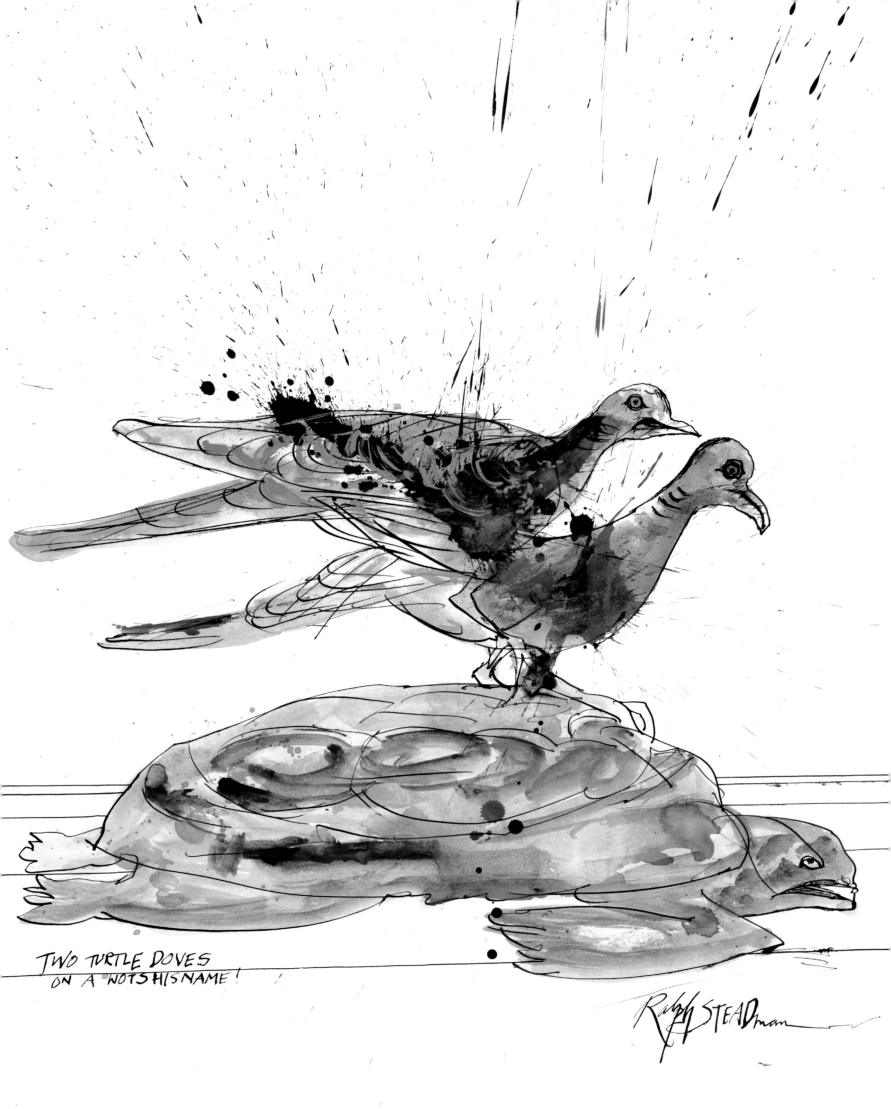

TWO TURTLE DOVES
ON A WOTSHISNAME!

Ralph STEADman

Thought this local story would lift your spirits! They have stopped a huge Medway Building Project in Chattenden, here in Kent, because they have discovered a colony of 84 Nightingales breeding on the site!!

Ceri's Diary: This story of a breeding watch of Nightingales at first filled me with delight with nature seemingly winning out over 'progress', which usually implies development of land, often to the detriment of wildlife. Progress often looks like regress. This is a £1 billion venture to build 5,000 homes, shops and offices on an old Ministry of Defence site at Lodge Hill in Chattenden and I worry that money will have its way in the end. It could destroy approximately 144 hectares of prime habitat on this environmentally important Medway land, which is becoming overrun by new builds. This could set back environmental protection for years in the UK as it sets up unwanted precedents for destroying important wildlife sites.

The UK government has come up with a scheme called 'offsetting', which allows developers to build houses on important wildlife habitats if they create an alternative habitat elsewhere for the displaced creatures. In this case the developers have come up with a site in Essex. Quite how Nightingales travelling back from Africa to their usual breeding site at Lodge Hill will determine that they are now meant to move to Essex is beyond me. There is no certain outcome with this 'offsetting' and there is a deep concern that important wildlife sites and habitats may end up being destroyed forever. The Environment Minister in the UK is worried that environmental issues cause too many housing developments to be halted as solutions are explored. Surely an Environment Minister should be concerned about getting things right for the environment first and foremost and not about the rate of new housing.

November 2013. Natural England has just confirmed the site as an SSSI (a Site of Special Scientific Interest). The neighbouring Chattenden Woods are also included, which means someone is watching over this watch of Nightingales. Let's hope this is an end to the matter.

On exploring this story further, I have discovered that just because this is now a confirmed SSSI it does not mean the site is definitely protected from development. It means that the developers now have to find a way to compensate for the effect on the environment. This sounds like a loophole if ever I heard of one.

March 2014. Developers have now announced that they want to relocate the Nightingales to a 102-hectare site owned by the MOD, 20km away in Essex. How do you relocate birds? How do you make them stay there? This totally stinks and is a perfect example of how habitat change created by man is destroying the lives of many animals worldwide.

September 2014. The story and the intrigue continue as against all the scientific evidence and appeals to protect this area for the uniqueness of its wildlife, Medway Council has seen fit to finally approve the development of the land. It seems that 'progress' will have its way.

Natural England, the RSPB and the Kent Wildlife Trust wish the matter to be addressed by the Secretary of State for Communities and Local Government in the hope that he will

Nightingale
Luscinia megarhynchos

The beauty of a Nightingale's song is not reflected in its appearance. This is the ultimate LBJ (little brown job) of a bird. Nondescript, but boy when it opens its beak those notes float out in a beautiful liquid aural delight. It is the sound of summer and reminds me of standing in front of hedges in Norfolk listening to the performance of these skulking and hard-to-see birds. To the passing driver I must have looked ridiculous with my ear cocked as I drifted off into a Nightingale reverie by the side of the higgledy-piggledy country roads.

Ralph gives great beauty to such an understated bird. He catches it in full song, but perhaps the pressure over its future is causing a little stage fright as, unusually, it slips a bum note into proceedings, even though the artist suggests this is because it's happy. I'm not so sure.

The Nightingale is now in a somewhat parlous state and numbers are in decline. The BTO has revealed through a study of Nightingales that numbers of the bird have declined by an unbelievable 53% between 1995 and 2008, which is enough to suggest that it will soon end up on the Red List of endangered bird species. There is much work still to do to understand exactly why this decline is continuing apace. Habitat change is one of the main reasons, as is constant grazing by the introduced Muntjac Deer, which has left a dearth of nesting habitat for this little crooner. But the reality is that we need to find a way to maintain the right kind of habitat for the bird. This is crucial to its continued survival. If we don't find the answers then there will never be a chance of a Nightingale ever singing in Berkeley Square.

hold a public enquiry on the matter. In his wisdom, he has passed the matter on to the Minister of State for Housing, from whom not a dickie bird has been heard. I have left the names of the politicians out of this tale, as there will, in all likelihood, be different people in power by the time this book is released. Such power over our natural world is so easily passed on to someone else in politics. The story waits for its conclusion.

Our challenge is to live in harmony alongside the other millions of species with which we share this beautiful planet. Our carelessness, indifference and greed have driven many species to the brink of extinction. Yet, with wit, creativity and determination we have what it takes to save nature.

This is the greatest challenge we face in the 21st century.

Martin Harper, Conservation Director, RSPB.

EXTRA! EXTRA!!
NIGHTINGALE
SINGS
BUM NOTE!!!
'COS IT'S
HAPPY!!!

a bum note!

Ralph STEADman

Ou

Psittirostra psittacea

As mentioned above, we have seen this bird before, but no matter. No harm done and Ralph tells me that there are only 50 remaining. The truth is that it would be a miracle if there were that many still in existence as it has not been genuinely seen since the 1980s.

Ua Pou Monarch

Pomarea mira

This French Polynesian bird hails from the Marquesas Islands and has not been seen since 1985. A traditional forest-dweller, it is uncertain where the bird may be these days if it is still in existence. Much of its known habitat has been destroyed due to overgrazing and fires, and it has also suffered predation by introduced mammals, in particular rats of the blackest kind. These are all factors in its disappearance. An extensive survey in 2013 failed to locate the monarch and it looks ever more likely that it has become extinct.

Fatuhiva Monarch

Pomarea whitneyi

The Fatuhiva Monarch, a large flycatcher, is another resident of the Marquesas and is endemic to the island of Fatu Hiva. Historically, this has been a safe haven and the species was considered secure up until 2000 when Black Rats were spied for the first time. Since then the downfall of this monarch has been dramatic and the population has dwindled to 33 mature individuals. Feral cats are also thought to be a major threat, as well as bush fires in the dry season, agriculture and loss of forest habitat, which are all starting to take their toll. Rat and cat controls are underway wherever possible and an innovative way of distributing bait in inaccessible areas has been devised by using catapults. Translocation of the species and a captive-breeding programme are being considered to create a new dynasty for the monarch.

White-throated Flowerpecker

Dicaeum vincens

The White-throated Flowerpecker is endemic to Sri Lanka and its status is Near Threatened. I think Ralph just liked the delicate colourings of this bird and decided to paint it even though it is not on the critical list. The bird's population is probably in decline due to habitat loss through agriculture, mining, logging and firewood collection. It is a protected species and plans are in place to make a survey of the bird's population and habitat and to ascertain its condition.

Loose-crested Aaooha-ho-ha

Inventus steadmanii

It is 'wind gag time' again. Anyone would think Ralph has a fart-gag addiction. This odd-looking creation comes from the small village of Pooleenesia, which sits on a windy promontory on the dark side of Toadstool Island. But there is, at least, a genuine use for his wind. His eruptions are so noxious that they keep all sea-faring hunters away from the nextinct that live here. His neighbours have learned to deal with his protective stench.

But the question remains, can birds smell things? This divides opinion. Some say yes and some say no. Sight and hearing are important to birds, but what of these other senses? Recent studies have suggested that birds do have a good sense of smell, which is as important to them as any other sense. Some birds may indeed use it for navigation or in search of food or for identifying individuals. I always wonder how birds in flocks of thousands wander around and find their partner. Is it their sense of smell? I don't know for sure, and the research continues. One thing is certain: no matter what the state of your sense of smell, no one can mistake the aroma of a Loose-crested Aaooha-ho-ha.

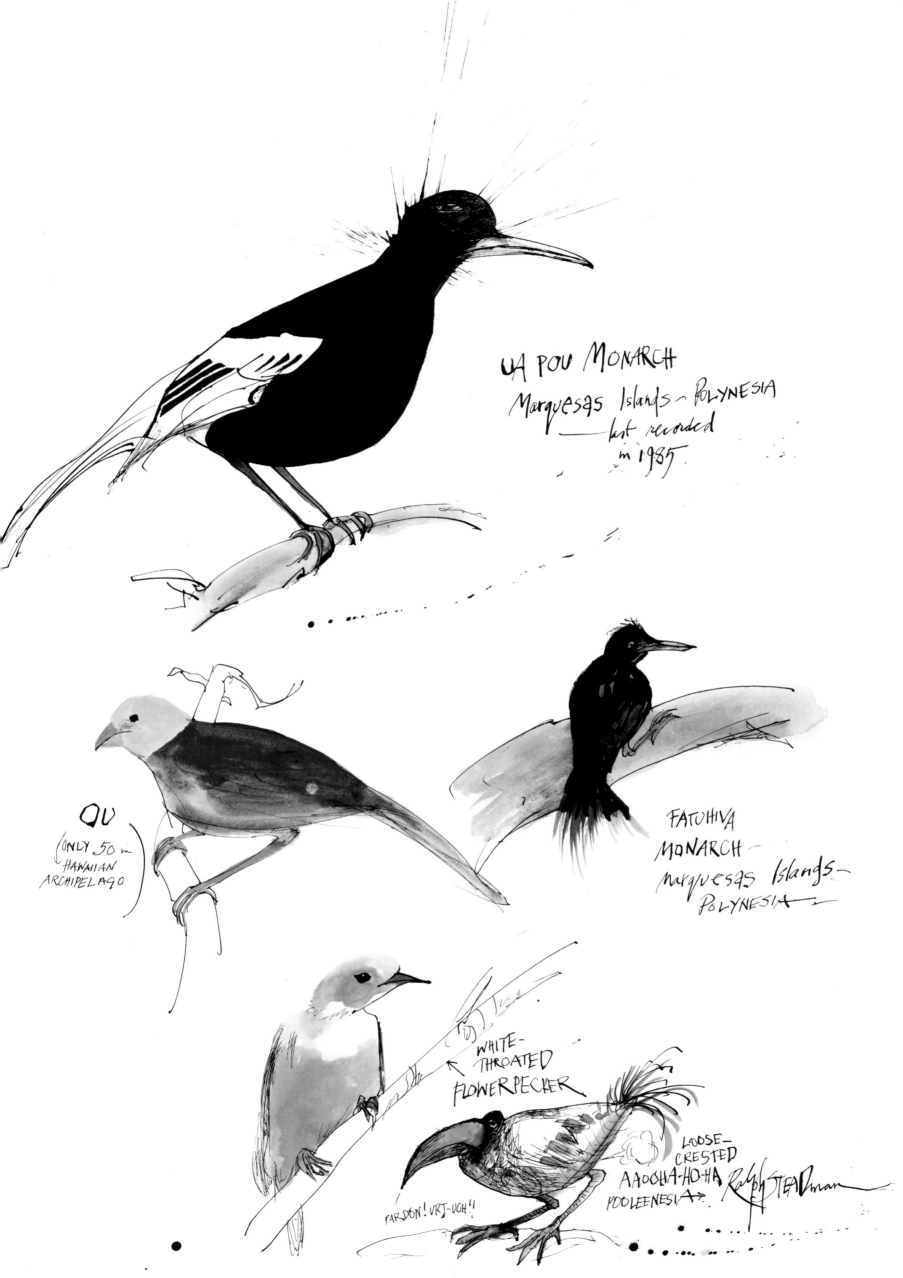

UA POU MONARCH
Marquesas Islands ~ POLYNESIA
last recorded in 1985.

OU
(ONLY 50 in
HAWAIIAN
ARCHIPELAGO)

FATUHIVA
MONARCH ~
marquesas Islands ~
POLYNESIA

WHITE-
THROATED
FLOWERPECKER

LOOSE-
CRESTED
AAOOHA-HO-HA
POOLEENESIA

PARDON! URJ-UGH!!

Ralph STEADman

Phone:

Ceri: I think it would be good to look at the Black Stilt, as there are only 29 of them left in the world. It is critically critical, if you can have such a thing.

Ralph: So he's on his bike if we're not careful. A Black Shrike on a bike…

Ceri: It's not a Black Shrike; it's a Black Stilt, whose numbers wilt.

Ralph: Oh right! Black Stilt… Black Stilt… Black Stilt… Not Black Shrike… on a bike.

Ceri: Exactly.

Ceri's Diary: And then he went and drew a Black Stilt on a bike but due to rhyming difficulties he went ahead and used the line 'Black Shrike on a bike' anyway. It could have read, 'A shrike made this bike, it was built for a Black Stilt.'

Black Stilt

Himantopus novaezelandiae

A native of New Zealand, this is just about the most endangered shorebird in the world with only 29 mature individuals in the wild. A successful captive-breeding programme has been introducing new birds into the wild and this is protecting the species from becoming extinct, but it's a long road that conservationists and the bird are travelling, one which has been continuing for the last 20 years or so. Slowly but surely progress is being made and the control of predation by mammals, harriers and gulls has also aided the situation. The hope is to create a self-sustaining population on a predator-free island and perhaps then we'll see Black Stilts riding around everywhere on their bikes and never mind the shrikes!

I keep asking myself why birds are measured by the number of mature individuals and not just the total number of birds that exist? After giving this much thought and doing a little bit of research on the matter I think it is because mature individuals are capable of breeding, and that is what counts in a species. They have the ability to create more birds and it is as simple as that.

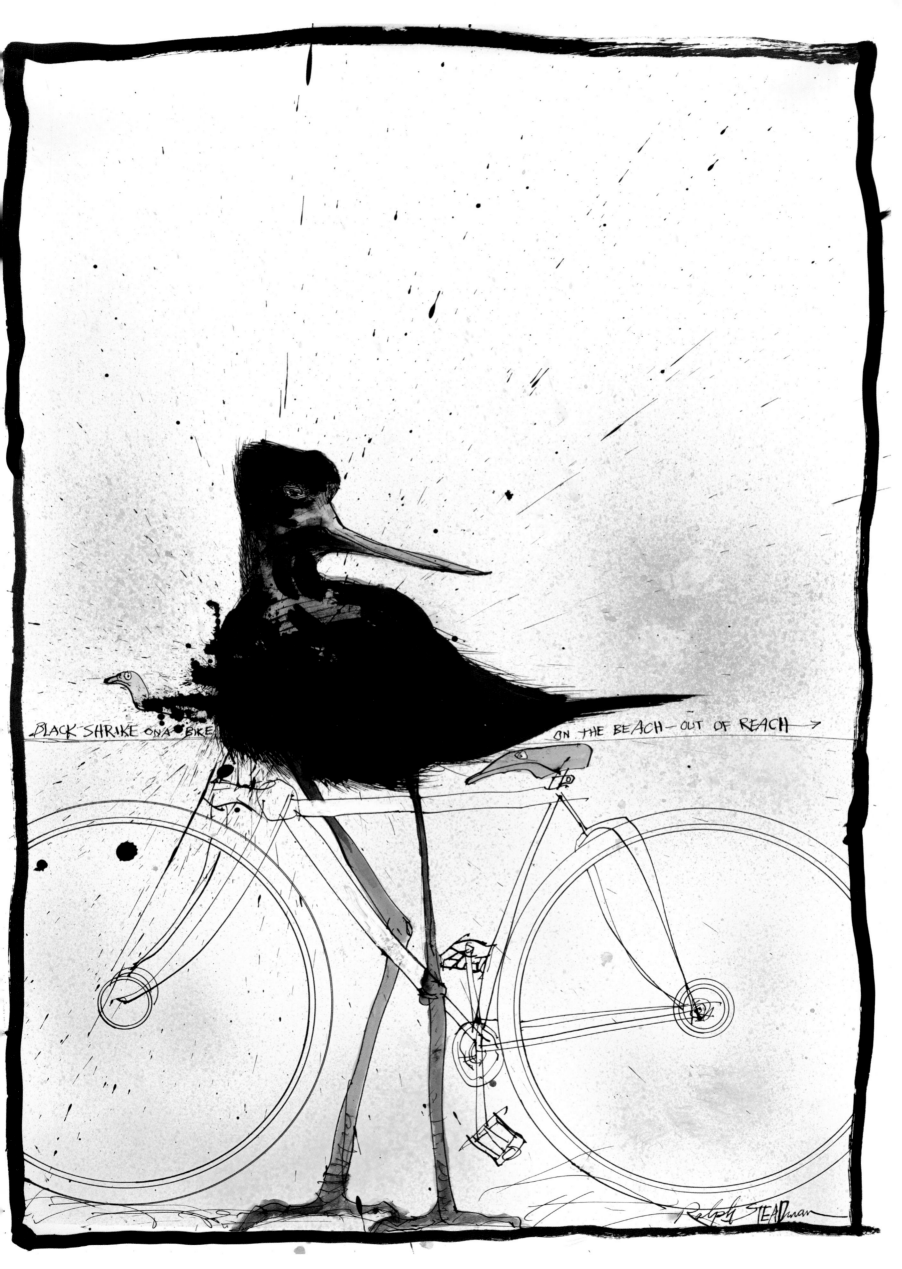

BLACK SHRIKE ON A BIKE

ON THE BEACH - OUT OF REACH →

Ralph STEADman

Ceri's Diary: I find this picture a little bit sad as it seems to sum up the plight of so many of our birds. I imagine the Sapphire-bellied Hummingbird being surrounded by exotic South American plants amid the mangroves and forests of its world. But here we are with this tiny bird sat on one solitary branch. Could this symbolise the end of its natural world? Have its once-colourful surroundings disappeared just to become a blankness that is slowly enveloping everything? I look at the bird creeping in from the bottom of the page and he has no colour either. Is this the effect of ongoing nextinction? Is this the ghost of the same bird? I can't abide the thought of a monochromatic world where the last vestiges of bird colour are being drained by our constant need for progress in the name of humanity. Time we did something in the name of wildlife instead.

If you have ever seen a hummingbird it is hard to let go of the image of its beauty and agility, and the feeling of sheer wonderment at its ability to hover with that motion blur of wing movement enabling it to perform its magic and suspend itself in mid-air. And Ralph's splats have created a moment of drama, as the red splat appears to be right over the hummingbird's heart.

Sapphire-bellied Hummingbird

Lepidopyga lilliae

This Colombian hummingbird is another bird whose population decline is linked to the decline of its habitat. Loss of its preferred haunt of mangroves and forests, as well as pollution, urbanisation and the sale of land to create a port, are all factors in the bird's shrinking future. It is hoped that habitat restoration is possible as well as increasing the amount of protected area for the species.

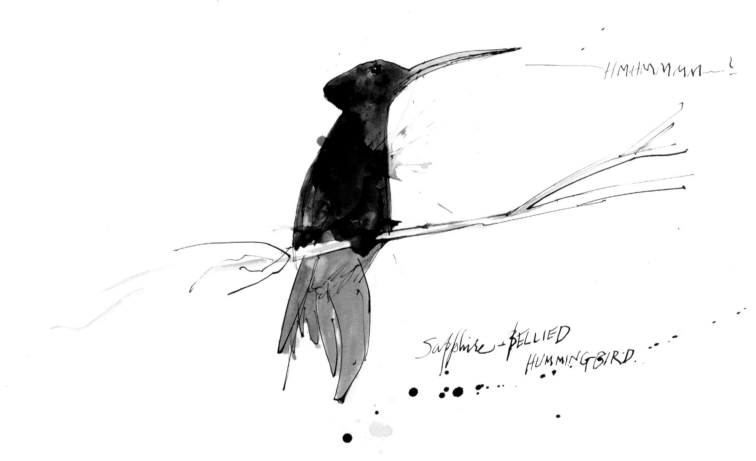

HMHMMMM

Sapphire - BELLIED
HUMMINGBIRD.

Black-breasted Puffleg

Eriocnemis nigrivestis

The Black-breasted Puffleg is endemic to Ecuador and lives on or near the Pichincha Volcano. It is believed to have been far more widespread than it is now, but habitat destruction caused by deforestation for timber and charcoal as well as the conversion of land for agriculture and cattle grazing have all affected the bird. Numbers are between 140 and 180 mature individuals and are declining rapidly.

In 2005, it became the emblem bird for the nearby city of Quito. Since then, the Jocotoco Foundation has bought land to create a reserve for the species, and Bird Holidays, a birdwatching tour company, has bought 26 hectares of land next to this reserve as part of a carbon-offsetting scheme to reforest the area with native cloud forest. Neighbouring reserves also offer protection for the bird and the future is starting to gleam a little for this particular puffleg.

Turquoise-throated Puffleg

Eriocnemis godini

There were searches for this bird in 1980, which proved fruitless. Its habitat was believed to be in Ecuador and possibly Colombia but it has not been recorded since the 19th century. There are hopes for future searches to locate it, but for the moment this bird is considered as Critically Endangered and probably extinct.

Colourful Puffleg

Eriocnemis mirabilis

This bird is confined to an area of the slopes of the Andes in south-west Colombia. It was first recorded in 1967. Habitat destruction and fragmentation as well as logging and the clearance of trees for coca growing all contribute to the threats facing the bird. The lulo fruit was grown here under the forest canopy, and this deterred logging, but in the 1980s disease set in, the lulo trade was lost and the logging restarted. It is hoped that the replanting of lulo fruits will prove a success and will steer people back to a different trade. Awareness programmes also hope to engage them with the conservation story of saving the Colourful Puffleg.

Dusky Starfrontlet / Glittering Starfrontlet

Coeligena orina

What a name this endemic Colombian bird has! It exists in two locations on the West Andes at Páramo de Frontino and Farallones del Citará, the former being an area rich in gold, zinc and copper. Mining companies are interested in this, but political instability has prevented mining from becoming an ongoing reality… yet. In 2005 Fundación ProAves set up the Dusky Starfrontlet Bird Reserve and there are plans to extend Las Orquídeas National Park to include Páramo de Frontino. This will need serious law enforcement as the land is poorly protected. But again, there is hope.

Gorgeted Puffleg

Eriocnemis isabellae

This puffleg was only described in 2007 and exists in a tiny area of the Serranía del Pinche in south-west Colombia. It is believed that its natural habitat of elfin forest covers less than 10 square kilometres and is under threat as it is being altered for agriculture and coca plantations. An ongoing conservation plan involving local authorities, communities and conservationists is underway and will hopefully secure the bird's future.

BLACK-BREASTED PUFFLEG.

TURQUOISE-THROATED PUFFLEG

COLOURFUL PUFFLEG

DUSKY STARFRONTLET

GORGETED PUFFLEG

PUFFED OUT — A STUDY...

Ralph STEADman

Piping Plover

Charadrius melodus

This is a bird that is on the Near Threatened list, which is just below the levels of endangerment that we have mainly been dealing with. But as I now know, Ralph can't resist a bird that can hold a tune or in this case a note. It is in some ways a success story, as since 1991 its numbers, which had been in decline for the previous 40 years, took a turn for the better, due to good conservation management. It is found in the USA and Canada, along the Atlantic Coast, on the Great Plains and in the Great Lakes area.

Grand Comoro Drongo

Dicrurus fuscipennis

Endemic to Grand Comoro in the Comoros Islands, off the south-east coast of Africa, the Endangered Drongo has a population that is estimated to be about 70 strong. It lives on the slopes of Mount Karthala, an active volcano. Introduced predatory mammals, such as civets, mongooses and rats, coupled with habitat loss due to logging and agriculture have contributed to its problems. But for the moment the species appears to be stable. There are intentions to create a national park on its home territory and perhaps reforestation will occur, as well as working on creating locally organised ecotourism to provide alternative incomes for the inhabitants of Mount Karthala, thus protecting the bird further.

Cozumel Thrasher

Toxostoma guttatum

This Mexican species, as Ralph has pointed out, has had its numbers thrashed to fewer than 50. A hurricane in 1988 seemed to account for a lot of what was once considered to be a pretty common bird. Further depletions happened during additional hurricanes in 1995 and 2005. There have been few sightings since and exact numbers are uncertain. Boa Constrictors (introduced in 1971) and introduced cats are also thought to be a threat. Searches are ongoing to discover whether the bird is still extant and then further plans can be made to ensure the survival of what is left of the thrasher.

Antioquia Brush-finch

Atlapetes blancae

Unfortunately, this is another bird that may have left the playing field some time ago. It was described in 2007 from three specimens, two of which were undated and the third of which was taken in 1971 in Antioquia in the Central Andes of Colombia. Recent searches in 2007 and 2008 have not been able to find the bird, but hope has not yet been totally abandoned.

Starry Owlet-nightjar

Aegotheles tatei

Surely this is one of the most beautiful-sounding names for a bird ever created, and what a weirdly wonderful creature to look at as well. This bird is the first to be featured in this book that is considered Data Deficient, i.e. there is not enough information on its population or the threats to the species to determine whether it is indeed endangered or not. It is rumoured to be common along Papua New Guinea's border with Indonesia. Let's hope there are more birds than we can imagine existing in the starry night.

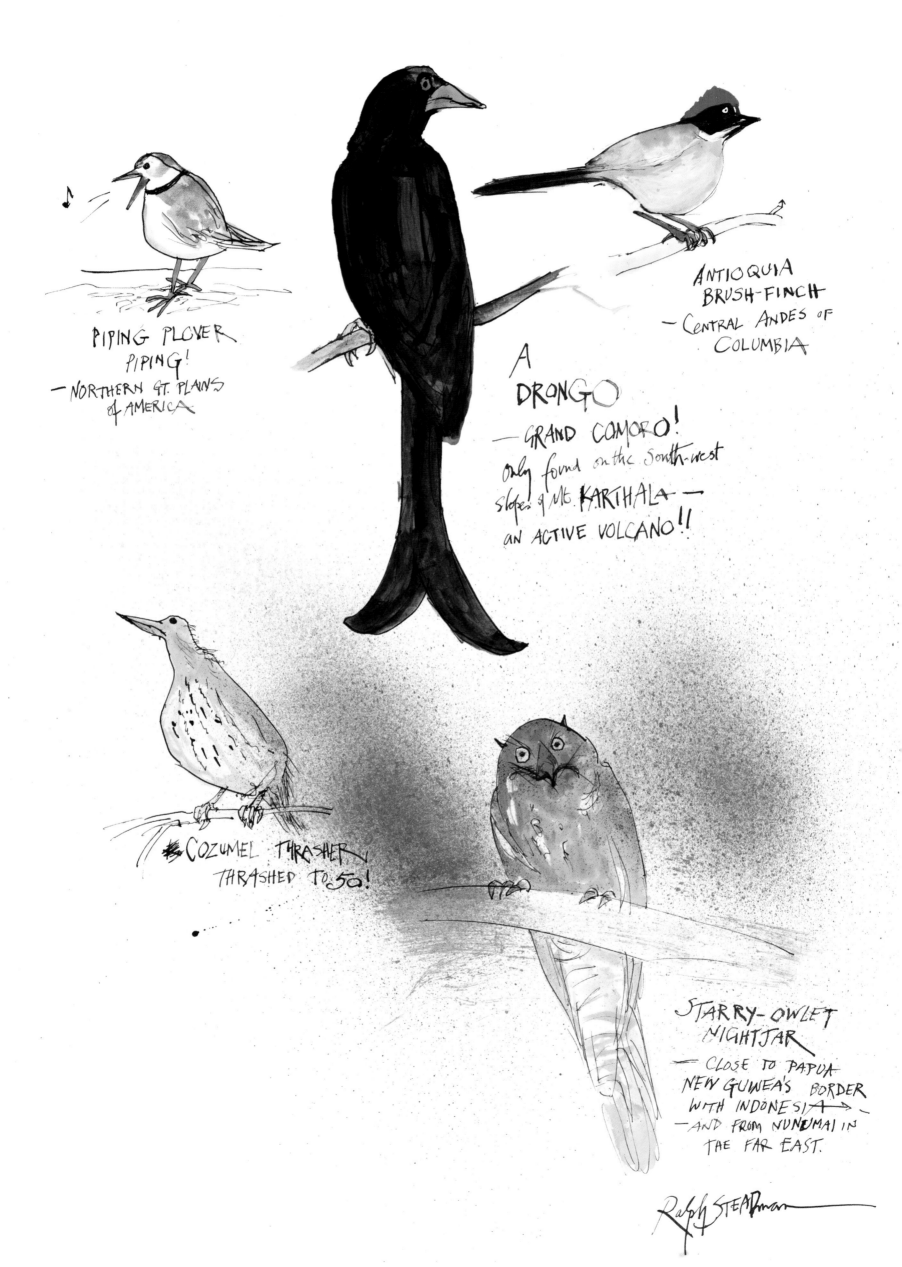

PIPING PLOVER
PIPING!
— NORTHERN GT. PLAINS
of AMERICA

A DRONGO
— GRAND COMORO!
Only found on the South-west
slopes of Mt. KARTHALA —
an ACTIVE VOLCANO!!

ANTIOQUIA
BRUSH-FINCH
— CENTRAL ANDES of
COLUMBIA

COZUMEL THRASHER
THRASHED TO 50!

STARRY-OWLET
NIGHTJAR
— CLOSE TO PAPUA
NEW GUINEA'S BORDER
WITH INDONESIA →
— AND FROM NUNUMAI IN
THE FAR EAST.

Ralph STEADman

Indigo-winged Parrot

Hapalopsittaca fuertesi

Previously only known from a specimen collected in 1911, the Indigo-winged Parrot was rediscovered in 2002 on the western slope of the Central Andes in Colombia. The bird is threatened by habitat loss because of logging and conversion for cattle pasture. Land is being protected for the species and education-awareness programmes are in place. Only time will tell if the parrot can keep on squawking in the cloud forest as it eats its way through the mistletoe berries it loves.

Brown-backed Parrotlet

Touit melanonotus

Even in the 19th century this bird was considered a rarity and it is known only in a few locations along the south-east coast of Brazil from Bahia to Paraná. Habitat loss has contributed to the Brown-backed Parrot's decline, with agriculture, mining and urbanisation amongst the main culprits for this. Protected areas for the birds exist and surveys continue to study its status.

Red-fronted Macaw

Ara rubrogenys

This macaw lives in south-central Bolivia and is threatened because of habitat degradation due to agriculture and various human activities. Pesticide poisoning may also play a part in its decline. Macaws are popular within the caged-bird trade and from 2004 to 2005 26 Red-fronted Macaws were recorded going through the Los Pozos pet market in Santa Cruz. There are four more similar markets there, so who knows the full extent of the birds being taken from the wild and then sold, and how many end up smuggled out of the country by one means or another is anyone's guess. Bolivian law prohibits the birds' capture and sale, but this is not being effectively enforced. Education programmes need to be initiated to halt trapping and nest poaching and some resolution needs to be found to stop the agricultural processes that are harming the macaws. Much work needs to be done to save this beautiful bird from the nextinct pile.

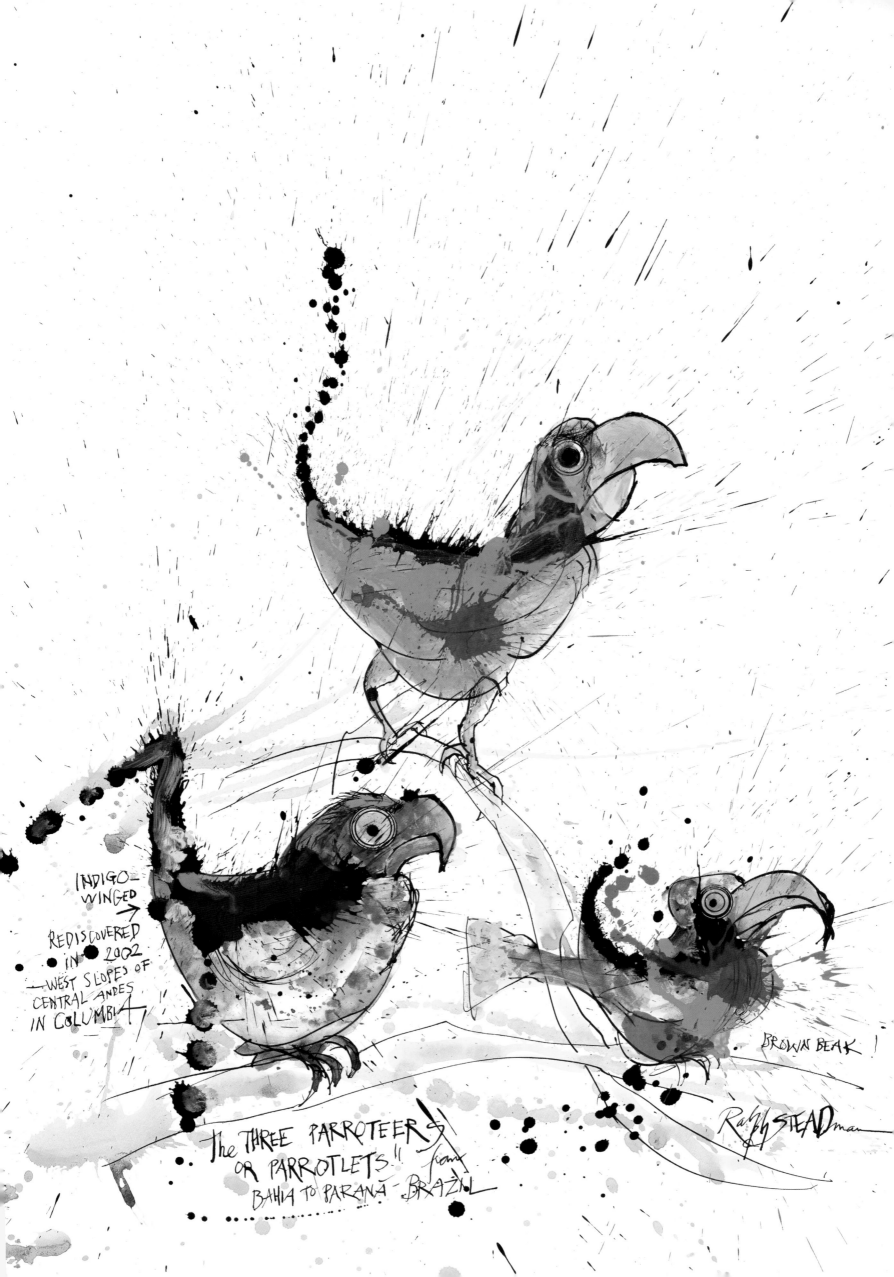

INDIGO-
WINGED
→
REDISCOVERED
IN 2002
WEST SLOPES OF
CENTRAL ANDES
IN COLUMBIA

BROWN BEAK !

The THREE PARROTEERS
OR PARROTLETS !! from
BAHIA TO PARANÁ - BRAZIL

Ralph STEADman

Blue-eyed Ground-dove

Columbina cyanopis

So this is a ground-dove and Ralph immediately places him up on the roof tiles. This is typically contrary behaviour from the artist. But the bird's rich colour needs to be seen from far and wide, so I can understand why Ralph has perched him high. If only it were so noticeable in the real world then it wouldn't be so hard to track down.

The Blue-eyed Ground-dove is a very rare inhabitant that has been recorded a handful of times across Brazil, with the last confirmed sighting being in 1992. Consequently, the population size is estimated at a paltry 50–249 mature individuals. Historically, it has always been considered a rarity, but it's a thin line between that and Critically Endangered, as it is now considered to be. Its favoured habitat is the Brazilian *campo cerrado* grasslands, which were abundant until recently, which does not make it easy to understand why the bird was so scarce. But the recent loss of great swathes of this habitat has surely exacerbated the situation. Between 1950 and 1993, the *cerrado* became dramatically altered due to conversion for agriculture, grazing, invasive vegetation and burning. The ground-dove is a protected species and unfortunately recent searches have not managed to locate it, but these will continue, as will surveys of the bird once it is discovered.

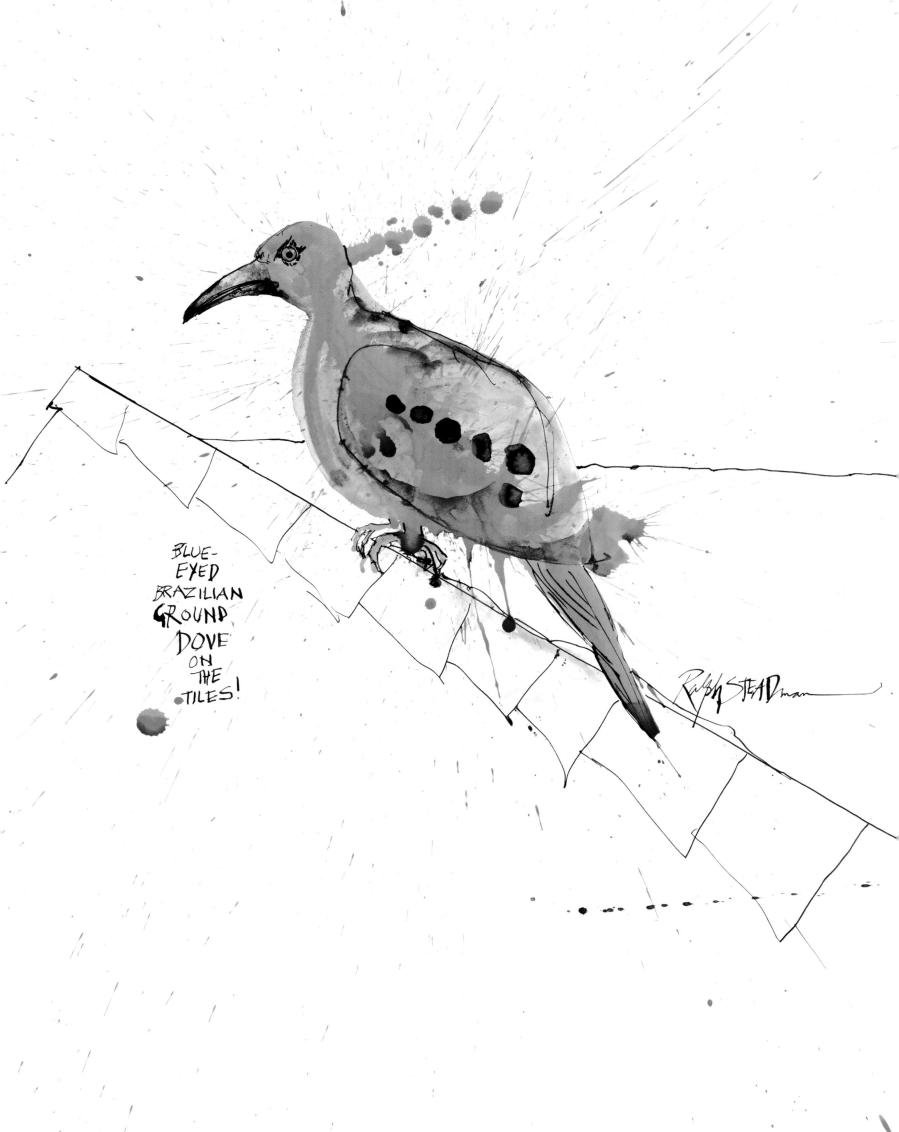

BLUE-
EYED
BRAZILIAN
GROUND
DOVE
ON
THE
TILES!

Ralph STEADman

Let Them Eat Bird

This apocalyptic and sinister picture of birds at the food table is a terrifying interpretation of what happens to many of the world's small songbirds. They end up as a dinner for the greedy. Here we see the diner at one end of the table capable of engulfing in one giant mouthful a whole plateful of cooked birds. It reminds me of the story of French President Mitterrand's last meal. In France one of the greatest delicacies is Ortolan Bunting. This small and protected species was (and still is) regularly trapped in the French countryside and then prepared as a meal by locking the birds in darkened rooms for a month and feeding them millet to fatten them up. The disorientation caused by the lack of light makes them eat constantly, thus filling them well beyond their capacity. Once their tiny frames (this is a bird that normally weighs less than 30g) are full they are drowned alive in Armagnac, plucked and then roasted. They are eaten whole although some may prefer to leave the head or the feet. Often the diner will place a napkin over his head, for several reasons. One is to keep the aroma of the meal within reach, the next is to not show the mess one can make whilst eating it, and thirdly it is supposed to hide their guilt for eating this songbird from the eyes of God.

When Mitterrand ate this final repast, he did so in the heartland of Ortolan Bunting cuisine, the Landes region, which is south-west of Bordeaux. He gathered his friends around him on New Year's Eve 1995 and consumed oysters, foie gras and two Ortolan Buntings. He did not eat again before his death a few days later.

In 1999 under a European Directive it became illegal to hunt and sell ortolans.

In 2007, with upwards of 50,000 birds still being killed, the French government promised to act. However, the trapping of the birds continues and estimates are that 30,000 ortolans a year may still be being caught and eaten. The price on the market is anything upwards of £100, so it is also good business.

Fines of up to €4,000 are possible for offenders caught trapping or cooking the birds. Diners are still not considered guilty parties. Much has been made of the issue in France, with the Landes Federation of Hunters stating that the number of birds caught is negligible and not significant enough to damage the ortolan population. But it's not only that these birds are caught mid-migration between Scandinavia and Africa, it's also the way they are treated on their way to the plate. It is barbaric, and as much as it is an old custom, we have to remember that customs die out. It is felt that many turn a blind eye as this is a tradition that has gone on for centuries. My thoughts are that rape and pillaging used to be common back in the day but they are not acceptable today. Times change, values change, but sometimes people don't.

But this is the story of much hunting and trapping in the world today. Songbirds are caught all over the world and prepared as meals. In Spain you can meet people with bags full of robins for sale, or thrushes. In Cyprus lime-sticking continues. In Egypt, name your bird. What makes us consider the lives of animals so worthless? A bird's life is cheap and so easily taken by the trappers. It is time to begin to set traps for the trappers and let's rid ourselves of this curse upon the small birds of the world.

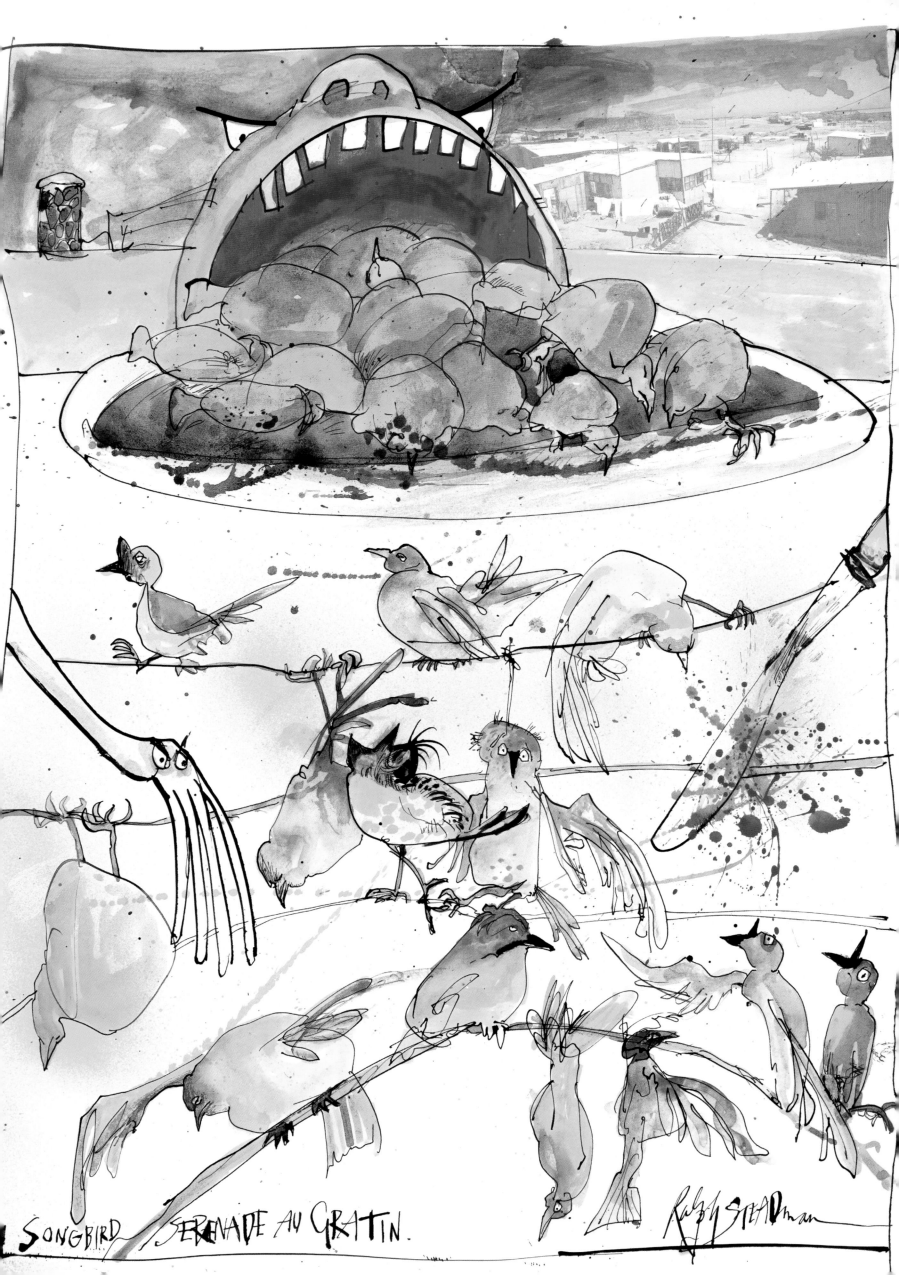

SONGBIRD SERENADE AU GRATIN.

Ralph STEADman

Posing Stork

Pink-headed Duck

Rhodonessa caryophyllacea

If you want to make a name for yourself then head on over to remote wetlands in northern Burma and attempt to find yourself face to face with the Pink-headed Duck. Officially it has not been seen since 1949, but a potential recent sighting and reports from locals mean that there is still a chance that the duck is ducking out of the limelight and living in seclusion. Habitat loss and hunting are the main reasons for the demise of what was already a pretty rare bird. There are suggestions that it may be nocturnal, which makes its rediscovery all the harder. Time to dust off those torches and take a night stroll in search of this lost but not forgotten bird.

White-headed Duck

Oxyura leucocephala

The Endangered White-headed Duck is most definitely a citizen of the world. It is found in Spain, North Africa, across the east Mediterranean, Russia, Kazakhstan, parts of central and southern Asia and various points in between. It probably numbered more than 100,000 worldwide during the early part of the 20th century but now its numbers have dwindled to 5,300–8,700 mature individuals. The biggest threat to the bird has been hybridisation with the non-native North American Ruddy Duck, which would in time have destroyed the White-headed Duck population. Because of this the Ruddy Duck has been subject to culling in various countries, including the UK, which has killed 6,200 of them, accounting for 90% of the UK's population. Hunting and egg collecting have also played their part in the demise of the White-headed Duck. Plans for its conservation include attaining protected status for the bird in all of its resident countries, implementing hunting bans and keeping a keen eye on its suitor, the Ruddy Duck. Ruddy ducks!

Baer's Pochard

Aythya baeri

The Baer's Pochard breeds in Russia and north-eastern China and winters further south in various locations, including India, Bangladesh and Burma. Loss of its wetland breeding grounds as well as hunting have led to a rapid decline in numbers, which now sit somewhere between 150 and 700 mature individuals. The bird needs to gain protected status across its range and it is hoped that a captive-breeding programme will come into play and eventually strengthen population numbers.

Daft Duck

Daffinus diddlinus

Ducks have always been known as either dabbling ducks or diving ducks. Dabbling is when you see a duck's backside in the air as the bird submerges its top half into the water and feeds just below the surface, and a diving duck, naturally, dives deeper into the water. Well, here Ralph has found another type of duck. Diddling ducks. This is the art of cruising with feet splayed in front. Does it help with feeding? No, it's diddling. It's a little like skiing without the accidents. And I hate to speak anthropomorphically, but a Daft Duck enjoys doing this immensely.

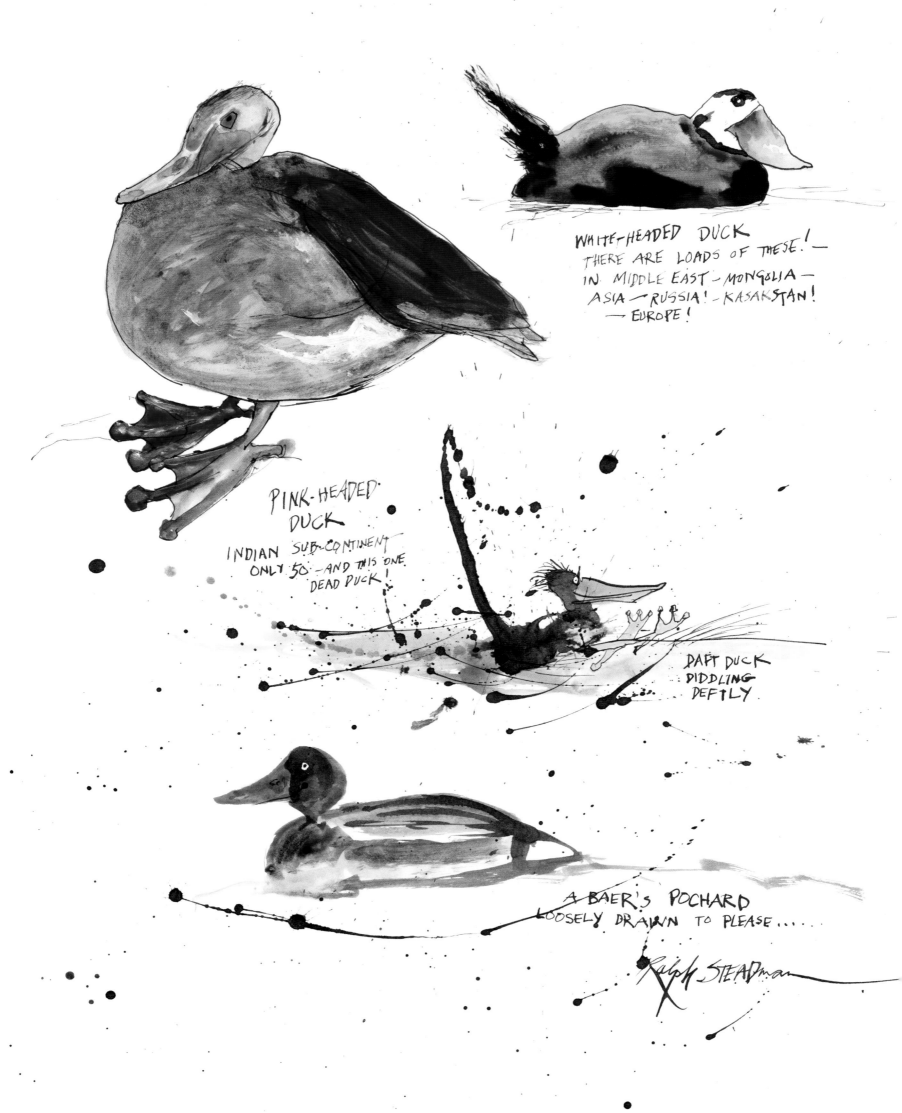

WHITE-HEADED DUCK
THERE ARE LOADS OF THESE! —
IN MIDDLE EAST — MONGOLIA —
ASIA — RUSSIA! — KASAKSTAN!
— EUROPE!

PINK-HEADED
DUCK
INDIAN SUB-CONTINENT
ONLY 50 — AND THIS ONE
DEAD DUCK!

DAFT DUCK
DIDDLING
DEFTLY

A BAER'S POCHARD
LOOSELY DRAWN TO PLEASE.....

Ralph STEADman

Bahama Oriole

Icterus northropi

The Bahama Oriole lives in open forest and relies upon palms for nesting. The effect of Lethal Yellowing – not an invention from Ralph, but a disease that has destroyed great swathes of coconut palm in the last few years – threatens the oriole, as does brood parasitism by the Shiny Cowbird, which lays its eggs in the oriole's nests. This newcomer arrived in 1990 when it spread its wings to join the Bahamian community. Habitat loss and introduced predators such as rats and cats also threaten the oriole and numbers have been reduced to 93–180 mature individuals. Research continues to identify the best way forward for the species.

Cozumel Thrasher

Toxostoma guttatum

The thrashed gag along with this most threatened Mexican species have made their second appearance in the book. And why not? (See previous entry, on page 158.)

Bachman's Warbler

Vermivora bachmanii

The Bachman's Warbler breeds in the south-east USA and winters in Cuba and occasionally Florida, although it has not been seen since 1988 and there hasn't been a breeding record since 1937. Drainage of breeding-ground swampland and loss of dense growth of bamboo, coupled with the conversion of land to sugarcane plantations in Cuba, have left the bird with nowhere to go. Until the last possible sites have been explored it cannot be considered extinct, but there are no plans afoot for any conservation action, as no warblers have been found. What would Turner and Overdrive have made of it? Because those that have been looking for the bird 'Ain't Seen Nothing Yet'. Sorry, couldn't resist that one.

Montserrat Oriole

Icterus oberi

Volcanic eruptions between 1995 and 1997 nearly finished the Montserrat Oriole for good, leaving it existing only in two small areas of the island. Nest predation by rats and Pearly-eyed Thrashers is also a problem, as is the potential damage to its habitat by feral pigs. Rat and pig control is intended and research continues to determine the causes of the bird's continued decline.

Fuerteventura Stonechat

Saxicola dacotiae

This stonechat is considered Near Threatened because of loss of habitat due to road building, golf courses and tourist and residential building work. Introduced species are also a threat. Plans are in place to raise awareness about the bird, keep an eye on its population and look at controlling predators.

Glaucous Macaw

Anodorhynchus glaucus

The Glaucous Macaw has not been reported since the 1960s but was once widespread across parts of Argentina, Uruguay, Paraguay and Brazil. Habitat loss due to agriculture and human colonisation has been the main threat, as well as hunting and trapping. Possible areas where the bird may still be found need to be explored, and several searches have taken place, but without any findings yet.

Russet-bellied Spinetail

Synallaxis zimmeri

This Peruvian Andes-dweller is Endangered because its habitat is in decline due to cattle grazing and land change because of agriculture. There is no protected area within the bird's range and attempts are being made to find a designated safe haven.

Banggai Crow

Corvus unicolor

Until recently this crow was only known from specimens taken in 1884 from the Banggai Archipelago in Indonesia. Between 2004 and 2007, searches of the forest on the mountain slopes of western Peleng discovered that within it there was a small band of the corvids which remained alive, and some smaller numbers of birds at lower levels of the island. The probable cause for the bird's decline is deforestation. Since its rediscovery, awareness campaigns have begun and there is a hope to create some protection for the forest and therefore for the bird.

Blue-throated Macaw

See previous entry, on page 56.

Blue-eyed Ground-dove

See previous entry, on page 162.

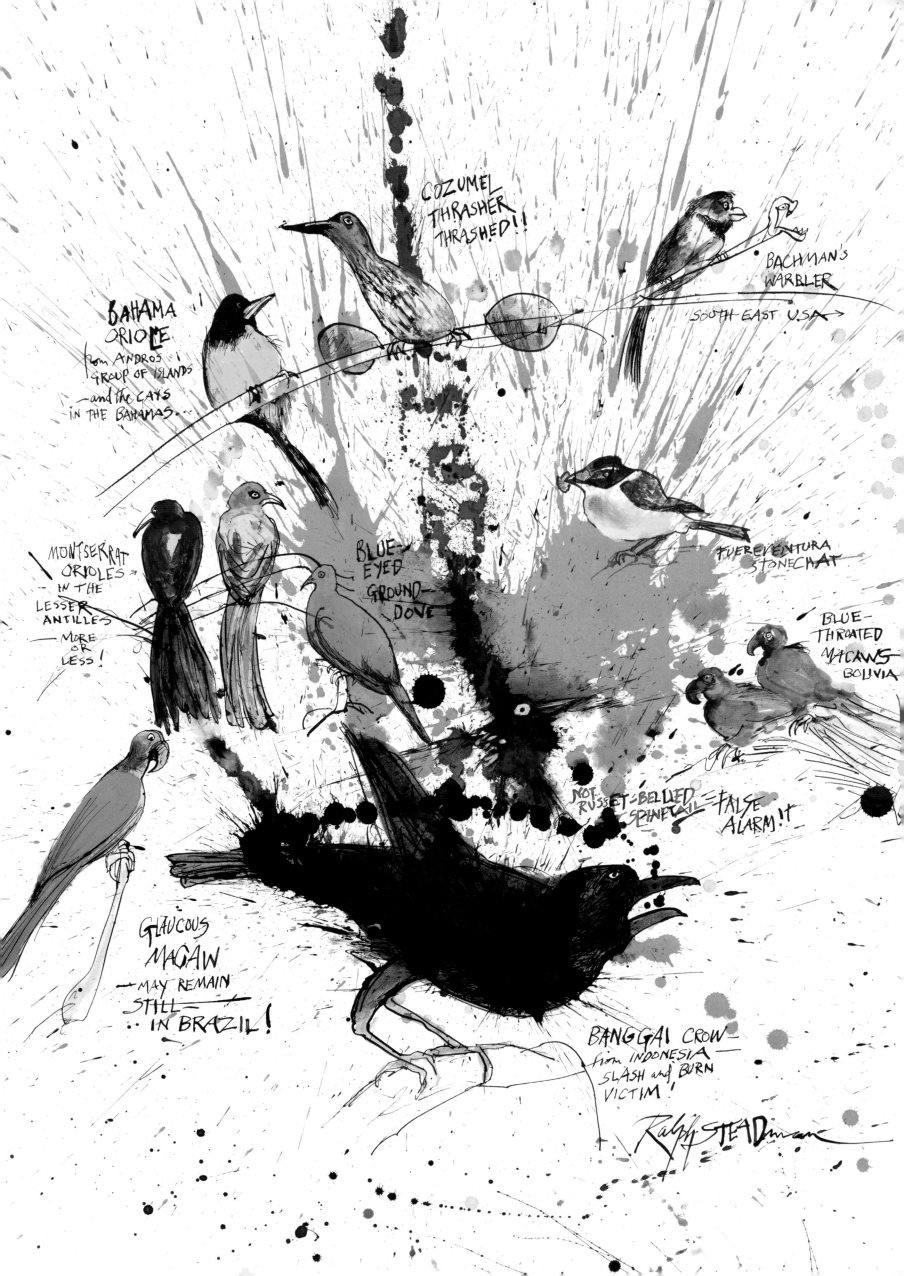

COZUMEL THRASHER THRASHED!!

BACHMAN'S WARBLER

SOUTH-EAST U.S.A. →

BAHAMA ORIOLE
from ANDROS GROUP OF ISLANDS —and the CAYS IN THE BAHAMAS

MONTSERRAT ORIOLES → —IN THE LESSER ANTILLES — MORE OR LESS!

BLUE-EYED GROUND-DOVE

FUEREVENTURA STONECHAT

BLUE-THROATED MACAWS BOLIVIA

NOT RUSSET-BELLIED SPINETAIL =FALSE ALARM !!

GLAUCOUS MACAW —MAY REMAIN STILL—· IN BRAZIL!

BANGGAI CROW— from INDONESIA— SLASH and BURN VICTIM !

Ralph STEADman

Ceri: Cap'n, I have been in touch with the Orange-beaked Spotted Bald Emulsion Cootflake and he has suggested that today is a good day to draw his immortality, the Ooshut Doorbang. It is the time for him to awake from his deep sleep and what an historic moment that is for you to capture.

Ralph: I had better go and get some more ink. I love wet ink.

Ceri: I shall prepare the launch for us to go ashore and while you get your inks I will set up your drawing board and await your return.

Ralph: Very good, Midshipman Levy! Carry on.

Orange-beaked Spotted Bald Emulsion Cootflake

Dispositione nervosi

The cootflake is the PA to the Ooshut Doorbang and is considered to be most efficient. It has been a pretty cushy gig as the ooshut has lain dormant all these years, but there has always been admin to take care of, so thank God for the Pip Leak who has handled so much of this clerical work on behalf of the cootflake.

The cootflake is ever so concerned at the boss returning. What is the ooshut going to say after all these years? Has everything been handled well enough since the great god bird went to sleep? Nervousness courses through the body of the bird and it shivers with fear of disappointing the god guv'nor of the boids.

Blue Orange-beak Pip Leak

Exiguus adiutor

This tiny little insignificant creature is actually the PA to the PA and does everything perfectly. In fact, it does everything so well and is so well hidden from view that no one knows that it is the brains behind the cootflake's work. This is really what the cootflake is concerned about – that the Ooshut Doorbang is going to suss the situation immediately and sack it on the spot. But the tiny PA to the PA is not driven by ambition and is happy just to be the secret driving force behind the cootflake, who is much more capable of dealing with the public, general questions about His Godliness and all that caper. Behind every great Orange-beaked Spotted Bald Emulsion Cootflake, you'll find an even greater Blue Orange-beak Pip Leak.

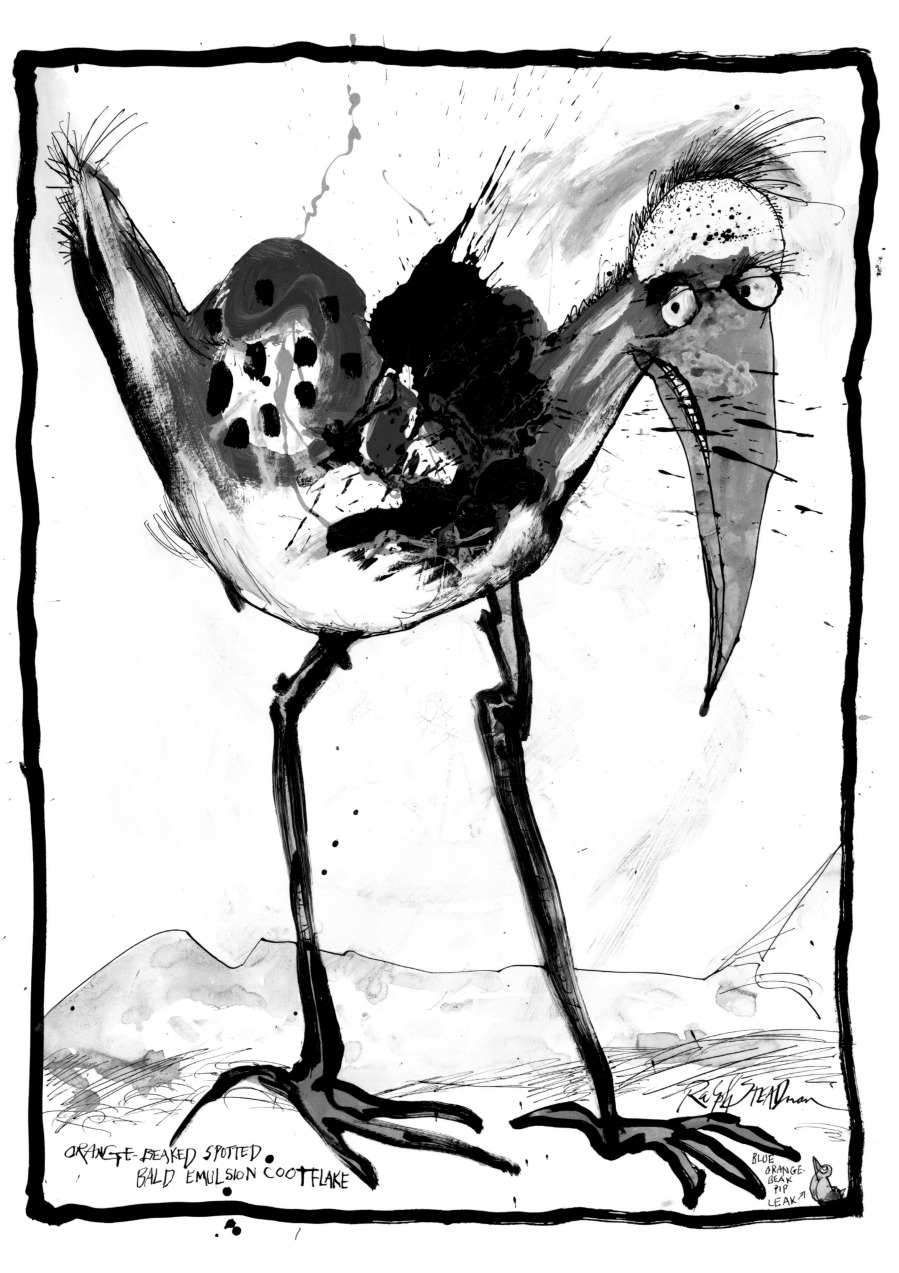

ORANGE-BEAKED SPOTTED.
BALD EMULSION COOTFLAKE

BLUE
ORANGE.
BEAK
PIP
LEAK

Ooshut Doorbang

Luxuriosa deus

In this picture, Ralph has captured the moment when the Ooshut Doorbang showed what he is truly all about. He is the great protector of the nextinct, but for many centuries he has lain dormant waiting to be awoken and to bring peace back to the birds.

Kevinio Rodrigues has been getting more and more into the dark arts and occult side of bird hunting as his tried and tested methods have not been working so well any more. The birds have sussed his nefarious methods out. After finding a rare copy of Romeo Error's *Bird Hunting with Satan* in his local boot fair, Kevinio has been trying all the various spells and wickedness within the book. Here he is accompanied by a demon, which actually came free with the book, to help him on his mission. The last of the blue-panted bird-killers no longer works with Kevinio and has become a Taoist monk, and wishes to make amends for the harm done to the Basic Bird.

In Error's book, it is written that to become the ultimate hunter, indisputable and dreadful champion of the trap, gun and snare, one has to summon up the bird god that is the Ooshut Doorbang as he begins to wake from his thousand-year slumber and strike him down before he has full use of his faculties. With his lotions, potions and demon in tow, Kevinio incants the spell and the bird god materialises, stirring where he lies, on the sandy beach, where they now find themselves. His eyes open slowly, and his body begins to twitch into life. The demon shouts, 'Now master, it is time! Put an end to the bird world forever!' This is followed by the obligatory demonic cackle.

Kevinio, seeing the ooshut awake but still weak and defenceless, cannot resist the urge to tell him how much he is going to enjoy hunting every last bird on the planet with the new superpowers he will gain with the death of this feeble-looking bird god. Unfortunately for Kevinio, as all baddies are prone to do in this situation, he gloats over his forthcoming success for a moment too long and this gives our hero time to digest and reflect on the matter. He is then primed and ready to spring into action.

Kevinio howls with laughter as he states, '... and this will be the end of the bird world forever. And I, Kevinio Rodrigues, will be known in every corner of the land, even though the earth is round and can't have corners. I will be known, once and for all, as The Greatest Extincter. They will all fall at my hands, especially the Needless Smut. No one needs him!'

Through the tears of joy and mirth, Kevinio raises his axe to smite down upon the last obstacle in his way to becoming a legend. And it is in this moment that our hero, the Ooshut Doorbang, makes his familiar war cry of a slamming door, which he projects behind the two would-be murderers. They both turn and with that movement they are lost. The ooshut slams them to the ground in an instant and in the blink of an eye covers them both in sand, burying them quicker than an Orange-beaked Thrust can run, and at the same time he is dribbling spittle and guano all over the sand that covers them. Why? Because this is no ordinary sand – it is concrete sand, which immediately hardens at the slightest hint of moisture, which it craves as it is not near enough to the sea to be touched by the tidal waves. As the bird god's spittle hits the surface of the beach, Kevinio and his sidekick are entombed in cement, trapped forever. The guano? What purpose does that serve? Nothing really, it's more of a statement. Why doesn't the demon do something demonic, sinister and dark to fix the situation? Well, just think about it, he came free with a book bought in a boot fair – how good can he really be at his job?

And so these two forever remain on Concrete Beach, a symbol that everything is possible, that nothing is necessarily lost and that with a little bit of belief and hard work the status quo doesn't have to be the only way. Things can always change.

The Ooshut Doorbang now lives very comfortably in the penthouse nest overlooking his handiwork, to make sure there is no escape possible. He is the guardian of the island and has vowed never to go to sleep for such a long time again. In fact, he has invested in two alarm clocks just in case one fails and he oversleeps.

Nowadays, Concrete Beach is a safe place to go as the remaining concrete sand has been removed and replaced by normal sand. Birds like to go there for their holidays and they and their fledglings play for hours in front of Kevinio and his devil chum. Kevinio is in despair as he watches all this joyous bird activity and, even worse, they all feed him to keep him alive, so now he is dependent on the very creatures he has striven all his life to kill. Of course the devil needs no food, but he knows that when he eventually gets home, if he ever gets home, he's going to be in really big trouble with his dad. They both reflect and come to the same conclusion: life's a funny thing.

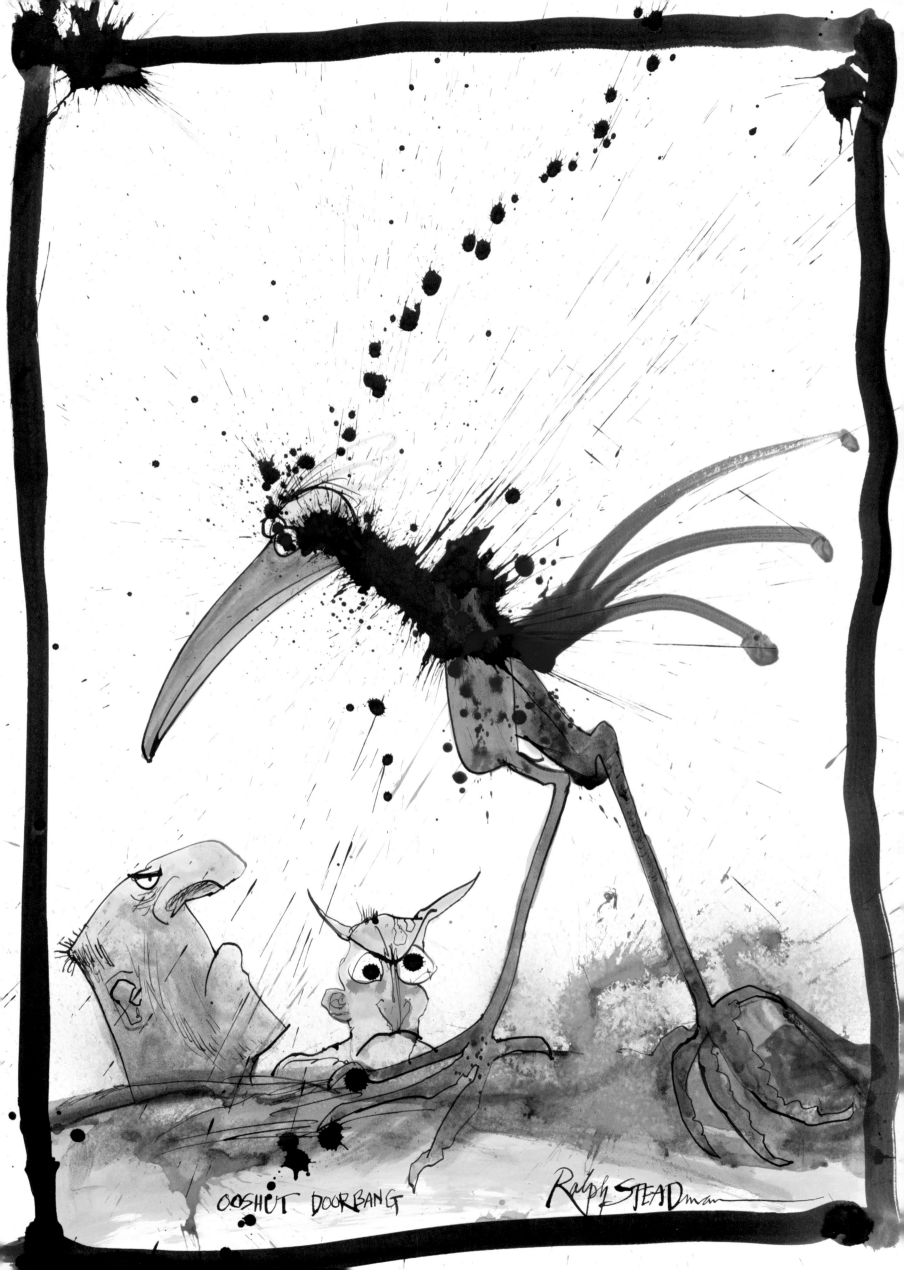

OOSHUT DOORBANG Ralph STEADman

Ceri's Diary: Ok, there's no real reason for Ralph to pick these birds other than owls look so damn fine. And these have a tenderness about them that makes you want to look after them. And below these two elegant creatures is an owl alone. He sits under his own crescent moon, from which hangs a little trinket. Is it food, a shiny thing or cheese? Who knows? It just is.

Madagascar Red Owl

Tyto soumagnei

The Madagascar Red Owl is considered to be Vulnerable and its rainforest habitat is rapidly deteriorating due to encroachment by an ever-growing human population, as well as logging, clearance for agriculture, slash-and-burn cultivation, and fires caused by bad farming practices. Several sites where the owl lives are protected, but a larger amount of protected habitat is still warranted. A serious head count is needed to ascertain exactly what the status of Ralph's sleeping beauty is.

Nicobar Scops-owl

Otus alius

This is an owl that is known as Data Deficient, so therefore there is not much I can write about it. It's a lovely-looking bird but who knows how many may exist. There have been two specimens of the bird collected on Great Nicobar and one was caught in 2003 on Teressa Island, both part of the Nicobar Islands in the Bay of Bengal in India. Clearance of coastal forest because of agricultural conversion, road building and human residential growth threatens the bird. Surveys are planned to determine the number of owls on the islands.

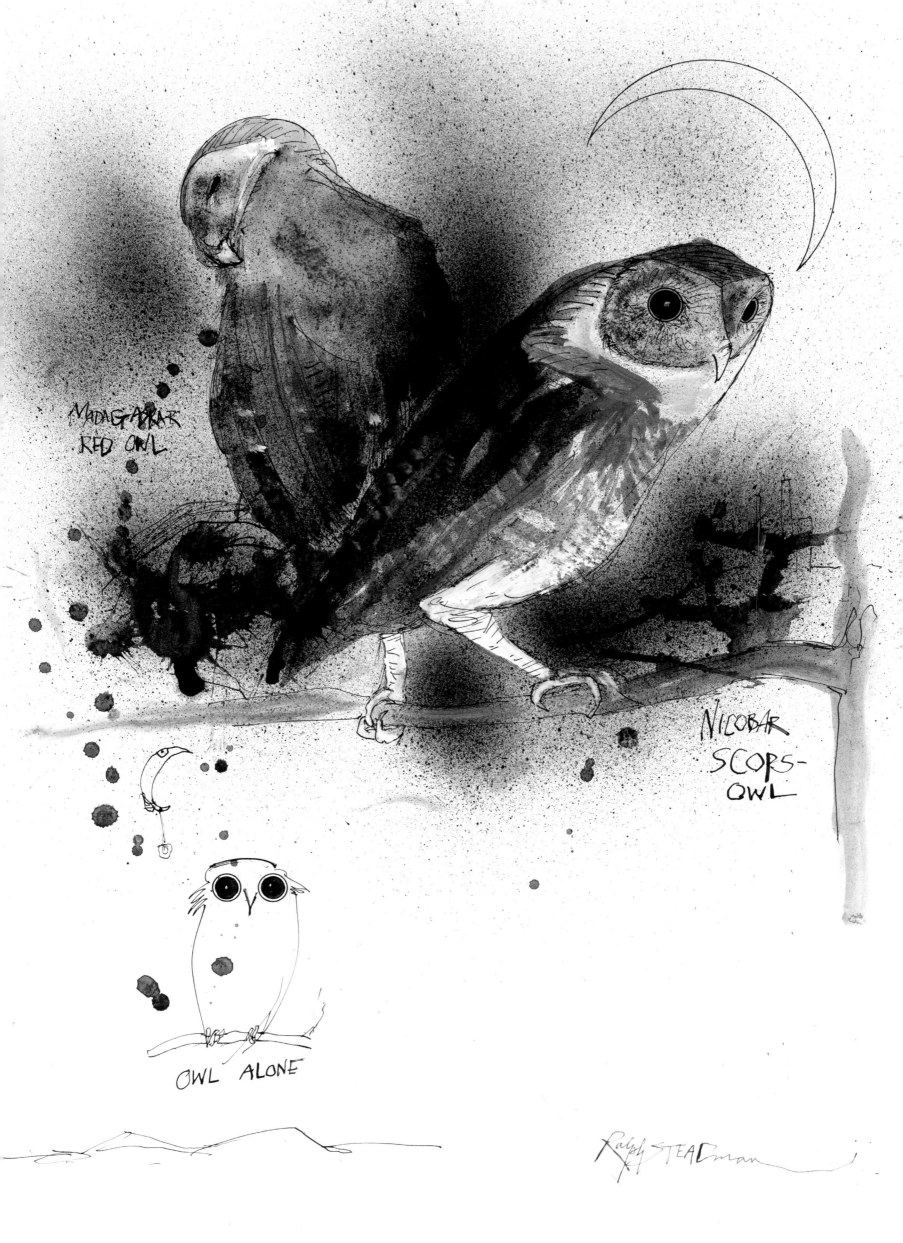

MADAGASCAR
RED OWL

NICOBAR
SCOPS-
OWL

OWL ALONE

Ralph STEADman

Beck's Petrel

Pseudobulweria becki

Not seen since specimens were taken at sea off Papua New Guinea in 1927 and the Solomon Islands in 1928, this petrel was potentially rediscovered in 2003 off the coast of New Ireland in the Bismarck Archipelago, Papua New Guinea. This was confirmed in 2007 when an expedition saw several birds in a week, in the same area as the previous sightings. Its breeding grounds are unknown but are believed to be in the montane forests of New Ireland. If so, the threat to its population is probably predation by introduced cats and rats.

Magenta Petrel

Pterodroma magentae

This petrel was another soul that had been lost at sea since it was collected in 1867, until it was rediscovered in 1978 breeding on Chatham Island, New Zealand. Introduced species such as rats, cats, pigs and possums threaten the bird, but predator control is working and its numbers are increasing. The work continues and perhaps this petrel will become downlisted. What a turnaround for this species.

New Zealand Storm-petrel

Fregetta maorianus

This bird was rediscovered in 2003 off the North Island of New Zealand, having been considered extinct since the early 19th century. Successful rat eradication on outlying islands may have benefited the species and in 2013 its breeding grounds were located. Work is being carried out to learn more about the species and clarify its population size, but for now it is thought to number fewer than 50 birds.

Fiji Petrel

Pseudobulweria macgillivrayi

Again, this petrel was only known from an 1855 specimen taken from the island of Gau in Fiji, was considered to have become extinct and then was rediscovered in 1983. Introduced rats, cats and pigs threaten its future and three full-time staff are employed by Nature Fiji to oversee its well-being. Location of the nests within underground burrows, and surveys of its habitat and numbers, are essential to ensure a future for the Fiji Petrel.

Galápagos Petrel

Pterodroma phaeopygia

This petrel is endemic to the Galápagos, where it breeds in burrows on several of the islands. Introduced mammals, such as cats, dogs, rats and pigs, threaten the bird's existence, as do collisions with power lines and radio towers. A wind-power farm on Santa Cruz is appearing to have less of an effect on bird mortality than first feared. A long-term monitoring programme is in place and it is hoped that predator control will be successful.

Guadalupe Storm-petrel

Hydrobates macrodactylus

This storm-petrel was last recorded was in 1912. Its downfall is probably due to predation by feral cats and the destruction of its habitat by goats. There has been no survey of the bird for years and until this is done it is impossible to say for certain that it has become extinct, but funds have become available to search Guadalupe in Baja Clifornia, for the species. Goats have been removed from the island, whilst money is now being raised to eliminate feral cats.

Jamaica Petrel

Pterodroma caribbaea

This petrel hasn't been seen since 1879 and is presumed extinct. It's a long time to be out of sight, but as we have seen with other petrel species there is hope. It is worth remembering this is a nocturnal species, and birds are notoriously difficult to locate in the dark. Go for a night-time swim around Dominica or Guadeloupe and you may just discover this 'missing in action' bird.

Mascarene Petrel

Pseudobulweria aterrima

This petrel is now believed to breed only on cliff sites on Réunion Island in the Indian Ocean. Predation by cats and rats is an issue, as are streetlights and manmade lighting. These attract juveniles into town, where they become grounded, and death beckons in these alien surroundings. Luckily, many birds have been rescued thanks to a public-awareness campaign. A recent expedition to find the Mascarene Petrel successfully encountered a group of 33 birds at sea. This is the first sighting of the birds out on the water and has provided invaluable data on their flight and behaviour, and allowed comparison to other petrels. Remarkably, one bird was photographed in flight with an obvious bulge of an egg inside its body, which is believed to be the first time that any bird has been shot in this way.

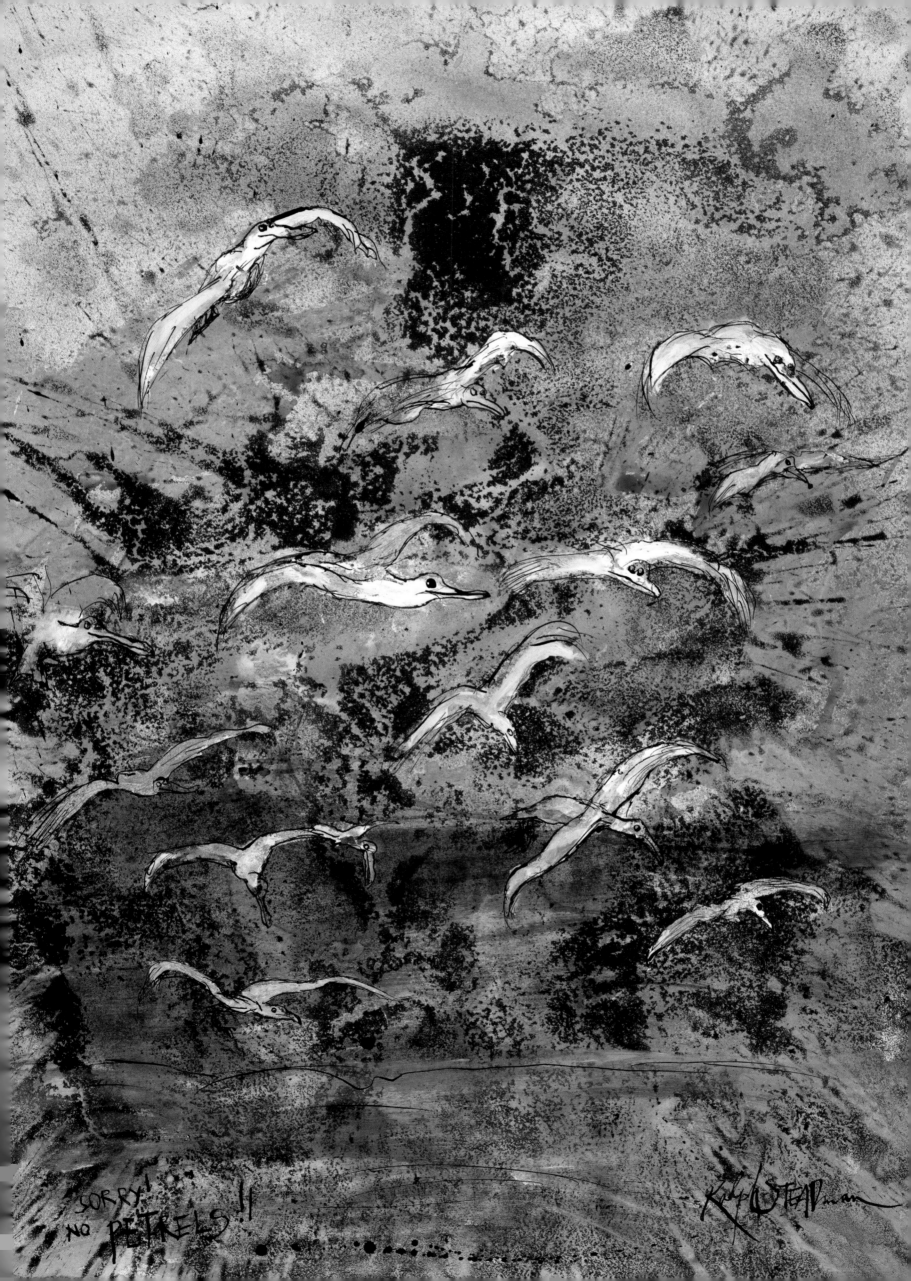

SORRY!
NO PETRELS!!

Laysan Duck

Anas laysanensis

The Laysan Duck was once widespread across the Hawaiian Islands but became isolated on Laysan Island. Thanks to the removal of introduced rabbits on Laysan during the 1980s, the duck's population has begun to thrive. A translocation programme to the Midway Atoll National Wildlife Refuge in 2004 and 2005 has been proving successful, although it has suffered due to an outbreak of botulism and was then hit by a tsunami in 2011, as was the duck population on Laysan. Still, the bird fights back and the numbers are now estimated at somewhere between 500 and 680 mature individuals. Keep this up and the Laysan Duck may just end up having the last laugh.

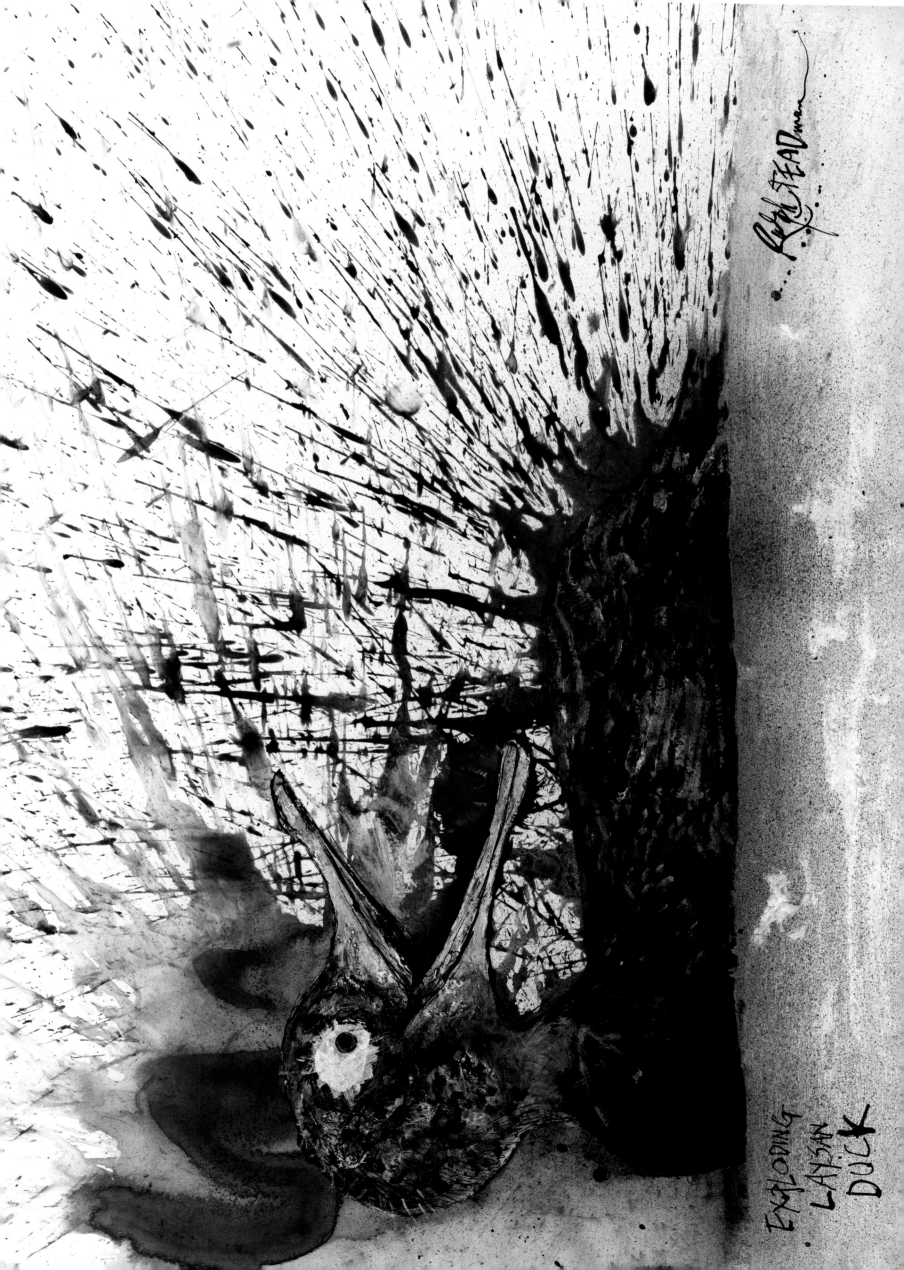

EXPLODING
LAYSAN
DUCK

Balearic Shearwater

Puffinus mauretanicus

The Balearic Shearwater breeds exclusively in the Balearic Islands in Spain. Predation by introduced mammals such as cats, martens and genets is a large problem, and the number of birds lost as bycatch because of longline fishing may be much higher than first believed. Population numbers have been hard to estimate due to the excessive number of immature and non-breeding birds within the shearwater population. Therefore, the number has been set at between 9,000 and 13,000 mature individuals, which is equivalent to 13,000–20,000 birds in total.

All the breeding sites for the Balearic Shearwater are now protected, apart from one at Formentera, which is just outside the designated area. It is hoped that control and eradication of predators at the breeding sites will eventually happen, as well as awareness campaigns aimed at the fishing community, which hope to solve the problem of bycatch. Studies will also assess the damage caused by overfishing and determine the impact of pollutants on the birds.

BALEARIC
SHEARWATERS

Basket Case

Today Ralph shows me some wickerwork from an old basket or something similar that he has found and stuck on a board, but he doesn't quite know where to take it as a picture. As he shows it to me I say that it immediately reminds me in a somewhat abstracted way of the clap nets I have seen used illegally on Malta and which are in use worldwide as trappers continue their pursuit of birds. When a bird steps into the middle of the clap net area a drawcord can be pulled, which brings the net over the bird. Often a tethered live bird is used to lure birds in with its calls and song. I tell Ralph that to my eyes the wickerwork is crying out for a trapped bird in the cage-like centre of the piece. It's funny how this piece turns up straight after the trapping incident here in Spain. Serendipity is playing its part again.

Trapping can cause damage to the environment as great swathes of vegetation and habitat are destroyed to make way for nets that have to lie as flat as possible on the ground. In Malta I have witnessed areas of protected countryside that have been concreted for this very purpose. Decoy birds are essential and are worth a high price themselves. Apparently, a Hawfinch can command between €100 and €150 per bird. I recently read of a Maltese driver being stopped on a ferry home from southern Italy who had close to 700 songbirds (including 326 Hawfinches) crammed inside boxes that were only a few centimetres wide. The haul of birds had been estimated to have a value just under €32,000. It doesn't take much to work out that this is very big business indeed.

The man was found guilty and sentenced to nine months in jail suspended for two years and a €2,000 fine. Sadly, some of the birds had already died when they were first discovered and nearly 500 more died while waiting as evidence, in an unsuitably sized quarantine area, for the case to come to trial. The rest were finally released.

Ceri's Diary: I am still in Spain and today I am with my cousins, Paco and Debbie, and Paco's brother Joaquin, at their campo, an idyllic plot of land on which they grow fruit and vegetables and have an area where they can eat and relax. It is also a great spot for birds and as usual after lunch I head off for a walk around the area. I am lucky as I kick up a couple of Hoopoes, which fly up into the air, and also a Golden Oriole flies past my nose at Mach 8. Then overhead I hear a flock of bee-eaters chirruping their way to somewhere. There are the usual Goldfinches, Greenfinches and Siskins whizzing around and I marvel at the colours of the birds I see in a short walk and feel lucky to be part of such a scenario.

Back at the campo, Joaquin tells me a story from the last few days. He was in the campo when he noticed a motorbike, which he didn't recognise as belonging to any of the locals, loaded up with all sorts of odd equipment on it. There have been numerous trappers in this area because of the richness and diversity of the birdlife. He looked around the area and found a man removing small birds from a mist net. There were Greenfinches, Goldfinches and Siskins. This was not far from the campo, but quite well hidden from prying eyes, except those that know the land. Joaquin went back to get his mobile and phone the police but he was too late as he heard the bike start up and the man was gone.

A few days later he saw the same motorbike parked up again and this time with no sign of the man. Knowing what he would be doing, he phoned the police, who arrived quite quickly, arrested the man and charged him with illegally trapping birds. Apparently the police had been after this man for some time. This time, thanks to the vigilance of Joaquin, the man was caught and faces a hefty fine. But trapping is a curse for the small birds of the world and more needs to be done. It is worth educating people about what to look for, to be able to recognise the signs of wildlife crime. It is not necessary to intervene, and a simple phone call to the police should suffice, as in this case. Of course, catching one man and his mist nets is just a drop in the ocean, but small ripples ultimately make waves.

I was chatting with some people last night and they were talking about someone they knew who was into trapping. Apparently, this person loves birds and wanted to trap them so he could hear them sing all the time at home because he was so captivated by their song. I suggested that perhaps he should get used to listening to them in the wild and take in his surroundings while listening to the birds. This suggestion was met with blank looks. I tried to explain about the way I felt about the issue. People may have a genuine love of birds and want them close to them, but where does one draw the line at the taking of a wild bird and placing a free-flying creature within an invariably far too small a cage? I think it's quite a male thing, this appropriation and desire for ownership. A control over what is normally uncontrollable. How does one make people realise that we should leave our wildlife in the wild? After all, one less songbird out there is one less voice in the choir. And we don't want to listen to the occasional soloist, do we? Gradually, we are losing the abundance of voice out in our landscape and one day, God forbid, there will only be the sound of silence and that is no way for our world to be.

Why does the caged bird sing? Probably, because there is nothing else to do within its confines, and who knows what it may be singing. It may be a song of freedom and the lamenting of the loss of its previous life. I know I am humanising the situation now, but perhaps that is the only way we can try and register the utter wrongness of a wild bird in captivity.

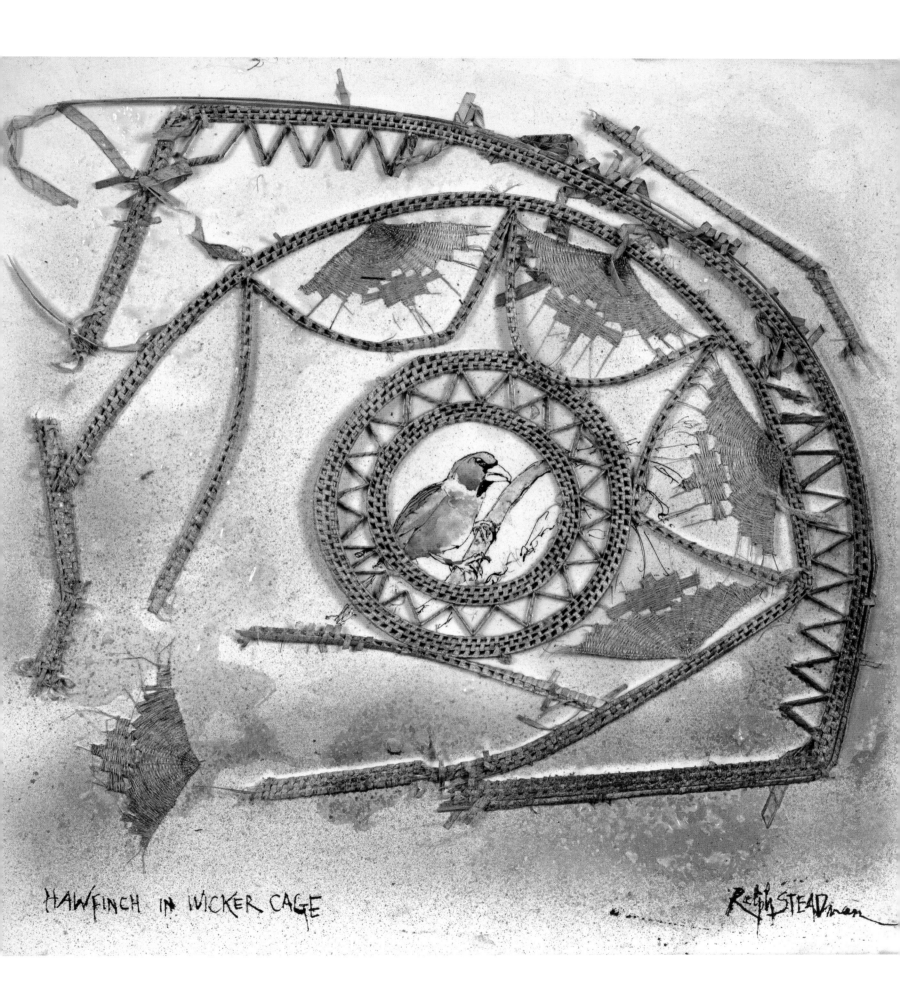

HAWFINCH IN WICKER CAGE Ralph STEADman

Unsociable Leftwing

Politicus incorrectus

Finally! We mentioned this fella so long ago, right back in the early days of nextinction, and now he arrives on the day we hear such big political news. How appropriate, and better late than never. This is the leader of The Unsociables Party and is so frightfully unsociable that he is the only member of it, but he also believes that this is the right number of members to clearly ratify his decision-making. It is his left wing itself that is the most unsociable part of him and here we see it using its dismissive wing flutter to shoo anyone or anything away. (As can be seen in this picture, a constituent is trying to ask a question but is suffering the usual roughhouse treatment from the leftwing itself.) No one can get close enough to him to express an opinion and it is rumoured that the left wing is so miserable that it will not even acknowledge the existence of the rest of its own body. For many years the boid has been campaigning for independence for the dark side of the island from the rest of Toadstool Island, but so far the only independence he has managed to secure is his own from every other bird. Who'd be a politician?

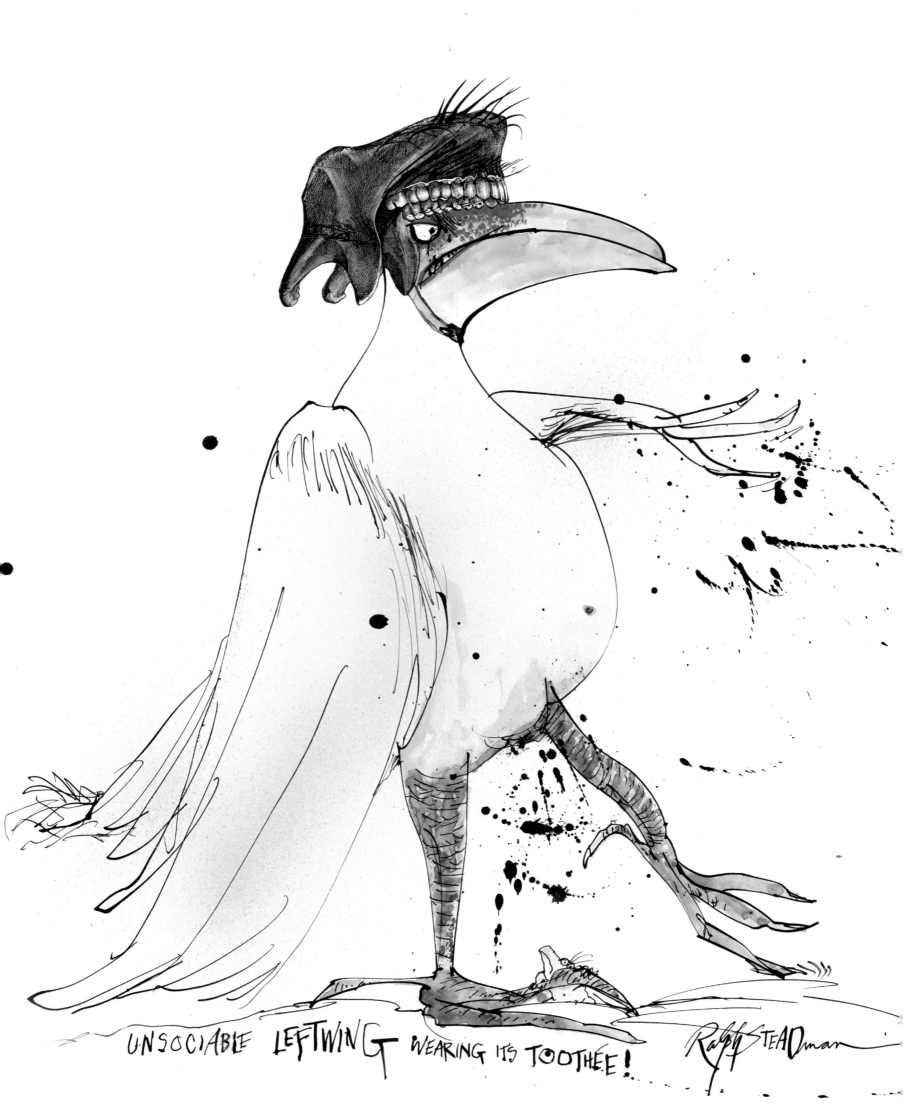

UNSOCIABLE LEFTWING WEARING ITS TOOTHEE!

Ralph STEADman

Hooded Grebe

Podiceps gallardoi

I have a soft spot for grebes. One of the first moments of birding that I witnessed was the Great Crested Grebe performing its mating ritual and the pair made me feel humble in their presence. Their entwining, rhythmic water dance captured my heart and since then, even though they are very common in the UK, whenever and wherever I see them I never fail to stop and watch their graceful glides across the water. I love the little head shakes and flicks they sprinkle throughout their elaborate courtship. They are elegant birds so it is with deep regret that I record that one of their brethren is in such deep trouble.

The Hooded Grebe breeds on a small number of lakes in the south-west of Argentina and winters at Santa Cruz, on the Atlantic coast. It is threatened by nest predation from Kelp Gulls and adult predation by introduced American Mink; surprisingly, Rainbow Trout compound the problem with predation of nests, chicks and sometimes adults, as well as being a competitor for food. I would never have guessed that a trout could eat a bird for dinner. It is also possible that Brown Trout predate the grebe on its wintering grounds.

The number of grebes is estimated at between 660 and 800, but work is needed to ascertain more exact numbers, which is proving difficult due to the inhospitable nature of its breeding habitat. Also needed is more knowledge of the grebe's migratory route. There is much to do, but on the upside, most of the breeding habitat has recently been declared as a national park, which should help the birds enormously. Colony Guardians have been created too. What constitutes a Colony Guardian, I hear you ask? They are local people whose job it is to protect nests from predators, to collect breeding data and to work with the local communities to ensure a safe environment for the bird.

The Hooded Grebe was only discovered in 1974, and how ironic that such a new introduction to the world could be leaving it so soon after its first registered appearance. But conservationists are working overtime to save the bird. Let's hope the bird and its dance can be saved. *Baila, pajarito, baila!* (Dance, little bird, dance!)

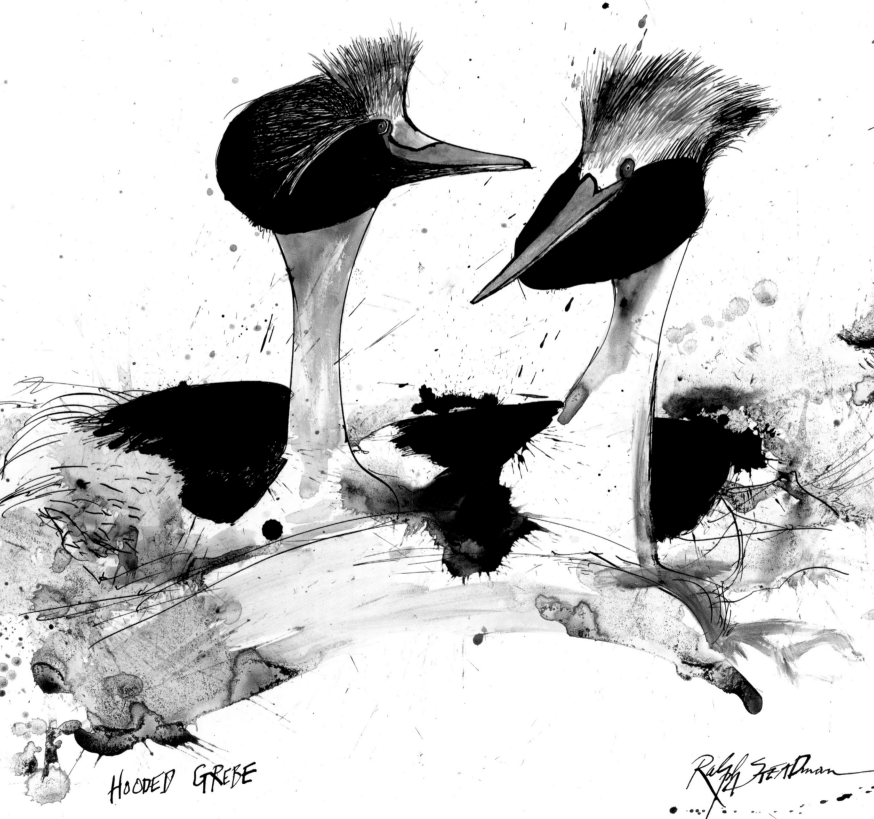

HOODED GREBE

Ralph emails:
I just done this Thingy owl and was wonderin' if it is rarer than a fresh piece of knicker elastic!!???

Phone:

Ralph: I'm just beginning to work on the Philippine Eagle; he's a religious bird. He's a bird of pray.

Ceri: So it's a one in a Manillian bird.

Ralph emails:
Hier ist die Schmoogen Finch – the tiny GONZOT!!

Gustav Rahler! XXXXXX

Phone:

Ralph: You see this little fellow here? He's my studio assistant. He sits at the top of my board and keeps an eye on what I'm doing. Tells me where I'm going wrong. Some think he's a chaffinch but he's actually a gonzo finch, a Gonzot.

Ceri: He's well camouflaged against the splatter. And he must be quick as there's not a drop of splatter upon him.

Pernambuco Pygmy-owl

Glaucidium mooreorum

The Pernambuco Pygmy-owl is a recent discovery, having first been found by sound recorded in 1990. Since then it has been seen in forest in the Reserva Biológica de Saltinho, Pernambuco, Brazil and also in Usina Trapiche. Since 2004, the species has not been seen. Legal restrictions are in place to halt the destruction of the forest but these are proving futile as the spread of fire and illegal logging eats further into the habitat. Stringent law enforcement is needed, as well better protection for the owl's forest dwelling. Surveys are needed to locate the species once more, and using playback of the bird's call can increase the chance of finding it deep within the forest.

PERNAMBUCO
PIGMY-OWL

Eskimo Curlew

Numenius borealis

The Eskimo Curlew is yet another once-abundant species that has been lost, this time since 1963. It cannot be considered to be extinct until the search for all possible breeding sites has been exhausted. It has to be that if any curlews remain their numbers are tiny, probably fewer than 50 in total. There have been several unconfirmed sightings but the future does look bleak. Up until the 1870s, extraordinary-sized flocks of Eskimo Curlews would migrate from the Northwest Territories in Canada, fly across North America and down to the southern parts of South America, ending up in Argentina, and possibly Uruguay, Paraguay, southern Brazil and Chile. Once the Passenger Pigeon was shot from the skies, the Eskimo Curlew became the hunter's chosen victim. This explains part of the problem, but undoubtedly the loss of much of the prairie the bird used on its return to the north – due to agricultural conversion – and the dearth of its favourite food source, the Rocky Mountain Grasshopper, may finally have done for this once-prevalent curlew. All one can hope for is that a flock rises up that has been hidden away all this time. Wouldn't that be magnificent? Actually, what is that rising up in the background of the picture? Could it be?

TALL ESKIMO
~~C~~CURLEW AND SPARE BEAK! and ODD FLUTTER!!

Ralph STEADman

Phone:

Ceri: You do know that you have done the Red-headed Vulture before, don't you?

Ralph: I know that I have but it was important to show you something you may not be aware of. This is the EXPLODED Red-headed Vulture, an altogether different species. I have discovered that this particular vulture hibernates and, much like a diver gets the bends from ascending from the depths too quickly, this bird explodes if it wakes from its slumber too rapidly! No one knows that about this bird. Yet again we have discovered something unique on our travels as we sail far and wide across the seas of Nextinction.

Ceri's Diary: And as we near the end of our journey across the seas of Nextinction our editor's thoughts turn to the cover of the book. How do you choose one bird to represent all of the Critically Endangered birds we have encountered? What symbolises the message we are trying to send out? Which bird works for the artist as well? An albatross is quite a symbolic creature that everyone knows, but perhaps we need something that stands out in a different way, a bird that invites the onlooker in. We have some contenders at the moment, ranging from cranes to owls, albatrosses, vultures, bustards and shags. Hmmm… watch this space. Maybe it will turn out to be something unexpected.

Exploded Red-headed Vulture

Explotus immensus

Well, who am I to argue with the captain of this ship? The artist perceives the world around him in a unique way and I am more than happy to listen, learn and be entertained by the Captain, my Captain.

After all, maybe this explosion is symbolic of what is happening to our birdlife today. The disappearance of our world's habitats and the loss of so many birds are akin to an atom bomb (does anyone ever use that phrase any more?) being dropped upon our wildlife, which now faces daily destruction. Something has to give and it has to give soon.

If an exploding vulture can get a point across, then I'm all for believing every word that Ralph tells me, as there is more truth and reality in his pictures and words than any number of politicians spreading their deceit.

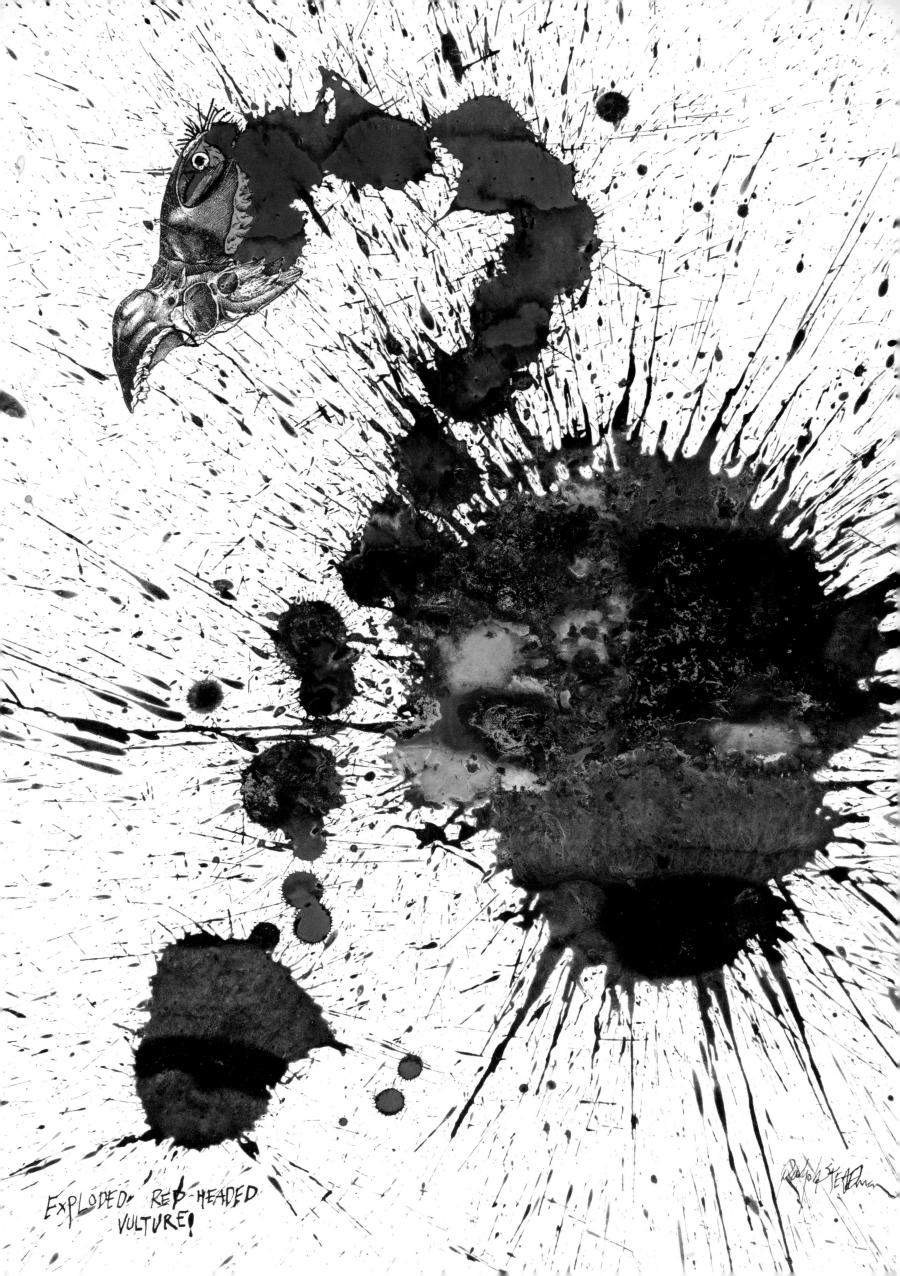

EXPLODED: RED-HEADED
VULTURE!

Medium Tree-finch

Camarhynchus pauper

The Medium Tree-finch is endemic to Floreana in the Galápagos Islands. Agriculture has decimated much of the finch's habitat and predation by introduced species is also affecting the birds, but the blood-sucking parasitic fly *Philornis downsi*, which dwells inside finch nests and causes 41% of nestling mortality, poses the largest threat. It is believed the fly has got a stronghold because the bird's habitat is next to land that has been cleared for fruit trees, which are a perfect domain for the fly. The agricultural area of Floreana has not been under the same protection as other parts of the islands, but successful attempts to reduce introduced species are helping the bird. Plans are also underway to find how to control this harmful fly. There is a hope that the national park will, in time, include this part of Floreana and then the future of this finch will be a cinch.

Mangrove Finch

Camarhynchus heliobates

This was a resident of Fernandina and Isabela Islands in the Galápagos, but it is now thought to be extinct on Fernandina, leaving it to fight for its existence in two small areas of mangrove habitat on Isabela. The main threats to it are the Black Rat, *Rattus rattus*, so bad they named it twice, other introduced predators such as cats and, once again, the nest-dwelling parasitic fly, *Philornis downsi*.

Ralph has written here that the Mangrove Finch loves bugs on cactus spines. What he means by this is that the finch is adept at using an actual cactus spine as a tool to dig bugs out of crevices in wood. Pretty smart, huh? And now someone needs to dig the species out of the hole it finds itself in. Work is underway to control predators and with time a translocation programme hopes to rebuild colonies of the bird to inhabit the mangroves once more.

Tired Splatter Finch

Camarhynchus defessus

The Tired Splatter Finch is the finch that Darwin and time forgot. Often overlooked because this boid is too tired to get out and about. In fact, it was he who first spied the HMS *Beagle* sailing towards land and he manically flew faster than he ever had and with more purpose as he told all his relatives about the incoming ship. Meanwhile, Darwin was looking out towards the island, hoping it wasn't going to be a duffer when he spied a fluttering crimson speck. Raising his scope to his eye, he cried out, 'Some kind of finch! Yikes, let's get ashore.'

Back on land the Splatter Finch spread the word that there were visitors coming to the islands and that everyone should greet them by forming a welcoming party. This would turn out to make Darwin's job so much easier and he had the Splatter Finch to thank for organising the hospitality. The only bird not to wait around to say hello to the disembarking crew members was the Splatter Finch. After his exertions in delivering the news across the islands he was exhausted and he headed back for a snooze deep in the forest. He woke much later than planned to see the boat was sailing off, and discovered a lot of his friends had gone too.

He thought it would have been nice to join them and be one of the infamous gang that was heading off to a new world, but he discovered that Darwin and his friends had not been so nice while he slept. They had killed a lot of his finch friends and were happy about this, apparently picking up the bodies and admiring them. Why like things when they're dead? They don't do anything then, he thought.

Darwin, having become so excited with his immediate finds at the time of disembarkation, had completely forgotten about the first red finch that he saw, and only when he was miles away did he realise that this was a specimen he had forgotten to take. He always regretted that he never looked for the crimson critter that began the whole chain of events that would lead to his theory of evolution. So there you have it: our little Tired Splatter Finch is unknowingly one of the great missing pieces of scientific history, as Darwin never mentioned the missing finch in his work. It is probably just as well, as the fame and the glitz would have been all too much for a little country island boy like the Tired Splatter Finch. But science owes him a big drink.

MEDIUM
TREE-FINCH

TIRED
SPLATTER
FINCH

MANGROVE
FINCH —
LOVES BUGS
ON CACTUS
SPINES

A FLINCH OF FINCHES

Ralph STEADman

Rougie Baby

Libero amori

'I was there in the summer of love, man!' states Rougie Baby. 'Haight-Ashbury was my street. I showed the Grateful Dead how to play, taught Timothy Leary how to tune in, put the psych in psychedelia and *Easy Rider* was my film, baby. I mean it was my story; those cats based it on what happened to me for real. I am the o-rig-i-nal Rougie Baby, baby! You know, I go back years, I have seen it all, brother. I remember when the Dodo was a real regular Joe-do. His demise was a no-go, a no-no, it was so low, what they did to him. Man, I've seen it all and a lot of it I have loved but what those people do to us birds is messed up.'

Rougie Baby is the genuine hippie throwback of Toadstool Island. He teaches yoga and transcendental meditation although is often too deep in thought to answer the door to prospective clients. This left-wing boideologist with his tripped-out speak and carefree ways is the free thinker of the community and is always presenting alternative lifestyles and ideas to the other birds. At the moment Rougie, also known as the Red Radical by the locals, is busy negotiating with the island's mayor, the Needless Smut, to obtain funding to grow fields of hemp and his main mantra these days is 'Hemp is the future and Darwin was a cat, man!'

Ceri Diary: Whether Darwin was a cat is uncertain, but Ralph found this early portrait of him as a monkey man. I tell you, evolution just blows my mind every time. I need a lie down and a cup of green tea. Peace out.

ROUGIE·BABY

Spix's Macaw

Cyanopsitta spixii

The Spix's Macaw is often referred to as the world's rarest bird and the truth is that it is probably extinct in the wild. There are about 120 or so individuals in captivity and that's believed to be it. It has been a funny old road for this bird, which was first collected in 1819 in Brazil by Johann Baptist von Spix, a German naturalist. He believed his specimen to be a Hyacinth Macaw and it was only posthumously that Johann Wagler, his assistant, identified it as a completely new species, and so Spix's Macaw came into existence. This rare parrot earned an immediately unwanted fame as collectors wished to own this brand new species, and hunters wished to find birds for the voracious appetites that needed to be sated. Consequently, continual captures led to the demise of the bird. Decimation of its natural woodland habitat has also been blamed for its disappearance. It is hoped that annual releases of captive-bred birds into suitable habitat may bring the macaw back from the brink of being a dead parrot.

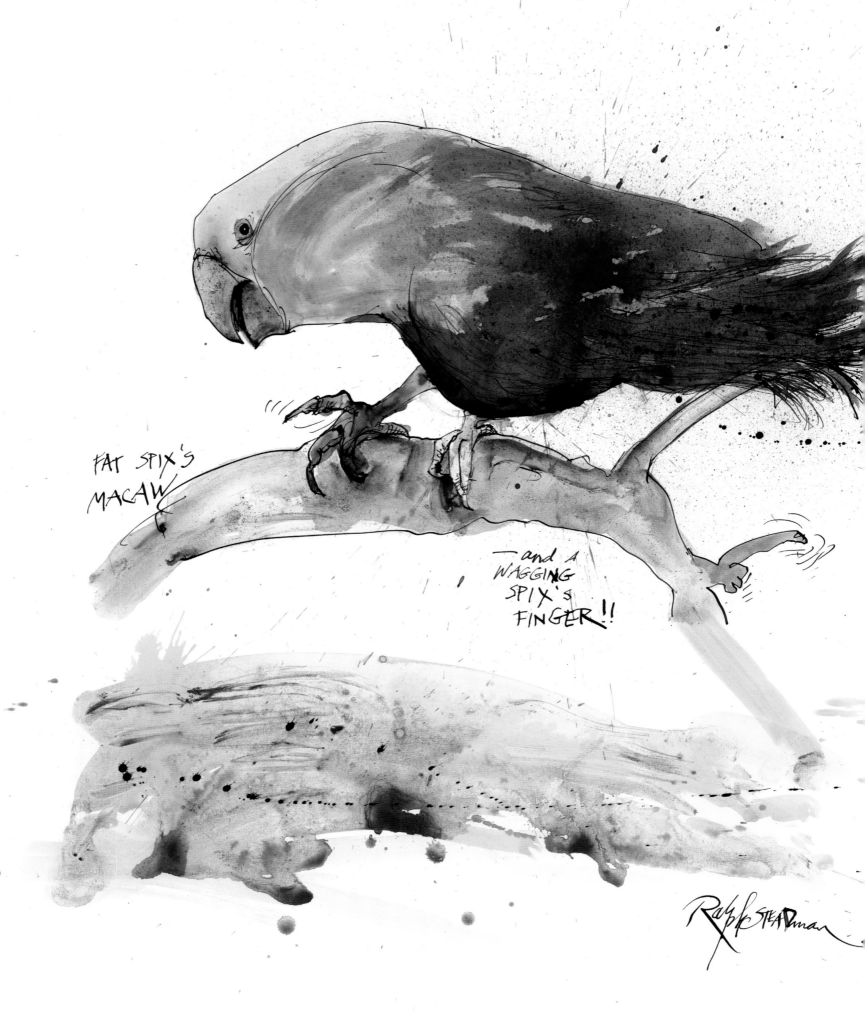

FAT SPIX'S
MACAW

—and a
WAGGING
SPIX'S
FINGER !!

Ralph STEADman

All for the Glorious Twelfth

The plight of the Hen Harrier

Phone:

Ralph: I've just sent you a mess…

I thought moment of impact, gunshots, bang, there's a story being told.

Ceri: I think it's a powerful and disturbing picture that people will appreciate on so many levels.

Ralph: It's not accurate, but it doesn't matter. It's an impact picture. I was throwing ink on the page and then I realised that the red ink was blood and so I carried on.

Ceri's Diary: It's no mess to me. It captures that awful moment when a majestic creature is shot down and the chaos that ensues from that 'moment of impact'. The bird's loss of control and where on its body it has been hit determine whether it plummets to the ground or haphazardly continues flying until it cannot do so any more. Then its descent to the ground can be one of the most saddening and distressing sights in the world as it relinquishes its power and its ability to fly. Much like a superhero having his or her superpowers removed.

The plight of the Hen Harrier in the UK is the worst-kept secret to those in the bird world, but more people need to know exactly what is happening with this beautiful bird. It's all for the sake of the "Glorious Twelfth" (12 August, the day the grouse-shooting season begins, which runs until December). The grouse-shooting industry is purportedly worth £60–£70 million and this is money that is well worth protecting. A day out on the moors a-shootin' can cost thousands of pounds to bag some grouse, and consequently the land is diligently cleared of possible grouse predators such as Hen Harriers, Buzzards, Peregrines, Foxes and Stoats. These are hunted fervently and there is usually only one outcome if a nesting pair of harriers is found on grouse territory. The Hen Harrier was once a widespread resident of the UK's moorland, but relentless persecution by gamekeepers has led to the numbers of harriers spiralling downwards and out of control. Only three pairs bred in England in 2014 and all had to be watched over and protected day and night. This cannot continue, as soon we will have no Hen Harriers left, and I defy anyone who has seen a Hen Harrier quartering a field in search of grub to be anything other than impressed by its grace, power and elegance as it hunts.

It can be said that much money from the hunting community goes into conservation and game management that has helped birds such as the Golden Plover, Lapwing and Curlew. However, there is a temptation to say that this is almost akin to hush money, as maybe I'm wrong but I can't find a mention of their money being spent to help any bird of prey. Is it fair or correct to save one species and not another? Can it be that so many grouse are taken by raptors that they are destroying a multi-million-pound industry? I don't think so.

Ralph: We are the biggest finger pointers in the world. People could go out 'finger pointer hunting' there are so damn many of them. Look closer to home and point those fingers inwards!

Ceri's Diary: It is very easy to point our fingers at issues abroad and be horrified at the amount of wildlife that is being killed in the name of sport all over the globe, but sometimes we should look closer to home and admit that we have a major problem in our own land. It may even be too late to have this discussion, but we owe it to the creatures that inhabit our land to stop this persecution now. In Scotland, raptor persecution is at its worst for five years and this cannot be allowed to continue.

There is nothing that sends a stronger message than a hunter putting down his gun forever. Look at Sir Peter Scott, who became one of the world's great conservationists. He was a keen hunter and shooter of ducks. But one day he saw an injured duck floundering in the River Severn and was unable to help. In that moment he changed and set about helping birds for the rest of his life.

Perhaps the Royal Family could learn from this example. They own a fair share of land in this country and we know that they are keen conservationists. I remember Prince William being moved by the plight of the hunted Black Rhino. But how to resolve that with the fact that he and other royals are keen hunters and recently he and his brother went shooting Wild Boar in Spain with the Duke of Westminster? This does nothing for their image as conservationists. If there is a genuine desire to help the world's wildlife, what better gesture could there be than for the Royal Family to put down their guns as Scott did all those years ago and publicly state that enough is enough? It would have a huge impact around the world and could be the shot in the arm that conservation needs right now. So what do you say, your Highnesses?

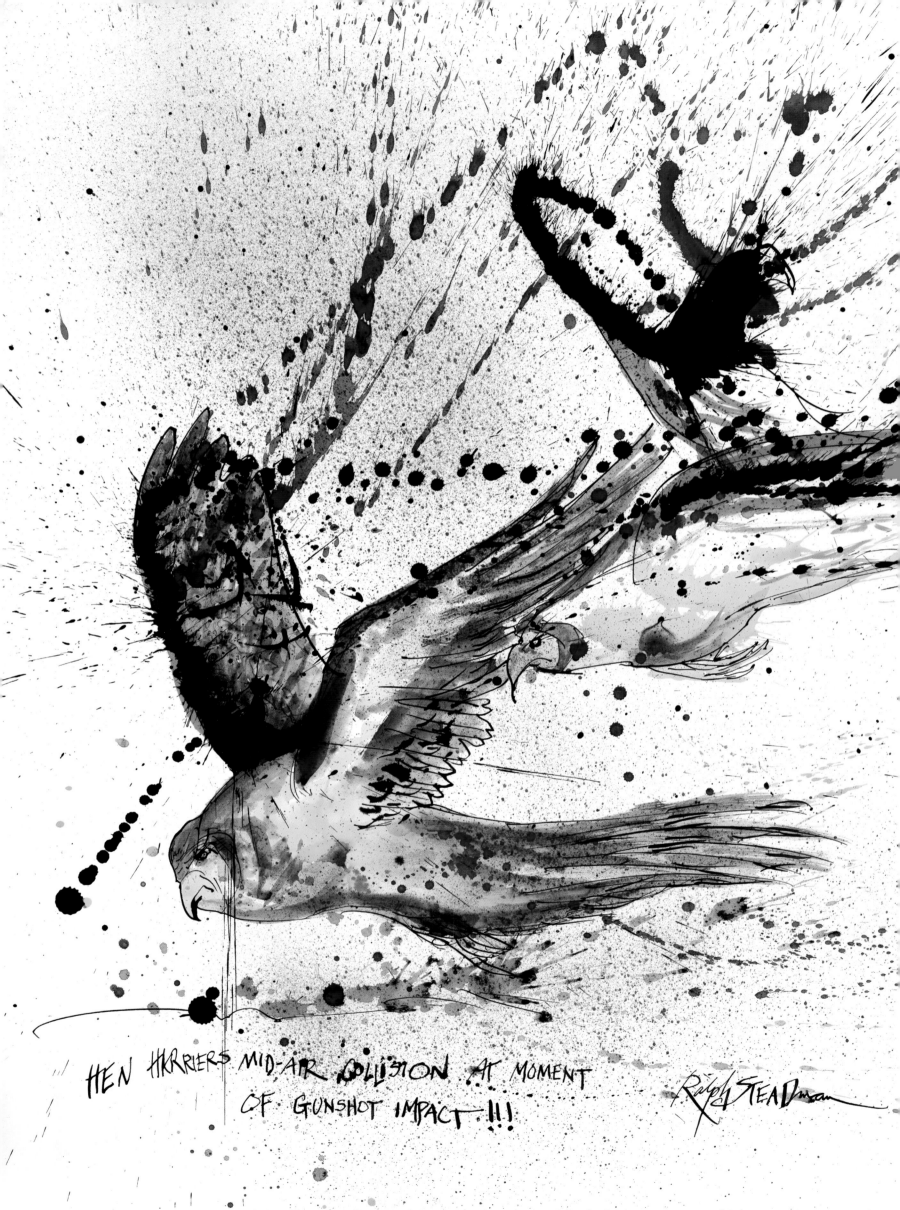

HEN HARRIERS MID-AIR COLLISION AT MOMENT OF GUNSHOT IMPACT !!!

Ralph STEADman

House Sparrow

Passer domesticus

The House Sparrow, or the Cockney Sparrer, for those Londoners who remember it as it fed, chirruped and hopped its way around London streets only a matter of years ago, is in trouble. Nextinction appears in many ways and although the global numbers appear safe, the sparrow has undoubtedly disappeared from many urban areas and is facing local extinctions across the world. In the UK it has a Red status as over 70% of the population has simply vanished, in particular from our cities. Does this suggest that urban modernisation is too much for them? Sparrows have always lived side by side with man, but now they seem to be disappearing from urbanity and those that have not died may well have moved to the country. These days life in the city may be too difficult for them to survive.

Have a look at sparrow headlines from around the world. 'COMMON BIRD GOES UNCOMMON', 'MYSTERY OF THE VANISHING SPARROW', 'INDIA BID TO SAVE HOUSE SPARROW' and the repeating headline of 'WHERE HAVE ALL THE SPARROWS GONE?' Good question.

Our relationship with birds has always been a strange one and none more so than with the mighty sparrow. In Britain during the First World War it became a persecuted species because of a fear the bird would eat all the wheat and destroy our grain supplies it was therefore considered to be an enemy of the people. Every parish would have its own sparrow-shooting club to deal with terminating flocks of these birds.

Mao Ze Dong did the same in the Great Sparrow War in the late 1950s, calling on the Chinese people to destroy the bird, again in order to save supplies of grain. Millions upon millions of sparrows died because of this directive. This report comes from a Shanghai newspaper in 1958 under the title, 'The Whole City is Attacking the Sparrows'.

On the early morning of December 13, the citywide battle to destroy the sparrows began. In large and small streets, red flags were waving. On the buildings and in the courtyards, open spaces, roads and rural farm fields, there were numerous scarecrows, sentries, elementary and middle school students, government office employees, factory workers, farmers and People's Liberation Army shouting their war cries. In the city and the outskirts, almost half of the labour force was mobilized into the anti-sparrow army. Usually, the young people were responsible for trapping, poisoning and attacking the sparrows while the old people and the children kept sentry watch. The factories in the city committed themselves into the war effort even as they guaranteed that they would maintain production levels. 150 free-fire zones were set up for shooting the sparrows. The Nanyang Girls Middle School rifle team received training in the techniques of shooting birds. Thus the citizens fought a total war against the sparrows. By 8pm tonight, it is estimated that a total of 194,432 sparrows have been killed.

In 1959, scientists discovered in autopsies that only a quarter of the material found inside sparrows was the protected grain; the other three-quarters were harmful insects. Ironically, locusts and other insects that would have been kept at bay if the sparrows had survived were destroying grain crops. A famine occurred and millions of people died. Nature had its revenge and the war was over.

History is littered with stories of the mishandling of our relationships with birds and we never seem to understand when we have gone too far and created an imbalance in nature. Birds are often the greatest indicator of problems in the world, hence the 'canary in a coalmine' scenario. The bird smells gas, is the first affected, falls off its perch and man is saved, and it's the same with habitat issues. If we take notice of what the birds are telling us about the world around us, we can make adjustments that could be beneficial to all.

Perhaps Ralph's gnarly and grumpy old sparrow has had enough of hanging out with humans and is setting off down the old straight and narrer road out of town and heading for a quieter life in the countryside. Who could blame him?

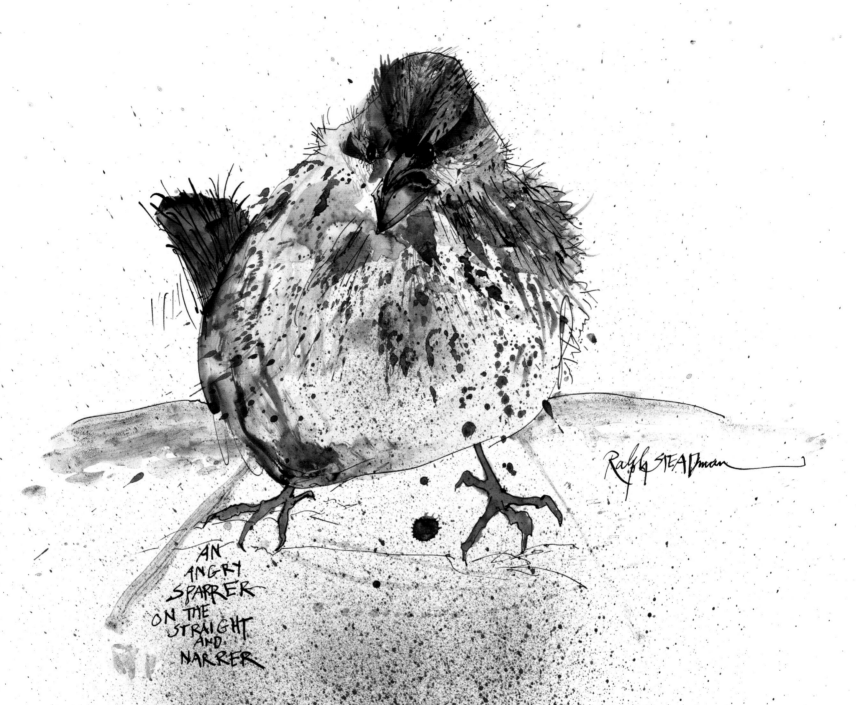

AN
ANGRY
SPARRER
ON THE
STRAIGHT
AND
NARRER

Ralph STEADman

Bali Starling

Leucopsar rothschildi

Not only is this a beautiful bird to look at but it is also a beautiful bird to listen to as it has an extremely melodic voice. These two factors have been its downfall, as they have led to it being desired by collectors. Consequently it has been hunted by poachers for the caged-bird trade to within a note of its final song. There are now probably fewer than 50 birds in the wild and the future is seemingly going to have one less song in the air.

The remaining wild birds live in the Bali Barat National Park, on the island of Bali, and captive-bred birds have been released to integrate with the flock. The Wildlife Conservation Society carries out surveillance at various key markets and trading points in Indonesia to ensure that the caged-bird trade is missing one particular voice.

Black-winged Starling

Sturnus melanopterus

The Black-winged Starling is endemic to Bali and Java but now and then has been found on other islands. Along with its friend the Bali Starling, this is one of the most prized songbirds in the caged-bird trade, especially in Java, which is notorious for its huge bird markets. It was until very recently a common bird, but now its numbers have declined rapidly thanks to the desire of the avaricious songbird collectors. It is believed that the population has declined by 80% over the last 10 years, leaving perhaps 600–1,700 mature individuals. These are shocking numbers for a species to lose. There is also the idea that pesticides are having a major effect and the truth of this needs to be ascertained. Control over the bird trade must be implemented and if deemed harmful then pesticides need to be controlled correctly.

There is a lot of work ahead to save these starlings, but much is being done to ensure these birds keep singing.

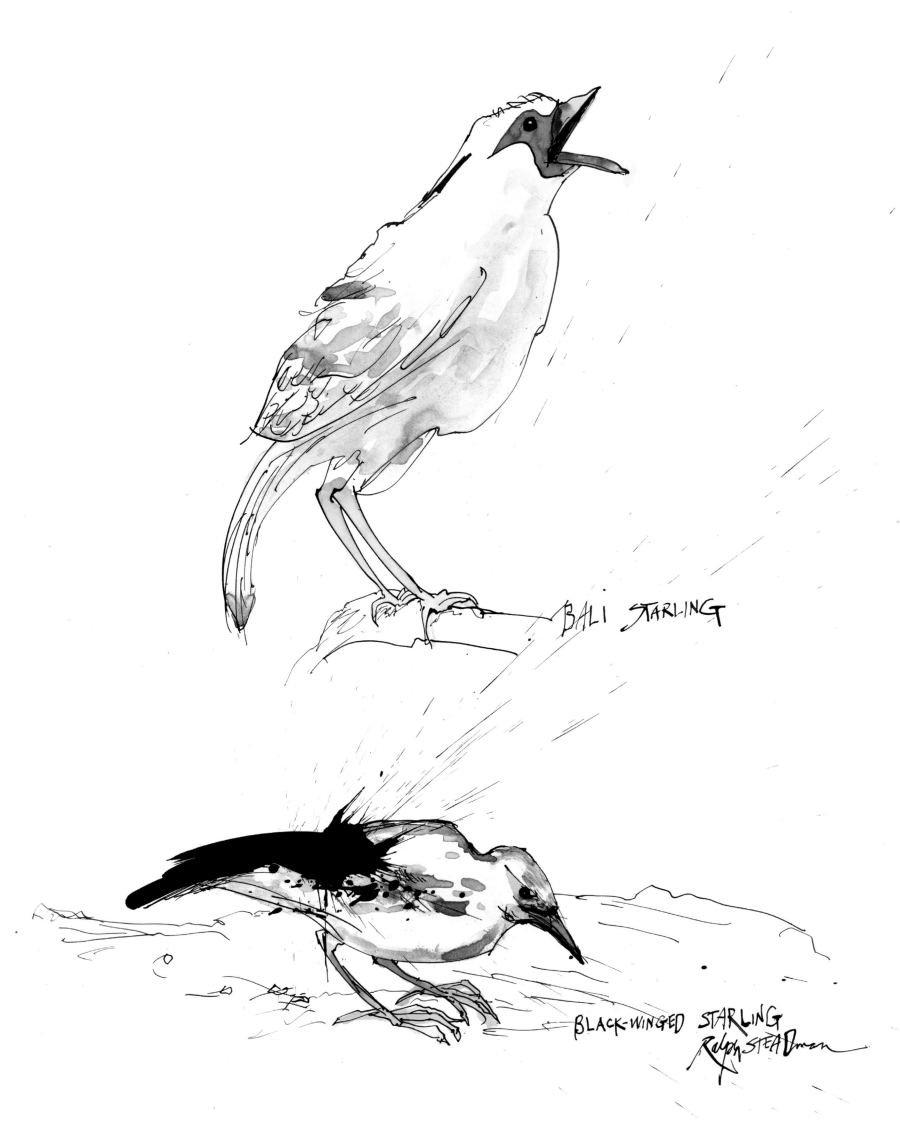

BALI STARLING

BLACK-WINGED STARLING
Ralph STEADman

Ceri: What do you call a know-it-all about birds of prey?

Ralph: I don't know, what do you call a know-it-all about birds of prey?

Ceri: An eagletist.

Ralph: And do you know what they call a know-nothing about birds of prey?

Ceri: I don't know, what do you call a know-nothing about birds of prey?

Ralph: An eagletit or an eagletwit.

Ceri's Diary: If there is one raptor I have been waiting to see enter this cavalcade of creatures, then it surely has to be the Philippine Eagle. It's such a peculiarly magnificent bird and Ralph has given it the right royal treatment, although in this picture the eagle looks a little world-weary and battle-worn. His expression is heart-wrenching as he forlornly thinks about everything he has been through and tries to work out why he is so persecuted. If ever there was a time that a monarch needed the support of its people then it's right now.

Philippine Eagle

Pithecophaga jefferyi

These magnificent regal raptors are Critically Endangered due to loss of their forest habitat because of logging, cultivation and potentially mining, but the greatest threat is that of being hunted for food by locals. A slow reproduction process also doesn't help, with a single chick being born every two years from one pair of birds that mate for life. Public-awareness campaigns, captive-breeding programmes and protection of the bird's forest habitat are all aiming to make a difference to this eagle, and its fortunes may soar once again.

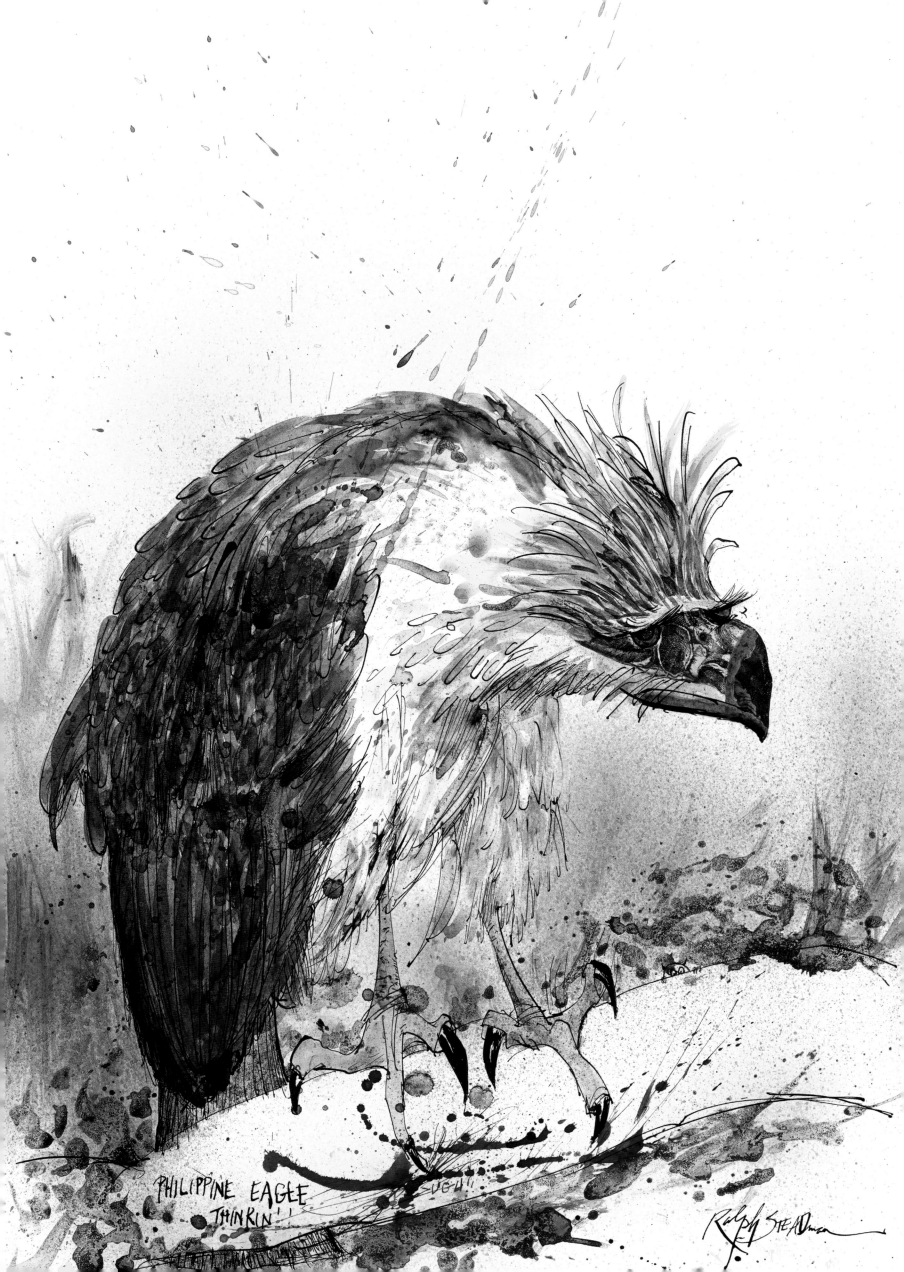

PHILIPPINE EAGLE
THINKIN'!

Ralph STEADman

Ceri's Maltese Diary: Thursday 9th April 2015
I am off to Malta to witness the referendum to decide on the future of spring hunting on the island. Every spring Turtle Dove and quail are shot down as they head north to breed and even though this practice is banned throughout Europe, Malta has a derogation, which allows spring hunting because it is claimed there are insufficient numbers of these birds for hunters to shoot during the autumn migration. Surely to shoot them in spring before they breed is tantamount to shooting a whole unborn family. Perhaps this is one of the reasons there are so few birds to shoot come autumn time. There is also the added truth that many other species migrating north are also shot down over Malta and spring hunting needs to be stopped.

Friday 10th April 2015
Having considered themselves the poor relations of Europe, the Maltese could change their perceived status from pariah to saviour in one fell swoop. All it needs is a big fat No to spring hunting. There is no doubt that after months of campaigning by the hunters and SHout (Spring Hunting Out) the country is split, families are split and the balance is precarious, but seemingly swaying towards the banning of spring hunting. The 'SHout' campaign has been drumming up a huge amount of support on the island and the latest polls indicate the No (to spring hunting) vote to be ahead by between 7–9%, which seems like a pretty decent lead to me. Malta has a unique opportunity to become the conservation trailblazer of Europe, where the people have been presented with the opportunity to effect real change for the lives of European birds. I trust the Maltese to make the right choice. Surely more than half of the island must be against the needless slaughter of birds? Mustn't they? We will see, but the signs are good. People who had no idea about the issue of hunting in their country are now more informed and on Saturday will prove exactly what they have learnt. Let's hope they show themselves to be wise students.

I have met up with my old friend, BirdLife Malta's Conservation Manager, Nik Barbara and we head for lunch with old and new friends. Here are new faces continuing old work, while old faces have come back to Malta for this momentous weekend. There is an air of expectation and I find a tear wells up from within. A tear of harmony for these people who are sat here and for all those whose tireless fight over decades may finally have their day this weekend. Is hunting a sport? Football, cricket, rugby, tennis, these are sports but none of them involve the deliberate death of any person or creature. This referendum is for all those birds, which have lost their lives here on Malta; it is a memorial to them and a marking point for the future generations of birds, which after Sunday, should gain safe passage over this island.

Phone:

Ralph: Here is the *Steadmanitania*. That's us on the deck.

Ceri: I love it. And you've captured my best side. It is the finest stick-man rendition I could have hoped for. I treasure it. You look pretty good too.

Ralph: The sign writer who painted the ship's name had a terrible stutter.

Ceri: I believe it was Sidney Stammers who did it.

Christmas Island Frigatebird

Fregata andrewsi

The Christmas Island Frigatebird is endemic as a breeding bird to Christmas Island in the Indian Ocean. This puffed-up bird is looking to attract a mate. The problem is there are not that many birds around for him to attract. The most recent survey in 2003 suggests the population stands at between 2,400 and 4,800 mature individuals. If figures are correct then it is believed that the population has dwindled by 66% in the last three generations, hence it is considered Critically Endangered.

So what are the threats to the bird? Phosphate mining back in the 1940s was responsible for clearing approximately a quarter of the frigatebird's breeding grounds, and resultant dust fallout from the mine saw off one colony at Flying Fish Cove. Other issues have been marine pollution, getting caught in fishing lines and also overfishing. Future plans for mining may also threaten the bird, and there is the possibility that introduced Yellow Crazy Ants (again not a Ralphism) may present a problem in the near future. Attempts at total eradication of these ants have so far proved unsuccessful. The frigatebird only breeds once every two years and then only one bird fledges, so everything is being done to secure its future. A survey is needed to study the birds' success rate in breeding, mining needs to be halted near the colonies and the ants need to be cleared from the island. Then perhaps it will be a merry Christmas Island.

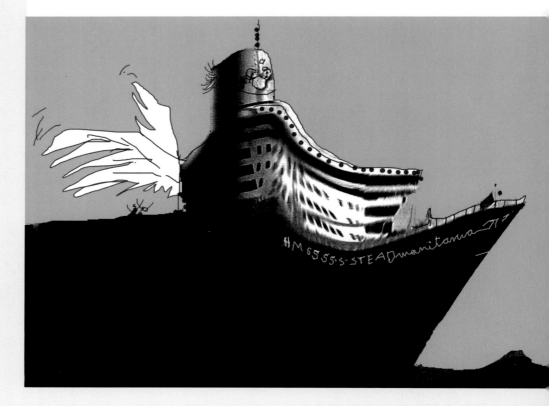

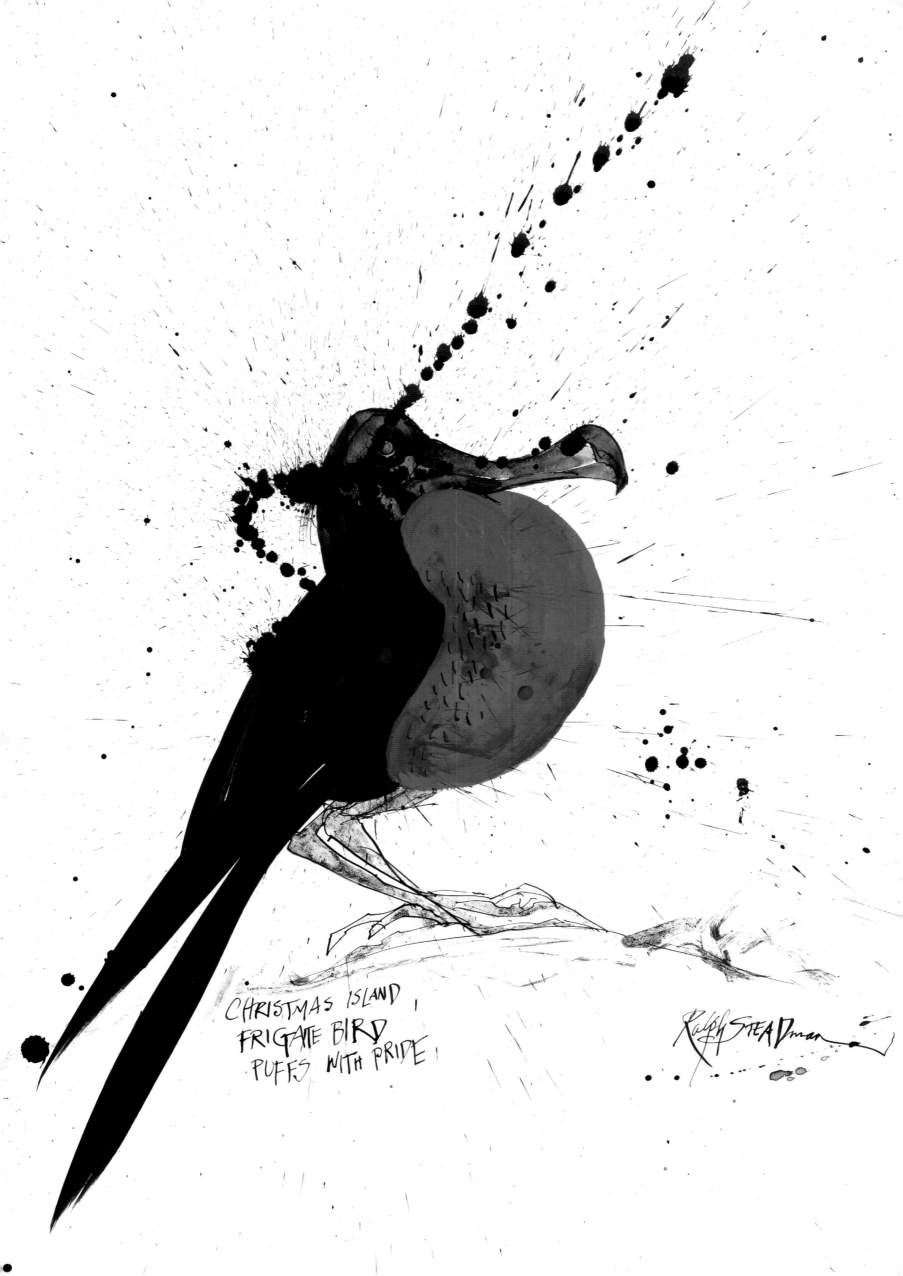

CHRISTMAS ISLAND
FRIGATE BIRD
PUFFS WITH PRIDE

Ralph STEADman

Ceri's Maltese Diary: Saturday 11th April

Hope is in everyone's hearts, minds and steps. It is the day of reckoning and I am going to the polling stations to gauge the atmosphere. People cannot congregate or gather within 50 metres of the polling stations to avoid harassment and arguments breaking out. On the 50-metre marks, which are sprayed on the pavements in green ink, there are always groups of hunters and it feels intimidating to walk through them to get to the stations. There is tension in the air and perhaps this is because the hunters fear they may lose the vote. One of the BirdLife staff is having their picture taken with her voting card by a friend and suddenly there is uproar as the hunters surround us and call the police over. They are objecting to the photo being taken as they were standing in the background. A lot of shouting takes place and then one hunter makes a move towards me and whilst trying to push me over, attempts to grab my camera and throw it to the floor. I defend my corner without resorting to violence – the last person I hit was when I was eight – and then give him a mouthful of my opinions, which surprise me with their vehemence. He backs off and the police, once they have seen the offending photo deleted, ask us to move away from the scene. Tensions are running high.

The rest of the day I spend in a yellow London taxi helping ferry disabled and elderly people to various polling stations. And finally the voting stops at 10pm. There has been a 75% turnout, which is pretty impressive. All we can do is wait until the morning to see the outcome.

Sunday 12th April 2015

We congregate at our hotel to watch the result live on TV. Nik and his co-workers are in the counting hall as are the hunters seeing how it all unfolds. We hope to hear the outcome before the TV station does.

A phone rings and we are told it doesn't look good, then it rings again. We have lost. We look at the TV, which doesn't have this news yet. We hope they know something our people inside the counting hall don't. But then the TV tells us it is true. It has all happened in a matter of moments, a rapier thrust and we are rent asunder, terminally sliced apart. There is nothing left to do but cry…

The hunters are travelling around the island in carcades, firing blanks up into the sky, cheering and celebrating as if they have won the World Cup or a World War when in fact all they have done is won the right to kill wildlife. I don't understand people. How can this be a celebration? I am too dazed to comprehend anything.

Ralph emails:
Question: Is a sad pie crustfallen?

Now it is COLD and this morning I awoke with shocking muscle pain, which I tracked down to the region high above the RECTUM-ANUSdelSIGMOID-FLEXURE!!! In fact I have been studying my Anatomy Books for most of the day – and the pain has subsided to subsumus levels… I will keep you informed – it will not galmulate beyond a certain finctus anolaizalitumaticus rasp!!

Here is…

Dwarf Olive Ibis

Bostrychia bocagei

This Critically Endangered forest-dweller is found in the region of São Tomé, São Tomé e Príncipe, which is Africa's smallest state. The ibis head count is pretty small too, with numbers estimated to be between 50 and 249 mature individuals.

Even though in the past cocoa and oil-palm plantations have been responsible for the clearance of much lowland forest, as has the conversion of wooded private land into farms, these are not considered the main threat to the ibis right now. Hunting seems to be the principal offender; for example, in 2006, 16 birds were shot, and there have been other incidents and deaths. Expansion of cocoa plantations and restoration of oil-palm plantations may affect the habitat in the near future. African Civets, Mona Monkeys, Black Rats and Weasels are also a predatory threat. Law enforcement is essential to ensure that the protected forest remains exactly that – protected. Awareness-raising campaigns for the local community have taken place and local people are being taught how to work as conservationists on behalf of the bird. Ecotourism could hopefully give locals jobs as bird guides and it is thought that a captive-breeding programme may be worthwhile.

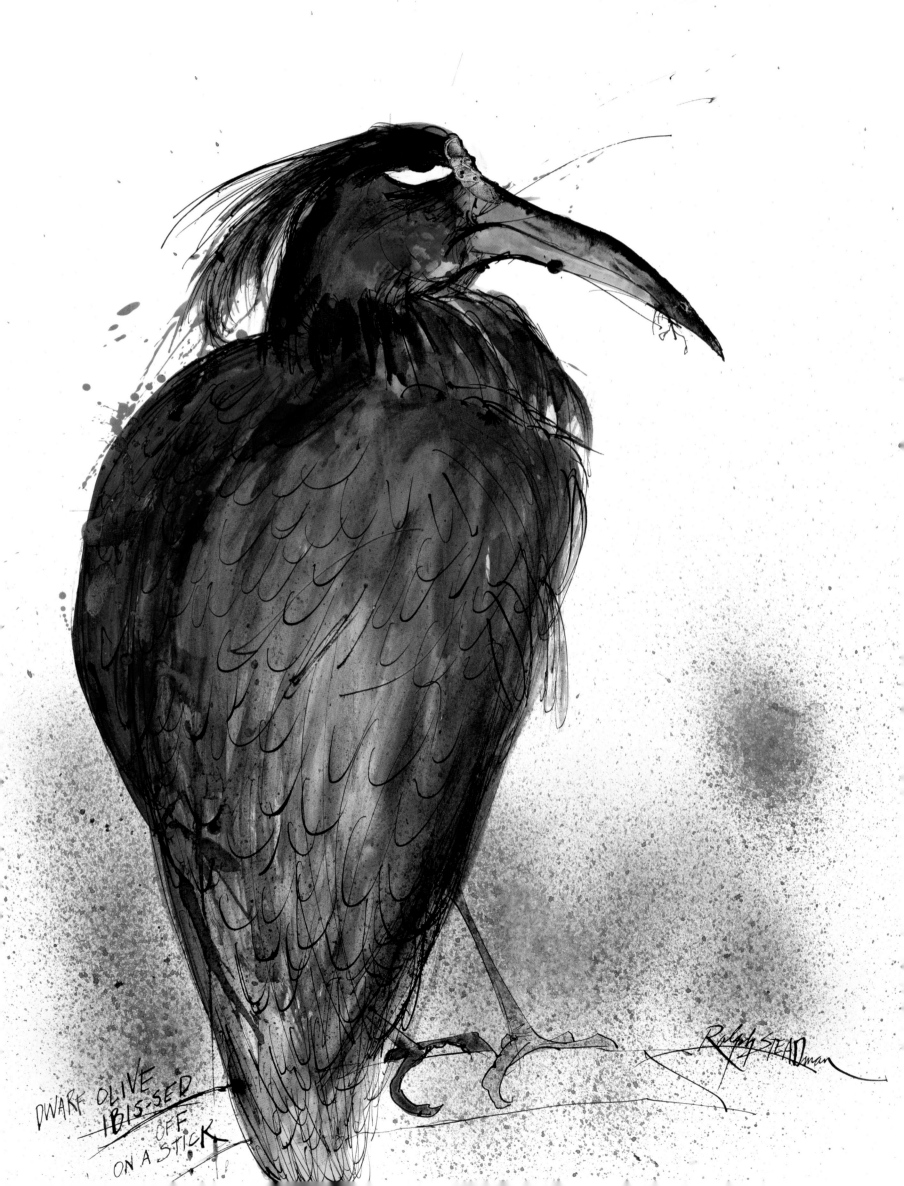

DWARF OLIVE
IBIS SED
OFF
ON A STICK

Ralph STEADman

The facts: the Referendum was lost by 50.4% to 49.6%. So marginal that I am surprised there wasn't a recount. This figure equates to 2,220 people on an island of nearly half a million that have made the difference.

The Prime Minister, Joseph Muscat, makes a statement that this is the last chance saloon for the hunters and no illegal activity will be tolerated and anything untoward will bring about the end of the hunting season. Let's see if he is a man of his word.

For those that don't know, the spring hunting season starts first thing tomorrow morning. It's back to the grindstone and time to protect the birds again as they are not safe. Not safe at all...

BirdLife Malta's President, Geoffrey Saliba has this to say, 'the referendum has been lost by a very few thousand votes. This means that virtually half the people of Malta voted in favour of life and in favour of nature. Half the population want things to change, and this is not something one can ignore. As even the Prime Minister said, the picture has now changed forever'.

Ceri's Diary: This is a vigorous rendition of this vulture, which is apparently vulching. It's a new verb to me, but why not? It makes as much sense as the rest of the book. I vulch, you vulch... Let's all do the vulch. Could join boiding as the next great dance craze.

Indian Vulture

Gyps indicus

The Indian Vulture breeds across south-eastern Pakistan and southern India. The bird has always been adept at living alongside humans and is regularly found in or near towns and cities, living off the human detritus and scavenging at rubbish dumps and wherever it can find a tasty snack. It has always played an important role in India's ecosystem, often being responsible for clearing away animal and human remains. The number of mature individuals now stands at 30,000 and it is believed that the Indian Vulture lost more than 97% of its population in the mid-1990s due to feeding on carcasses of animals that had been treated with the drug diclofenac. As discussed earlier in the book, this has also affected other species of vulture. A second drug, ketoprofen, has also now been identified as a vulture killer, and hopefully this will go the same way as diclofenac and will disappear from use.

Reparation for the vultures has been difficult but slowly the future is looking brighter for them. Meloxicam has been proven to be a safe alternative to diclofenac and it is hoped that this drug will be taken on board and used by everybody concerned. Diclofenac is still being used illegally, but it is hoped that awareness programmes will change people's minds and get them to use the new harmless medicine instead. A diclofenac destruction event held in Nepal in 2010, when many vials of the drug were ceremoniously destroyed, can only help spread the news of the danger that vultures face. Safe feeding sites have been created as well across the Indian subcontinent. Vultures also play a major part in the consumption of dead human bodies in the sky burials of Nepal and Tibet. With an enormous amount of effort, vultures may be able to continue their work on our behalf without any more of them being buried. Let them eat humans!

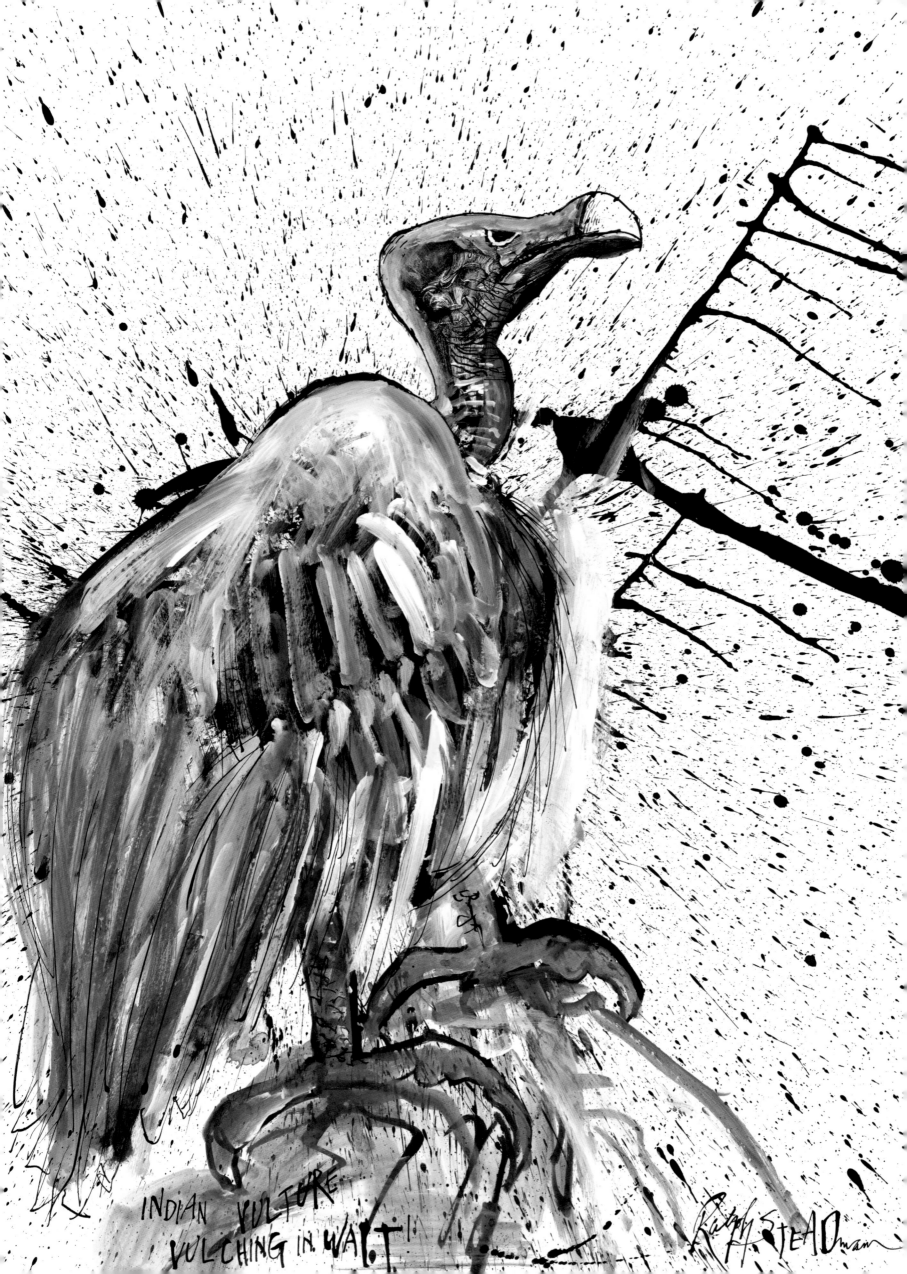

INDIAN VULTURE
VULCHING IN WAIT!

Ralph STEADman

Liben Lark

Heteromirafra sidamoensis

On a small piece of grassland, measuring no more than 36 square kilometres, on the Liben Plain in Ethiopia lives one of the world's rarest individuals, namely the Liben Lark. It is estimated that this bird could become extinct within the next two to three years and the race is on to save it from this end. The population crashed by 40% between 2007 and 2009 and the numbers now total between 130 and 390 mature individuals; it doesn't help that there are far more males than females in the community. Humans encroach ever further into the bird's habitat and permanent cultivation of land is the major threat to the lark. Grassland is being continually lost to this cultivation, and overgrazing is also a huge problem. Once the local people were nomadic; they worked the land when they passed through and would then move on. But now there are more people than ever within the area thanks to the influx of refugees from many neighbouring war-torn and starving regions.

Encroachment by vegetation and scrub is also creating an enormous problem for the habitat, although recent clearances of the scrub have had a noted success. In 2012, 25 male larks were heard to be singing, and five were on cleared patches of grassland that had not held any birds since counts had begun in 2007. Surveys hope to find an answer to stop the extinction of this lark, and work is continuing to clear the scrub and to create non-grazing land. Even though help cannot happen quickly enough there is definite *liebe* being given to the Liben Lark.

Raso Lark

Alauda razae

Once found across several islands in the Cape Verde archipelago in the Atlantic Ocean, the Raso Lark is now only found on the uninhabited Raso Island: human settlement in the 15th century finished the bird off elsewhere. The species responds to rainfall, which is essential to its well-being during the breeding season, but unfortunately the rain in this part of the world is becoming ever more erratic. Predation by geckos and introduced cats, rats and dogs, especially ones that may have come ashore from fishing boats, has also been a threat to the bird. However, the island is currently mammal free. Population surveys are carried out yearly to ascertain the levels of the lark population and work is being carried out to understand the necessary conditions for successful breeding. It is important to make fishermen and tourists aware of the dangers the birds face when animals are brought onto the island. There is also talk of establishing a second colony of larks on another island.

Speckled Odium

Maculosus odiosus

This bird is an odious creature, a miserable wretched being and one that prefers a solitary existence. Its twisted DNA has sired the creature known as… The Speckled Black, the devourer of nature.

Tweeter

Perpetuus admonitio

Speckled Black

Nextinctus terribilis

And here we have the most surprisingly symbolic picture. This tiny little creature, this Tweeter, seems to be defiantly standing there in the face of the Speckled Black's rage, blackness and nextinction. And we must stand defiantly with the Tweeter and not allow more and more birds to disappear from sight. The Speckled Black *is* nextinction and nextinction is for the most part created by man.

This journey on board the HMS *Steadmanitania* has taught me that something can always be done to help our endangered creatures, and help we must. Nature is no longer in control of its own extinctions, as our adaption of the world has accelerated extinction beyond the natural rate for many species and left a new set of manmade rules, which wildlife has found hard to accept and even harder to play by.

I regularly place a lot of the blame for much of the world's problems at the doors of corporations, conglomerates, banks, supermarkets, pharmaceutical companies, oil companies and the fishing industry, etc, etc... I can make the list endless, but two things they all have in common is that humans run them, and money wins out over the planet every time. We have to redress this balance and we need to reconnect with the world around us. We are in the sixth age of extinction and this one is pretty much down to us and our unique use, or abuse, of the planet. Birds are the greatest indicator of ecological imbalance and when they disappear the drama of our collapsing ecology will unfold further. We must listen to the birdsong and understand what it signifies, take note and change. It is not too late. For millennia, nature has allowed us to coexist within its world, but now we have become so powerful we need to return the favour and allow nature to coexist within our world.

Just watching birds go about their lives can bring a tranquillity that is often missing from our own speed-driven daily chores. Slowing down occasionally and stepping into nature can be so therapeutic, good for the mind, good for the soul and a tonic for the spirit. After all a walk without birdsong is just a walk, but a walk with birdsong is an affirmation of life, an experience that often lifts our hearts. It is essential to keep those bird notes, whether bum notes or pure, ringing in the air as a reminder that there is a whole wild world out there that cares not a jot about our mortal ambitions but is permanently affected by them. In this case, silence would not be golden.

Dawn chorus: let's take it from the top…

Ralph emails:
This is one for the gloom gluttons! To cheer their day up. It's a flutter of colour.

Ceri's Diary: This sighting of the Rainbow Lorikeet is the last flourish at the end of the *Steadmanitania's* long journey as Ralph plots our course out of here. In my Captain I trust.

Ralph: Weigh anchor, Very Petty Officer Levy!

Ceri: Twelve stone, sah!

Ralph gives one long blast on his penny whistle, stokes up the engine and we head away from the dark side of the island. I look back and I am certain I can see wings waving us off. I watch Cap'n Essence as he steers us away from these murky waters and into welcoming turquoise sea... We are on our way home and I am proud to have served alongside the true captain of nextinction on yet another adventure.

Ralph: Right then, what about the Regal Tweegull, the Glass-eyed Green Eye or the Pernicious Mould...

Ceri: Put the pen down, Ralph, it's time to stop. Let's have a cuppa...

++ STOP PRESS ++ STOP PRESS ++ STOP PRESS ++ STOP

Malta Spring Hunting Season Halted

A man has been sent to jail for one year and fined €5,000 for shooting a Kestrel outside St Edward's College. The shot, injured bird dropped from the sky into the school's courtyard as the children were on their break. Some hunters just haven't been able to control themselves, and the Prime Minister of Malta has finally taken action and stopped the spring hunting season early, thus bringing the killing of migratory species to a halt. Will there be a spring hunting season next year? We will have to wait and see. For now there is safe passage for birds over Malta.

++ STOP PRESS ++ STOP PRESS ++STOP PRESS ++ STOP

Rainbow Lorikeet

Trichoglossus moluccanus

The Rainbow Lorikeet is considered to be a bird of Least Concern, so it must be time to say goodbye. This picture gives me great joy and swells the heart with happiness that such a creature is flying free and is not endangered. This is how a bird should be; this is how the world should be. Spread your wings and fly free, little fella.

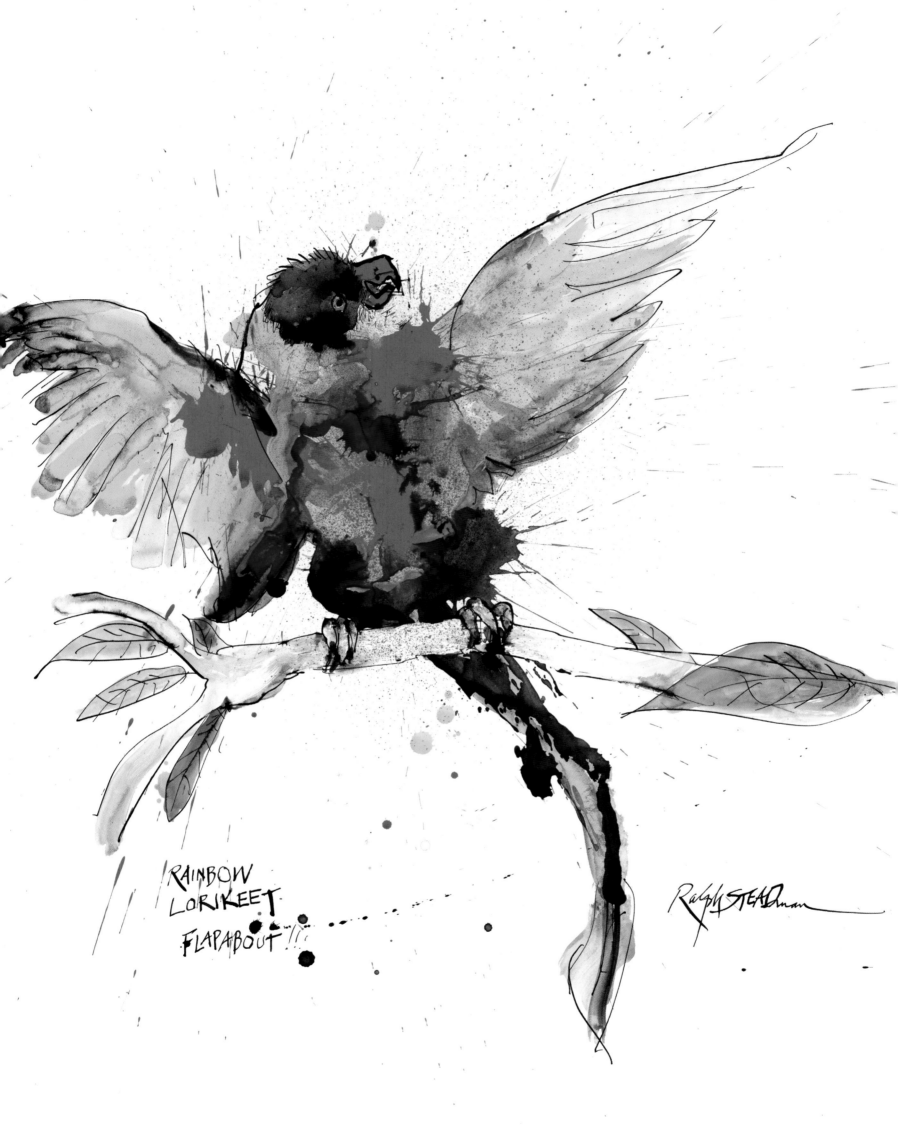

RAINBOW
LORIKEET
FLAPABOUT

Ralph STEADman

5

19

21

23

25

27

29

31

33

35

37

39

41

43

45

47

49

51

53

55

57

59

61

63

65

67

69

71

73

75

77

79

81

83

85

87

89

91

93

95

97

99

101

103

105

107

109

111

113

115

117

119

121

123

125

127

128

131

133

135

137

139

141

143

145

147

149

151

153

155

157

159

161

163

165

167

169

171

173

175

177

179

181

183

185

187

189

191

193

195

197

199

201

203

205

207

209

211

213

215

217

219

The Butterbird would like to thank:

Jackie Ankelen

Anna Steadman

Sadie Steadman

Grace Jenkins – Studio Archivist

Daniela Galvez Fountain

Triana Galvez Fountain

Ollie Williams

Toby Williams

Bloomsbury People – Jim Martin

Jasmine Parker

Marina Asenjo

Nigel Redman

Liz Shaw

Caroline Taggart

Julie Dando, Fluke Art

Nat Sobel and Adia Wright at Sobel Weber Associates, Inc.

BirdLife International – Jim Lawrence

Martin Fowlie

Ade Long

BirdLife Malta – Nik Barbara, Steve Micklewright, Caroline Rance,
Nick Piludu, Rupert Masefield, Geoffrey Saliba, Nimrod Mifsud

Rob Sheldon

Jimi Goodwin

Jeff Barrett and the Caught By The River crew – Robin Turner,
Andrew Walsh, Danny Mitchell and Carl Gosling.

Lady Catherine Saint Germans and the Port Eliot Festival

Ceri's Bird Effect diaries can be found at
www.caughtbytheriver.net/category/the-bird-effect/
www.thebirdeffect.com

Ralph and his work can be found at www.ralphsteadman.com

Many facts taken from the BirdLife Data Zone
www.birdlife.org/datazone

Recommended Reading:
 The World's Rarest Birds by Erik Hirschfeld, Andy Swash and Robert Still,
 published by Princeton University Press.

Artwork photographed by Grace Jenkins, other photographs by Ceri Levy.

This book has been printed with 100% collected and tinned guano.